"This book is a living archive ma —all of which are connected to real strug sure of genocidal crimes to neoliberal au: otests. *Grupo de Arte Callejero: Thoughts,* ho and resonate with other processes an graphy for other spaces. These pages trace the collective trajectory of a unique group that brought art to the streets, opened the streets to intervention, and most importantly, suffused intervention with subversion."

—Verónica Gago, author of *Neoliberalism from Below: Popular Pragmatics and Baroque Economies*

"Group de Arte Callejero's is a cartoguerrilla collective searching for justice 'from below,' in a city (Buenos Aires) and nation (Argentina) mired in amnesia. Their two decades of art activism constructs a street-level counter-history that methodically disturbs the complacency of the present. This timely and crucial book maps projects and theories concerning art and society, aesthetics and activism, but it is also a detailed dossier documenting Grupo de Arte Callejero's exemplary practice of publicly haunting those who fail to remember."

—Gregory Sholette, author of *Delirium and Resistance: Activist Art and the Crisis of Capitalism* and *Dark Matter: Art and Politics in the age of Enterprise Culture*

"Grupo de Arte Callejero takes up every aspect of art-making as a political question: not only what they make, but how they make it, with whom, and to what end. Most importantly, their work demonstrates the very real possibilities for art to contribute to social movement praxis, and even to amplify the most radical dimensions of movements. This book should be read by anyone interested in intersections of art and politics, radical human rights activism, and contemporary grassroots politics in Latin America."

—Jennifer Ponce de León, author of *Another Aesthetics is Possible: Arts of Rebellion in the Fourth World War*

"What you hold in your hands is a significant contribution to the history and practice of socially-engaged art and movement culture across the Americas. Grupo de Arte Callejero's *Thought, Practices, and Actions* allow us to consider their diverse range of concerns such as monuments, social memory, financial crisis, and policing with tactics and forms such as mapping, murals, graffiti, street installations—all with a high level of self-theorization, a healthy dose of self-critique, and a commitment towards impact and transformation.

Grupo de Arte Callejero is a true inspiration for anyone thinking about how to use images and poetics in collectively transforming a deformed political culture. At a time when digital text and image memes are shaping political imagination and discourse, there is not a better occasion to reflect on the work of those image-makers who put their bodies on the line."

—Daniel Tucker, author and curator of *Organize Your Own: The Politics and Poetics of Self-Determination Movements*

"Grupo de Arte Callejero brings us into a moment of heightened resistance, where artists are on the frontlines of calling out injustice through urban intervention and creative direct action. Rarely do we get to read such intimate insight as this collective has carefully chronicled and documented in their journey. Their work serves as a powerful example of how during moments of crisis and uncertainty artists can help bring focus, strategy and creative energy to propel us forward."

—Raquel de Anda, independent curator and cultural organizer

"This book is a much-needed overview of one of the most radical art collectives in the hemisphere. With critical contributions by Brian Holmes, Colectivo Situaciones, and many of the GAC's own members, Grupo de Arte Callejero's *Thought, Practices, and Actions*' shared methods, thorough documentation, and multiplicity of voices, stand out as an invaluable tool in the art of social transformation and the struggle for collective justice."

—Pedro Lasch, artist, professor of Art, Art History, and Visual Studies at Duke University, and author of *ART of the MOOC: Activism and Social Movements* with Creative Time

GRUPO DE ARTE CALLEJERO

THOUGHT, PRACTICES, AND ACTIONS

Grupo de Arte Callejero: Thoughts, Practices, and Actions
Grupo de Arte Callejero

Contributing members of *Grupo de Arte Callejero: Thoughts, Practices, and Actions*:
Lorena Fabrizia Bossi, Vanesa Yanil Bossi, Fernanda Carrizo, Mariana Cecilia Corral, and Nadia
Carolina "Charo" Golder; grupodeartecallejero@gmail.com. Some texts written in collaboration with
Rafael Leona, Colectivo Situaciones, and Mesa De Escrache Popular.

Translated by the Mareada Rosa Translation Collective. Special thanks to John Bohn, Alberto Garcia
Guerra, and Laura Gottesdiener for editorial assistance.

ISBN: 978-1-942173-10-6
LCCN: 2019942766

Common Notions
314 7th Street
Brooklyn, NY 11215
www.commonnotions.org
info@commonnotions.org

Design and typesetting by Morgan Buck and Josh MacPhee
Antumbra Design | www.antumbradesign.org

CONTENTS

ACKNOWLEDGEMENTS

To those who formed a part of Grupo de Arte Callejero—Lorena Merlo, Violeta Bernasconi, Pablo Ares, Las Rafaellas, Rafael Leona, Federico Geller, Sebastián Menasse, Alejandro Merino, Leandro Yazurlo "Tato," Marcos Luczkow "Santo," Juan Rey, Abel Orozco, Pablo Lehman, Natalia Mazer, Pablo Debella, and Ignacio Valdez—*gracias.*

Our additional thanks goes to the following individuals and collectives: Luciana "Luchi" Del Mestre, Juana and Carmela Imperiali Golder "Las Melli," Alejandro Imperiali "El Cuervo," Flora Partenio, Cristian Huiller, Caro Katz, Teresa Orelle, Solana Dubini, Karina Granieri, Leo Ramos, Marcelo Expósito, Ana Longoni, Sebastián Hacher, Beatriz Rajland, Antonia Dodaro, Cecilia Dekker, Olga (Rafa's mom), and Valerio Talarico.

Verónica Castelli "Verito," Carlos Pisoni "Charli," Lucila Quieto, Florencia Gemetro, Florencia Angeli, Laura Bondarevsky, Paula Maroni, Eduardo De Pedro "Wado," Gustavo Khun, Gabriel Salomón "El Gallina," El Mota (from Tucumán), Federico Casinelli, Emiliano, Marcia Recalde, "La Rusa" Karina, La Pepa, Walter, Miguel Santucho "El Tano," Pablo del Valle, Raquel Robles, Lola, Karina "La Gallega" Germano López, Nahuel Baglietto, Andrés Centrone "Potato," Mariano Porta, Mariano Walsh, Mariano Tealdi, Mariano Robles, Flavio Reggiani. Mariano Levin "Nito," Viviana Vázquez "Vivi," Sergio Segradel "Chacho," Florencia Lafforge, Ivo y Kelo, Alejo Rivera "Hijitus," Diego Genoud, Gustavo and Gabriela Bustos, Julieta Colomer, Hernán Cardinale, and Eduardo Nachman.

H.I.J.O.S. from Capital, Zona Oeste, La Plata, Zona Norte, Córdoba, Rosario, Santa Fe, Chaco, Tucumán, Madres de Plaza de Mayo Línea Fundadora, and Mesa de Escrache Popular.

Etcétera, Mujeres Públicas, Iconoclasistas, Colectivo Situaciones (Verónica Gago, Natalia Fontana, Mario Santucho, Diego Sztulwark, Edgardo Fontana,

Sebastián Scolnik, Ignacio Gago, Andrés Braconi, Diego Picotto), Editorial Tinta Limón, Taller Popular de Serigrafía, and Erroristas.

Loreto Garín, Nancy Garín, Federico Zuckerfeld, Ariel Devincenzo, Luciana "La Negra," Checha, Manuel Perrone, María Eva Blotta, Martín Bergel, Ezequiel Adamovsky, and Marilina Winik.

"Marol," Rodrigo Paz, Manuel Palacios "Manupa," Pablo Boido "Soncho," Tomás Eliaschev, Pablo Indio, Cecilia Fernandez, Eluney Caputto, Pelin, Pablo (the neighbor of Charo), Gabriel Baggio "Gabo," Nico Levin, Ignacio Ames, Roberto "Beto" Pianelli (representative of Metrovías). Manuel Ablin, Valeria Manzitelli, Beo, Pulika, and Julia Masvernat.

Frente Popular Darío Santillán, Es-cultura Popular, La Tribu FM, Cooperativa Sub, Delegados de Metrovías, Simeca, NBI, TNT Economía, Intergaláctica, S26, Cine Ambulante, Nacho and Diego.

Cine Insurgente, IMPA, MTD de Solano, MTD de Almirante Brown, Abriendo Caminos, Comunitaria TV de Claypole, Abajo la TV, TV Piquetera, TV Barracas, La Gomera, Comisión por la Memoria de La Paternal and Villa Mitre, Anahí, Richard, Pablo Russo.

Relatives of those killed on December 20, 2001, relatives and friends of Carlos "Petete" Almirón and Gatillo Fácil, as well as Coordinating Committee Against Political and Institutional Repression (CORREPI), Center for Legal and Social Studies (CELS), Servicio Paz y Justicia de Argentina (SERPAJ), and Encuentro por la Memoria.

María Arena, Eugenia Viera, Marta and Héctor Almirón, Karina Lamagna, Eva Márquez, Olga and Eliana Benedetto, Mariano Benítez, Cherko, María del Carmen Verdú, Olga de Arédes, Nora Cortiñas, Enriqueta Maroni, Tati Almeida, Marta Vásquez, Beatriz, Aída, Haideé, and Laura Bonaparte.

Víctor Carrazana, Nely (from Los Guardianes de Mugica), el Bicho, el Toro, el Sapo, el Negro Albin.

Manuel Castro, Jaime Galeano, Pablo Macana, Facundo (from H.I.J.O.S.), "El Cubano" Esteban, Sebastián Pedrotta y Osvaldo López, Pedro Cher, Rodrigo del MTE, María Langer.

Konstanze y Adolfo, Fabricio Pablo Caiazza "Faca," Inés Martino, Lorena de Solano, Virginia Gianonni, Bárbara Palacios, Camilo Carabajal, Soledad Pennelas, Virginia Mafasanti, Gabriela Bacin, Lea Ruiz, Frida (from Bajo Flores), Pablo Mikozzi and Guadalupe, and Juan Pablo Cambariere.

Alejandra Arancio, Carolina Petriella, Alexandre Santini, Sofía Panzarini, Gastón, Paula Castello and Larisa of La Tribu FM, Ananqué, and Thais Zumblick.

Sursystem, Los Verdes de Monserrat, FM Pirca de Tilcara, Los Guardianes de Mugica, Arde Arte, Indymedia, Planeta X (de Rosario), and Centro Cultural de la Cooperación.

Floreal Gorini, Graciela Carnevale, Cristian Alarcón, Suely Rolnik, Brian Holmes, Naomi Klein, Avi Lewis, Marcelo Brodsky, Osvaldo Bayer, León Ferrari, Gabriela Alegre, and Florencia Battitti. María Rosa Gómez, Liliana Belforte, Diana Taylor, Diana Raznovich, Alice Creischer, Andreas Siekmann, José Miguel Cortés, Mónica Carballas, Edgar Endress, Vicente Luis Mora, Rodrigo Alonso, Julio Flores, Carlos Filomía, Marta Dillon, Claudia Acuña, Diego Perrotta, and Eduardo Molinari.

Mariano Said, Tamara Kiper, Leonardo Migliaccio, Sergio "Resorte," Natalia Revale, Franco Basualdo, Ana Wandzik, Juan Ángel Szama, Lila Pagola, Sandra Mutal, Fede "Aguja," Diego "El Turco," Eugenia, Florencia, Daniel Malnati, Oriana Eliçabe, Nico (from Málaga), Paula Valero, Julie, Ananké Asseff. Quimey Lillo, Sonia Sánchez, Norita Strejelevich and Roberto (San Francisco).

Juan, El Chino, El Negro, Lorena, Rodolfo and Sonia de Claypole, Luis Ziembrowski, Gabriela Golder, Sergio Morkin "Lechuga," Oscar Brahim, Paloma Zamorano Ferrari, Inés.

Roca Negra, Lavaca, Revista Mu, Imprenta Germán Abdala de La Boca, Mutual Sentimiento La Sala, Huerta Orgázmika de Caballito, Imprenta Chilavert, Centro Cultural Raíces, Cine Libre Parque Abierto, and No a Las Rejas.

Bijarí, Contra Filé, Tres de Fervreiro, Espaço Coringa, A Revoluçao nao Será Televisionada Cobaia, Chela, Obreras de Brukman, Universidad Experimental (Rosario), and El Levante.

Proyecto Trama, Potlach, La Mar en Coche, Meine Akademie, Miles de Viviendas (Barcelona), Yomango, Galpón V, La Revuelta, Pañuelos en Rebeldía área Género, Espacio de Mujeres del FPDS, Feministas Inconvenientes, Las Anarkas Feministas, Las Histéricas, Las Mufas y Las Otras, Costuras Urbanas, Circo Social del Sur, Perseguidores (from Lomas de Zamora), La Chilinga, 17 Cromosomas, Humano Querido, Pepe Albano and el Reviente, Lanús se Mueve, Escalada sin Remedios, Mariana Baraj, and La Zurda.

TRANSLATORS' INTRODUCTION

The Grupo de Arte Callejero is a unique artistic and political experience that emerged in Argentina at the end of the 1990s. The 1990s in Argentina were years of neoliberal cuts and restructuring. Trade and capital markets were liberalized and privatization was the order of the day across all sectors of society, particularly in education. This restructuring, carried out under the government of Carlos Menem, produced a deeply unequal and stratified society. The end of the decade saw the appearance of new social movements, including, most famously, the *piquetero*, or unoccupied worker movements. Alongside these new social movements, new political art groups flowered, including Grupo Etcétera, Taller Popular de Serigrafía, Arde! Arte, and Grupo de Arte Callejero (GAC). These groups were strident in their critiques of the formal art world and sought to return to the political art traditions of the sixties and seventies (such as Tucumán Arde) to place the question of the relation between art and politics at the center of their practice. Among these groups, GAC stood out for its depth of engagement with the new social movements, for its critique of the formal art world (post a period of experimentation), and for the fact that, like Taller Popular de Serigrafía, the GAC was composed either entirely or primarily—depending on the moment—of women.

The nineties were also the moment of the politicization of the *desaparecidos*—the men, women, and children disappeared by the Argentine dictatorship (1976–1983). Official statistics have put the number of still missing and confirmed dead at thirty thousand. Members of the dictatorship, however, were never prosecuted. Instead, they were given immunity. In the nineties, a human rights group H.I.J.O.S. (Hijos e Hijas por la Identidad y la Justicia contra el Olvido y el Silencio, or Children for Identity and Justice against Forgetting and Silence) began to organize around and against the crimes committed by the dictatorship. In particular, the group developed a political practice known as the *escrache*, in which H.I.J.O.S. would identify a former member of the dictatorship involved in the death squads and would

organize his neighbors, using marches and months of going door to door to turn his neighborhood into a prison—into a space of social condemnation. The escraches attempted to create a means of redress in a situation where institutional legal remedies were not possible. The GAC, as many chapters of this book attest, was one of the new political art groups that worked closely with H.I.J.O.S. on the escraches.[1]

The Grupo de Arte Callejero's work is marked by its constant attempts to repurpose the traditions of artistic practice and visual communication for political ends. As Colectivo Situaciones writes in its concluding essay in this volume: "They have laughed without end at the very notion of *art*. First it was a trick: using it to be considered 'innocuous.' Art as the perfect excuse to appear inoffensive. Using art as one uses a false passport." Just as important to its work has been the critique of artistic institutions. In the early 2000s, as the international art world began to take notice of the new wave of political art emerging from Latin America, the GAC was invited to participate in the Venice Biennale. Two years later it would announce the end of its participation in this kind of high-end art event. As one GAC member commented, "Traveling for free is great! But it ends up not being free at all." What differentiates the group's work, in this moment at least, from other groups in the wave of new political art was its willingness to walk away from these circuits of the global art market.

The book you hold in your hands is a translation of the Grupo de Arte Callejero's book *Pensamientos, Practicas, y Acciones* (2009). That volume contains the collective's attempts to narrate its experiences, practices, methods, successes, and failures in its roughly first decade of work. As their own introduction explains the group's motivations and means for doing so, we won't reiterate those points here. Rather, we would like to offer insight into our motivations for translating the book, which for all of us was rooted in a particular historical moment in the United States (since 2011 and the emergence of the Occupy movement) and the resonance of the GAC's work and reflections with that moment. As one of the translation collective members put it:

> I initially agreed to work on translating the Grupo de Arte Callejero's *Pensamientos, Prácticas, Acciones* because I was interested in translation itself, and in some respects, I have continued to work on the project for this same reason. The act of translating—of considering meaning not just word-by-word, but also in terms of connotation and style—intrigues me and helps me to know a language in an intimate way. . . . Thinking about both languages, English and Spanish, at such close proximity allows me to think not just about *what* words mean, but about *how*—the mechanics and the politics of language.

1 For more on the escraches as a political practice, see Colectivo Situaciones, *Genocide in the Neighborhood*, ed. Brian Whitener, trans. Brian Whitener, Daniel Borzutsky, and Fernando Fuentes, San Francisco: ChainLinks, 2009.

Of course, there were other things, too: the project began around the same time as the Occupy movement exploded across the United States, and GAC's work seemed to resonate with the concerns of Occupy. As time went on, I began to realize that GAC's deep commitment to art *and* to politics felt particularly meaningful to me, as the intersection of art and politics is a question I grapple with both personally and academically—how can art intervene in politics? How can art be political? Not only are GAC's projects active and political, the group also wrestles in a real and transparent way with the politics of their work and with the politics of their group. For me, then, this book serves as testament to the political possibilities rooted in art and in collective action; it serves, too, as a reminder of the ways in which one historical moment can inform and teach another.

To close, a note on the text. Throughout the Spanish-language text, Grupo de Arte Callejero deploys at key moments the feminine *nosotras* (i.e, "we," but marked by gender as a "we" composed entirely of female-identified individuals). The translators have rendered these usages of *nosotras* with the stylistic innovation of the italicized *we* or *ourselves* (and the negation *none of us*). The *nosotros* form—which denotes either a group of men or a mixed-gender group —is rendered with the non-italicized we.

—Mareada Rosa Translation Collective

PREFACE

In the late nineties, even as the neoliberal policies of the Carlos Menem government laid waste to social institutions and individual life chances, a new kind of grassroots protagonism arose in Argentina. Activists in the North had long been aware of the Mothers of the Plaza de Mayo. Now there were also H.I.J.O.S. (Children for Identity and Justice against Forgetting and Silence). We hadn't heard much about these sons and daughters of the disappeared, nor about the piquetero movements of unemployed and dispossessed industrial workers who began cutting highway traffic with barricades of burning tires. But our ignorance wouldn't last.

On December 19th and 20th of 2001, the piquetero movements finally reached Buenos Aires. They were joined by broad sectors of the middle classes, whose bank accounts had been frozen in a last-ditch attempt to save the failed economic model. Hundreds of thousands marched on the Presidential Palace and the Congress, and they did what people everywhere else just dream about. They threw the politicians out. For about a year marked by terrible penuries and shortages of all kinds, daily life in much of the country was managed by general assemblies on the neighborhood level. The process was exhilarating by some accounts, excruciating by others. But it allowed an entire country to reinvent the meaning and practice of egalitarian politics, with consequences that endure to this day.

The year 2001 marked the height of the antiglobalization movements that burst into public awareness with the five-day uprising in Seattle in November of 1999. These were transnationally networked protest movements resisting draconian trade treaties that deliberately set out to make any kind of left-egalitarian program impossible. On a good day the protesters would block an international summit, paralyze a major city and unleash a wild Dionysian spirit that could easily change your life. I took part in the "counter-summits" and the "carnivals against capital," and like all my peers I came to view Argentina as a beacon of revolt against an unjust system. Driven by my interest in grassroots politics and activist art, in the spring of 2004 I finally went to see what the place was like.

I still remember the sensation of surprise, recognition, and amazement when I first encountered the street actions by the Grupo de Arte Callejero. Here were fearless activists gesturing with precise and striking images in the midst of self-organized social movements. They created tersely powerful graphics, pregnant with meanings that could only be unfolded in situation, by the imagination and the voices of spectators-turned-participants. The artists marched on latent sites of popular memory to create temporary or sometimes permanent monuments against indifference and oblivion. Collaborating with H.I.J.O.S. on the popular tribunals known as escraches, they inscribed the infamous history of the torturers and other henchmen of the dictatorship into the public space of the city, insisting that this was a history of genocide, since the aim was literally to annihilate leftist culture.

In certain respects, this form of intervention was directly comparable to that of Ne Pas Plier, the French graphic arts group with whom I had worked in Paris in the late nineties and early 2000s. There was the same radical clarity, the same need to put your own body on the line, the same concern for a choreography of protest orchestrated directly on the pavement. Yet the stakes were incomparable. In Argentina there was a lucid awareness that the economic abuses of the nineties were a prolongation of the military repression of the seventies. For them, memory was about today, not yesterday. As the Grupo de Arte Callejero writes in this book: "The Madres and H.I.J.O.S., even with their differences in strategy, do not accept the prohibition on public space. On the contrary, they use this as a stage on which they unfold a strategic cartography of action. This is a mode of action that emphasizes the role of memory as a *function of the present*, and not just the past. A live, active, and actual memory."

On that first trip I got to know all the members of the GAC, along with many other artist-activists of the period. I met them during street actions, such as the "Ministerio de Control," which is documented in this book. I went out to look at the extraordinary horizontal monuments to fallen protesters in the center of Buenos Aires, popular memory embossed onto the street. Gradually, I became aware of the carnivalesque dimension that had permeated the escraches, with the participation of the neighborhood marching bands known as *murgas* and the general atmosphere of irreverent satirical festivity. One of the things that was common to activist movements across the planet in that time, and perhaps still today, was a sense of defiance and joyful abandon born directly of isolation, weakness, and desperation. But the Argentines had taken it all so much further. The graphic works of the GAC (for instance, the group's denunciation of the Condor Plan, staged in public space in Rio de Janeiro) were literally *street signs to history*, intended to help you turn the next corner or even take the next step. Originality and personal style were not the issues here. Instead, it was about transmitting hard-won knowledge and experience across the generations.

In subsequent years I often returned to Argentina, and for a while I would also meet members of the GAC on the international art circuit (notably in Cologne, at the exhibition *Ex Argentina,* which had been in preparation at the time of my first visit). Their contribution to the artist-activist ethos was significant, particularly in combination with the theoretical texts of Colectivo Situaciones, which analyzed the process of social change in Argentina through direct encounters with activist groups, in parallel to the visual work of the GAC. However, the symbolic economy of representation in the art world never sat well with those who had preferred to stand before their government buildings yelling *¡Que se vayan todos!* ("All of them must go!"). In the end the GAC wisely chose to withdraw from the art circuit, thus avoiding the neutralization that comes with forced repetition.

Sometime in the mid-2000s the international left's interest in Argentina began to subside because of a perceived return to normalcy. That perception was entirely mistaken. What was actually happening, amid great controversy in Argentina itself, was the slow transformation of society in the wake of the 2001 rebellion. Street protest was now accepted as a necessary part of political life, and innumerable re-distribution programs began to lower the shocking levels of inequality. The human rights claims of Madres and H.I.J.O.S. were taken on by the state, which not only opened unique and powerful museums of memory, but also reopened trials against the henchmen of the dictatorship. Most of my friends seemed to agree: the Kirchner governments could neither be accounted a total victory, nor could they simply be scorned. Change is what you of make it, bit by bit. And somehow those bits have to be put together in the lives of groups and institutions, so that they last. This book is part of that process. Today in Argentina's major cities, the GAC's crystallization of the country's protest traditions can be seen in innumerable new variations, carried out by other hands. It is the visual language of a substantial shift in social reality.

For North Americans, the typical attitude is to consider all the foregoing as a fine tale from a distant land. The crucial difference, from such an outlook, is that *they* suffered a dictatorship followed by corrupt governments, whereas *ourselves,* we have real democracies. Such misplaced arrogance can now be contested. The citizens of Canada and the United States just have to take a closer look around them.

The example I will take comes from the 2010s in the city where I live, Chicago. Here a group of artists—mostly women, like the Grupo de Arte Callejero—faced its inability to go on living normally in the face of one incontrovertible fact: over a hundred African American residents of this city were tortured by the Chicago police detective Jon Burge and his "midnight crew" from 1972 to 1989. Some of the victims still languished in prison on the basis of confessions wrongly extract-ed, while all the perpetrators, including the known ringleader, remained free. The artists launched the project Chicago Torture Justice Memorials, which put out an open call for designs of speculative memorials to be submitted by members of the

public in a bid to extend the active memory of what had happened.[1] An exhibition was held in 2013, which included a surprising number of contributions from far-away Latin America.

Working in close collaboration with the People's Law Office and We Charge Genocide, Project NIA, Black Youth Project, and Amnesty International, the group of artists then resolved that the only way to pursue the project was to seek legislation from City Hall offering reparations to survivors, including cash settlements, a psychological counseling center, free education for survivors and their families, school curricula on the subject, a public memorial, and a formal apology from the city. This cause was amplified by the ongoing Black Lives Matter movement and by the journalistic revelation, published in the British newspaper *The Guardian*, that a police "black site" for clandestine interrogation and physical abuse was operating in Chicago in the present. Finally, the call for justice led to the passage of the first reparations legislation in the history of the United States on May 6, 2015.

That's neither a total victory, nor something to be scorned. The fact is that in the United States, and not just in Argentina, the unspoken history of our corporate, political, and military elites constitutes a dangerous threat to people of all races. Anyone who was repressed or entrapped by the police in the wake of the Occupy movement knows this very personally, like the three anti-NATO protesters who were taken to the clandestine facility in Chicago in 2012. The only solution is to remake our public space as a stage for a cartography of strategic action. What you hold in your hands is not a neutral document from a foreign land. We have much practical knowledge to learn from the experiences of our distant comrades, the Grupo de Arte Callejero.

—Brian Holmes

Brian Holmes is the author of the essay "Remember the Present: Representations of Crisis in Argentina," concerning the Argentine street art groups of the late nineties and early 2000s. This text was included in his book *Escape the Overcode: Activist Art in the Control Society* (Zagreb: WHW; Eindhoven: Van Abbemuseum, 2009). It can also be found online.

1 For more information, see www.chicagotorture.org.

GLOSSARY

ABASTO SHOPPING CENTER: A mall in Buenos Aires in the Abasto neighborhood, just northwest of the governmental and financial center. It also features a converted fruit and vegetable market.

TRIPLE A: The paramilitary death squad whose activity reached its height during the presidency of Isabel Perón (1974–1976), just before the military coup. Short for the Alianza Anticomunista Argentina (the Argentine Anticommunist Alliance), Triple A persecuted a wide variety of leftist groups, not limited to communist organizations, and became a part of the deadly state apparatus under the first military junta, led by Jorge Rafael Videla.

CASA ROSADA: The Argentine presidential palace and executive office, also known as the Casa de Gobierno.

DESAPARECIDOS: The men and women who were "disappeared" by the Argentine military dictatorship (1976–1983), often taken from their homes, held without legal recourse, detained, tortured, and assassinated—all without their families and communities' ability to account for their absence or any grave that marked their death. The term was coined to describe this particular phenomenon of political persecution experienced during the dictatorship.

DESOCUPADO MOVEMENT: Political organizations of the under- or unemployed. Also known as the Movimientos de Trabajadores Desocupados (MTD), or the Unemployed Workers Movements.

ENCUENTRO POR LA MEMORIA: Gatherings or meetings organized by Argentina's Comisión Provincial por la Memoria, which bring together groups that do activism around the questions of memory and reconciliation in Argentina. GAC was a major presence in these encuentros.

ESCRACHE: A political demonstration that emerged in Argentina at the turn of the twenty-first century. The organization H.I.J.O.S. started the escraches as a way of exposing the presence of unpunished, dictatorship-era criminals in the community. Since then, many other collectives and individuals have used the escrache as a way of public demonstration. The escraches have been characterized as public shaming and have been linked with other kinds of public ritual.

EZEIZA PRISON: The massive, high-tech penitentiary complex that functions as a women's prison, located on the outskirts of Buenos Aires. It primarily houses poor inmates and incarcerates a large number (about 20 percent) of immigrants.

H.I.J.O.S.: The organization Hijos e Hijas por la Identidad y la Justicia contra el Olvido y el Silencio (Children for Identity and Justice against Oblivion and Silence). Founded in 1995 in La Plata and Cordoba, this group of advocates is primarily composed of the desaparecidos' children, many of whom were kidnapped by members of the Argentine military and then raised by other families. They often discovered their true identities later in life through the work of the Abuelas of Plaza de Mayo.

LA TABLADA: A province in Greater Buenos Aires and the location of the barracks of an infantry regiment. On January 23, 1989, members of the left-wing/guerilla group Movimiento Todos por la Patria attacked the barracks as part of an effort to prevent a coup d'etat by the right. Forty people were killed, and the leader of the MTP, Enrique Gorriarán Merlo, was arrested. Many viewed Gorriarán Merlo as a political prisoner and maintained that his imprisonment was unjust. He was eventually released in 2003, shortly before Néstor Kirchner was inaugurated as president.

LUNFARDO: A type of slang particularly used in Buenos Aires.

CARLOS SAÚL MENEM: The Peronist politician and former president of Argentina (1989–1999). He is best known for enacting neoliberal reforms, pardoning members of the dictatorship, and presiding over generalized corruption.

MESA DE ESCRACHE POPULAR: A coalition of various political groups that went into a neighborhood in anticipation of an escrache to educate the residents and build solidarity and community participation.

METROVÍAS S.A.: A private Argentine company that took over part of the railway and metros in Buenos Aires after they were privatized in 1994 under Menem.

MILITANCIA: The political left in Argentina, which includes active Communist and anarchist groups. Different from the context in the United States, in Argentina these groups are present in the mainstream political process and their struggle is more visible.

NÚÑEZ: A neighborhood in Buenos Aires where one of the most infamous clandestine detention centers, the ESMA (Escuela de Mecánica de la Armada, or the Navy School of Mechanics), is located.

OBEDIENCIA DEBIDA AND PUNTO FINAL: Legislation passed under President Raúl Alfonsín to prevent the prosecution of the perpetrators of state violence during the 1976–1983 military dictatorship. Obediencia Debida stated that members of the military below colonel rank were exempt from prosecution because they were following orders. Punto Final set a very short statute of limitations for prosecutions of crimes during the 1976–1983 military dictatorship. Both laws were ultimately overturned.

PLAZA DE MAYO: The main plaza in Buenos Aires, which is a major hub for political activism in Argentina and is surrounded by a number of important buildings, including the presidential palace (the Casa Rosada). The Madres of Plaza de Mayo have famously protested the disappearances of their children at this plaza.

PIQUETE: Occupations or blockades of roads or buildings, which are meant to call attention to a particular issue. The piquete was a popular tactic of the Movimientos de Trabajadores Desocupados (MTD).

PUERTO MADERO: An upscale neighborhood in Buenos Aires located near the port. It is popular for its refurbished warehouse residences and restaurants.

RECOLETA: An upscale historic neighborhood in Buenos Aires that has seen a resurgence of bourgeoisie businesses and residence in the last several decades.

DOMINGO FAUSTINO SARMIENTO: The seventh president of Argentina (1868–1874). He was a member of a group of prestigious intellectuals (The Generation of 1837) and a prolific writer whose most-acclaimed work, *Facundo*, is one of the foundational texts of the Argentine literary canon.

SAN TELMO: A working-class neighborhood in Buenos Aires famous for its tango.

SILUETAZO: A chalk outline used by the state and its agencies to trace the bodies of corpses at a crime scene. The GAC reappropriates this imagery and language in its art in order to indicate where the state itself has committed a wrong. In addition, by using and inserting the siluetazos into public space, GAC reaffirms that those who have been killed or disappeared are still in some way present among the living.

INTRODUCTION

Why write a book?

Why does an art group known primarily for action rather than words decide to write a book? And why write a book about itself?

Those who knew us in the beginning, as well as those who heard of the GAC through one of our urban interventions, could easily doubt the seriousness of this book project. Those who are more institutional could also question the validity of this book's contents on the basis of not being written from an "objective" theoretical, critical, or historical stance in visual art and for not being organized in an academic fashion.

Here we find our first justification, which is at the same time an affirmation of the group: those of us who produce in the symbolic field should take responsibility for thinking about and producing knowledge for *ourselves* concerning what we do. Critics should not be the only ones authorized to produce discourses, theories, and trends based on the dissection of their objects of study. We don't have to delegate this work; it is our responsibility to think about our own practices, to push forward the work of translating accumulated experience into verbal language.

Thus, one can question the academic quality of this book (in any case, we never set out to publish an encyclopedia, a manual, or a history), but not the experiences considered over the course of time, which we attempt to collate here. Writing a book about *oneself*, as testimony, as legacy, as collective witness, as something that can transcend the very existence of the group and that will remain when the group no longer exists. . . . A glossed document. A reflection that from the position of today captures and gives form to a history in order to push it forward.

From this temporal perspective, we recognize that our experience is imbricated in a network of both earlier and later practices that feed off of one another. It is for this reason that the contents of this book are based more in popular knowledges than in grand theories. Our readers will have the chance to demythologize the GAC,

showing that we invented nothing new. Popular knowledge is based on the reappropriation of formats and procedures; at every moment mutant interpretations of older practices are being created.

After twelve years, we also see a generational difference (without exaggerating) with the new groups that are emerging. Hopefully, this book can add to these experiences without conditioning them, because we aren't trying to outline a dogma or model to follow either. But we do believe that each new utopian struggle that breaks out is organized using knowledge of the struggles preceding it, although perhaps only to refute them. . . .

There came a moment in which the need to act resulted in an explosion of interventions, direct actions, and other modalities whose key was spontaneity (which also supposes a mode of thinking). Today, it is essential to reflect on what was done and express this reflection in a concrete, tangible way so that others can use the knowledge. Now, thinking it over, the book is also an intervention, an intervention in the circuits of the production and distribution of knowledge. Making this book was a very difficult task, because *none of us* work in this field. *We* are more accustomed to communication through visual metaphors and, in general, the fact of being a group disposes us to the creation of our own internal codes, our own languages. We know very well that to write about what we have done is not simply to translate metaphors but to encounter new ones that allow for the construction of an alternative reading of what is already there—and to make it legible. Finding a way to make the texts flow, develop, and reach a certain depth took us more than a year of work, without counting the months of preliminary meetings, the periodic conversations about thematic axes, the discussions of the how and the what, of the why not sign as individuals, of the why this order of texts, etc.

For this reason, you will find that the texts in each chapter are independent of each other and that they were written by several *compañeras*. The forms of narration are diverse because they respect the manner in which each of *us* expresses *ourselves*. The revision and response were collective, as was the moment of decision concerning which topics to elaborate. There are texts that were written several times; others that were written in stages, in different moments; while others were born all at once. The diversity among the texts is so evident that it's like listening to different voices, sometimes within the same text. We want to be clear that this is a deliberate decision, not just disorder.

There are texts written in the first person that reflect as much an identity of an *us* as a more personal perspective, that of an individual inside the group. Some texts are in the third person, as if in certain moments we needed to distance ourselves from ourselves in order to describe better, or simply to see things from another position. It is not easy to detach oneself from such strong experiences in order to

record them; the intensity of the memories at times interferes with the rationality of the language. This perhaps is notable in some of the texts.

As the chapters don't proceed in a linear fashion, but are rather transversal reflections, we have included an appendix at the end of the book with a list of actions and projects in chronological order. In the majority of the texts there are actions referenced that are better described in the appendix.

Without a doubt this is not the most exhaustive book one could write about the GAC, nor the most complete, nor the most sharp and critical, but it is the one that we wanted to write. Here you will find our version of the GAC, as we understand it today. Perhaps tomorrow we will find some omissions or discrepancies. But this is where we are as of today.

Finally, *we* can say that the experience of writing this book has changed *us*, as each project that *we* have undertaken has changed *us*. Only this time, due to the importance that it took on, we have the feeling of not knowing where this change will lead us, what will be its effects, what the resonances of this book will be.

This title, "Salir por Salir," contains a difficult to translate play on the meaning of *salir* (to exit, to go out). The literal sense is of "exiting" or "going out" (as in *salir a la calle*, "to go out into the street") in order to exit or escape the situation of institutional art. The phrase has a secondary meaning as well as *salir por salir* carries overtones of "going out for going out's sake" or heading out to a party or event just because one feels the need to get out. We've translated the more literal sense of the title here due to the repetition of the verb *salir* throughout this chapter which we will translate as "exit." (Trans. note)

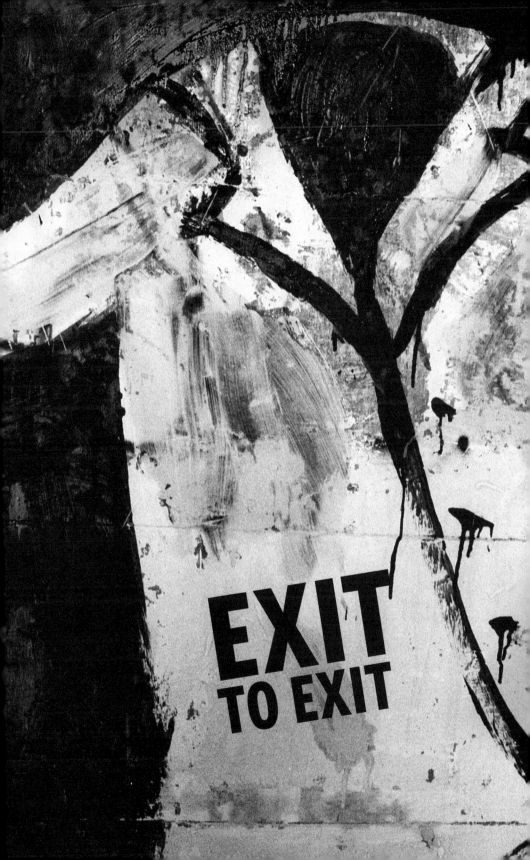

APRIL 2, 1997. "[A] white tent was raised in front of Congress. More than fifty teachers from around the country were preparing hastily to begin an unusual form of protest during that hot Buenos Aires fall: hunger striking in front of the Parliament until their request for a law that would, at a minimum, sustain the precarious economic situation of public education and its teachers was heard and addressed. Financing from genuine and permanent funds that would signify a real investment in education, particularly in the salaries of teachers. . . ."[1]

The installation of the White Tent was the most visible denunciation of the state of education in Argentina and, concretely, a standard raised against the implementation of the Ley Federal de Educación (Federal Law of Education) proposed and passed by Menem government.

At the beginning of 1997, several students from the Escuela Nacional de Bellas Artes Prilidiano Pueyrredón (Prilidiano Pueyrredón National School of Fine Arts) began to discuss an idea that we would later carry out: the formation of a group that, considering the plight of the teacher, would intervene in public space with visual tools. In this moment and in that context we were searching for forms of expression, intervention, and assistance to the teachers' hunger strike, which was the form the teachers chose for their protest. Consequently, on April 20, 1997, we made our first mural in Roberto Arlt Plaza.

This first "exit" was experimental in every sense: not only because of the materials that we used, which were uncommon for murals, but also because of the ritual character that enveloped the atmosphere of the action, oscillating between a performative act and an improvisation loaded with symbolic elements, a semi-clandestine act of the seizure of space. Of course back then we were not able to do this kind of reading—this only came with time—although perhaps that initial naivety was what made us able to experiment without preconceived ideas, without conditions, moved only by curiosity.

In this inaugural action several of the forms that would later become central to our practice were put into play: an exit to the street, group formation, working collectively, collaborating with a protest. In those days, the majority of the group was composed of students in the last years of their degrees in arts education, and as such, having major ties to education and the visual arts, we felt directly affected by these concrete educational issues. The context was the imposition of the Federal Law of Education, responsible for the impoverishment and the dismantling of education in the previous decade, the reduction of the budget for public universities

1 http://www.ctera.org.ar.

and the decentralization of resources for middle and grade schools. The negative responses to the teachers' protests were only the tip of the iceberg of a larger conflict regarding the neoliberal policies favored by society in this historical moment.

The art world was not particularly inspiring at the end of the nineties either. What predominated was so-called arte light (light art),[2] which portrayed the elite of the moment, evading any connection to social problems, excluding from its repertory anything having to do with the historical moment and at the same time glorifying itself for taking this position. Save a few exceptions, the lack of critical voices meant that the art world was a clear reflection of the epoch: a superficial proposal in the service of the neoliberal model of life.

We, not feeling a part of this environment, and with desires to bet on collective construction, began to paint murals.

The installation of the White Tent was a kick in the pants. However, this was not the only action that motivated us. At the end of the decade, the Menem administration left in its wake the grave effects of the neoliberal model: an increase in the external debt, the financial restructuring of the economy, and the disappearance of thousands of jobs, the general casualization of work, the privatization of all public services, and the descent of 14 million Argentines below the poverty line.[3]

In the face of this daily reality, one did not see great outbursts of conflict, at least not during the first half of the nineties, when the privatizations and the pegging of the Argentine peso to the dollar were widely accepted. One exception was the opposition to the presidential pardons given to the genocidists from the dictatorship, which did mobilize a great number of people. But between the mid-nineties and the end of the decade, a series of protests and actions gained ground in urban spaces and throughout the country, which centered on struggles for justice, work, education, and health.

The teachers on hunger strike and the members of H.I.J.O.S. doing escraches put into practice in urban environments new forms of resistance against state powers and society at large. In Buenos Aires and in the provinces in the north and south, the organizing of the desocupados and their piquetero struggle, which cut off transportation routes as a response to the politics of socio-economic "adjustments" against the working classes, interrupted and modified the public scene.[4]

2 See "Arte Rosa Light vs. Arte Rosa Luxemburgo" (Rosa Light Art vs. Rosa Luxemburg) http://proyectov.org

3 Miguel Bonasso, *El Palacio y la Calle* (Buenos Aires: Planeta, 2002).

4 In 1992, the oilfields, distilleries, and the plants of the YPF (Yacimientos Petrolíferos Fiscales, or the National Petroleum Fields) were privatized. This moment was a turning point that marked a before and an after, both with regards to the economic and social situation and in the life of the residents of the affected cities. The sale to private owners meant a 90 percent staff reduction through the layoffs of between 2,400 and 3,500 employees (Aguilar, M. A. y Vázquez, E.:1998; El Tribuno, 9/5/97). For those who managed to keep their jobs at the company, the privatization implied an extension of the workday, although in many cases the salaries were still cut. Some—the minority—of the fired employees were able to move to businesses subcontracted by transnational petroleum businesses with a salaried position, although many often worked only for their government subsidy. The protests

The repertory of collective actions in the cycle of open protest in 1997 constitutes a rupture and marks a new form of political resistance against the installation of a model that would commodify all social life. A second rupture was produced with respect to the use of public space: people began to place their bodies in the streets and in the roads confronting the social problems of the moment. The realization of these types of actions did not respond to a logic of action conceived as "spontaneous generation." Rather it was an invention forced by the need to express a growing social discontent.

To return to our first intervention: it was called "Teachers on Hunger Strike" and consisted of the production, beginning in April 1997, of more than 30 murals with images of work coats in black and white at various points in Buenos Aires. These beginnings were, for us, an experiment in collectivity, a characteristic that would be maintained in our subsequent actions. We experienced the space of the street as a place in which to express ourselves, and the means of doing it was to occupy this space without permission. From the first mural to the last, this modality prevailed as a consciously transformative choice, both for public space and for our subjectivities, as at this point *all of us* had been involved only in individual artistic production. It is a modality that, even with various changes in the formation of the group in the first year, became fundamental.

Perhaps the most important change the group underwent occurred between *our* first and second "exiting" to the street. *We* went from being four people and acting "intimately" to being a much more heterogeneous collective of twenty, with people who had heard about the action that we were going to do in Nuñez and who wanted to participate without having a clear idea of what it was all about. During that whole year, we fluctuated both in the number of participants and in the manner of creating actions. The street was also resignified for *us*: from actions of protest and the construction of communication, we moved to an attempt to reconstruct social bonds, everyday dialogue, and to a work that was more spontaneous.

The murals were made collectively; they were not designed beforehand but rather emerged on each occasion, although some, above all the first ones, had a very rough plan. Later, the outlines were burnt at the end of each intervention in a type of ritual action that left an afterimage on the wall. Due to this characteristic, one could say that the murals were closer to graffiti; during the week we would also pick out walls in different neighborhoods around the city.

that took place in 1996 in Cutral-Có (Neuquén) added roadblocks to the repertoire of collective actions. In June of that year, National Route 22 was cut off, an action that was repeated in April 1997, days after the roadblock placed in Tartagal-Mosconi.

The choice to make murals (a classic element in urban space) did not follow the traditional approach. It was not our objective to copy the realist figurative aesthetic of Ricardo Carpani[5] or of the Mexican muralists. We didn't want to return to the paradigm of the artist linked to the working class and its struggles for the dignity of work and redistributive justice.

If the images of the work coats were referential or iconic, the search for an aesthetic did not pass through realist representation. We understand realism here as an historical movement whose representations—alluding to the political as their principal theme—don't as much evoke "reality" as an ideal molded by a political position. The aesthetic search of the work coats was tied to the use of this element as a symbol of public education; in this case, we were working with empty work coats, without the body, which reveals that the protest was fundamentally conceptual. In the first two murals, the work coats were not even drawn but were real, stuck to the wall with spackle and less-than-stable adhesives,[6] announcing a tendency towards the non-representational. The idea wasn't to represent a situation on the wall, but to create a real situation, the action of occupying a wall and a space where the mural would be the result of this action. There was no in-depth research on the methodology of production. Each piece was figured out *in situ*. In this way, the objective was to complement the slogan "Teachers on Hunger Strike" with images of the work coats or a part of them. We worked covering large areas in black and white, and the work coats marked out on the surfaces had a very synthetic, plastic resolution, annulling all representation of volume, carrying a high contrast of black and white line and plane.

To "exit" to paint we dressed in black and upon finishing we took a photo, covering our mouths with ribbon, and burning the wall to leave an afterimage. This "placing the body" in space was a significant rupture in our manner of producing, as we were more accustomed to traditional formats of painting, sculpture, and engraving that we had learned in school at Bellas Artes. Never before had we produced from action, that is, placing our own bodies in action as a site of enunciation. And at the same time that we were discovering this performative dimension of making and doing, and collective making and doing, we were modeling a form of power, of confidence, of self-sufficiency. Every Sunday in 1997, we made murals. We were an open group in which those who desired participated, respecting certain rules of interaction. During this period, the relationship between *us* and the teachers who

5 Ricardo Carpani (1930–1997), founder, together with other artists, of the movement "Espartaco" (Spartacus). His concern for the social and his commitment to the popular classes are reflected in work where the theme of the desocupados, the workers, and the humble—in addition to the national—predominates. His figures, primarily masculine, evoke strength and fortitude and seem to be "cut in stone."

6 This generated a considerable problem both in terms of cost and durability of the images, which caused us to opt for other, more economic materials, such as iron alloys and lime paint.

were in the tent was minimal, although there were some encounters; our work, rather, was realized from an exploratory and thematic place.

This first experience also implied the fusion of the production of symbols and the idea of occupying the space of the street, epistemologically modifying the concept of production, transforming perspectives, opening channels of communication, breaking with structures that had closed in upon themselves.

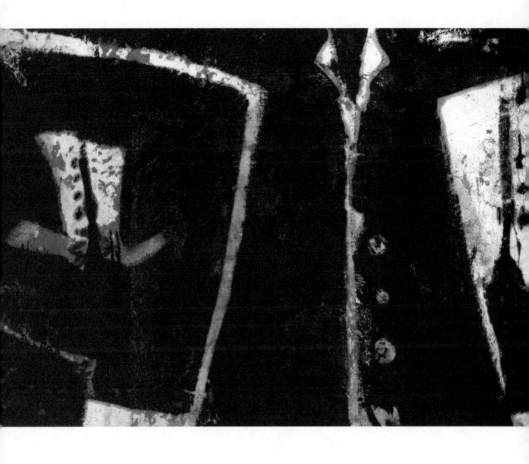

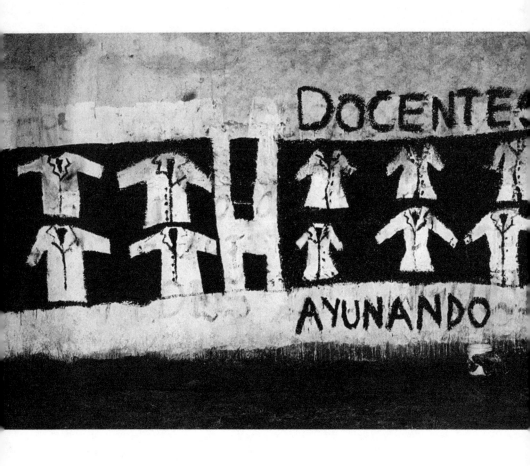

[wall reads: "Teachers on Hunger Strike"]

"I remember a powerful need for collective work and protesting. It was not only a protest for the teachers' cause, it was also a disidentification with the spaces that the visual arts occupied; taking new public spaces where the work was anonymous, collective, and reappropriable by anyone, in contrast to the hermeticism of certain circuits of art." —**Violeta Bernasconi**

GRUPO DE ARTE CALLEJERO: THOUGHTS, PRACTICES, AND ACTIONS

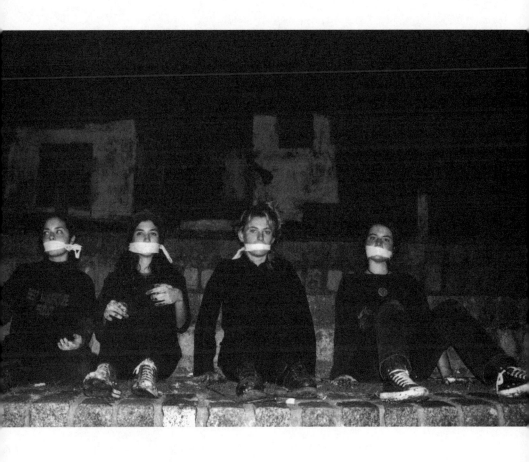

GRUPO DE ARTE CALLEJERO'S FIRST MURAL
ROBERTO ARLT PLAZA, APRIL 20, 1997

"It was the beginning, the first mural made by the GAC (Lorena Bossi, Mariana Corral, Lorena Merlo, and Violeta Bernasconi) where Mane Bossi recorded the actions with photography. This mural was made in Roberto Arlt Plaza in downtown Buenos Aires. We used black paint diluted in glue as the base of the mural. We stuck white work coats to the mural, which we then burned with a blowtorch, leaving an afterimage. When we finished the mural we took this photo with our mouths covered. The murals were transformed into an excuse to create a protest action, in this case, related to the teachers who were on hunger strike in front of the Congreso Nacional (National Congress) demanding a decent salary. The mural remained in the city, but now with an anonymous character." —**Lorena Merlo**

"With our desires we went out into the street, we felt the need to create a different image of the teachers' conflict, to assist from our place as artists, as young people, as future teachers, and to do so from an open and straightforward discourse."

—Alejandro Merino

GRUPO DE ARTE CALLEJERO: THOUGHTS, PRACTICES, AND ACTIONS

"*Here I am dreaming and playing. These moments 'full of energy and utopia' are remembered with much fondness, although the desires continue, today the tree of my life opens onto another sky and with luck future winds will intertwine us again. It's sad to see the majority not make it; many of the young are old, and few of the old are alive.*" —**Tato**

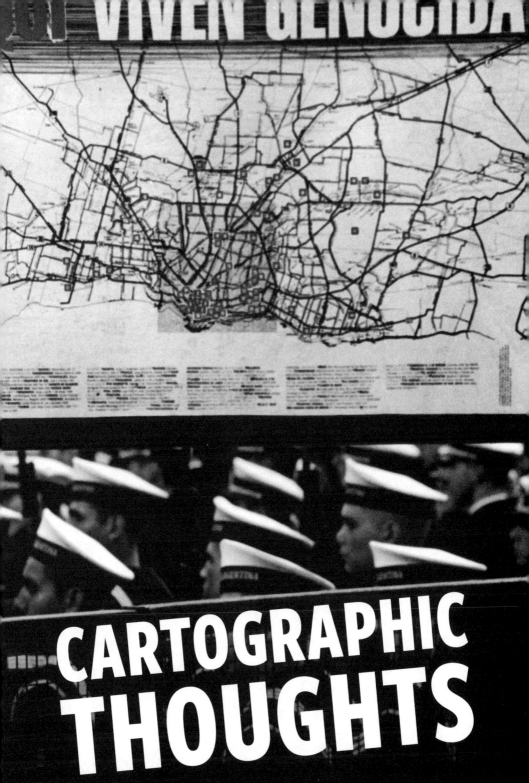

CARTOGRAPHIC THOUGHTS

I t is interesting to write about cartography; perhaps this book is the most expansive cartography that we've undertaken. When we began the GAC we decided to exit to the street, and in this exiting and transiting we traced the first lines of what would later become a conscious mapping of our journeys.

If in the beginning the "exits" to the street were more related to the seizure of space, quickly we began to differentiate between places depending on their characteristics—routes of more or less transit, a fondness for certain plazas or neighborhoods—and to choose them according to our needs. Plaza Roberto Arlt, where we did our first mural, became a space that we returned to in other moments. The train stations at rush hour were also important sites rich in meaning and affect for certain members of the group.

In the early days of the group, the interventions into these spaces were characterized by their immediacy. Yet, at the same time, a common thread wove its way through our trajectory, creating a record of each "exit." This record was available in two formats. The first was a group diary, where the exit was registered, as well as who went, the sketches, and the neighborhood chosen. Everyone wrote in this diary, and it formed both part of a ritual as well as a record of those neighborhoods we had worked in and those we hadn't. Another type of record of this initial stage was photographic, which we will speak about later. Both were a representation of a continuity across space and time, a tracing that was sustained across this accumulation of "exits" and that geographically outlined a route. Due to this, for me, the experience of the diary is the first map generated by the group, and it announces the intention of a journey across the collective body.

Later the maps served us in a strategic sense: to select spaces in which to intervene, to anticipate what the journey would be like, or to situate ourselves for a given action. This planning resulted from a need to deal with situations during interventions in public space that were increasingly complex and allowed us to work with other organizations in a coordinated manner.

The experience of planning, of what happens from one action to another, from one year to another, allowed us to construct a reading of political situations in the street beginning from a feeling-questioning: "How is the street doing?" At the same time, this reading changed from one moment to the next and was always a learning situation that opened up different ways of working.

One of them was to sketch previous strategies for actions, and this formed part of what we have called cartographic planning. This sketching of previous actions is the first of three aspects of what we call cartographies, or cartographic thoughts. One example of cartographic planning is the maps that we made before an escrache, where the characteristics of the place were marked out, the posts where we'd locate the street signs, the direction of traffic so that we could orient the poster correctly, and other details that we would later discard due to changes within the escraches

and to our group experience. These mappings have a value for the group, and usually they are shown only to those who will participate in the action. But they have another value in and of themselves: they delineate the desire for something that doesn't have a form, but that is possible within the force that a group of people linked by a place generates. It is important to note that when we speak of actions that require a certain strategic planning we are speaking of actions that had some risk, to a greater or lesser degree; in the planning, in fact, one tries to measure that risk and many elements of this measurement are taken from the methods used by the militancia concerning security, applying them according to our needs, and of course learning from our mistakes.

The second aspect of the mapping is the use of cartography to accumulate actions and struggles. These maps usually are a historical record of realized interventions. Used to compile and to denounce, they summarize work that persists over time. As a result, this cartography accumulates actions and struggles that are generated after years of work and is a two-dimensional representation of a given corporeal journey through militancy. In itself, each fragment of these maps contains part of a real trajectory, whose function is to return the actions to the map, which also implies a process of interpretation of that very experience. Cartography as accumulation works like a lens that fragments an action into several pieces, in order to then abstract some aspect, weaving together journeys and trajectories, giving them new meanings and new dimensions that are used to re-invent another totality.

Due to the fact that the creation of a map of accumulation emphasizes elements that have relevance at the moment of the map's preparation but not necessarily the moment of action, the effect achieved is to reconfigure the realized action under the parameters of the present in order to make it serve again, now in the present, as a denunciation. An example of these types of maps is "Here live genocidists," which in and of itself escraches the genocidists already escrached by H.I.J.O.S., Mesa de Escrache, and other groups and people involved in this practice. The first of these maps was published on March 24, 2001, and it was based, in part, on the idea of a triptych made up of a video, a diary, and the map in the format of a poster. The video shows the houses of the genocidists on a given day (in fact, one of the genocidists is even seen returning from the supermarket). It then shows images of the same house and the same district on the day of the escrache, while a list of those already escrached are added as red dots on the map, and this list denounces the continuation of the impunity that we endured most forcefully in the nineties. Seeing the districts and the addresses, it's not surprising that the majority of them live in Recoleta.

Finally, an aspect related to the most complex form of mapping: the cartography of relationships and contexts. We are accustomed to use this form when,

as a group, we feel the need to open ourselves up in order to understand reality, incorporating other perspectives, and when, for either internal or external reasons, we sense a break with a previous mode of working. One of the moments in which this need was expressed with greatest intensity was after 2001 when, due to the political situation and in conjunction with the homages to those who were assassinated in the December protests carried out jointly with Acción Directa (Direct Action), we maintained group discussions in order to understand what was happening, enumerating the spaces of resistance as a way to recognize ourselves in others through shared affinities. In those days, we met up with both old and new *compañerxs* in the streets, and working relationships[1] emerged between groups from one day to the next, united in collectives that were taking shape according to ongoing relations, movements, and conflicts. We then made a map with newspapers and pieces of cardboard that served to establish internal agreements in the group, since the very space of the group was being crisscrossed by these events. This internal mapping also forced us to take up real problems and gave us the chance to discuss and debate. From these conversations, common political positions were derived, as well as action and questions that helped us to move through that moment, and, once we had linked up with other groups, to be able to deal with what was happening as a collective.

The cartography of relations and contexts is a method for generating political interpretations. Many times these maps served to help understand situations from an internal point of view, and at times, owing to the desire to communicate these readings of relations and contexts, we arrived at a form of representing these readings via the maps, with these investigations serving as a catalyst towards generating actions in real spaces.

From their genealogy, these maps represent preoccupations, forms of moving towards the new, towards what we don't know how to deal with, and because of this the basis of this set of images is composed of questions that are our own and that have taken place in the processes of conversations with others—with our friends whom we have undertaken these searches, during these exits to the streets, through this thinking and thinking about. With them we converse and, many times, they give content to these maps, in which one can see represented the ideas of *compañerxs* who broadened our gaze.

Thus, the maps are not only an object of representation, nor an accumulation of information: they are also forms of expanding our own perspective via dialogue. As this concerns contexts and relationships, we argue that in these journeys we can observe forms of domination that in the day-to-day are difficult to

1 Working relationships as an intermittent union, be it for an ideological affinity or a situation of juncture, in order to realize a collective action that allows this recombination, with each group or person contributing a knowledge or practice previously performed.

see, not because they are invisible, but because they are hidden underneath the dominant continuum, which doesn't help to trace real relationships but rather generates immobile identities linked to ways of living that don't question the place given to them in the map of power. The additional information that we used for these mappings is accessible to all, given that it is already on the Internet or in other media. What is interesting is not the newness of the information used in the maps, but the relationships amongst these pieces of information arising from questions that displace the ordering of reality and its levels or relevance to find new paths, trajectories, or questionings.

In this text, I am labeling "cartographies" many things that, formally speaking, are not seen as maps, but that form part of an exercise that has to do with mapping, in the sense of the trajectories and the forms that an idea assumes as it continues across time in the body of a group.

If a map is formally an abstraction, *we* use this capacity for abstraction to ask ourselves about matters related to the everyday and thus give them expression.

If all maps have the function of showing or indicating, they do not all have the power to move or to produce displacement, nor the power to persuade. As our cartographic works were arrived at after intense experiences in these spaces of action, we can say that, for us, the map is a format derived from events. For this reason, these maps are charged with other meanings that an informative map does not have: they win the right to move/displace us and the power to persuade. To refer to our own maps, we begin by speaking of the scale one to one (1:1). With this, we are alluding to the continuous work of action-intervention that is realized before and after the creation of markers or signs on a map. Without this prior work our cartographies would be mere infographics without subversive elements. It is perhaps because of this, or because they speak in the first person, that the spectator is interpellated or traversed by the journeys presented; that as maps marked and used, whoever sees them uncovers the traces of a reality and the search to activate these traces. Each map contains hidden interpellations that in many cases attempt to locate the viewer in a reality that they might have ignored up until this moment. The first interpellation that I remember emerged from the utilization of the phrase "You are here," which was utilized to mark a former CCD (clandestine detention center). This street sign contains a map and a heading and the event I am speaking of took place in 1998. In this moment we hadn't developed a cartographic thinking, but this map formed part of a protest action. "You are here" served a mobilizing function by provoking a question. It was mobilizing because it reveals a place that we moved through every day but which many of us knew little about; and this same discovery has the power to bring you to other spaces, it transports you to an adjoining reality, exhibits its institutional cover-up at the same time as it reveals a historical continuity. This

same discovery generates more questions concerning other possible cover-ups, which range from "What other CCDs exist that I don't know about?" to questions related to one's own identity after the revelation of what had been covered up.

These explorations that I am describing emerge from accounts of people who are interpellated unexpectedly by an action. Each experience gives us another starting point for another possible mapping: that is, there are no maps with fixed or linear starting points, but rather punctures from a reality without a pre-established direction, guided by an idea that runs through all of them, that is the capacity to mobilize, to question, to establish relations, to reconfigure our own existence.

FOLLOWING PAGE:
Here was the former clandestine detention center known as El Campito. It operated from 1975 and continued until at least 1978. In this extermination camp, thousands were kidnapped, tortured, and assassinated—thousands among the total thirty thousand of the disappeared.

MVRAL 19

Participamos:
LAS Lores.
 MARIANA.
 CHARO
 VIOLE
 ALE
 ABEL
DEBUTA . SALVADOR.
 Y TATO Yo.

PINTAMOS EN MEXICO

UBICACION GEOGRA...

PLAZA

SAN JOSE

MEXICO

(PARED)

Estamos perdiendo la costumbre de
comer fideos antes de salir.
NOS DESPEDIMOS DE MATURIN. JA JA JA!
AHORA NOS VAMOS A JUNTAR EN MI TARLER (o
YA QUE EL GRUPO CRECE Y NOS ENQUILOMBAMe
MUCHO EN LO DE LORE, Nuestro lugar de encuen
mas grande y mas digamos rústico.
Estamos camino a CAMPANA ¿ que pasará
con la ilusion de que la gente se enganche.
esta propuesta.
Hablando del mural de ~~ayer~~. Pensamos que ha
respetar un poco mas la idea principal, ~~~~ o esa

UD. ESTÁ AQUÍ.

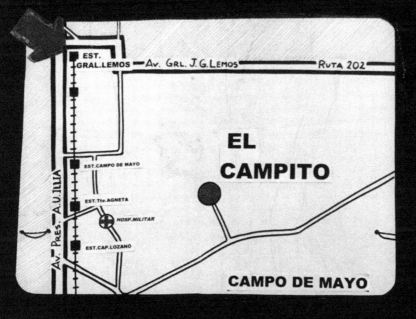

EST. GRAL.LEMOS — Av. GRL. J.G.LEMOS — RUTA 202

Av. PRES. A.U.ILLIA

EST.CAMPO DE MAYO

EST.Tte.AGNETA

HOSP.MILITAR

EST.CAP.LOZANO

EL CAMPITO

CAMPO DE MAYO

EL CAMPITO (o LOS TORDOS)

Aquí funcionó el centro clandestino de detención conocido como EL CAMPITO Operaba desde el año 1975 y lo siguió haciendo al menos hasta 1978. En este campo de exterminio fueron secuestrados, torturados y asesinados miles de personas que se suman a la lista de los 30.000 desaparecidos.

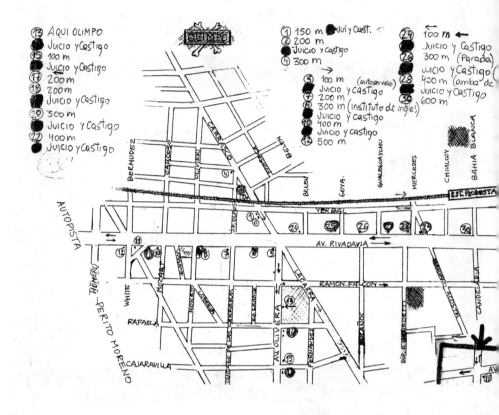

Map that shows the locations for street signs in the escrache of the former clandestine detention center El Olimpo. March 20, 1998.

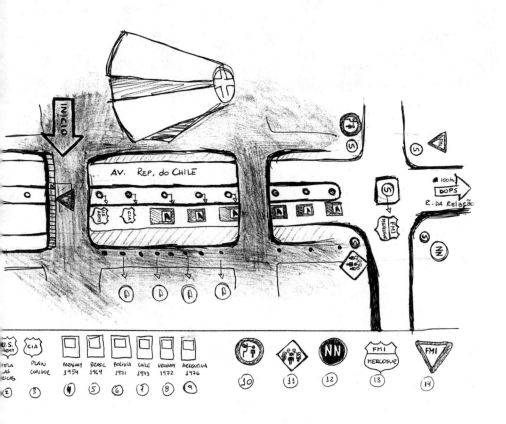

Map denouncing the Operation Condor, in an action realized in Rio de Janeiro during the Hemispheric Institute for Performance and Politics conference in June 2000.

GENOCI

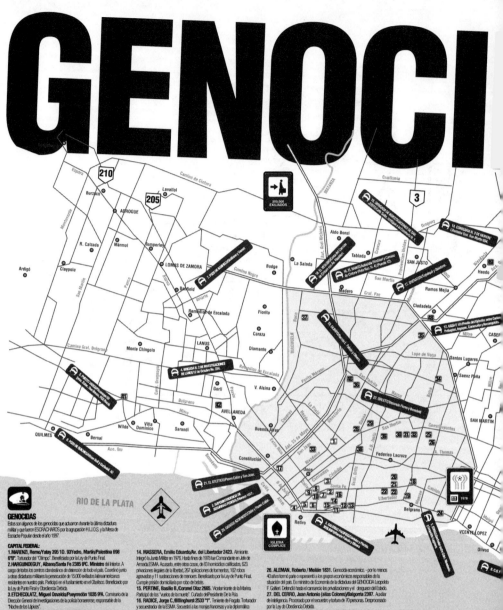

RIO DE LA PLATA

CAPITAL FEDERAL:

1. **MARENZI, Remo/Yatay 395 1D. 93/Yedro, Martín/Palestina 698 6°B".** Torturador del "Olimpo". Beneficiado por la Ley de Punto Final.

2. **HARGUINEGUY, Albano/Santa Fe 2385 6°C. Ministro del Interior.** A cargo de todos los centros clandestinos de detención de todo el país. Coordinó junto a otras dictaduras militares la persecución de 15.000 exiliados latinoamericanos residentes en nuestro país. Participó en el fusilamiento en el Obelisco. Beneficiado por la Ley de Punto Final y Obediencia Debida.

3. **ETCHECOLATZ, Miguel Osvaldo/Pueyrredón 1035 9°A.** Comisario de la Dirección General de Investigaciones de la policía bonaerense; responsable de la "Noche de los Lápices".

4. **MARTINEZ DE HOZ, José A./Florida 1065.** Genocida económico. Ministro de Economía. Durante su mandato la deuda externa se soncentó de 6 a 4 millones, con los cuales se financió el terrorismo de Estado.

5. **SUAREZ MASON, Guillermo/Libertad 982 Piso10.** Teniente Coronel. Jefe del Comando del 1er. Cuerpo del Ejército. Responsable de más de 12 centros clandestinos en Cap. Fed., Buenos Aires y La Pampa. En 1981 huye del país acusado por la Intriegol. Es juzgado y condenado en 1988 por 635 delitos (homicidios, secuestros, torturas y robos). Liberado por el indulto presidencial de Menem.

6. **ARRIETA DE BLAQUIER, Nelly/Arenales 735.** Responsable de la desaparición de trabajadores del ingenio Ledesma, del cual es una de sus dueñas. Participa de la asociación de Amigos del Museo nacional de Bellas Artes.

7. **SANCHEZ RUIZ, Raúl/Peña 2065.** Médico de la ESMA. Beneficiado por la Ley de Punto Final.

8. **DURAN SAENZ, Pedro/Av. Callao 1307 1.** Mayor del Ejército. Jefe del "Vesubio".

9. **MAGNACCO, Jorge Luis/M. T. de Alvear 1665.** Médico naval. Jefe del Servicio de Ginecología del Hospital Naval de la Capital Federal. Atendió partos de prisioneros en la ESMA. Trabajó en el Sanatorio Mitre, despedido en 1996 luego de reiterados escraches. Beneficiado por la Ley de Punto Final.

10. **WARCKMEISTER, Luis/Rodríguez Peña 1416.** Jefe de Personal del Estado Mayor General del Ejército. Beneficiado por la Ley de Punto Final.

11. **CORACH, Carlos V/Sinclair 3276.** Ministro del Interior de Carlos Menem. Bajo su mandato se llevaron a cabo represiones violentas contra manifestantes.

12. **GRONDONA, Mariano/S. L. Ruggieri 2930.** Periodista. Cómplice y colaborador.

13. **NEUSTADT, Bernardo/S. L. Ruggieri 2930.** Periodista. Cómplice y colaborador con la última dictadura militar.

14. **MASSERA, Emilio Eduardo/Av. del Libertador 2423.** Almirante. Integró la Junta Militar en 1976. Hasta fines de 1978 fue el Comandante en Jefe de Armada.ESMA. Acusado, entre otras cosas, de 83 homicidios calificados, 623 privaciones ilegales de la libertad, 267 aplicaciones de tormentos, 102 robos agravados y 11 sustracciones de menores. Beneficiado por la Ley de Punto Final. Cumple prisión domiciliaria por robo de bebés.

15. **PERTINE, Basilio B./Coronel Díaz 2665.** Vicealmirante de la Marina. Participó de los "vuelos de la muerte". Cuñado del Presidente De la Rúa.

16. **RADICE, Jorge C./Billinghurst 2533 "I".** Teniente de Fragata.Torturador y secuestrador de la ESMA. Secuestró a las monjas francesas y a la diplomática Helena Holemberg. Administraba los bienes robados a los detenidos. Viajó en el Merxenlivil. Formó parte de la Seguridad de Yabrán y fue custodio en el Congreso posterior a 1983. Beneficiado por la Ley de Punto Final y Obediencia Debida.

17. **SIMON, Julio (alias Turco Julián)/San Juan 1171.** Sargento Primero de la Policía Federal, SSF. Actuó en los CCD "Club Atlético", "El Banco" y "El Olimpo". Desprocesado por la Ley de Obediencia Debida.

18. **ACOSTA, Jorge E./Amenábar 2264 6°A.** Capitán de Corveta. Jefe de Inteligencia del GT hasta fines del 78. En 1983 seguía trabajando en Inteligencia en base a los archivos de ESMA. Vinculado al empresario Yabrán. Desprocesado por la Ley de Obediencia Debida.

19. **RIVEROS, Santiago Omar/3 de Febrero 1950 4°.** General de División del CIM de Campo de Mayo. Instaló el campo de concentración "El Campito" en donde desaparecieron 3500 personas. Imputado legalmente en Argentina e Italia.

20. **VIDELA, Jorge Rafael/Av. Cabildo 639.** Teniente Coronel. Comandante en Jefe del Ejército como Presidente de la Nación en la primera etapa de la dictadura. Cumple prisión domiciliaria por el robo de bebés.

21. **SAINT JEAN, Ibérico/Av. Cabildo 639.** General. Gobernador de la Pcia. de Bs.As. Desprocesado por la Ley de Obediencia Debida.

22. **OJEDA, René/Av. Cabildo 639.** General de Brigada. Jefe de la Policía Federal, del CIM. Beneficiado por la Ley de Punto Final y Obediencia Debida.

23. **KRINZONI, Ricardo G./Añasro 2124.**

24. **WHAMOND, James M. D./Av. Libertador 5312.** Secretario General Naval. Jefe de Aviación Naval. Responsable de los CCD que dependían de la Armada. Beneficiado por la Ley de Punto Final.

25. **ARAMBURU, Juan C. /La Pampa 4022.** Cerró sus puertas a las familias de los desaparecidos. Recibió de la dictadura 8 millones de pesos por sus servicios. Fue Arzobispo de Buenos Aires desde 1967 hasta 1990.

26. **ALEMAN, Roberto / Melián 1831.** Genocida económico - por lo menos 40 años formó parte o representó a los grupos económicos responsables de la situación del país. Ex ministro de Economía de la dictadura del GENOCIDA Leopoldo F. Galtieri. Defendió hasta el cansancio las privatizaciones y el desguace del Estado.

27. **DEL CERRO, Juan Antonio (alias Colores)/Balgomta 2397.** Auxiliar de Inteligencia. Procesado por el secuestro y tortura de 70 personas. Desprocesado por la Ley de Obediencia Debida.

28. **DONOCIK, Luis J./Honorio Pueyrredón 1047.** Represor. Trabajaba hasta el 2003 en SEGAR, empresa de seguridad privada.

29. **SCIFO MODICA, Ricardo "Alacrán"/Condarco 1955.** Represor. Hasta el 2002 trabajaba para el Estado.

30. **DI BENEDETTO, Agatino F./Av. Triunvirato 5177.** Médico Apropiador de la ESMA.

31. **PEYON, Fernando Enrique/Capdevila 2852 13B.** Capitán de Corbeta. Torturador y miembro del grupo de secuestradores de la ESMA. Miembro de la agencia de seguridad de Yabrán. Beneficiado por la Ley de Punto Final.

32. **ROLON, Juan Carlos/Capdevila 2852 8 B.** Teniente de Navío. Torturador. Integró los Grupos de Tareas de la ESMA. Participó del secuestro en 1977 de argentinos en Venezuela. Fue ascendido por Menem a capitán de Navío. Beneficiado por la Ley de Punto Final.

33. **ROVIRA, Miguel A. / Pasco 1032.** Asesino de la triple AAA. Hasta el 2002 fue el jefe de seguridad privada del METROVIAS.

34. **GALTIERI, Leopoldo Fortunato / Chivilcoy 3102 1°.** Teniente General. Presidente de facto. Culpable de todos los delitos cometidos en Entre Ríos, Chaco, Corrientes, Santa Fe y Misiones, como Comandante del Ejército (1976-1979). Culpable de la muerte de más de 800 combatientes en la guerra de Malvinas.

35. **WEBER, Ernesto Frimon Virgilio 1245 PB 3.** Subcomisario. Torturador y secuestrador en el GT 332 de la ESMA, responsable del secuestro de más de 3500 personas. Con pedido de captura del juez R. Garzón, acusado del delito de terrorismo de estado y genocidio. Beneficiado por la Ley de Obediencia Debida.

36. **DINAMARCA, Víctor Hugo / Benedetti 66 1A.** Servicio Penitenciario Federal. Actualmente vinculado al grupo Yabrán.

37. **BUFANO, Rubén Osvaldo / Madariaga 6236 PB 2.** Actuó como Agente de Inteligencia del Batallón 601. Participó del traslado de detenidos de la ESMA al Tigre. Fue custodio de genocidas y torturadores.

38. **WEBER, Ernesto Sergio / Comisario de la seccional 27 crespo (año 2005).** El 20 de diciembre de 2001, a cargo del 2 Cuerpo de Operaciones Federales, y siendo subcomisario de la Comisaría 1ra, dio «abrir fuego» contra los centros de manifestantes que se encontraban en la Av. de Mayo y 9 de julio expediendo la represión de la noche anterior, a cargo de Fernando de La Rúa decretó el Estado de Sitio. Sus subordinados, asesinaron a Gastón Riva, Diego Lamagna y Carlos Almirón. Hace poco más de un año, en julio de 2004, participó en la represión a los manifestantes que se concentraron en la legislatura de la Ciudad.

39. **HUGO, Mario Bellavigna / Cuenca 3446 3 D.** Párroco persignado. Acusado por Mauricio Merep, quien lo reconoció como el sacerdote que le avisaba al dueño de la empresa donde él trabajaba, que lo estaban buscando. El dueño de la empresa era Mario Pico, asesino de desaparecidos en la zona norte.

40. **VIDAL, Jorge Héctor / Robertson 1062.** Médico apropiador. Hizo las partidas de nacimiento de los chicos nacidos en cautiverio.

AVELLANEDA:

41. **CARNOT, Roberto R. / Av. B Mitre 5865 13 A.** Sub-prefecto de GT ESMA. Torturador. Beneficiado por la Ley de Punto Final.

QUILMES:

42. **BERGES, Jorge A. / Magallanes 1441.** Oficial principal médico de policía de La Plata. Responsable de la desaparición de niños. Desprocesado por la Ley de Obediencia Debida.

VICENTE LOPEZ/OLIVOS:

43. **OLIVERA, Jorge / Quintana 2215.** Teniente. Regimiento 22 de Montaña. San Juan.

SAN ISIDRO:

44. **PERREN, Jorge E. / Marconi 3495.** Capitán de Corbeta. Jefe de Operaciones del GT ESMA. Responsable del Centro Piloto de París. Torturador y secuestrador. Segundo de Acosta. Beneficiado por la Ley de Punto Final.

AQUI VIVEN

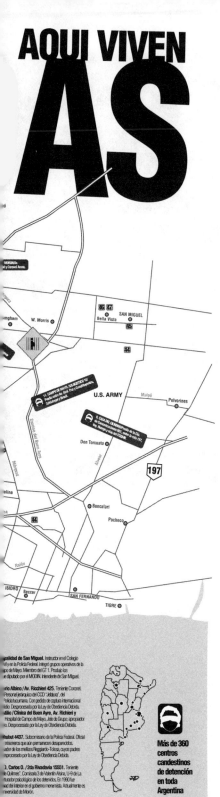

AS

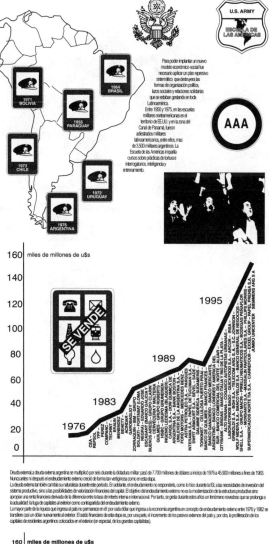

1971 BOLIVIA
1964 BRASIL
1955 PARAGUAY
1973 CHILE
1972 URUGUAY
1976 ARGENTINA

Para poder implantar un nuevo modelo económico-social fue necesario aplicar un plan represivo sistemático que destruyera las formas de organización política, lazos sociales y relaciones solidarias que se estaban gestando en toda Latinoamérica.
Entre 1950 y 1975, en las escuelas militares norteamericanas en el territorio de EE.UU. y en la zona del Canal de Panamá, fueron adiestrados militares latinoamericanos, entre ellos, mas de 3.500 militares argentinos. La Escuela de las Américas impartía cursos específicos de tortura e interrogatorios, inteligencia y entrenamiento.

AAA

SE VENDE

miles de millones de u$s

160
140
120 — 1995
100
80 — 1989
60
40
20 — 1983
0 — 1976

CEA – REPSOL – YPF – PEREZ COMPANC – TECHINT – BRAUN – BEMBERG – BENETY – ZORRAQUIN – IBM – GRUPO NEGRA – EDUARDO JOSÉ ESCASANY – BANCO GALICIA – BUENOS AIRES – GRUPO CLARIN – GUILLERMO GREGORIO HONETTI – HSBC – GRUPO GRÜNEISEN – INDUPA – GRUPO BLAQUIER – CARGILL S.A. – DON QUIMICA DE ARGENTINA S.A. – MERCEDES BENZ – UNILEVER DE LA ARGENTINA S.A. – FORD MOTORS – ROEMMERS – PEROL PETROLEO – MOLINOS RIO DE LA PLATA – INTERAMA S.A. – PAPEL DE TUCUMAN S.A. – ALTO PARANÁ – SIDERCA – SIDMERCA – DALMINE SIDERCA – SIDMERCA – TORNEO S.A. – NIDERA S.A. – SA DE PETROLEO – BANCO DE QUILMES – BANCO FRANCES SUR – BANCO COMERCIAL DEL NORTE – ALUAR – LEDESMA S.A. – BGH S.A. – TELECOM ARG. S.A. – S.C. JOHNSON – GRIMOLDI S.A. – BGH S.A. – TELECOM ARG S.A. – BODEGAS PEÑAFLOR – WOLF NEGRA S.A. – MACRI DE MEXICO – PIRELLI – PRIMAS S.A. – SHELL S.A. – GRUPO MACRI – PIRELLI NEUMATICOS – EXXES S.A. – PHILIPS MORRIS S.A. – SUPERMERCADOS NORTE S.A. – CARREFOUR – MASSALIN PARTICULARES – PHILIPS ARGENTINA S.A. – JUMBO UNICENTER – SIEMENS ARG S A

Deuda externa La deuda externa argentina se multiplicó por seis durante la dictadura militar: pasó de 7.700 millones de dólares a inicios de 1976 a 45.900 millones a fines de 1983. Nunca antes ni después el endeudamiento externo creció de forma tan vertiginosa como en esta etapa.
La deuda externa también cambia su naturaleza durante este período. En adelante, el endeudamiento no responderá, como lo hizo durante la ISI, a las necesidades de inversión del sistema productivo, sino a las posibilidades de valorización financiera del capital. El objetivo del endeudamiento externo no es la modernización de la estructura productiva sino apropiar una renta financiera derivada de la diferencia entre la tasa de interés interna e internacional. Por tanto, se gesta durante estos años un fenómeno novedoso que se prolonga a la actualidad: la fuga de capitales al exterior como contrapartida del endeudamiento externo.
La mayor parte de la riqueza que ingresa al país no permanece en él: por cada dólar que ingresa a la economía argentina en concepto de endeudamiento externo entre 1976 y 1982 se transfiere casi un dólar nuevamente al exterior. El saldo financiero de esta etapa es, por una parte, el incremento de los pasivos externos del país y, por otra, la proliferación de los capitales de residentes argentinos colocados en el exterior (en especial, de los grandes capitalistas).

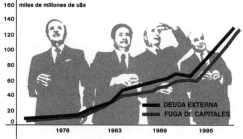

miles de millones de u$s

160
140
120
100
80
60
40
20
0

1976 1983 1989 1995

— DEUDA EXTERNA
— FUGA DE CAPITALES

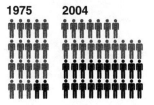

1975 2004

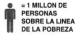
= 1 MILLON DE PERSONAS SOBRE LA LINEA DE LA POBREZA

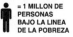
= 1 MILLON DE PERSONAS BAJO LA LINEA DE LA POBREZA

Más de 360 centros candestinos de detención en toda Argentina

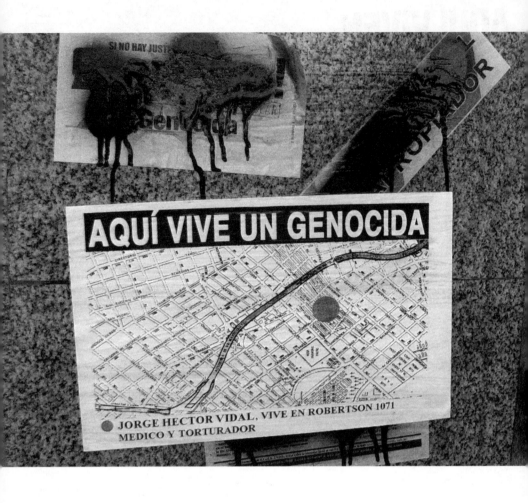

Map *A Genocidist Lives Here*. Escrache against Jorge Hector Vidal,
Flores neighborhood. December 27, 2003.

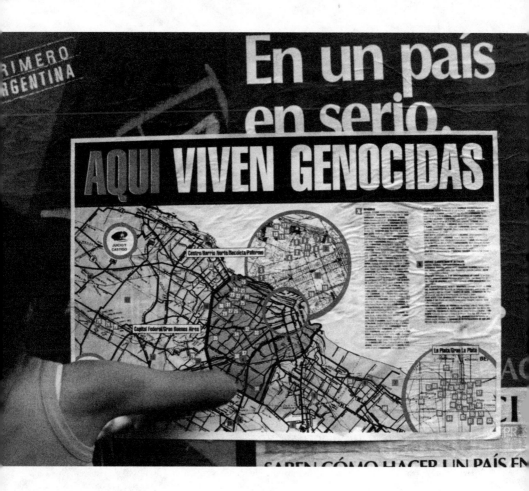

***HERE LIVE GENOCIDISTS*. MARCH 24, 2004.** Along the route of the March
24 march, posters that contain the addresses of the genocidists being escrached
were hung up. This poster was used on the same date in 2002, 2003, 2004, and
2006. Each time the design was transformed and the addresses of the newly
escrached genocidists were added.

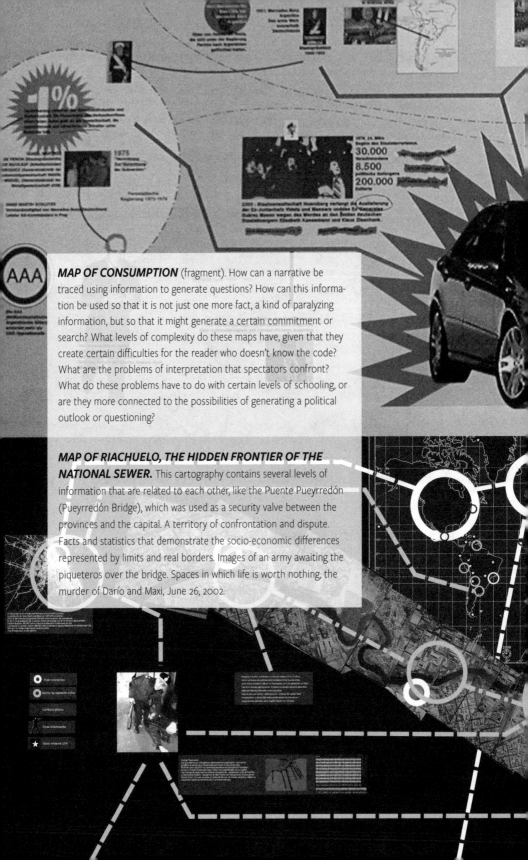

MAP OF CONSUMPTION (fragment). How can a narrative be traced using information to generate questions? How can this information be used so that it is not just one more fact, a kind of paralyzing information, but so that it might generate a certain commitment or search? What levels of complexity do these maps have, given that they create certain difficulties for the reader who doesn't know the code? What are the problems of interpretation that spectators confront? What do these problems have to do with certain levels of schooling, or are they more connected to the possibilities of generating a political outlook or questioning?

MAP OF RIACHUELO, THE HIDDEN FRONTIER OF THE NATIONAL SEWER. This cartography contains several levels of information that are related to each other, like the Puente Pueyrredón (Pueyrredón Bridge), which was used as a security valve between the provinces and the capital. A territory of confrontation and dispute. Facts and statistics that demonstrate the socio-economic differences represented by limits and real borders. Images of an army awaiting the piqueteros over the bridge. Spaces in which life is worth nothing, the murder of Darío and Maxi, June 26, 2002.

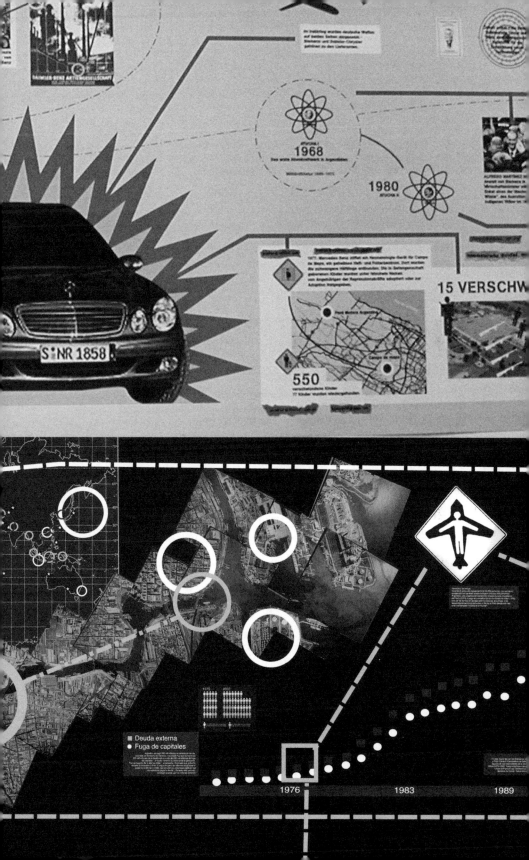

CONCEPTS AND PRACTICES OF JUSTICE

EXPERIENCES FROM THE MESA DE ESCRACHE

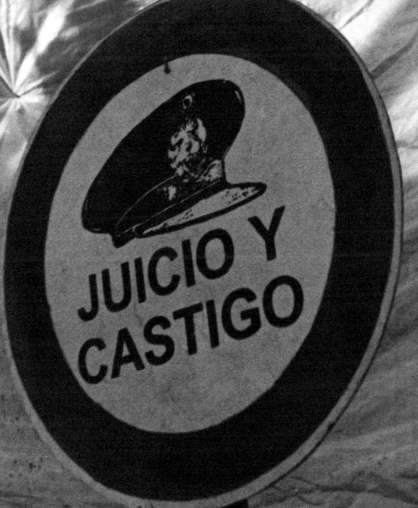

JUICIO Y CASTIGO

THE ESCRACHES: A BRIEF HISTORY

The first escraches in Argentina were realized by the group H.I.J.O.S., which emerged in 1995 out of the need to denounce the impunity of institutional justice, namely the passage of the laws Obediencia Debida and Punto Final, as well as the presidential pardons.

The word escrache signifies in Argentine lunfardo "to bring into the light something hidden" or "to reveal what power hides:" the fact that our society lives with murderers, torturers, and kidnappers, who until this moment lived their lives in a comfortable anonymity.

The beginnings of the escrache were very tied to the social and mediatic interruption by the group H.I.J.O.S. and strongly impacted public opinion. From the beginning, escraches broke with various "traditional" forms of doing politics, especially in their use of creativity, joy, and the carnivalesque as tools for struggle.

At that time, the escraches were organized solely by a commission from H.I.J.O.S. But from the beginning, groups, art collectives, and other people began to come together to collaborate on this new practice. At first, the escraches consisted of interrupting the workplaces or homes of a genocidist linked to the dictatorship. Highly visible figures, such as Astiz, Martínez de Hoz, Videla, and Massera, were chosen as paradigms of the repression. It was necessary to appear in the media, so strategic dates were chosen. The objective was to put the issue on the map, and we worked to spread the action in both the neighborhood of the escrache as well as in the city center. The idea was for people to repudiate the genocidists still on the loose, to create "social condemnation," to question the absence of a legal punishment. The slogan became: "If there is not justice, there is escrache." ("*Si no hay justicia hay escrache.*")

It was during the escrache against Magnacco that we began a project in the neighborhood where the genocidist lived. Magnacco, a kidnapping doctor and the Head of Obstetrics at the hospital Sanatorio Mitre, was fired from his job after the escrache, thanks to social repudiation.

It was from this moment that an attempt was made to deepen the work in specific neighborhoods. In that context, in 1998, the Mesa de Escrache was established as a working group of diverse social organizations from a given neighborhood (in the first Mesa there were several art groups, leftist political parties, unions, students, and musicians).

For each escrache, the Mesa de Escrache moved itself into a neighborhood to begin the work of a territorial construction based on the features and issues of each place. The escrache became an event that united neighborhood experiences, where the neighbors were actors rather than mere spectators. As such, the search for a media figure like Videla or another famous member of the

dictatorship was replaced by escraches of figures less well known but no less involved in the genocide.

The objective was not simply the number of people who joined the march of the escrache, but rather to favor construction in the neighborhood through preliminary activities in that space, respecting its singularity, its tempos and its subject matter. Beginning in 2001, the Mesa de Escrache Popular went into neighborhoods and began to build relationships with different social organizations, cultural centers, musical groups, student centers, and assemblies. Film series, talks, activities in schools and plazas, and open radio all took place. There was a strong sense that the escrache was a form of justice that broke with the representations of institutional justice: a justice constructed by people in the day to day via the repudiation of the genocidist in the neighborhood, the reappropriation of politics, and the reflection of the subject matter of the present.

Starting in 2003, a new set of figures began to be escrached: those who were complicit with the dictatorship and who continued to be professionally active. It began with the escrache against Héctor Vidal, a kidnapper of babies born in captivity and a falsifier of birth certificates, who was living freely thanks to the laws of Obediencia Debida and Punto Final. Six months after the escrache, his medical license was revoked. In 2004, the priest Hugo Mario Bellavigna was escrached; he was the leader of the church of Santa Inés Virgen y Mártir, worked as a chaplain in the women's prison Devoto between 1978 and 1982, and was a member of the "Comisión interdisciplinaria para la recuperabilidad de las detenidas" (Interdisciplinary Commission for the Rehabilitation of the Detained) where prisoners were tortured and manipulated. In 2005, it was police captain Ernesto Sergio Weber's turn. He participated in different repressive acts during the democratic period, among them the repression that occurred directly outside the Legislature after the vote approving the Código Contravencional (Criminal Code); he was also responsible for the deaths during the repression in Buenos Aires on December 20, 2001.

THINKING WORK IN THE NEIGHBORHOODS

The Mesa de Escrache works from an idea of equality. Its practice aims at social condemnation, which asks for the participation of society in general, and is oriented towards an encounter between emotion and the desire for a just society. Its organizational structure is reflected in each weekly meeting, where opinions are exchanged and decisions are made via consensus, with a clear tendency towards horizontality. In this sense, the working group distances itself from every idea of political practice as that of individual actors, where in an action some have more

rights than others, or whose actions serve to create a spectacle of individual pain. As Alain Badiou notes, no politics will be just if the body is separated from the idea, even less if it is realized as a spectacle of the victim, since "no victim can be reduced to their suffering, within the victim it is humanity as a whole who is beaten."[1]

For this reason, the practice of the escrache centers on living memory, which creates and acts, generating political practices by means of joy, celebration, and reflection.[2] It moves away from the practices of judicial power, which reify and individualize social problems, and which generate a spectacle represented in the practice of justice. Here we encounter the idea of Agamben, who writes: "Law is not directed toward the establishment of justice. Nor is it directed toward the verification of truth. Law is solely directed toward judgment, independent of truth and justice. This is shown beyond doubt by the force of *judgment* that even an unjust sentence carries. The ultimate aim of law is the production of a *res judicata* in which the sentence becomes the substitute for the true and the just, being held as true despite its falsity and injustice."[3]

The process of the escrache interrupts everyday life in the neighborhood. Having picked a target, the Mesa de Escrache Popular moves into the neighborhood where the genocidist lives. Its arrival produces worry and curiosity, since every weekend the neighbors see a group of people handing out info sheets explaining the criminal record of the next target of the next escrache and inviting them to participate in the working group. The group meets in a public space, which means that over time the neighbors get to know the members and know why they are there. The answers of the neighbors are varied and imply distinct levels of participation. We understand participation in a broad sense, as the act of communicating events, for example, when a neighbor rings another neighbor's doorbell to tell her that a

1 Badiou, Alain, "The Idea of Justice," conference presentation given on June 2, 2004, in the Facultad de Humanidades y Artes in Rosario, Argentina.

2 A memory, in some way, is a vision of the social and historical world. For this reason, "the memory" does not exist. Rather, we have instead memories, visions, selections, the forgotten, recollections chosen with the passage of time, and the collective constructions of these past "facts." Given all this complexity, the memories are not mere recollections but rather constructions of the individual and society in a dynamic and joint relation marked by a historical and social moment. Memories raise sensory disputes about sense, bravery, power, etc.: abandoning the false idea of a "complete memory" (as Mariano Grondona, host of *Hora clave* has expressed repeatedly his program). Memories are multiple, like the diverse subjects that make up society. That the dominant power tends to homogenize us, seeking to impose its normalizing logic and build its disciplinary power, is a theme that we must be aware of in order to build our means of resistance. To take up Foucault's idea that there are not power relations that do not include resistances, that resistance exists because it is where power is: it is then, like power, multiple and everywhere. From the Mesa de Escrache, building resistance is a response to the transcendence of the social genocidist organization; it is a means of saying "enough already." In the process of the escrache, a form of power is attempted as a verb, of making-power as the power of relation, of the power of recognizing oneself in differences and similarities, of power building collectively. In this collective building, memory is not a puzzle where the pieces form a unified image, but it is, as Pilar Calveiro notes, "a kaleidoscopic vision. . . that would imply all those bits of the moving figures of the kaleidoscope."

3 Giorgio Agamben, *Remnants of Auschwitz: The Witness and the Archive*, trans. Daniel Heller-Roazen (Zone Books: New York, 1999), p. 18.

genocidist lives next door. Another example would be the information these same neighbors offer about the everyday practices of the genocidist ("He gets his hair cut there," "He eats breakfast every day at such and such an hour in this bar," "He is friends with this guy," etc.).

The practice of the escrache generates multiple interventions, including those by the family members, friends, and institutions that defend the genocidist. There is, for example, a constant tearing down of the posters with the genocidist's photograph, as well as telephone threats, accusations of defamation, and, in some cases, police persecution to intimidate and seize the belongings of those participating in the escrache.

Day by day in the neighborhood, the practice of the escrache constructs images that mark the genocidist, removing him from his everyday anonymity. The walls begin to say, "There is a torturer in this neighborhood" and "If there is not justice, there is escrache." The neighbors are now on alert, receiving flyers and dialoguing with the participants in the escrache. The aesthetics of the neighborhood change, symbolically cornering the genocidist: no neighbor can ignore what is occurring because when they leave the house there is a poster on an otherwise abandoned wall; when they go to the store, there is a map clearly marking the home of the genocidist; when they throw a piece of paper into a public trash bin, there is already a sticker on the bin denouncing the genocidist; when they stroll through the neighborhood on the weekend, they confront a group of people discussing and denouncing genocidal practices. In this way, the landscape of the neighborhood changes, giving expression to a social problem that invades the furthest corners of the neighborhood.

While it is very important to do the escrache against the genocidist, at the same time the escrache is an excuse to come to a neighborhood and take on the problems of the present. From this place, we have worked together with neighbors on problems of housing, police violence, corruption in the courts, the fear of talking about the past, creating spaces of encounter and reflection that relate the genocide to new problems. It is in this sense that Colectivo Situaciones hypothesizes: "Today's escraches, more than yesterday's, plunge into the community and work with the residents of that community. They also have developed a sense of gratitude, an unselfishness, the "for anyone," that has been lost in contemporary political activity."[4] This plunging that Situaciones mentions is nothing more than the logic of the encounter, which stimulates the Mesa itself, since it is not interested in "raising consciousness" as in traditional politics, but rather the Mesa, from this encounter and socialization with the "other(s)," creates moments in which the members of the group and the actors in the neighborhood are enriched by their stories and experiences, with one result of the escrache being this listening and learning from

4 Colectivo Situaciones, *Genocide in the Neighborhood*, trans. Brian Whitener, Daniel Borzutzky, and Fernando Fuentes (ChainLinks, 2009), p. 91.

the other. Once it is time to move to other neighborhoods, actors in the group and those in the neighborhood will continue to discuss what occurred in this shared lived experience.

In this sense, we can understand the practice of the escrache as a possibility of opening a process of political subjectivity, as it is defined by Rancière: "An enactment of equality—the handling of a wrong—by people who are together to the extent that they are *between*."[5]

WALKING JUSTICE

Following an internal discussion of the simple demand "Justice and Punishment," which was directed at the courts, the practice of the escrache turned in a new direction: that of the "social condemnation." Many debates were had concerning the meaning of that slogan. One of the positions advanced was that social condemnation was a means to realize justice and punishment. Another maintained that social condemnation also could be realized as an end in itself. This debate marked a turning point in the thinking of the Mesa de Escrache, establishing an idea and a practice of justice that exceeded the institutional frameworks of the state and its rule of law.

It is from this point of view that the escrache can be seen as an investigation of the representations of justice in neighborhood practice.

With the arrival of the government of Kirchner and, in June 2005, the annulment of the Obediencia Debida and Punto Final laws, a new moment emerged in the prosecutions of the dictatorship and with this, a shift in position regarding social organizations and movements. The question was raised: with these new trials, would the escraches end? Our thinking was that the practice of the Mesa was a kind of social work, starting from thinking of the genocide not as an individual condition but as a collective one. The answer then was that in the best of all possible outcomes, if all the military repressors were put in prison, the process of the escrache would still continue, because its principal objective was to reflect on the social transformations and the rupture of the network of intersubjective relations produced by the genocide in order to also address current social conflicts. In this way, an idea of justice that distances itself from the logic of institutional justice began to be formed.

The Mesa de Escrache began to transform notions of time: the escrache isn't based on a past event, nor on an idea of future reparation. We position ourselves far from the idea of waiting for some resolution made by "others," or by state

5 Jacques Rancière, *Disagreement: Politics and Philosophy*, trans. Julie Rose (Minneapolis: University of Minnesota Press, 1999), p. 61.

institutions when it's convenient for the national executive power— and, when, this executive power might only rig the results with the judges, it demonstrates how little the idea of a just society actually matters.[6]

As such, the Mesa de Escrache reflected on the meaning of social condemnation thinking of it as an everyday construction that implicated all of society. Social in that it involves problems that were not individual but that cross from neighborhood to neighborhood and day to day and that touch the most distant parts of the social network. From the practice of the escrache, we consider the military assassins of the last Argentine dictatorship to be genocidists, and this involves understanding that the seventies and the beginning of the eighties produced a radical alteration in society. From this perspective, the Mesa has the construction of a space of reflection and social protagonism as an objective in order to tackle the problems that the last dictatorship left us and the new problems that we have acquired in our so-called "democracy" (both processes which solidified neoliberalism).

This was an attempt to construct a social condemnation seeking the production of justice outside of institutions and constituted within the day-to-day life of the neighborhood via a process of reflecting on the past and present. The neighbors choose to not have genocidists as neighbors, and they demonstrated their repudiation of them. For example: after meetings of the working group in a particular neighborhood and after the march of the escrache, a building association got together and asked the genocidist to move somewhere else because they didn't want to live with him any longer. The actions in the neighborhood aren't reduced to the genocidist; public actions and activities related to current social problems are also produced. For example, the last escrache in Walmart was undertaken for three reasons: the precaritization of work today, the persecution of working men and women who tried to organize, and because the head of security in the supermarket was a genocidist from the dictatorship. This is how the Mesa proposes to transform vis-à-vis a "walking justice," one connected to a knowledge of the past, which is considered along with the present. A walking of everyday justice, neither programmatic nor future-orientated, coinciding with Badiou's notion that justice is the name of the capacity of bodies to carry ideas in the struggle against modern slavery, "to pass from the state of the victim to one who stands up." Justice is a transformation: it is a collective present of a subjective transformation, as a process of construction of a new body fighting against the social alienation of present-day capitalism.

6 We concur here with Derrida in his idea that law is always an authorized force; that in fact there is not law without force. As he writes: "Instead of 'just,' we could say legal or legitimate, in conformity with a state of law, with the rules and conventions that authorize calculation but whose founding origin only defers the problem of justice. For in the founding of law or in its institution, the same problem of justice will have been posed and violently resolved, that is to say buried, dissimulated, repressed." Jacques Derrida, "Force of Law: The 'Mystical Foundation of Authority,'" in *Deconstruction and the Possibility of Justice* (Drucilla Cornell et al., eds.), London: Routledge, 1992, p. 23.

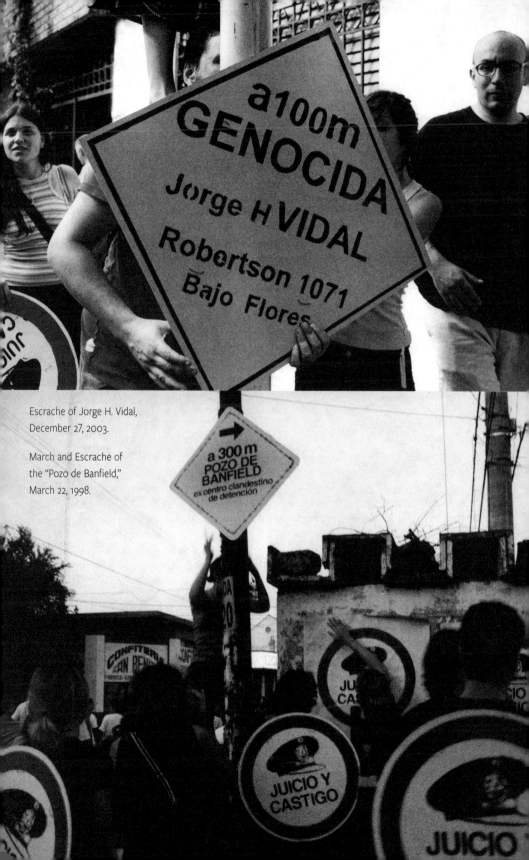

a100m
GENOCIDA
Jorge H VIDAL
Robertson 1071
Bajo Flores

Escrache of Jorge H. Vidal,
December 27, 2003.

March and Escrache of
the "Pozo de Banfield,"
March 22, 1998.

a 300 m
POZO DE
BANFIELD
ex centro clandestino
de detención

JUICIO Y
CASTIGO

JUICIO

JUI
CAS

JUSTICE AND PUNISHMENT: COURTS OF RETIRO, COMODORO. MARCH 19, 1998.

This was the first time that we went in public with street signs in the context of the trial of Massera.

a 300 m
Rubén Osvaldo
BUFANO
GENOCIDA
Madariaga 6236 PB 3

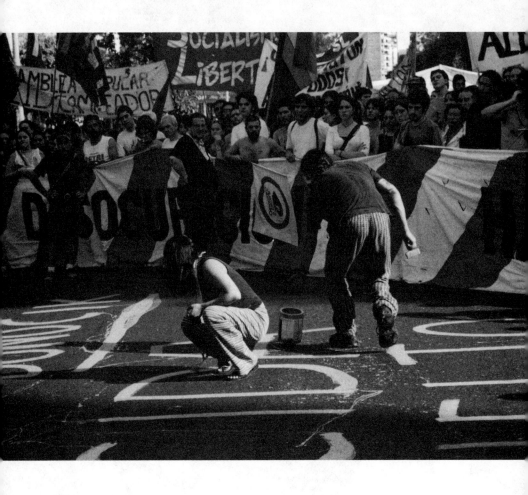

Escrache of Luis Juan Donocik. December 14, 2002.

GRUPO DE ARTE CALLEJERO: THOUGHTS, PRACTICES, AND ACTIONS

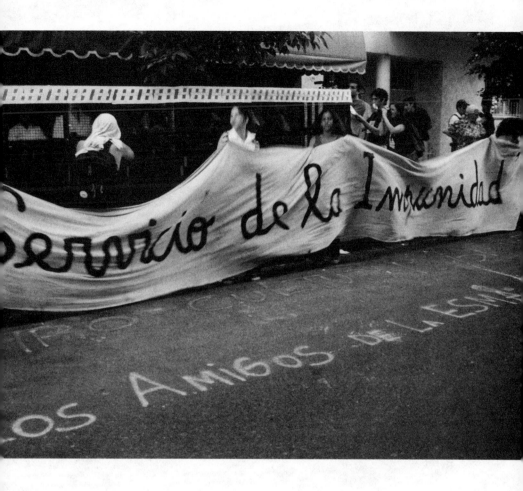

"The banner 'In the Service of Impunity' was conceived of and realized by the compañerxs from H.I.J.O.S. in 1999. Since then it has been used in all the escraches: it is held in front of the police barriers that protect the repressor's house, alluding to those who protect the genocidists. This photo is from the escrache of Donocik in December 2002." —Charo

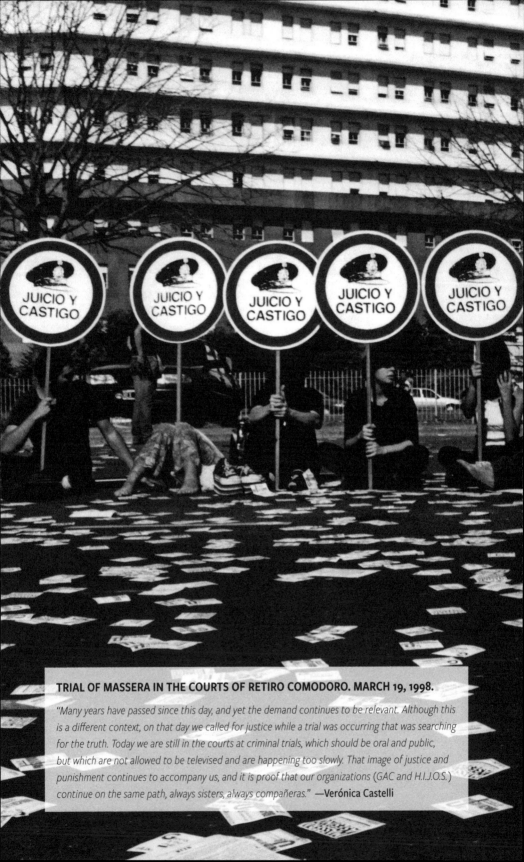

TRIAL OF MASSERA IN THE COURTS OF RETIRO COMODORO. MARCH 19, 1998.

"Many years have passed since this day, and yet the demand continues to be relevant. Although this is a different context, on that day we called for justice while a trial was occurring that was searching for the truth. Today we are still in the courts at criminal trials, which should be oral and public, but which are not allowed to be televised and are happening too slowly. That image of justice and punishment continues to accompany us, and it is proof that our organizations (GAC and H.I.J.O.S.) continue on the same path, always sisters, always compañeras." —Verónica Castelli

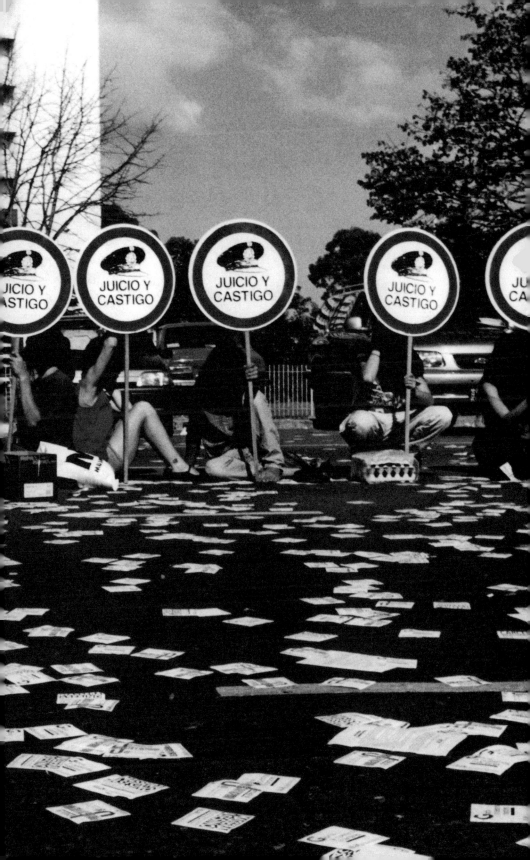

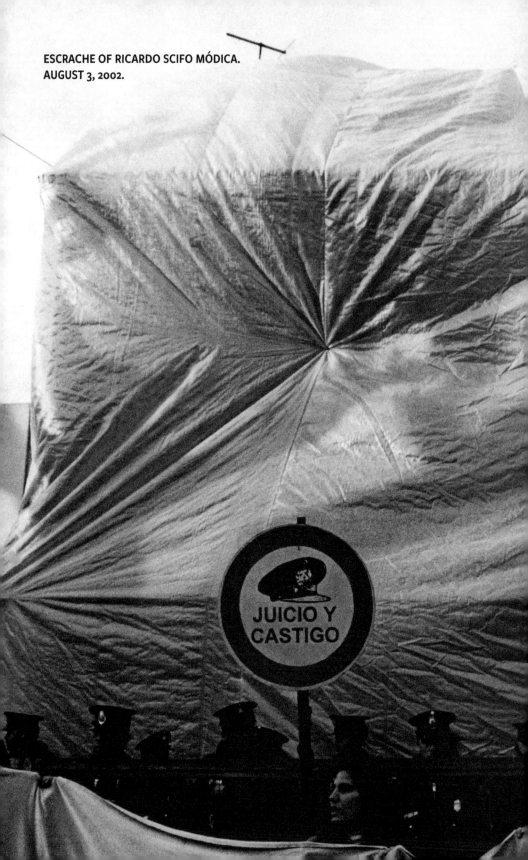

ESCRACHE OF RICARDO SCIFO MÓDICA.
AUGUST 3, 2002.

JUICIO Y
CASTIGO

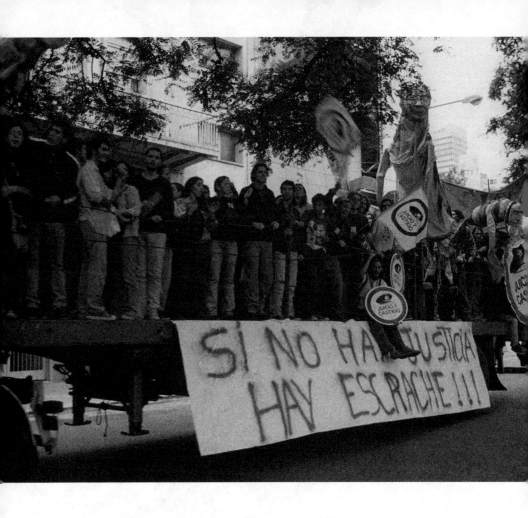

"If there is not justice, there is escrache!!!"

First mobile escrache, passing the homes of various genocidists
from the last military dictatorship. December 11, 1999.

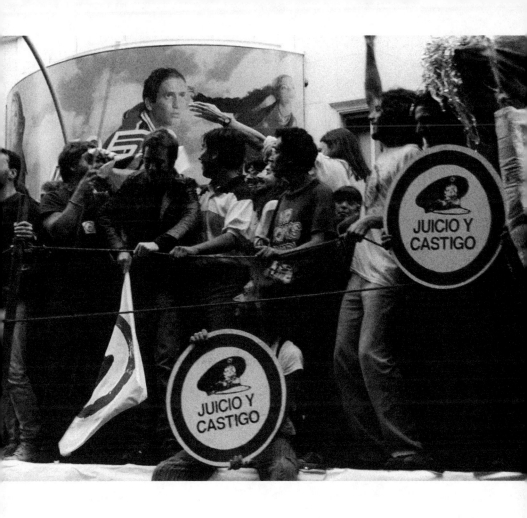

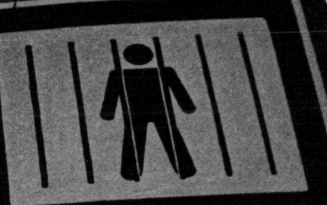

CLUB
ATLETICO
ex-centro
clandestino de
detención

THE ESCRACHE
AS A POINT OF DEPARTURE
FOR RETHINKING THE IMAGE

ESCRACHE: THE USE OF THE IMAGE

In 1998, we carried out a year of activities around murals, moving into experiences of visual and graphic interventions and working with signs in the street.

The escrache was developed by H.I.J.O.S. in 1996 and became visible in 1997. The practice of the escrache immediately attracted us as an action that collectively thought of other means of building justice in the face of the impunity that those guilty of genocide were relying on. After the passage of the laws Obediencia Debida and Punto Final and after the pardons from Menem, a new perspective from which to think of what to do with the absence of justice became necessary, as did seeking other forms of conceptualizing and creating this perspective. Social condemnation arose as an end in and of itself, without losing the demand for justice and punishment.

We were called by the action towards another means of politics not only from a thematic standpoint, but also from symbolic and generational ones, and as a space to interact with others.

For GAC, it was then that the first change in our activities was produced: central to what brought us together was work concerning state terrorism and visual production as a means to intervene politically. With respect to a more political language, our relationship was very informal. Gradually, we started to get involved in discussions, discourses, and the decisions that this implied. None of us came from a militant space, so when we started to work on the escraches we invariably positioned ourselves in another place, and it sharpened our gaze. By working on repression and its consequences, we explored, from the point of view of representation, matters that were difficult to represent. In fact, the most familiar models from protest iconography are generally too iconic or too referential, and we didn't identify with them.

These first moments marked a line of work that would be sustained from there on out: from diverse forms to themes, the centrality of denouncing would always be maintained. All the projects sustained this methodology to a greater or lesser extent.

It was with the first escraches that we consolidated as a group and, at the same time, the group was limited to the people who were members then. We argued with others about how to properly denounce, how to do escraches, which were the most precise tools and methodologies, what were the objectives for each action. And internally, amongst ourselves, our work revolved around how to symbolize this struggle. The escrache gave us a dual dynamic: it simultaneously marked the closure inward, and it opened us outward.

This opening outward came at the moment in which the construction of justice, the demand for justice and punishment, the struggle for the memory, and the

vindication of the disappeared was not only tied to the struggle of family members of militants from the seventies. It was also taking root within people who did not have familial relationships or militant ties to the disappeared, among people who were of the same generation as the children of the militants of the seventies.

Those first meetings, which took place on Mondays at the office of Familiares de Detenidos y Desaparecidos por Razones Políticas (Relatives of those Detained and Disappeared for Political Reasons), were shared with other groups that were also becoming more militant in the wake of the escrache. H.I.J.O.S. was also working as the glue to other, more autonomous experiences and using a different perspective on human rights.

In the beginning, we were participating from a slightly external position: accompanying the process. Afterwards, we contributed and involved ourselves more. Our participation was further increased when the activity of the escrache opened up completely and Mesa de Escrache Popular was created. As such, the demands made visible by the family members who were accompanied by others broadened and created a very powerful political position, totally different from the forms or traditional spaces belonging to parties or unions. At that time, we felt the need to mark and signal the spaces in the city that had served as CCDs (clandestine detention centers), thinking of the nonvisibility of those spaces and the ways in which they were or were not recognized by people passing by. We proposed working on the physical spaces of state terrorism and their invisibility with the objective of unveiling the subjects (by means of an escrache) who participated in the dictatorship. We took into account that the majority of the CCDs were not built specifically to be used for the dictatorship, but rather that commissaries, military offices, and public buildings were recycled for the purposes of repression and extermination. For this very reason, in order to signal these spaces and make them visible, the experience of the escrache was helpful.

Here our CCD proposal took on a double meaning: while it was enmeshed in a project that has the political soundness of the escrache, it allowed us to think through the denunciation from a different angle. Our idea was expanded with the contribution of the original compañerxs from H.I.J.O.S., who made us aware of the need to accompany the escrache with signs of denunciation. The sign as image began to form part of the action of the escrache and grew alongside the denunciation of the oppressors; also the slogan "Justice and Punishment" became a symbol of the struggle, like the slogan "Living Ghosts" of the Madres of Plaza de Mayo had been in another moment in time.

Our contribution is in the thinking through and making of images in relation to the energy that working on the escrache generated. From the beginning, we chose to use the aesthetic of signage, using mock street signs (made of wood painted with acrylics, printed using silk screens or stencils), to subvert the real codes:

maintaining colors and icons but completely changing their meaning. The space being used is the same as the real spaces in the city: on the posts that one finds on the street. We sought to place the signs in spaces that were amply visible both to the passerby and to the driver. These signs served as a spatial intervention in the city, losing and discovering themselves in the daily visual pollution, managing to infiltrate the framework of the city itself.

The great transformation that was implied for us in thinking of the image in the escrache concerned, on the one hand, language: the idea of tweaking a determined code (urban street signs). On the other hand, it was the idea of a temporal event that was repeated as a carnivalesque interruption of which the signs were the trace, that which remained "after." The temporality of the escrache made possible the emergence of a type of serial image that reappeared each time. Besides marking the path, the signs mark a time, intervals of time, between escrache and non-escrache, and also between the escrache and other spaces where the same signs appeared copied by other groups. Perhaps for this reason we can consider all of the projects where signs were deployed as a large conceptual unit that spans from the group's beginning to the present day. It is not accidental that each time someone refers to GAC, they refer to our best-known work: that of the signs. We continued making the street signs throughout all those years, even in other spaces, and the signs were reappropriated by other groups and collectives for their own activities, which were different from the escraches of H.I.J.O.S. or the Mesa de Escrache Popular. Also, with time, the signs' uses changed, and they were converted into other objects, such as fliers, maps, decals, flags, t-shirts, etc., depending on the different activities, needs, and reformulations.

PARQUE DE LA MEMORIA

The Parque de la Memoria (Remembrance Park) was an initiative of human rights organizations that was presented as a project to the legislature of the city of Buenos Aires at the end of the nineties. The objective was to create a space in front of the Río de la Plata to remember and pay homage to the thirty thousand disappeared. To this end, the Comisión pro-Monumento a las Víctimas del Terrorismo de Estado (Pro-Monument Commission to Victims of State Terrorism) was formed, integrating all of the human rights organizations, as well as representatives from the Buenos Aires city council. The idea consisted of a park with various sculptures and a central monument to the victims of state terrorism. There was an international competition, in which GAC participated, to choose the sculptures, and *we* were chosen along with other proposals. The decision to participate in this contest was not easy. It is necessary to contextualize the decision in the

political situation of 1999, when groups were considering how to break open a system that seemed closed to any expression of a vindication for the seventies. In this sense, it seemed important to us to use the competition as an excuse to deepen work on the concept of state terrorism without closing it off strictly in the era of the Argentine dictatorship (1976–1983), but also extending the exploration to Argentina's relationships with the dictatorships from the rest of Latin America and, after, towards the national and international policies of control and security that continued during the periods of the so-called "democratic transition" and during the consolidation of bonafide neoliberalism.

Upon deepening this exploration, our work in the escraches expanded, since we were able to use street signs across a greater range of spaces and with the end goal of generating a dialogue between images and concepts. The desire to extend and complicate the denunciation (in addition to the CCDs and the oppressors) was what we felt gave coherence to our decision to participate in the Remembrance Park competition.

Taking up signification and the question of how to build or imagine an homage to the disappeared created various difficulties for us—these were, above all, linked to the question of how to develop a project of denouncing that was capable of plumbing the historical dynamic of the past forty years without accepting the chronological division proposed by the organizing institution. In addition to expanding our own perspective with regards to the iconic resignifications, this project confronted us with two concrete problems: on the one hand, beginning to think about how to pay homage, and, on the other, how to face the ideas of institutionalization or monument-making from our practices of denunciation. The problems amassed over time.

MEMORY SIGNS

The nearly sixty signs were conceived and planned from urban experiences. Resignifying actual street signs, tracing a route and story guided by a historical line. They were located along the coast in front of the Río de la Plata. Each sign aimed to represent a situation or event related to state terrorism, both acts of repression and economic measures, as well as the rise of resistance. Being similar to street signs—in this case in terms of materials and supports that are used by the road and highway department—at first glance, these signs conveyed a sense of order that acquire a totally new meaning as they point to the events that are the object of the signs' denunciations. Some of the signs include short texts with the intention of supplementing the image to which they refer. Each sign can be read individually or as part of one or various paths, dialoguing with whomever makes the trip, who

is also the one deciding how to experience these signs: individually, in groups, or in their totality. In the first version in 1999, the texts were faithful quotes from different sources. This was changed in the most recent version, since the choice of quotes in the original version was the result of an impossibility with regard to writing those texts *ourselves*. Over the years and as a result of much experimentation, we were able to put into words our own thoughts and while we used some quotes, these were intermixed with our own impressions. The initially proposed images were also changed over time, revalorizing and articulating concepts related to the social and economic policies of the last two years.

The deepening of the theoretical, conceptual, and political framing made us re-think the images and discourses that we were using. It was in this way that we passed through projects like "Operación Condor" ("Operation Condor"), "Conectado" ("Connected"), "Escrache Pass" ("Escrache-Pass"), "Estampitas" ("Stamps"), and "Aquí Viven Genocidas" ("Here Live Genocidists").

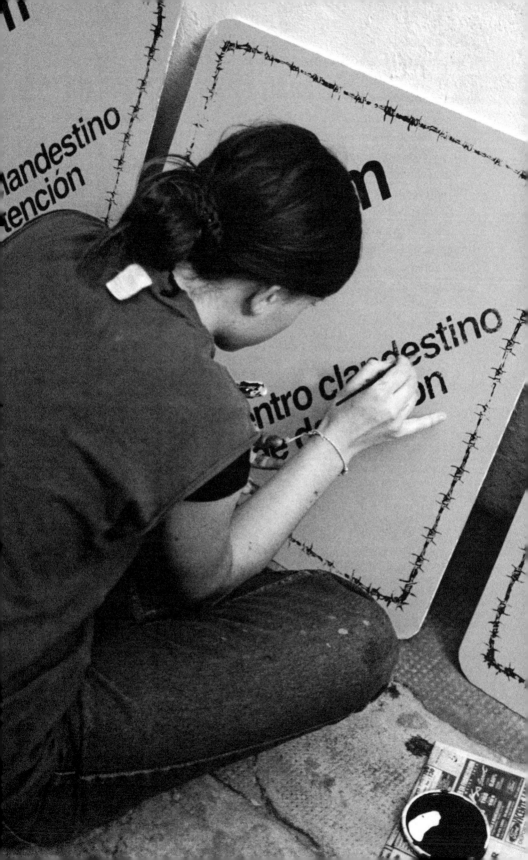

HERE LIVE GENOCIDISTS

by Mesa del Escrache Popular and Colectivo Situaciones

The escrache allows for the construction of a living map. A living map of the many types of existence of memory in the neighborhoods the escrache traverses. And the perception of its different levels of *potencia* (power).

A living map distinguishes itself from the graphic cartography that we are accustomed to using, and which we present here, in a specific aspect: beyond representing what an activity has done and its effects, a living map attempts to activate the capacity for an experience at the same moment in which it is unfolding.

A living map does not so much propose exhibiting images as producing them. Rather than just spreading information, a living map is created by learning from encounters that are undergone, by creating new names for the intensities that are discovered. Also, besides detecting the relationships that already exist between facts, a living map manages to trace other, unsuspected links, which modify those facts and remake them.

While the objective of the living map is not so much the production of a map, its activity does not stop mapping out the places through which it passes. It builds spaces where memory stops being something transcendent from the distant past in order to show its current importance. The living map is a type of registry that, as a condition, reclaims a public implicated in the experience of an out-of-joint present with an unstable foundation.

Live mapping does not seek to register the neighborhood that (geographically) exists, but rather the neighborhood that appears when certain images tied to the memory of power and resistance are activated. Such a map does not arise from a perspective that flies overhead (in a helicopter): it traces segments whose trajectories are organized by the escrache.

The methods of live mapping are similar to those of an investigation, of that which evolves through the learning process. It involves chance and a quest without a defined objective but motivated by will, desire, surprise. . . and the fight against the intolerable.

Live mapping is combat. However, it is not organized by the rules of war. The neighborhood does not become a battlefield where two sides confront each other for the control of the territory. It is about the construction of a typology, a survey of the existing modes of memory, and of the capacity of the escrache to valorize: to compose itself of images from the past that empower it, and to decompose those that hurt it. The escrache does not confront the hidden genocidist: it combats impunity.

During the experience of live mapping, the escrache was not reduced to a group of activists that go to a neighborhood to renounce injustice. It is experienced more as a singular mode of taking on memory that, among other things, manages to persist, to recognize its possibilities, and to build the future in an inexhaustible search for justice.

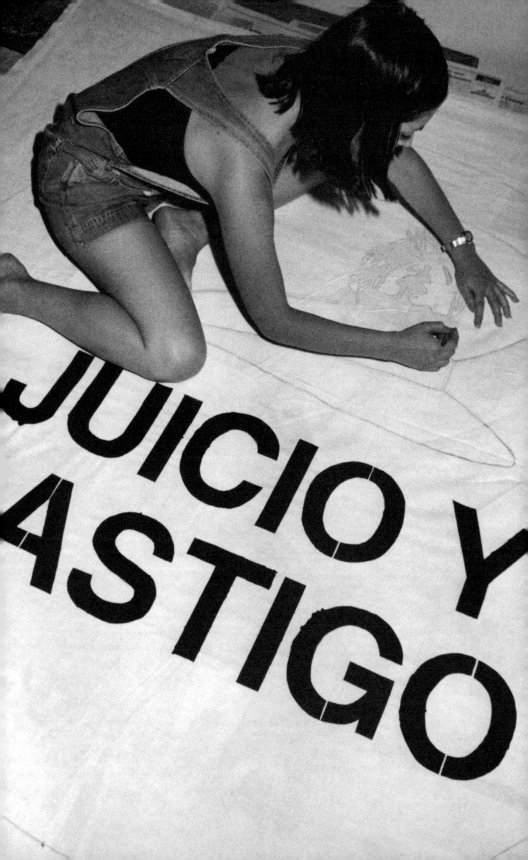

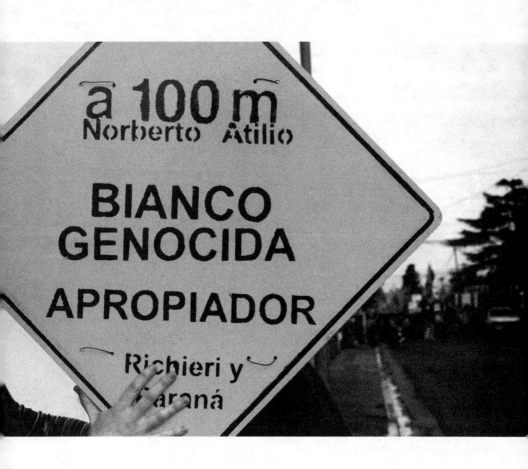

Escrache of Norberto Atilio Bianco, Kidnapping Doctor.
September 4, 1999.

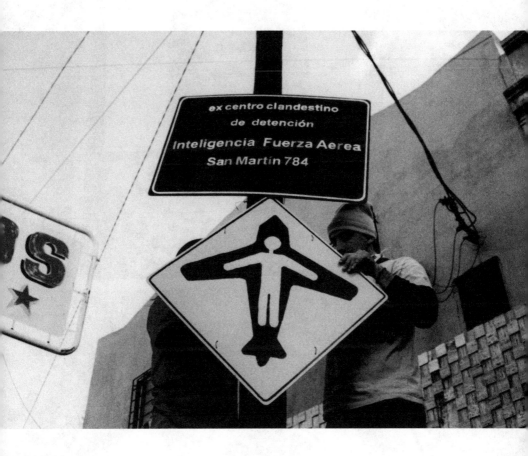

Escrache of the Air Force in Morón (Buenos Aires Regional Office of Intelligence).
April 19, 2003.

GENOCIDA
MASSERA
Libertador 2423

JUICIO Y CASTIGO

a 200m
EL OLIMPO
ex centro clandestino
de detención

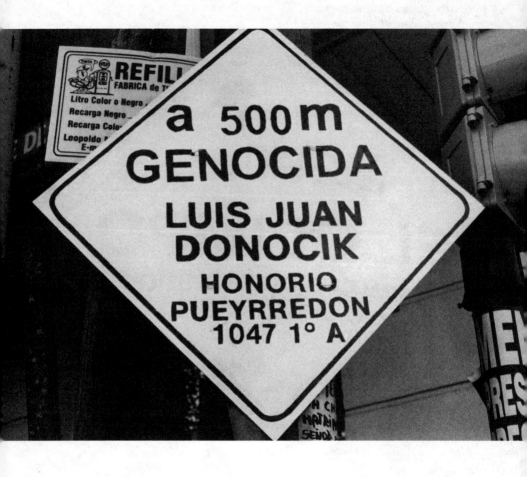

Escrache of Luis Juan Donocik. December 14, 2002.

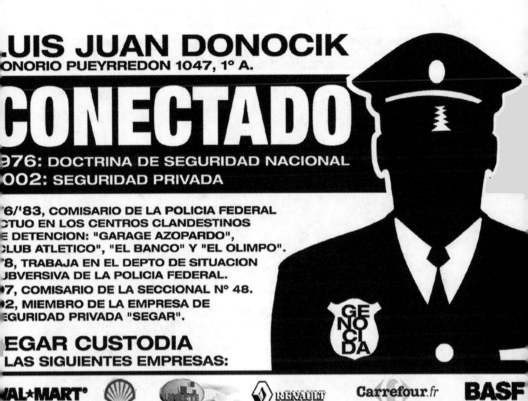

The image above identifies the target of the escrache, Luis Juan Donocik, his address, and the important link between his work as a participant during the dictatorship and his current work as a private security provider. It lists his employment history, beginning with the clandestine detention centers, and continuing with his role in the police in the nineties and later his role as a member of the private security company Segar, which provides services to the businesses whose logos are at the bottom of the image. (Trans. note)

Escrache! pass EL 08.09.01

15 hs./San Juán y Entre Rios

escrachepopular@yahoo.com / Kasa de H.I.J.O.S. Venezuela 821 Cap. Fed / 4331-2905

1 genocida
Miguel Angel Rovira
Jefe de seguridad de *Metrovías*

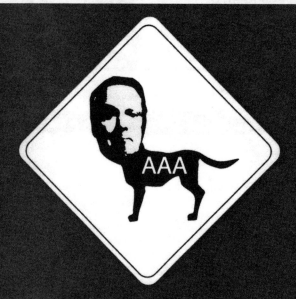

GENOCIDA
Miguel Angel Rovira

Jefe de seguridad de *Metrovías*

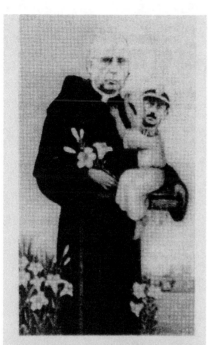

CARDENAL ARAMBURU
REVERENDO COMPLICE

SI NO HAY JUSTICIA **HAY**
Escrache!

Cardenal Juan Carlos Aramburu
·Cerró sus puertas a las familias de los desaparecidos

·Calificó a las organizaciones de derechos humanos de comunistas y subversivas.

·Recibió de la dictadura 8 millones de pesos por sus servicios.

·Fue Arzobispo de Buenos Aires desde 1967 hasta 1990 compartiendo su poder con Onganía, Lanusse y Videla.

·Negó la existencia de desaparecidos y defendió el informe final de la dictadura que fue condenado hasta por Juan Pablo II.

·Durante el gobierno de su amigo Menem defendió hasta el hartazgo el indulto y la política de privatizaciones.

Vive en: La Pampa 4022
su tel. es el 4551-0583 (solo desde tel. públicos)

Escrache!
Miércoles 19 de Diciembre
nos encontramos en **La Pampa y Triunvirato**

ESCRACHE OF ARAMBURU. MARCH 23, 2002.

This flier was conceived of, and used in, the process of the escrache of Cardinal Aramburu. It was distributed at church doors throughout the Buenos Aires neighborhood of Belgrano, garnering a different reception depending on the zone where it was passed out. The escrache of Aramburu was planned for December 19, 2001, in the framework of an homage to the priests of the Third World. Aramburu was the face of the Church's complicity in the last military dictatorship. On December 19, H.I.J.O.S. and La Mesa de Escrache decided to suspend the activity due to the state of emergency declared by Fernando de la Rúa. The escrache was finally successfully carried out on March 23, 2002, alongside the escrache of Roberto Alemann, in what was called "Escrache x 2."

The flier reads: Cardinal Aramburu, Complicit Reverend / If there is no justice, THERE IS THE *ESCRACHE!* / Cardinal Juan Carlos Aramburu / Shut his doors to the families of the Disappeared / Classified human rights organizations as communist and subversive. / Received eight million pesos from the dictatorship in exchange for his services. / Was the Archbishop of Buenos Aires from 1967 to 1990, sharing his power with Ongania, Lanusse and Videla. / He denied the existence of the disappeared and defended the final report of the dictatorship that was condemned even by Pope John Paul II. / During the government of his friend Menem, he defended pardons and the policies of privatization ad nauseum / He lives on La Pampa 4022 / His telephone number is 4551-0583 (only from public telephones) / *Escrache!* Wednesday, December 19/ We will meet at the intersection of La Pampa and Triunvirato. (Trans. note)

OPPOSITE PAGE:

ESCRACHE-PASS. SEPTEMBER 8, 2001.

Thousands of subway passes, which resembled the ones distributed by the company that administers the transit service, were printed as part of the escrache of Miguel Angel Rovira, an ex-member of Triple A who worked as a personal security guard.

IMAGE
AND MEMORY

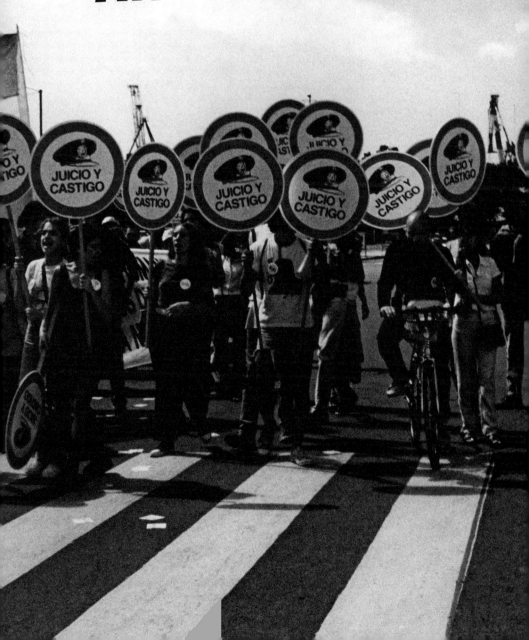

Since its formation in 1977, the Madres of Plaza de Mayo have made the disappeared visible through the mothers' own bodies. The act of being in the plaza, occupying that space and circulating within it, gave form to the struggle against the impunity that existed during the worst of times in the dictatorship. Every Thursday, transcending the known cultural repertoire and iconography, the mothers were present with their resolve in the Plaza de Mayo. Through their bodies in motion, they offset the proclamation of martial law and the prohibition against public meetings.

Since Argentina's transition to democracy, the Madres have prolonged and vindicated this embodied practice. The white handkerchiefs emphasize that the "mothers' action is highly symbolic and the use of public space is consciously strategic." The Madres acted against the repressive system of representation that so effectively limited the possibilities of visibility and expression.

For many years, "living ghosts" was the slogan used by human rights organizations against those culpable for the atrocities. Since its appearance, the slogan was always linked to a forceful use of public space and of the accompanying image. The acts and interventions in the public space produced it as a site in which the traces of the recent past are transmitted and where these traces are placed in relation to the construction of public images.

With the return to democracy came the continued push towards condemnation. At first, the testimonies of survivors, relatives, and witnesses occupied a central space. For many Argentines, the terrible stories of what happened opened many eyes and many ceased to deny the atrocities of years past. The CONADEP report and the trial of the ex-commanders constitute two paradoxical moments in the explosion of testimony.[1] In this moment, the theory of the two demons was elaborated. A little later, still under the presidency of Raul Alfonsín, the laws of impunity were passed (Obediencia Debida and Punto Final). Finally, Menem signed a presidential pardon for those who had led the dictatorship's state terrorism.

THE ESCRACHE

The escrache, which emerged from the works of H.I.J.O.S., also works in the realm of the symbolic. Both the Madres and H.I.J.O.S. use public space, denouncing and marking the houses of the dictatorial repressors and their accomplices. Their action consists in signaling and narrating the links that connect thirty years of impunity

1 The Comisión Nacional sobre la Desaparición de Personas or CONADEP was a commision created in 1983 and tasked with investigating state crimes of disappearence during the dictatorship. The commision's report *Nunca Más* (Never Again) was released in 1984 and laid out, in disturbing and damning detail, the methods, archives, physical sites, and participants in the tactic of forced mass disappearance as well as the names and backgrounds of its victims. [Trans. note]

with the present reality in Argentina. The Madres and H.I.J.O.S., even with their differences in strategy, do not accept the prohibition on public space. On the contrary, they use this as a stage on which they unfold a strategic cartography of action. This is a mode of action that emphasizes the role of memory as a *function of the present*, not just the past. A live, active, and actual memory. We always think of the construction of memory in this sense: from the present, from the action, recuperating spaces, denouncing events and people, creating links between the past, present, and future. In this act of making every day the present, memory begins to be constructed from what was recuperated and from where one is intervening. In this way we move from the escraches to the project of the Parque de la Memoria, in which the official objective was to pay homage to those disappeared between the years 1976 to 1983. In the face of the state-sanctioned chronology of history, we developed our first group initiative to work in a broader historical framework, inquiring into the causes and consequences of the dictatorship as a way of complicating and questioning the sense of historical time. We arrived at this approach from the action-image that we practice in the escrache, as the escrache was the opening that pushed us into more complete and complicated projects. In the act of denouncing, we felt the necessity to deepen our work, both discursively and textually, making complex the image of the condemnation, not only for a mere theoretical undoing but also to take responsibility for the limitations when it comes time to communicate. We need to, then, feed from other discourses to create new images. It is in this way that we construct a rich collective reading of diverse materials on the dictatorship and the period that preceded it—from a different analysis. We propose research as part of this communication process, using images that start from feeling and not purely from a rational place. At the same time, we have formed strong bonds with H.I.J.O.S and with other human rights organizations.

THE CONDOR PLAN

With this plan to deepen our work and due to an invitation we received to participate in the Hemispheric Institute of Performance and Politics' conference in Rio de Janeiro in 2000, we decided to address the repression that was coordinated at the regional level and was enacted through the U.S.-backed Operation Condor. At that time, in Buenos Aires, we had already realized escraches against this "operation" at Automotores Orletti, where a former CCD held civilians from various Latin American countries hostage as part of Operation Condor. Going to Brazil, we found it interesting to think about how an intervention with similar characteristics to the escrache would work in a city where something of this nature had never been thought through nor attempted. This urban intervention consisted in positioning

thirty-six road signs that denounced the Condor Plan. Students, human rights organizations, and social organizations joined in this action. The signs were located on the boulevard of Avenida Chile all the way to the building where the CCD had functioned. These signs condemned the participation of the CIA and various sectors of the political and economic elite's support for the repression. Within the installation, we placed caution tape, similar to the kind used to mark off a crime scene to make it inaccessible to the public.

In this type of action, the installation of street signs is used as a narrative installation and each sign functions as a linguistic unit; the text functions as an icon.

AGAINST THE BLACKOUT OF TERROR

Another one of our experiences was our trip to the Ledesma power plant in 2003. Every July, for the last twenty-five years, there has been the march against the 1976 blackout.[2] We proposed an installation of posters that were being finished during that very march. These posters give an account, but at the same time, each image speaks for itself. Juxtaposed with the sordid and deserted landscape that surrounds the power plant, the posters competed with no surrounding images. It was interesting to see how the different proposals dialogue in such diverse ways—both with the place and with the people that inhabit that space.

JUSTICE AND PUNISHMENT

As a group, we participated in the Marcha de la Resistencia, which takes place every December in the Plaza de Mayo, coordinated by the Madres of Plaza de Mayo, and which is made up of a spectrum of diverse social and human rights organizations. For us, these marches are an expansion of our practice, now that we have found a new place in which to participate and belong in these escraches.

The Plaza de Mayo is the symbol of various struggles, and we would like to leave our mark on that symbolic and important space. In the central pyramid,

2 On the night of July 27, 1976, the Ingenio Ledesma power plant cut off the electricity supply of the entire town and its surroundings to facilitate an operation by police, military and plant foremen to search and plunder the homes of the residents of Libertador General San Martín and Calilegua, province of Jujuy. In trucks of the company more than four hundred workers, students and professionals were kidnapped. They were transferred to the company's maintenance sheds, where they were tortured and disappeared for months. Today there are more than forty disappeared in this area. Through terror blackouts, and kidnapping and disappearances, the company Ledesma (like so many others) tried to reaffirm its control and absolute authority over its workers. Today Ledesma S.A. (belonging to the Blaquier family) continues to act jointly with security forces. Their employees work under extremely precarious conditions, collecting miserable salaries, and facing repression before even a minimal revolt. In addition, the toxic emissions that the company produces contaminate not only the environment, but they are also extremely dangerous for current inhabitants. [Trans. note]

where the madres march every Thursday, there are painted white handkerchiefs on the ground. On the day of the march, the pyramid served to sustain a complex structure with thousands of pictures of the disappeared. It was in that space that we decided to intervene with the image Juicio y Castigo (Justice and Punishment) made for and used in the escraches.

During the beginning phases of the escrache, we began consolidating the slogan Justice and Punishment with the dual focus on demanding institutional justice without losing sight of the importance of constructing a social condemnation. The symbol was created based on a proposal from H.I.J.O.S. In the same way that the slogan Living Ghosts was an emblematic image for many years, through the escraches, the phrase Justice and Punishment became the strongest and most representative slogan of this new generation.

As a symbol, its communicative function was easy to access; it was rearticulated through each activity and was reappropriated by various organizations, from human rights organizations to the desocupado movement, especially after the assassination of the piqueteros Maximiliano Kosteki and Darío Santillán. Pins, posters, flyers, and signs were made with this message: Justice and Punishment.

For the installation at the Plaza de Mayo, we wanted to imagine posters that were not as temporary as those used in the escraches, which in general have varied durability. In general, some posters can last for more than a year, while others are removed immediately after the march. It was as if they took part in a play where those who removed the set were not part of the production, rather the reverse. After each escrache, we would see the posters in the police stations of the neighborhoods, or, in the best-case scenario, in the house of some militant comrade.

We painted on a piece of cloth a circle with a diameter of two meters, printed with stencil. This type of circular flag was used during the escraches and the marches. In December, we made it more permanent by coating it in polyester resin on the pavement of the Plaza de Mayo during the Marcha de la Resistencia. Our idea was to remake a similar version each year and to then accumulate and reiterate the same demand. It was a conquest of that public space and, through this, the need to begin caring for our "mark."

A few days after the coating, the first image was covered with white paint. That is: instead of removing it, they covered our sign by making a huge white circle. It was done in the moment of transition between the Menem and the De la Rúa governments, with the excuse that the swearing-in of a new president deserved a clean slate in the main plaza.

We insisted once more with the image, reinforcing it with a stencil over the white circle. We insisted again upon the conquered space, on the same geographic point, maintaining it, conserving it, fighting for it. Similar attitudes were sustained in relation to the homages paid to the victims of December 20, 2001, in the places

where they were assassinated. This reiterates, time and time again, the need to turn the same place against the power that seeks to erase it. That is why we placed another flag in 2000 and 2001, which were removed completely after the rebellion of the 20th of December, in which the Plaza de Mayo was almost left in ruins and after, during the "clean up," they took the circle. But in 2002 and 2003, we placed the same image in different parts of the plaza.

NEIGHBORHOOD ACTIONS

These neighborhood actions have precedents, such as what happened in San Telmo beginning in the mid-nineties with the group Encuentro por la Memoria and its work there. For a long time, together with the San Telmo assemblies, this group organized marches that passed in front of the homes of the neighborhood's disappeared or the places where they were kidnapped. The important thing here was to create a mark, but in an inverse way from what was achieved with the escraches, where the mark was for the repressor. The mark of the homages works to create a sense of everyday memory and to construct micro-histories. It wasn't about looking for a symbol for the disappeared; rather, we we thought about what could characterize each one of them. In that way, the pictures of the disappeared of San Telmo were resignfied using only their gaze. During the march-homage we placed little squares with the cropped photos, together with the name and former address of each person. At the same time, we told the neighbors about who lived or worked in those places, who had been kidnapped in such and such corner or building. These types of actions were realized in several different neighborhoods in the city of Buenos Aires.

LEGITIMIZING ACTIONS OF THE STATE
WITH RESPECT TO HUMAN RIGHTS

The decision to create the Espacio Memoria y Derechos Humanos (Remembrance and Human Rights Center) in the Escuela Superior de Mecánica de la Armada (Navy School of Mechanics or ESMA; a former clandestine detention center) constituted another means of marking a place. On March 24, 2004, President Néstor Kirchner formalized the return of the property to the Buenos Aires city government and, according to certain analyses, this was a milestone in the activation of memory of the dictatorship.

Now we must analyze what type of reactivation of memory this represents and how it can be analyzed in the context of the works and actions realized up to the present day. The recuperation of the ESMA, with multiple monuments and tributes, produced an oversaturation of memories (and forgetting), especially during

2006, with the objective of commemorating the thirtieth anniversary of the coup of 1976. It was a type of oversaturation that generates confusion when one thinks of the reconstruction of memory we wanted and that we were attempting to create.

We noted a sense of strong ambiguity. On the one hand, the tributes to the disappeared were becoming "official," and at the same time, there emerged interesting proposals from neighborhood organizations like the Coordinadora de Barrios por Memoria y Justicia (Coordination of Neighborhoods for Memory and Justice) and the work of each committee, in specific neighborhoods, in relation to the disappeared in each city.

Concurrently, for *us*, something was being lost and something was being recuperated. The demand for justice and punishment as a symbol of an entire period of history lost all sense, or at least was not causing a disruption in the way it had previously been. What happened with the uses of the symbols during those years is complicated, especially when we perceived that they were losing meaning or that they were no longer recuperating what *we* wanted them to restore. As a result, for the March of Resistance in 2004, we decided not to print the image Justice and Punishment as we had done throughout the years, as we now felt the absence of a critical discourse and we felt a certain level of discomfort when faced with the weight of what had been created. We decided then to hang *Blancos Móviles* ("Moving Targets," see respective chapter).

Throughout the year that followed, we refused to think about what to do with those symbols that had already been created, and we moved with much uncertainty in the face of this conjuncture and its relation to the idea of memory. It was not an explicit intention but rather not knowing what to say. If we were to continue participating in escraches and other activities, the group production pointed in other directions.

This not knowing what to say/not knowing what do was visible in various organizations and groups that worked to support the fight of the human rights organizations. There is a tension, which can be synthesized quickly in the following question: with, against, or beyond the state? The positions become radicalized and polarized and, at some point, practice is arrested and annulled. These are moments of investigation: does a construction of images and a politics of memory exist that is different from the fetishized model of official politics? We also ask ourselves: how do we construct images within these spaces and what is our contribution, if that's what it is, in moments as rare as this one? Our challenge is to think of new practices capable of new forms of memory construction. Forms that can be created in neighborhoods, in popular culture, or within movements and that, beginning with the production of images, manages to represent/present symbols that not only serve to narrate or recount but that also have the power to denounce with regard to what is being presented.

One cannot deny that from the escraches and homages in tile, to the videos and photographs of each march, we are faced with actions and interventions that demonstrate the importance of the visual, the image, as narrative forms of memory and identity, especially sensitive and powerful in these new ways of practicing politics. The visual is critical in the construction of identity and generational memory. After so much practice and so much experimentation, it is important to ask what type of construction generates a different form of communication and visibility, in contrast to the official forms. In an attempt to answer this question, I think it is necessary to review the constructions of memory across time and to detect which ones can connect up with potentialities (visual, symbolic, political, declarative), against state marking, which fixes, many times in unproductive ways. In order to find ways that have the strength to make anew these images, to register the changes and to produce new temporalities, there must be a new investigation.

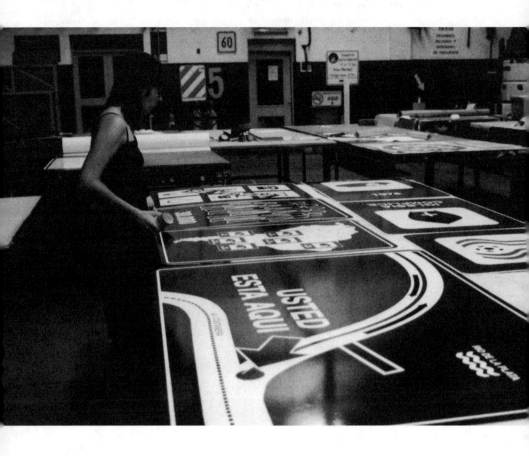

Images from the workshop in which we made the
signs that were later installed in the Parque de la Memoria.

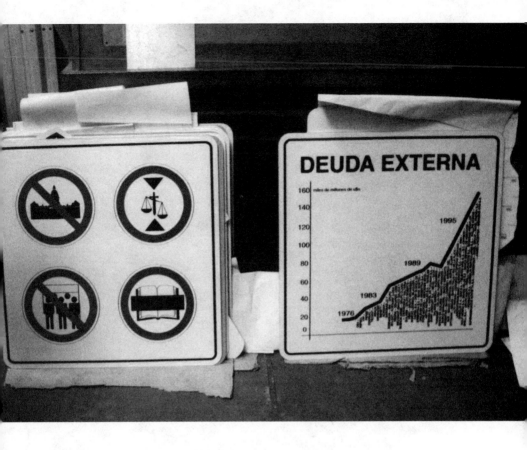

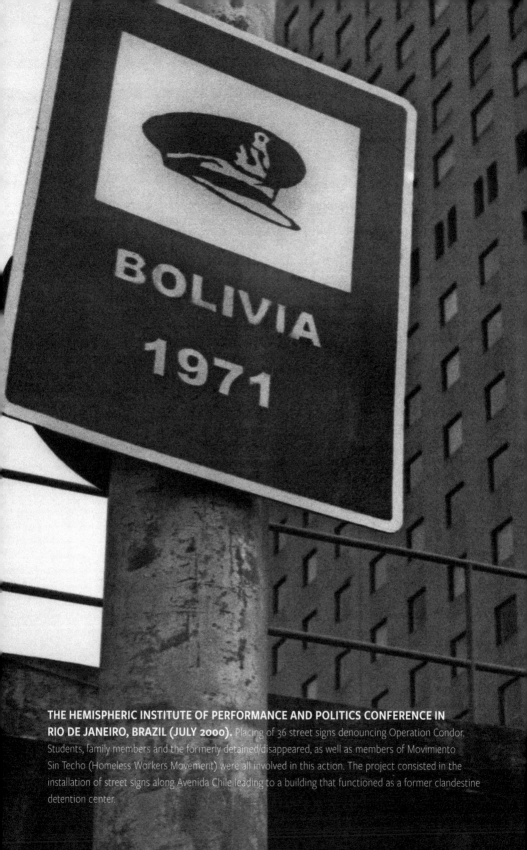

THE HEMISPHERIC INSTITUTE OF PERFORMANCE AND POLITICS CONFERENCE IN RIO DE JANEIRO, BRAZIL (JULY 2000). Placing of 36 street signs denouncing Operation Condor. Students, family members and the formerly detained/disappeared, as well as members of Movimiento Sin Techo (Homeless Workers Movement) were all involved in this action. The project consisted in the installation of street signs along Avenida Chile leading to a building that functioned as a former clandestine detention center.

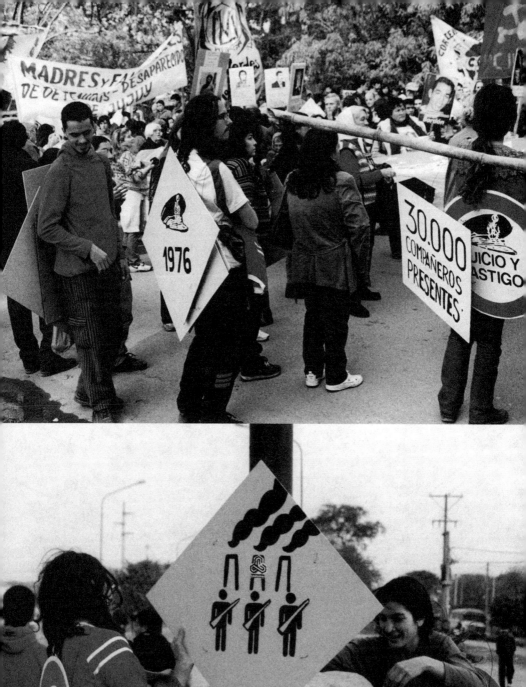
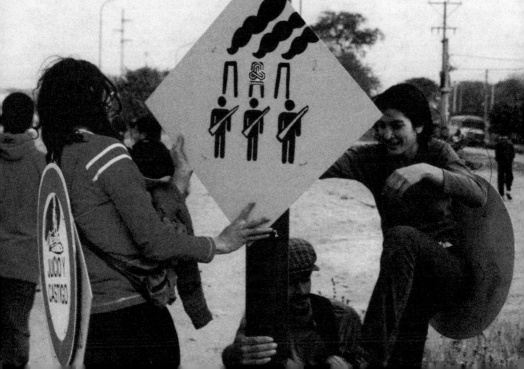

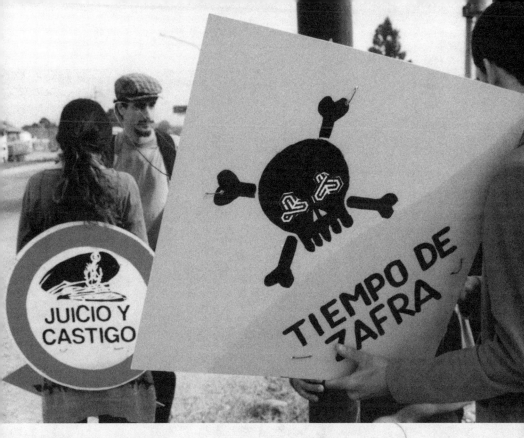

SEQUENCE OF STREET SIGNS, LEDESMA (JULY 26, 2003). This action took place during the annual march against the night of terror, known as the "Night of the Blackout," inflicted by the state in this city on July 27, 1976. A series of street signs were hung denouncing the complicity of the sugar manufacturing company Ledesma with the military dictatorship.

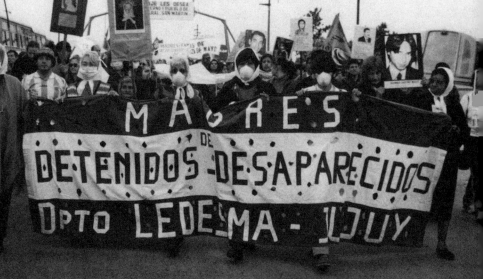

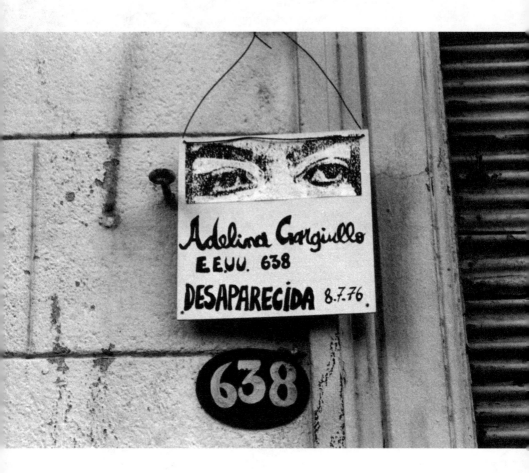

HOMAGE TO THE DISAPPEARED OF SAN TELMO (MARCH 23, 2003).
An action organized by neighborhood organizations linked to the human rights and
anti-impunity organizations. We passed through the neighborhood marking the
houses where disappeared had lived with signs and paint on the curbs.

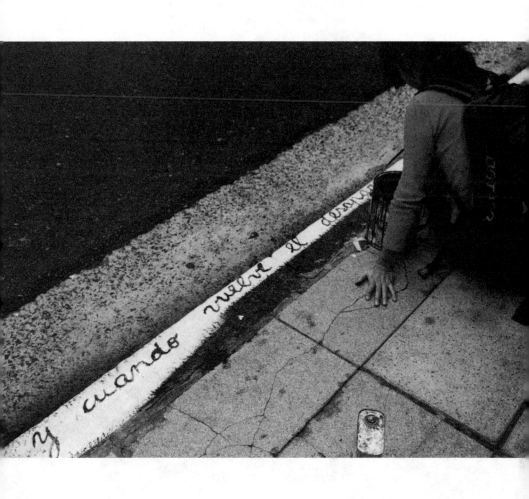

ADA VICTORIA PORTA

Desaparecida 07/08/76.
18años.
Estudiante de la Facultad de Derecho.

LIVING GHOSTS IN THE LAW SCHOOL

It is the beginning of classes in the University of Buenos Aires School of Law. The classroom is filled with the sunlight of an autumn that is just underway. The boys and girls talk before sitting down, as they do, before class starts. However, they have lingered longer than normal and no one has sat down. They are frozen, standing in front of their seats, pointing at something stuck to the backs of the seats. There is a message that they are reading. They move from seat to seat, and each has a different text. They do not sit. They are pale, their conversations are whispers, their gestures uncertain. The smiles that they carried as a memory of their weekend are gone. They don't sit; they continue moving from bench to bench in a disorganized manner.

"What's going on?" I ask. They don't respond; a couple of girls mumble something but their voices break.

"We can't sit," says someone in the back.

I ask again, insistently, "But what is it?" while I approach the seats.

There are hundreds of stickers, each different, and each with the name of a male or female student, teacher, or worker who was disappeared from this department. The text gives the name, age, specialty and/or degree they were pursuing. Reading them, I forget why I'm here, and I begin to move through the seats as well. There is a lump in my throat but I begin to speak, and together the class is transported to a different time and we talk. Like never before, everyone participates, and when the hour ends we continue the discussion in the hallways, with groups of students leaving the other classrooms.

Intervening in the benches with these texts created not only a break in the normality of a university class in order to discuss the military coup of 1976 and the state genocide. It also made present the experience of each of these disappeared. For an instant, the action made us sense these missing lives, enabling us to put names to the faceless disappeared and locating us in each of their lives, in each name, in each age, in each gender.

EDUARDO DE PEDRO, SON OF ENRIQUE DE PEDRO, LAW STUDENT ASSASSINATED ON APRIL 22, 1977. He began law school in 2000. There he joined with Franco Vitali and Norberto Berner, both children of members of the JUP (Juventud Universitaria Peronista, or the Peronist University Youth) in the seventies.

Twenty years after the military overthrow, 1996 was a year in which society woke from a long slumber. In the law school, that awakening consolidated itself in the beginning of 1999, with the birth of independent student organizations; there began the long road to revision and memory. The students in these new organizations opened the law school's doors to cultural and human rights groups to discuss the new concept of JUSTICE under the slogan No Tolerance for Injustice. This led the GAC compañeras to the idea of intervening in the law school and interpellating the 30,000 students, placing in each of the spaces where they sit the names of the disappeared students under slogan "You are in their place."

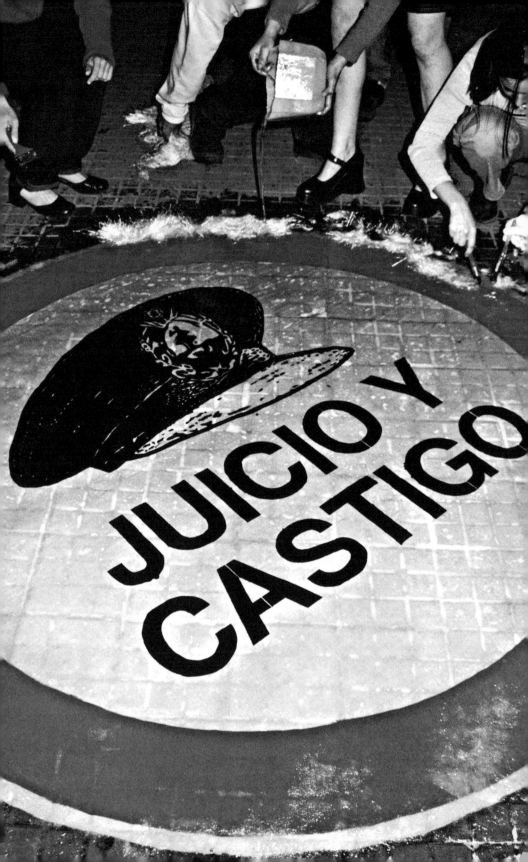

MARCHA DE LA RESISTANCIA. During the Marcha de la Resistencia that was carried out in the Plaza de Mayo in the month of December, the slogan Justice and Punishment was affixed to the floor of the plaza, made from cloth of two meters in diameter. It was realized during four consecutive years, beginning in 1999.

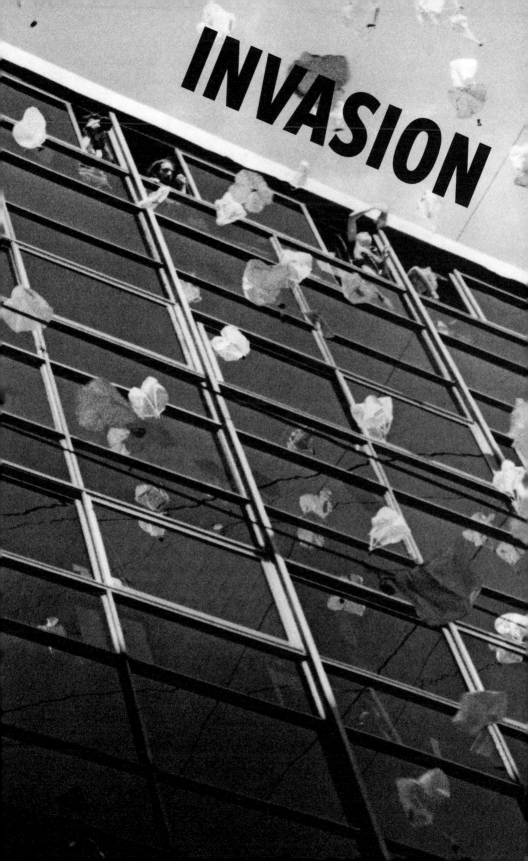

This project was developed in two stages. The first consisted of an intervention on advertising posters and on the buildings of multinational companies with stickers that compared military models to those of businesses. A comparison was made with three military icons: the tank, the missile, and the soldier, accompanied by a key. Icons and texts were placed over a target or bullseye (see photo).

A combat tank is characterized by having weapons and a heavy armor, as well as a high degree of mobility that allows it to cross difficult terrains at relatively high speeds. It is one of the most fearsome and versatile weapons in modern warfare.

We used the image of the tank that crushes, invades, sweeps, and advances territorially with the definition of multinationals as corporations that dominate consumption, goods, natural resources, as well as the economy and politics of a country.

The missile evokes information technology or cybernetics, which came into being as a discipline destined for war, introducing the concept of feedback into other sciences. This image accompanied the definition of the mass media as the shaper of public opinion and as the carrier of a model that normalizes one form of being and possessing.

The soldier is an icon of the security system, in charge of monitoring, controlling, and dissuading by means of force (through its use and threats of its use) to prevent all potential destabilizations of the current economic regime.

The comparison of the military images that accompany the definitions of the three agents responsible for implementing and developing the neoliberal model lay bare the functioning of a silent economic genocide. It is a group process: the effects of the actions of multinationals, assisted by the mass media that generates a favorable opinion of that model, and the backing obtained from private and state security forces.

But what meanings do these images open up? They reveal the unsaid. They interrupt the hollow, neon-lit, immaculate structures of global capital. They undo the fiction of the optimistic discourse legitimated and sustained by a media that endorses the expropriation of natural resources and the health services, education and communication systems (via the monopolization of transportation and means of communication) and exalts the goodness and benefits of privatization. They expose the hidden, shady actions of those who organize this party for the few with an undisguised obscenity. They speak to us of the waste and the leftovers that are left after their celebration.

Political and economic power is allied in the same objective. The cruelty of this power's violence is represented by a tank, a missile, or a soldier over a bullseye.

The second stage of this project was completed with the launching of toy soldiers with parachutes from a building in downtown Buenos Aires. During the week prior to the launch, we went out as a group to intervene with stickers in the windows

of businesses, banks, and offices in the downtown area. After long days of meetings with other groups accompanied by various *compañerxs*, we prepared each one of the parachutes that would suspend each of our ten thousand soldiers in the air.

Toy soldiers rained down from the sixth floor to the ground below. In the street, women, men, and children jump trying to catch them in flight. They don't know what it is, but it grabs their attention. Bus drivers, taxi drivers, commuters halt and stare at the sky; office workers in the buildings across pause their work, come to the windows and attempt, some with success, to snag this object that zigzags in the air. They stretch out their hands to grab them before they fall to the asphalt below.

They don't know what it is but there they are, suspending daily time and their routes, forcing those in transit to look up, while some run after these toy soldiers with parachutes, transfixed by them. And thousands continue to fall and the wind carries them further and further away.

A few minutes have passed, and now we have no more soldiers to throw. We look down, and we are greeted by the *compañerxs* who came to watch the action and who are filming what is happening with a camcorder. It is five o'clock in the afternoon of December 19, 2001.

Martial law, the president who steps down and leaves flying over the rooftop of the Casa Rosada in a helicopter, the freezing of bank accounts, the looting of the banks, the impunity of the institutions backed by the state and the corporations, the impunity of those responsible for the repression during these days, December 19 and 20.

The phrase "country risk" (an International Monetary Fund economic indicator), so often used by De la Rúa, is forgotten. And other numbers appear: 50 percent of the population below the poverty line and 25 percent below the line of abject poverty.

The media reproduces the images of the multitude in the streets, the face-offs, the repression, the deaths, and the broken windows. The targets of the protests are the businesses, the multinationals, the banks, the government institutions, and the security forces. This is an insurrection of a multitude that delegitimizes political representation with the demand *"que se vayan todos, que no quede ni uno solo"* ("all of them must go, not even a single one can stay").

This time we are surprised by the close-ups of these windows that the media shows, where bullets pierce the stickers, over those bullseyes that we had affixed.

We cannot stop associating this image with forms of magical thought and myth-making that sections off a particular zone of everyday life, and which gives it a heightened meaning in order to turn it into a durable narrative. Such myths are not only the children of desire, but also of horror and of the void, of the feeling of flight that surrounds all human action. The bullet hole in the bullseye closes the action, or it imprints it with another meaning—one that was unforeseen.

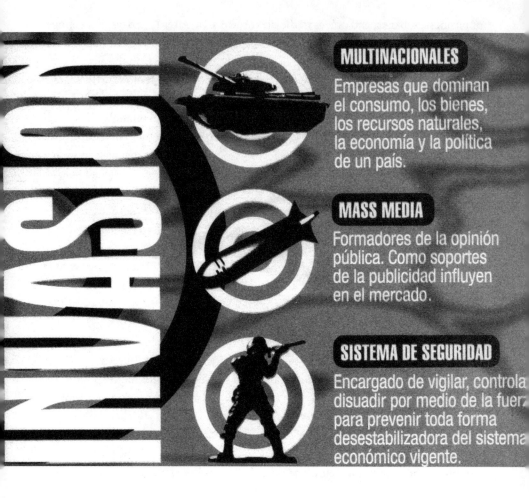

Multinationals: Businesses that dominate consumption, goods, natural resources, the economy and the politics of a country. Mass Media: Shapers of public opinion. As supporters of advertising they influence the market. Security System: In charge of monitoring, controlling, and dissuading by means of force in order to prevent any destabilization of the current economic regime. (Trans. note)

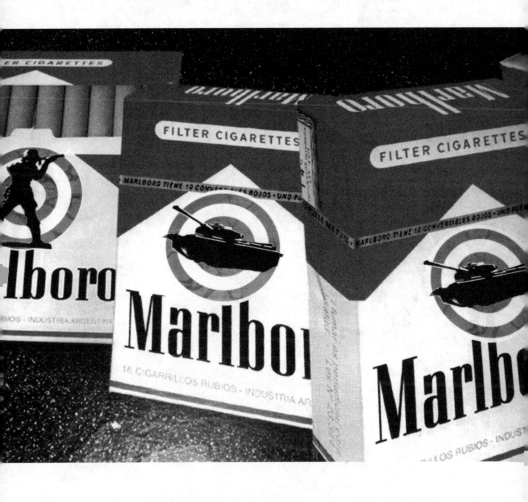

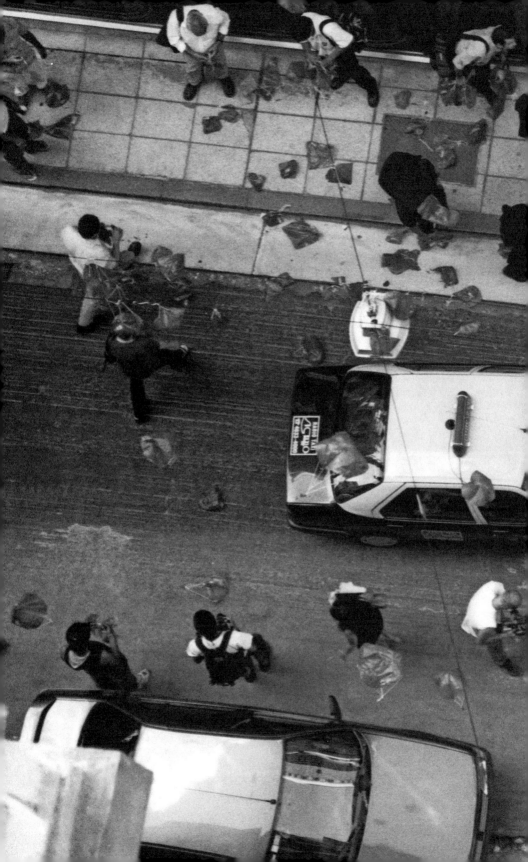

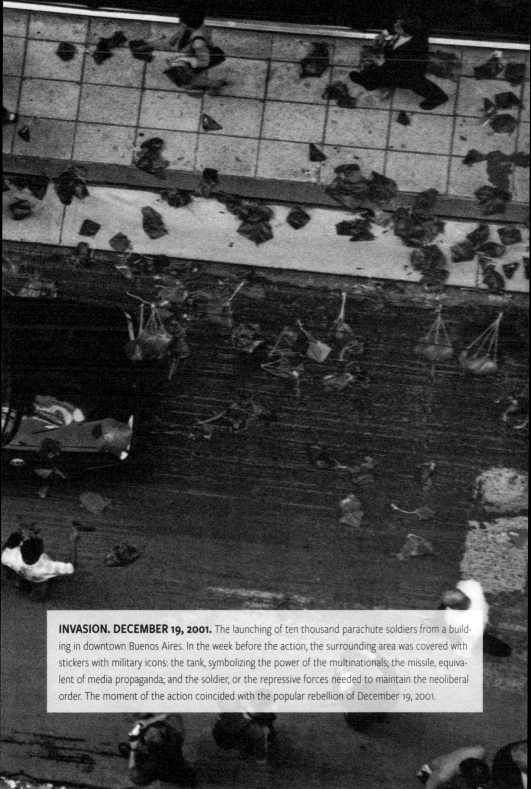

INVASION. DECEMBER 19, 2001. The launching of ten thousand parachute soldiers from a building in downtown Buenos Aires. In the week before the action, the surrounding area was covered with stickers with military icons: the tank, symbolizing the power of the multinationals; the missile, equivalent of media propaganda; and the soldier, or the repressive forces needed to maintain the neoliberal order. The moment of the action coincided with the popular rebellion of December 19, 2001.

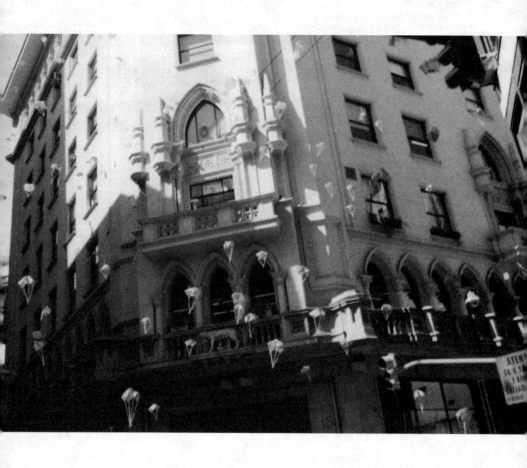

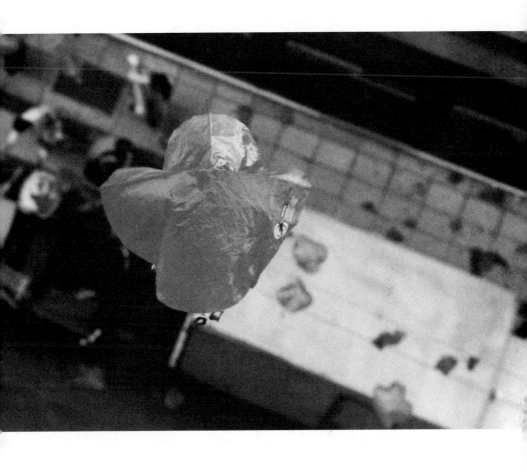

GUSTAVO
BENEDETTO

Asesinado por la represión policial
en la rebelión popular del 20/12/01.

NUNCA TE VAMOS A OLVIDAR

Tu mamá y tu hermana

esta PLACA
FUE DESTRUIDA
POR LA POLICÍA
EL 21/11/02 A LAS
3 HS.

GUSTAVO
BENEDETT

19TH AND 20TH OF DECEMBER

The events of December 19th and 20th contained a multiplicity of voices and bodies. It was an unexpected collective process. Far from the centralized organizations, it was the insurrection of a diverse multitude, with a forceful rejection of any organization that pretended to represent, symbolize, or hegemonize the meaning of the event. A movement of that present, a mark in history.

Insurrection, which refuses the government's martial law and delegitimizes its form of politics—*"que se vayan todos, que no quede ni uno solo"* ("all of them must go, not even a single one can stay")—interrupts the antiseptic space of the nineties, sharing in the encounter with others, in diverse retroactive complaints condensed in the event. Irruption of dissent in privatized public space.

The public scene is occupied by the multitude. The surprise and emotion of finding oneself with other struggles, other groups. An instant that unites these fragments of disarticulated social fabric.

The subjective sensation of the group fighting either in silence or in solitude with the desire of affirming ourselves were far away in this moment of encountering and getting to know other groups, with their experiences, struggles, desires, practices, and other forms of living.

The experience of self-affirming popular power. The power that refuses hierarchies of institutionalized politics opens and inaugurates a cycle of struggles and produces resonances of the event.

The multiple subjectivities, the contagion of the power generator of actions, unfold new forms of political practices: occupying the street.

The visibility of alternative, independent experiences, of counter-powers, with a questioning of alienated labor and individualism. Direct democracy, autonomous organizations, piqueteros, MTDs (Unemployed Workers Movements), recuperation of factories by their workers, political, cultural, social demonstrations.

The empowering of the multitude occupying abandoned spaces where neighborhood assemblies begin to operate, where blockades and piquetes of roadways are set up. Actions with other collectives are coordinated, the ritual of going to the Plaza on Fridays continues, without set goals, without a fixed direction. Occupy space: to be.

We worked together with the groups Arde! Arte (Burn Arte), Argentina Arde (Burn Argentina), La Mar en Coche (The Sea in the Car) and others; the euphoria and contagion of this energy made possible the realization of diverse actions moving from self-affirmation to denouncing. Multiple creative potencias, artistic and non-artistic, unfolded in each demonstration in the form of a popular celebration.

The justification for martial law given by the government and reproduced in the media was that of protecting the middle class from the "looting" of the "excluded." But the middle class was also affected by the freezing of bank accounts and

the looting of their savings. The justification for martial law in "the name of" has no connection to reality. The middle classes were also in the streets, banging pots.

The empty grimace of the state tries to impose someone who has popular acceptance; the political parties rehearse new scripts to continue their representations.

Those who disappear for a time from public space and the media are the traditional political figures who were spontaneously escrached.

For a little while one hears multiple voices amidst the univocal narrative of the media. A space is opened in the media for diffusion and multitudes, the figures of poverty levels appear. A brief reconsideration of the nineties. A strong critique of neoliberal politics as implemented by the Menem government and his followers.

The events of December 19th and 20th left more than thirty-four dead in Argentina, of which five compañeros were killed in downtown Buenos Aires. In this context, our group along with other collectives, realized actions and interventions. We organized with the families of those murdered by police repression in the planning of memorials and protests, along with Acción Directa, the motorcycle delivery workers' union, and other organizations that joined month after month.

The aim of the homages was to intervene in the sanitized space of history. To leave a mark, a trace, a sign. To create a place out of urban space designed for the non-place, a place with memory, to make this memory present, to activate it, to reactualize it, to mark it. To appeal with a voice of dissent, to construct a space that opens rather than closes meaning, to denounce the death of these protesters in the same place where they were killed, and to denounce the police and the parapolice forces.

We made plaques with legends describing these events and created a route where one could read a text denouncing the names of those responsible for the murders and brief biographies of each of the assassinated.

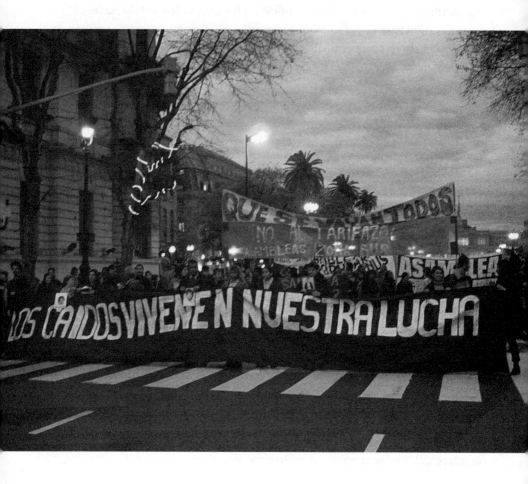

**DIRECT ACTION. HOMAGE FOR THOSE MURDERED BY POLICE
REPRESSION IN THE POPULAR REBELLION OF DECEMBER 20, 2001.**
*"The years pass and so do hopes for a better country, which those murdered on
December 20, 2001, were searching for. But just thinking that their deaths were not
in vain assures us that our small worlds, which have changed so much, will someday
have the color of justice, the smell of equality, the taste of new earth. The fallen live
on in our struggle without a doubt. And one day they will be our victory as well."*
—Maria Arena

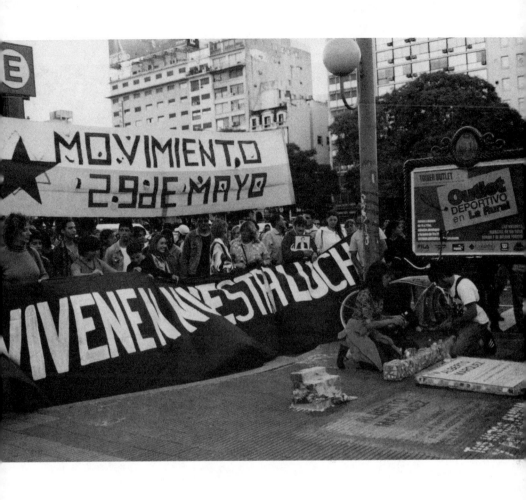

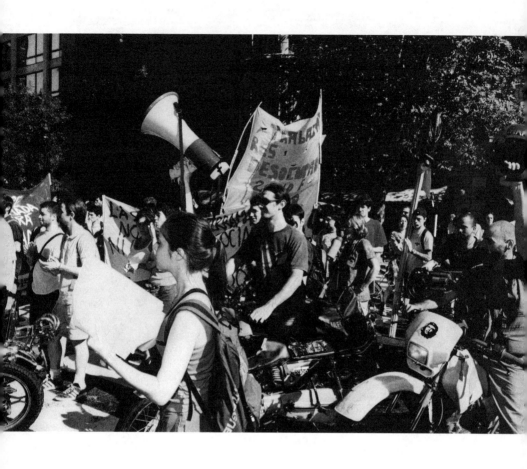

GRUPO DE ARTE CALLEJERO: THOUGHTS, PRACTICES, AND ACTIONS

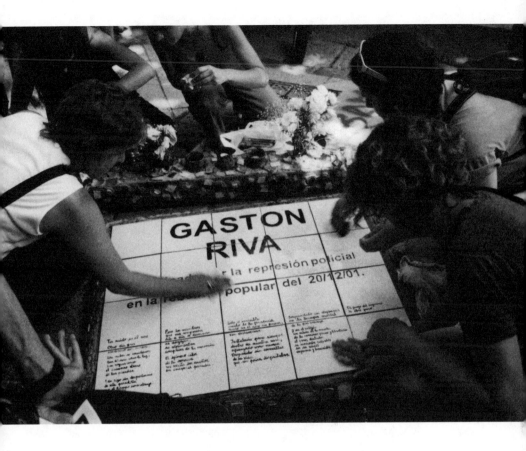

"After the days of December 2001, several of us visual artists who had the desire to continue in the streets approached GAC, who in this moment participated in the Committee of Direct Action of H.I.J.O.S. The first and almost only activity that we realized together was the marking of the sites where five people were murdered in the afternoon of December 20th near the Plaza de Mayo, bringing together family members, compañerxs and friends of the victims, and antirepression organizations. The first march-homage was realized on January 10, 2002, and during the following two years, we came together weekly to organize an action on the 20th of each month, where we would return to these sites, add additional layers to the signage, taking care of these spaces and reading a text in which we declared our intention to construct sites for the memory of those murdered and in which we denounced the concrete and intellectual authors of their deaths." —Carolina Katz

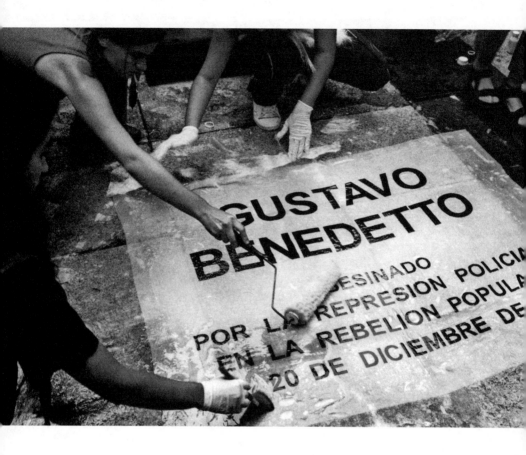

GUSTAVO
BBNEDETTO
POR LA ... ESINADO
REPRESION POLICIA
EN LA REBELION POPULA
20 DE DICIEMBRE DE

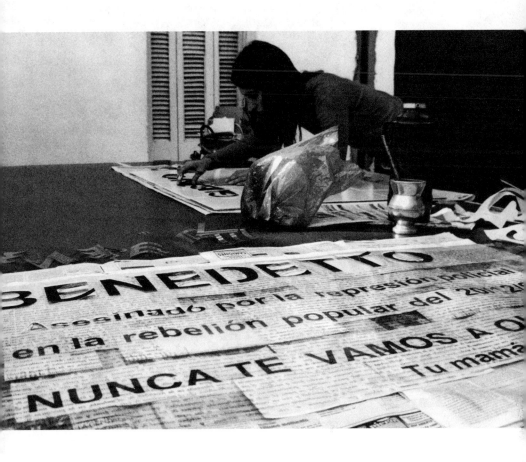

"My contribution to the direct action collective was via art. In the cultural center Usina del Arte in La Boca, where I give painting classes, we painted and we fired the ceramic pieces that would form a part of the homages to the victims of December 19th and 20th, 2001. With permission of Soledad Maratea, a ceramics professor, we worked in the classrooms and the patio of the cultural center in the middle of the students, children entering and exiting their studios, who were interested in the action and who thereby became conscious of what had happened in those days."
—**Solana Dubini**

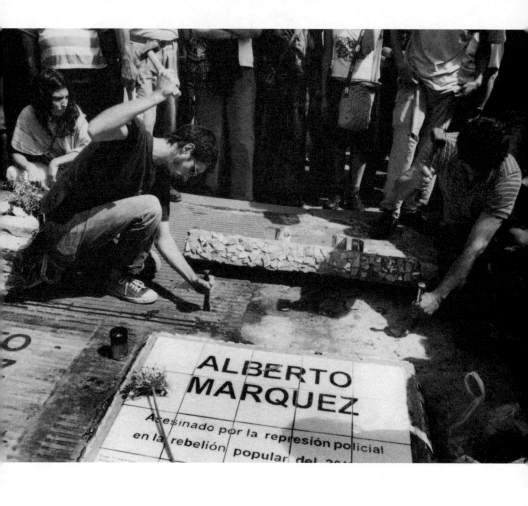

The text inside the image is part of the photograph:

ALBERTO
MARQUEZ
Asesinado por la represión policial
en la rebelión popular del 20...

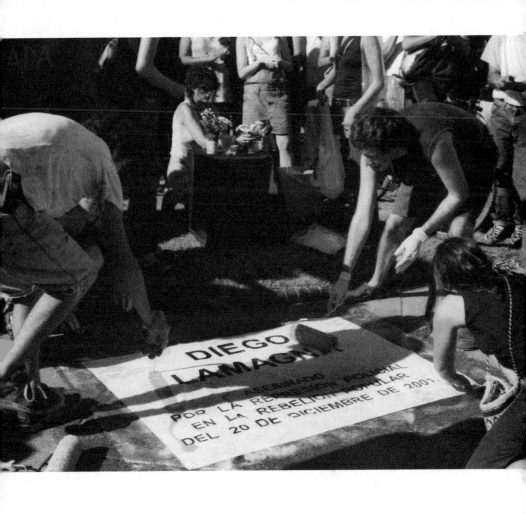

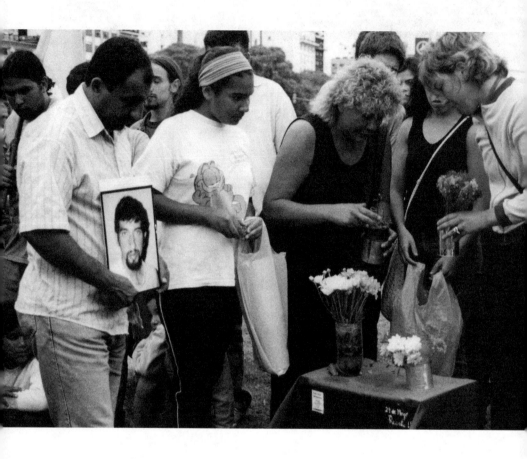

"The meaning that we give to the action is that of an homage, a moment of condensation, intuition, and collective contestation. To be there, outside, overflowed. We also called it the route, searching for, in this path, new forms of thought and struggle. A desiring and ethical movement, a common patrimony that acts as a mark and trace of questions that we ask ourselves in the present. In each plaque, we denounced repressive politics and affirmed ourselves a social and cultural change."

—Karina Granieri

GRUPO DE ARTE CALLEJERO: THOUGHTS, PRACTICES, AND ACTIONS

CARLOS
"PETETE"
ALMIRON

Asesinado por la represion policial
en la rebelion popular del 20/12/01.

"La sangre derramada sera la tinta
que escriba la nueva historia".

Carlos "Petete"
Almirón
Militante de
CORREPI

CORREPI

29 de Mayo
Presente !!

Con mucho cariño
a Carlos
"Petete"

Carlos "Petete"
Almirón

» PETETE « Ni Olvido,
Ni Perdon

DIEGO
LAMAGNA
Asesinado por la represión policial
en la rebelión popular del 20/12/01.

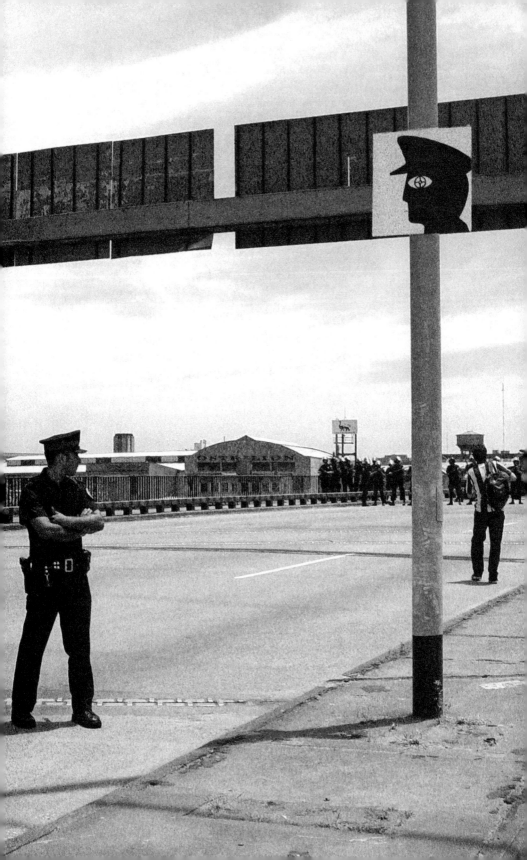

JUNE 26, 2002

The piquetero movement returns to take the streets. There are multiple blockings of highways across Argentina. In the suburbs of Buenos Aires, there was a strong police repression, with arrests and many wounded, and two compañeros dead: Maximiliano Kosteki and Darío Santillán.

The failed attempt by the state to blame other piqueteros for the deaths lasted only a short time. *"Piquete y cacerola la lucha es una sola"* ("Pickets and pots: the struggle is the same") is the motto that one hears in the massive mobilization against the government that occupied the streets of the capital.

The *piquetes* interrupt the circulation of commodities and of capital. The MTDs no longer appear in the media as indigents excluded from the structure of production, but their protest and poverty are criminalized. The nation-state with its gang of armed officers and paramilitaries rush to defend the interests of national and multi-national capital.

The political scene is modified again with the murder of Kosteki and Santillán. The emergency government presided over by Duhalde and sustained by the Partido Justicialista from the province of Buenos Aires calls for new elections with the aim of legitimating a new power.

MINISTRY
OF CONTROL

A silent genocide emanates from the liberal economy. The logic of the market separates and erases the origins of processes, it reifies subjectivities and identities, it produces stereotypes that circulate as representations that are then repeated and multiplied by the media. The police and the media define some zones and people that are "dangerous" and others that are "in danger." They construct crime maps, detect risks, and propose secure borders. A cartography of threats reorganizes the city. It produces a city fragmented into zones (neighborhoods, streets, houses) that are either secure or insecure. It organizes the inside and the outside. The insecure neighborhoods of the city are those in which control and self-control develop by means of reductions in space, trajectories, and connections: insecurity is the source of immobility. The search for safe routes and for narrower areas of circulation reduces the terrain of the daily experience. The city divided into zones indicates a zonification of life.

Fear, intangible, reproduces itself daily as exchange value in interactions; fear as surplus value, sown in the air we breathe; fear installed, disguised in the dichotomy of security-insecurity. It prevents the processes underlying the construction of identities from being exposed: "included," "excluded," "degraded," "dangerous," and "in danger." The intangible fetishization and naturalization of poverty and of violence are already part of the urban landscape. An intangible control like house arrest translates itself into a concrete reduction of the places we can go and the uses of space, time, and interaction.

The state occupies public space once again. Security forces appear again at demonstrations, at street barricades, and in the neighborhoods of the Buenos Aires suburbs. And with the usual modus operandi of terror they forcefully evict people from the ex Padelai (the building of the Children's Aid Organization), the Asamblea en Barracas (Assembly of Barracas), the Brukman factory and the MTD San Telmo.

In accordance with the city government's "gentrification" plan, people are displaced from occupied buildings located in zones that have been converted into exclusive, high-value spaces for real estate. Puerto Madero and San Telmo are an example of this.

The state rearms itself and rearticulates its mechanisms of control. It returns to circulating the discourse of security in order to "normalize" things. There is a retreat in the struggle, and tangible and intangible control increases. The discourse of "insecurity" takes hold as a source for the production of immobility.

We carried out several interventions and actions against the evictions in which we directly rebuked the "included-protected" as a collective subject, with the intention of making this subject reflect on itself, violating its "security" and for an instant putting it in a supposedly dangerous situation. What would it do? Would it get involved with the displaced? What position would it adopt?

In order to develop these actions, we constructed ourselves, according to the method of overidentification, as the Ministerio de Control-Subsecretaría de Planificación Urbana para la No-Vivienda, Plan Nacional de Desalojo (The Ministry of Control-Subsecretariat of Urban Planning for the No-Housing, National Plan for Eviction), and we did polling in San Telmo (the neighborhood where the occupants of the ex Padelai building were evicted on March 9, 2003) and in the shopping mall in Abasto (in recognition of the violent repression and eviction of the workers from the Brukman factory, on April 19, 2003).

By overidentifying ourselves with this institution, we usurped its function and assumed the uniforms of a government institution. We used an institutional image for the table, the ballot box, the folders, the polls, and the identity cards of the pollsters, wherein it was made clear that we were "agents" of this "Ministry of Control." With the method of overidentification, the logics of certain ways of thinking, including dominant norms and values, is taken seriously. Every institution, in addition to its concrete significance, has a symbolic function in the cultural grammar, since it transmits cultural, social, and political values.

Not a single man or woman surveyed doubted our affiliation with a government institution, nor did the name "Ministry of Control" catch her attention. With regard to the text of the polls, which began with a sworn declaration in which the man or woman surveyed ceded her/his residence (if she/he had one), the second paragraph announced in an ironic way: "You will be evicted soon. Complete the required sections of the following form." Below that, it offered the possibility of choosing the means of eviction: forceful, with the media present, which forces would intervene, if it would be with repression, with lead bullets, with the detentions of people, with dead, with wounded. In addition, we offered other alternatives in case the person being surveyed turned out to be in favor of the eviction: "Where would you like to be relocated? How would you like the media and the rest of society to refer to you? Do you believe that we Argentines are supportive, just, and humane?" (See poll text). We did the polls face-to-face, and in the case of San Telmo, we also slid them under the doors of houses, apartment buildings, and businesses. In addition to managing a successful overidentification, in which we were somewhat legitimated as "government agents," nobody doubted our authority, and what caught our attention most was that the majority of those men or women who were interviewed responded to the different options for eviction. It did concern some of those polled, and they made comments outside of the alternatives offered by the poll.

With this non-poll, since the point was not to collect data, we tried to expose the false naturalness of the discourses and actions through which power constitutes itself and then reproduces itself, thereby endorsing these violent operations of eviction.

In another opportunity, on the occasion of the repression and violent eviction of the female workers from the occupied Brukman factory, we did polling in the food court at the Abasto mall; in this case, we approached the tables, placing the polls in the diners' hands and telling them: "Yesterday we evicted Brukman; tomorrow we will evict you."

The response was one of total estrangement. We could, in a way, invade that space of leisure, pleasure, and consumption, inserting the problematic of the female workers who, just a few blocks away from the mall, were camped out resisting and fighting for their source of income. But with the non-poll, we were also asking people to reflect on the evictions.

At the same time, on another floor of the mall, a press conference was taking place with the people who were organizing a festival of independent films; we went toward the room and left a poll on each table, along with a ballot box so that people could deposit them there.

Given the significant presence of private security in this space, we were accompanied by two compañeros who "kept watch" and warned us when some of the uniformed guards realized what we were doing.

DIRECT ACTION IN THE SILOS OF PUERTO MADERO

This was one of the most synchronized and risky actions of the group, because we were dealing with a high level of exposure, caution, and coordination. The idea was to infiltrate the Festival de la Luz y el Sonido (Festival of Light and Sound; March 16, 2003) organized by the city government, which was responsible for the evictions in the ex Padelai, with the goal of using this massive event to raise awareness of the evictions. Just two days prior to the event, we decided to make a banner with the inscription: "Eviction and Repression Festival" with the signature "*gob. bs. as.*" (government of Buenos Aires), which would be unfurled from the silos while the festival activities were taking place. We knew that a group of climbers was going to perform acrobatics on the silos, and we thought this performance would be an effective moment to occupy the space.

The twenty-meter banner, of a somewhat dark fabric, was painted on Saturday and Sunday before going to the festival, and we tested the rolling and unrolling and added extreme weight so that it would unroll quickly. We used a precarious system to unfurl it, with a little lighted coil that would burn through the threads keeping it rolled up, while maintaining a certain distance from those who were hanging it on the roof of the silo. The idea was that while the coil was burning, the compañerxs had time to go down the back way in order to get away from the scene, which was guarded by agents of the navy.

We arrived on Sunday at two p.m., and we divided into two groups, each of which had a cell phone. The group charged with hanging the banner went up the silo's back way and stayed hidden for eight hours, receiving information every so often about what was happening outside from the other group which was below, amongst the crowds of people.

We checked the schedule, and we watched the festival performances one by one. It was already night when the group of climbers did their performance on the silos, descending and dancing from one side to the other, while the big reflecting lights illuminated their choreography. The intention of the group stationed in the silo was to unfurl the banner after the climbers left, but their departure was slow, which added a great deal of anxiety and adrenaline to the wait. For a few moments we thought that the festival was about to end, that the people would leave and that we wouldn't be able to carry out the action. But just as the event was about to end, and as we heard the line "It is the flag of my country" from the patriotic song playing through all the speakers, the banner unfurled and the compañerxs that had been up above were already with us; our happiness was triumphant, immense. With big smiles, we left with the crowd, and in spite of the fact that the compañerxs were a little scraped and bruised and exhausted, we went out to celebrate. We learned of the aftereffects of the action several days later, when we found out that the event organizers had asked the climber-acrobats to remove the banner from the site.

The next morning, the banner was still on the silos of Puerto Madero, unfurled in broad daylight, visible to all.

EVICT YOURSELF IN PROGRESS

As a group we were invited to participate in the exhibition *Arte en Progresión (Art in Progress)*, and in spite of our decision not to work in these spaces in the art world we considered this a good opportunity to speak about the eviction of the MTD San Telmo from the building adjacent to the Museo de Arte Moderno (Museum of Modern Art, MAM).

After the eviction of the MTD San Telmo from Avenida San Juan 383 (the MAM building), we intervened in the area that had been fenced off with the poster: *"Próximamente shopping para artistas"* (Coming soon: a mall for artists). We used the poster along with the action in the *Arte en Progresión* show on May 3, 2003, at the Centro Cultural General San Martín (General San Martín Cultural Center), which we participated in with Colectivo Situaciones. In this case we put together another poll that specifically targeted the artistic community. The text began by saying: "As part of the National Plan of Eviction carried out by the Ministry of Control of the nation and the city government, this space has been cleared out and set aside

for the activities of the artistic community."[1] We also revealed those responsible for the evictions: "This important initiative has been made possible thanks to the support of the Museo de Arte Moderno, the special operations group of the federal police (known as GEO), and the courts in charge of the CGPS (Centers for Management and Participation). You will be able to decide on and get involved with this government initiative."

This action was accompanied by some banners that we hung inside and outside the site with the phrase: "Now Showing: Eviction" and some photos that attested to the before and after of the eviction.

This intervention-action caused a stir. Before the inauguration, we were questioned by the curator of the show, and later they drove us out of the place where we had placed the table and the ballot box. The director of the Centro Cultural General San Martín arrived and asked that we put them in a place where "they wouldn't interrupt the crowd flow."

The pollsters approached people who were arriving at the Centro Cultural General San Martín's entryway. Later, inside the hall itself, there was debate raised by the artistically-inclined public that attended the show, the director, Marcelo Masetti, and the Secretary of Culture of the City of Buenos Aires, Jorge Telerman. This debate lasted for a long time, too long for all of us, since we don't like to hear the political rhetoric of the power structures, with its logic of representation so detached from vital praxis, so distant from our own ways of making and thinking reality, so different from the construction of autonomous politics. Some were seduced by the art of oratory and some of us simply felt sick to our stomach, which was enough to make us realize that we should leave. We had achieved our principal objective: changing the grammar of the site. Our intervention was effective, since we were able to destabilize for an instant "secure" and legitimized sites and discourses of "normality." By establishing the problematic of the evictions within the artistic community, we helped to modify the customary reading of the space-institution of art, thereby displacing the center of attention away from the show and toward other significations that were neither foreseen nor expected.

1 The new site for Spain's Cultural Center in Buenos Aires will be constructed in the ex Padelai building, a space donated to them by the city government.

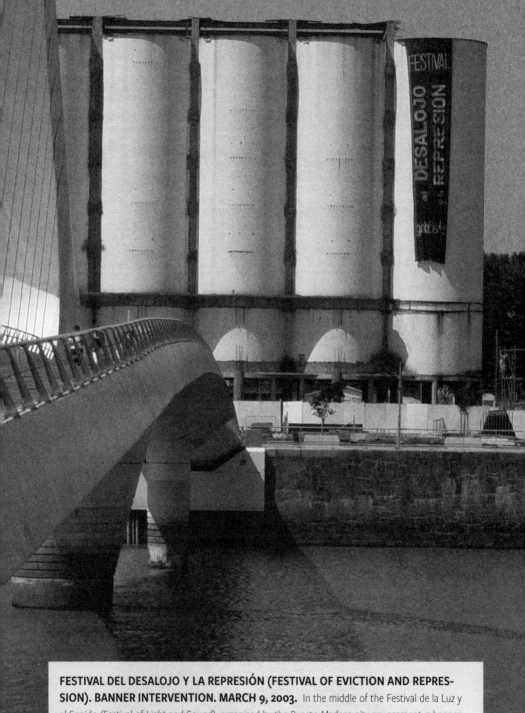

**FESTIVAL DEL DESALOJO Y LA REPRESIÓN (FESTIVAL OF EVICTION AND REPRES-
SION). BANNER INTERVENTION. MARCH 9, 2003.** In the middle of the Festival de la Luz y
el Sonido (Festival of Light and Sound), organized by the Puerto Madero city government, a banner
of twenty meters was unexpectedly unfurled from some silos, with the slogan Eviction and Repression
Festival signed by the city government of Buenos Aires. The public immediately associated the text
with the violent evictions that had occurred that week.

Ministerio de Control
Subsecretaría de gestión e industrias culturales

Plan Nacional de Desalojo

DESALOJARTE // EN PROGRESION

Como parte del Plan Nacional de Desalojo, que lleva adelante el Ministerio de Control de la Nación, el Gobierno de la Ciudad Autónoma de Buenos Aires ha decidido impulsar el Plan DesalojArte / en progresión, cuyo objetivo es dedicar algunos de éstos espacios desalojados a la actividad de la comunidad artística de la ciudad. Esta importante iniciativa es posible gracias a la colaboración del Museo de Arte Moderno, el grupo Geo de la Policía Federal, los juzgados a cargo y los distintos CGPs. Ahora, por medio de esta encuesta, usted podrá también decidir e involucrarse en esta iniciativa gubernamental.

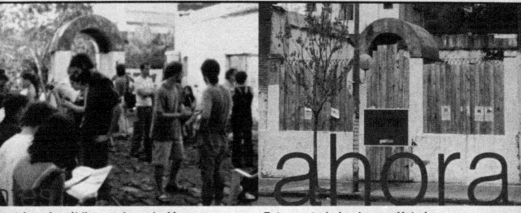

patrimonio público en degradación. Estamos trabajando para Usted...

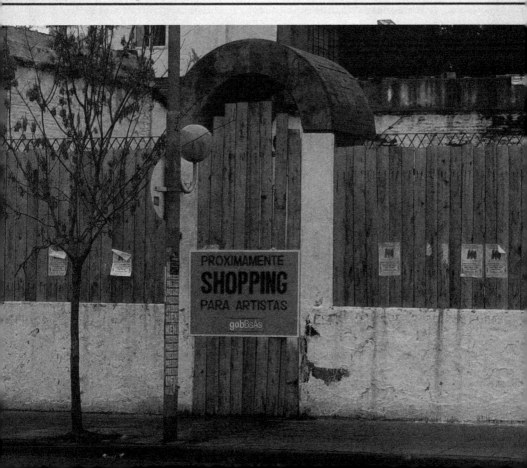

PROXIMAMENTE
SHOPPING
PARA ARTISTAS
gobBsAs

Ministerio de Control
Subsecretaría de gestión
e industrias culturales

Plan Nacional de Desalojo
Formulario nº 2

DESALOJARTE // EN PROGRESION

Como parte del Plan Nacional de Desalojo, que lleva adelante el Ministerio de Control de la Nación, el Gobierno de la Ciudad Autónoma de Buenos Aires ha decidido impulsar el Plan DesalojArte / en progresión, cuyo objetivo es dedicar algunos de estos espacios desalojados a la actividad de la comunidad artística de la ciudad. Esta importante iniciativa es posible gracias a la colaboración del Museo de Arte Moderno, el grupo Geo de la Policía Federal, los juzgados a cargo y los distintos CGPs. Ahora, por medio de esta encuesta, usted podrá también decidir e involucrarse en esta iniciativa gubernamental.

① Marque con una ✗

¿Sabía usted que hemos logrado dar el primer paso del Plan Desalojarte / en progresión, al recuperar el predio ubicado en la avenida San Juan 383, que estaba siendo usurpado por el grupo auto-denominado Movimiento de Trabajadores Desocupados (MTD) de San Telmo?

- [✗] No estaba informado/a
- [] Estaba informado/a a través de los medios de comunicación
- [] Me enteré porque fui desalojado/a en esa acción
- [] Me enteré porque pertenezco al Museo de Arte Moderno de Buenos Aires, y estuve en la planificación
- [] Me enteré porque pertenezco al mundo de los negocios inmobiliarios

② Marque con una ✗

¿Cuál es su opinión sobre la adjudicación de este importante predio desalojado al Museo de Arte Moderno (MAMba), con el fin de construir un shopping para artistas, gracias a la gestión de un crédito del Banco Interamericano de Desarrollo (BID) a tales efectos?

- [] Muy de acuerdo
- [] De acuerdo
- [✗] Me es indiferente
- [✗] Era hora que se acordaran de los artistas
- [] Hay que desalojar a todos los curadores y artistas
- [] Me parece muy bien que el Grupo Geo sirva para algo
- [] Deseo participar del negocio: ¿a quién tengo que "tocar"?
- [✗] ¿A quién le dejo mi curriculum?

③ Marque con una ✗

¿Qué importancia adjudica Ud. a la construcción de un espacio dedicado al consumo de bienes artísticos, en un contexto cultural especialmente preparado a tales fines?

- [] Mucha
- [] Poca
- [] Me es indiferente
- [✗] Me resulta una porquería
- [] No sé qué es un bien artístico

Y ME ES ESTRIDENTE

▶ ▶ ▶

④

¿Podría definir un orden de prioridades (del 1 al 9) entre los siguientes servicios que prestaría el shopping de artistas?

- [✗] Pelotero
- [✗] Mc Donalds
- [✗] Seguridad privada
- [✗] Servicio de internet y juegos en red
- [✗] Outlet de productos artísticos
- [✗] Una peña de los curadores *zombis* .
- [✗] Galería de exposiciones con Sala VIP, tráfico de influencias

⑤ Marque con una ✗

El gobierno de la Ciudad prevee, en el marco del plan DesalojArte / en progresión, nuevos desalojos en provecho de la comunidad artística. ¿Cuál de estos predios le gustaría desalojar próximamente?

- [] Grissinópolis
- [] Padelai (¡ah! Ya lo desalojamos...)
- [] Clínica de Haedo (próximo desalojo 7 de mayo)

Colabore informándonos sobre otros espacios posibles a ser desalojados:

MI CASA, EL CEMENTERIO, UN ARDILLAL, OSILOTES, PESCADERIAS Y CIGUEÑALES

⑥ Marque con una ✗

De cara a las próximas elecciones para Jefe de Gobierno, ¿cree Ud. que este plan mejora la imagen de la gestión?

- [] Tanto que favorece la relección de Aníbal Ibarra
- [✗] Mucho
- [] Un poco
- [] Casi nada
- [] Tanto que favorece la elección de Mauricio Macri

⑦ Marque con una ✗

En nuestra ya vasta experiencia en desalojos hemos encontrado algunas resistencias. Se hace imprescindible usar la fuerza legítima para garantizar nuestra política de espacios públicos. ¿Qué a método a Ud. le han parecido más apropiados?

- [✗] Modelo Brukman: de madrugada, con un ejército policial y a las patadas
- [] Modelo Padelai: de día, con presencia y complicidad de los medios de comunicación
- [✗] Modelo Sasetru: con despliegue intimidatorio militar
- [✗] Modelo De la Rúa: autodesalojo con tecnología aérea

TODOS SON BUENOS

Nombres *MATEO*

Apellidos *AMARAR*

Seudónimo *EL TURCO*

DNI

Firma

Gracias por su colaboración!!!

RECUERDE: "La propiedad privada está por sobre el derecho a la vida" (jueces Sala VII)

Ministerio de Control
Subsecretaría de gestión
e industrias culturales

PLAN NACIONAL DE DESALOJO

Ud. Será desalojado próximamente. Complete los requisitos del siguiente formulario:

DECLARACIÓN JURADA

Mediante la presente solicitud de desalojo, yo, _Agustina Herrero_ , con domicilio constituido en _Pintos 3090_ , ciudad / localidad _BsAs_ , provincia _____, **renuncio a mi derecho de poseer una vivienda digna** y solicito la inmediata intervención de la autoridad gubernamental y policial para efectuar en forma urgente el desalojo de mi lugar de residencia, **a fin de beneficiar a los grupos económicos que negocian con el gobierno.**
Firma: _____
Aclaración: _Agustina Herrero_
Documento: _____

1. Elija su propia modalidad de desalojo (marcar con una cruz)

☐ **DESALOJO "DE QUERUSA"** : un día volvés a tu casa y tenés las cosas en la calle.

☒ **DESALOJO MEDIÁTICO:** con presencia y complicidad de los medios de comunicación.

☒ **DESALOJO VIOLENTO:** con intervención de fuerzas de seguridad.

Fuerzas intervinientes:
☒ PFA - INFANTERÍA
☒ PREFECTURA
☐ GENDARMERÍA
☐ PATOTAS PARAPOLICIALES

Con represión:
☒ PALOS
☐ BALAS DE GOMA
☒ GASES LACRIMÓGENOS
☒ CARROS HIDRANTES

Con detención de personas: (indicar cantidad)
☐	HOMBRES
☐	MUJERES
☐	NIÑOS
☐	ANCIANOS

Con Muertos: (indicar cantidad)

Con Heridos: (indicar cantidad)

Con destrucción de bienes y pertenencias: (indicar monto total de la pérdida deseada) $ [_____] (son _Lo Menos Posible_ pesos)

Consultá nuestro PLAN ESPECIAL PARA DESALOJO DE ESPACIOS COMUNITARIOS. Promoción exclusiva para Asambleas barriales, Movimientos de desocupados y Fábricas recuperadas. Con o sin intimidación previa, con o sin orden judicial. ¡LLAMÁ YA!

MINISTERIO DE CONTROL (MINISTRY OF CONTROL). 2003. Survey forms created in order to question the evictions ordered by the city government of Buenos Aires at various points around the city.

ARTE EN PROGRESIÓN (ART IN PROGRESS) EXHIBITION IN THE
CENTRO CULTURAL GENERAL SAN MARTÍN. MAY 3, 2003.

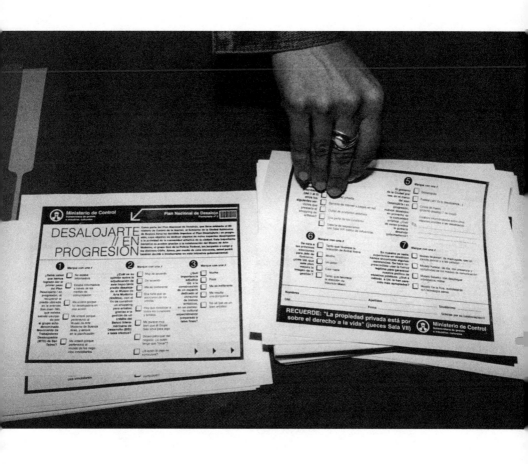

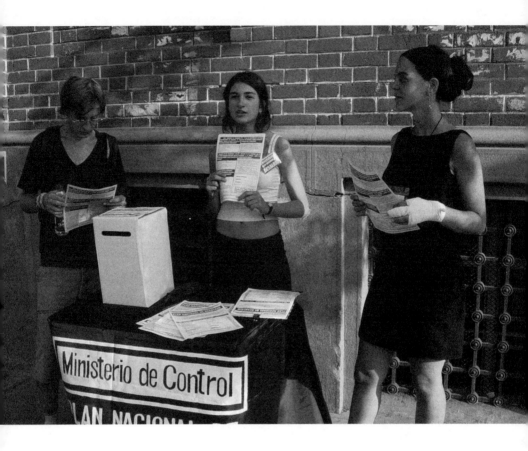

MINISTERIO DE CONTROL. PLAN NACIONAL DE DESLOJO
(MINISTRY OF CONTROL. NATIONAL PLAN OF EVICTION).
MARCH 9 AND 16, 2003.

The city government of Buenos Aires embarked on a series of evictions at various points around the city, above all in its historic heart, in the neighborhood of San Telmo. The group put up a stand on that neighborhood's busiest corner, from which "official" promoters from the "Ministry of Control" would go out to poll neighbors and tourists. The questions sought to find out which way people would like to be evicted, how to renounce the right to decent living conditions, how to become excluded from, and devalued by, society. The activity was carried out on a number of occasions in the same neighborhood.

RIGHT: The same survey was used for the National Plan for Eviction, which we carried out in the Abasto mall, within the context of a series of actions denouncing the eviction situation. April 19, 2003.

GLOBOS DE DIÁLOGO (SPEECH BUBBLES). MARCH 24, 2005. Speech bubbles were pasted over public advertisements during the march on March 24, 2005. They read as follows: Do you know that Carmen, Marcela, and Margarita are prisoners in Ezeiza because they asked for jobs? Do you know that there are political prisoners today? Do you know that Elsa, Marcela, and Selva are imprisoned in Caleta Olivia because they asked for jobs?

The speech bubble on the previous page reads: "Do you know that there are political prisoners today?" (Trans. note)

Our style of communication takes its point of departure from territorial and situational work and not from universal structures, which touch down in one territory or another without any particular level of previous knowledge or contact. Our search, on the other hand, lies in the establishment of shared parameters, be they ideological, aesthetic, or emphasizing the very dynamics of the spaces in which we are working.

Our experience takes its point of departure from working with images and iconography that, through activism and development over time, are open to appropriation or reinterpretation by others, who, by virtue of using them, recreate them as symbols.

In our work, we prioritize processes and/or proceedings and political content that, in and of themselves, propose ways of speaking beyond aesthetic or artistic projects.

As such, the images that are produced in these spaces and with these actors are far from being "works of art" suddenly transposed into the context of the street; but they are also greatly distanced from the practice of aesthetic agency understood as a kind of knowledge or as a technical specificity or as a language, which some group produces for others who have specific needs or problems.

In order to understand this difference, the ethical and political position that serves as our point of departure is very important. Also significant is the concrete need to establish a link, since we don't feel privileged in the face of the problems that we denounce and make visible, but rather we take sides and give our voices to articulating through speech and thought what we are living. We act from this radicality that serves as a resistance to normative culture, but at the same time, we do not define ourselves as countercultural.

The idea of coordinating with other groups emerged from the development of these communication practices. In this sense, it is important to make it clear that we are not referring to an imposed or preexisting network, composed of such-and-such organizations or at the service of such-and-such communal actors, but from shared experience and human contact, which generates links between people and groups that share visions and experiences and that collaborate to generate spaces that break with the establishment, not to oppose it, but rather to build from a different place.

Working with others as much in networks as between different groups serves to highlight the ways in which the work that emerges may be part of a communicative experience that unfolds from a "communal being" that takes its shape from different settings and actors. This "communal being" crystallizes as it interacts with the various interventions that are so often presented as conflicts in the context of everyday life. From there, a new level of multiplicity in communication opens, in which distinct reactions or responses are not anticipated, but rather connected to

the reaction of these subjects. Furthermore, the interpretation and reinterpretation of these reactions depends upon the communicative practices that develop inside these contexts or circuits.

When one interrupts public space—or any other space to which he or she has not been invited—in order to act on something that is happening there, one alienates others, which results in another round of decision-making connected to the question of intervention. This is one of the most notable points in communication: how the male or female other represents support or disagreement with what is being seen/lived or what is experienced versus what one feels in the face of the need to react or question. The city itself produces many linguistic tools, and when they are used for communication and not for the purpose of alienating bodies, they provoke unusual ties within the flow of daily life.

We know that our production is based in mobility, and that this is in accordance with the changes in the affective, political, social, and symbolic context of each historical moment and with how we situate ourselves as men and women within it. In this way, the communicative tools vary greatly from one situation to another. The most important thing, however, is that this mobility is the basis for our form of communication itself: in which each person, in the space of creation, enacts a transformation just as much as being transformed as a man or as a woman—they make crisis as well as being part of the production of crisis. It is precisely in this moment when personal and group desires are put into play and the trajectories of experience are addressed.

Searching for an opening to escape from the politics of urgency, in which something is always given preference over desire. At times this something that is given preference is as absurd as an agenda from the militancia themselves.

Searching for creation from feeling, from a place related to daily life, which is so often made invisible or silenced by other urgent agendas that promote tradition over the creation of new senses or spaces.

From its very beginning, GAC considered itself a space for creating collective and individual feelings, cross-cut with the necessity of dialoging with others. This has always led to taking a stand, a transformation in play, and a permanent crisis in the search for more diverse utopias. This is the structure of a communicative action in permanent development.

We know that reality is made up of multiple layers and that these layers intervene in how what we do reaches people; the search for a stance in the face of a daily reality is especially present in this process. For this reason, when GAC began, and because of its participants, it already carried within itself a search for that utopia, for that construction of a space beyond the identities imposed and proposed by the system in order that the system might recognize them as such and such sector, movement, or stream.

We try to remain in that space of mobility. Mobility of subjects—individual and collective—who find themselves in a process of the creation of communicative action, since in the action itself we recreate languages to provoke "living thought" about ourselves as men and women and about those who are interpellated through our actions.

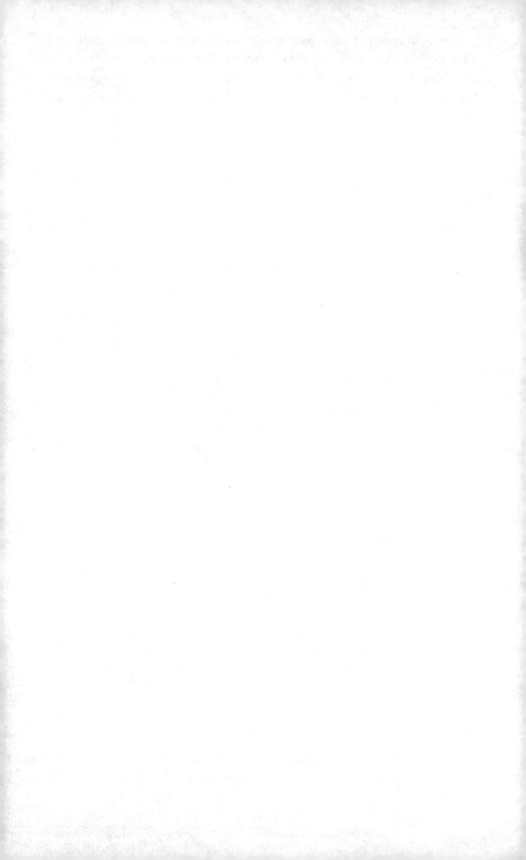

METHODOLOGIES

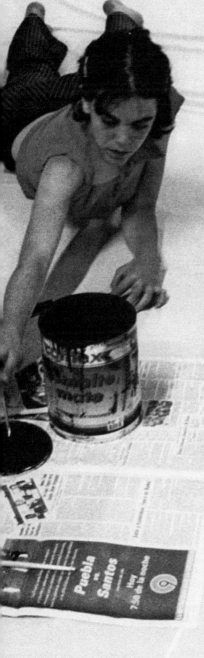
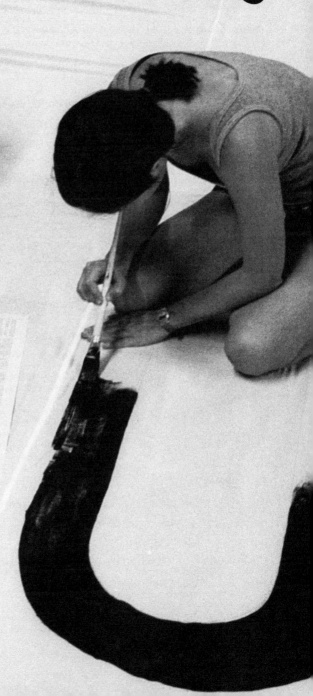

W hat do we do? How do we do it? How are we thinking about what we do? For each question one would be able to come up with a multiplicity of responses, since there's no single way within the group for approaching production, nor is there even a unified position about the what and the how, and furthermore these both change with time. No single moment of production is the same as another, nor does what we construct as discourse mean the same thing across different moments and settings.

Therefore, the questions should be: what common characteristics do we detect across the diversity of our production? What are the variables that change? Is there a transferable knowledge that can be distilled from it? And seeing as we are not creating a rule book, nor an encyclopedia of practices, what format can be given to this nonlinear reflection?

A listing, grouped by blocks, in which the ordering of the list does not establish a hierarchical relationship between concepts and without a defined temporal organization. Blocks that intertwine, that superimpose. . . .

Here is an approximation:

WORK INSIDE OF THE GROUP

→ Dynamic of the meeting, placing in common, confrontation, consensus as a result of the interplay of tensions among individualities
→ How relationships of power are articulated and disarticulated from within
→ The affective

WORK WITH OTHER GROUPS

→ Space of the meeting
→ Field work, the importance of the time for mutual recognition
→ Accessibility of practices in relationship to others: determination of formats, choice of materials, technology access
→ Image as excuse, as a communication device between groups and from the group outward; interactivity

THE FORMATS

The visual intervention and, within it, the presence of the graphic. / The performative action, the "placing of the body." / Playfulness as motivation for work and as a device for connecting with the other. / Direct action vs. long-term projects, where the process of construction becomes evident over time.

THE SERIAL AND THE SINGULAR

(from our perspective):

→ Actions or interventions that exist in different times and places but that compose the same idea, the same discourse. The full significance is understood via a reading of the whole.

→ Precise actions, independent of others in time and space, that may or may not have to do with others thematically, but that make up a unity in themselves and can be "read" autonomously.

THE SPECTACULAR VS. THE DISCRETE

→ The effect of size, quantity, and proliferation of the object-image, as well as the high or low visibility of the body that intervenes in the space.

→ The mass, the party, the march. Being inside, being outside. The minimal, the face to face.

→ The limits of the visible, where intervention begins and where it ends; the gaze of the viewer that signals what becomes a new text inside of a context.

Falsification, distortion, disguise. / Parody, irony, etc.

Ways to appropriate culturally dominant discourses in order to achieve their conceptual inversion. Many of these practices are known as guerilla communication and have been studied and classified both by theorists and activists from the fields of art, politics, and communication.

EFFECTIVENESS AND EFFICACY

→ How these concepts are thought out from a communicative point of view.

→ How to think from the point of view of a social transformation, the "changing of someone's mind."

→ What predominates: the quantitative or the qualitative. The comprehensiveness of a discourse is not necessarily equivalent to its efficacy.

→ Depending on the case, how to measure this efficacy, what the indicators will be. The importance of the "return" or feedback.

→ For those whom we are speaking to, how we think about a "spectator." Thinking the spectator as a non-passive recipient, as a coparticipant in the construction of the discourse. Or rather, thinking the spectator as a subject of confrontation.

→ Efficacy measured inwardly; up to what point our actions transform *us*.

→ The urgency of speaking, when it is more important "to respond" rapidly than to first go through a process of reflection, when the reflection comes after the action.

THE DYNAMICS OF THE METHODS

→ Variation in time, place, and situation.

→ How certain strategies that were effective in one moment have become obsolete or create an effect contrary to what was intended.

→ How the dominant discourse adopts methods and formats that used to be forms of resistance, for example political campaigns and advertising.

GENEALOGY OF CERTAIN PRACTICES WITHIN THE GROUP

How one format transitioned into another, or how knowledge from accumulated experience with a particular format could be recuperated. For example: although performance has been present since the group's beginnings, it has recently begun to be valued for its own sake, beyond even the strictly visual-graphic, beginning in the year 2000, with actions like *El juego de las sillas (Musical Chairs)* or *Paracaídas (Parachute Soldiers)*. The same can be said about graphic language, which gained a more profound dimension starting with *Aquí viven genocidas (Here Live Genocidists)* and as a visual register of a political symbolic action in the escrache and also in the cartographic pieces, in which the intersections of the experiential and the conceptual were represented.

GENEALOGY IN RELATION TO THE HISTORY OF SYMBOLIC PRODUCTIONS

Here we should clarify how that genealogy was granted recognition.

Under the dictatorship, a generational divide was imposed in relation to the production of popular cultural understanding and knowledge, with certain forms legitimized or not by the artistic institutions; this divide is a reality that was uncovered slowly via research that contributed to the reconstruction of this history. When we began working, we were not very familiar with what had been done in our country and in other places; in tandem with the development of our own production we were able to obtain information about earlier local experiences with which we had much in common but also many differences. Since we tended to build our practices in a mode of casual discovery, we could not say that there were conscious lines of paternity with the groups that came before us. However, we do recognize certain obvious analogies, which make us think about the variables that have influenced the emergence of various forms of response, as well as of the construction of dissident discourses that are similar to those of distant times and/or places.

THE QUESTION OF THE AUTHOR

→ About the idea of intellectual property vs. collective creation and shared knowledge.

→ The anonymous character of particular productions.

→ The authorship of a certain action-intervention or image is reconfigured according to the context and according to the agents involved in its construction. There is no single author, but rather multiple speakers and identities according to each case.

→ The unsigned as a stimulus for reappropriation.

→ When certain circuits demand a signature: an exhibition or a talk in an institutional space.

→ Questioning the idea of originality, of "who came up with it first."

→ Disagreement with the idea of the author as an exaggeration of the role of the artist: the artist as the enlightened producer of symbols, as the one who possesses knowledge and translates it for the masses.

At this point, we need to pause for a minute in order to elaborate our position, since it is very common within the artistic community (although not in the militancia) to usurp the authorship of particular modes of creation. We believe that it is more fruitful to study the unifying characteristics that gave rise to similar production in different eras than to organize names on a timeline. Furthermore, prioritizing authorship as a mechanism of validation does not contribute to a reflection on what has been done; on the contrary, it makes definitively invisible those already marginalized by history. This view is influenced by the dominance of the auratic aspect of a work and by the fact of conceiving of whatever is being made as a "work of art," thereby canceling out the spillover between political and artistic practices.

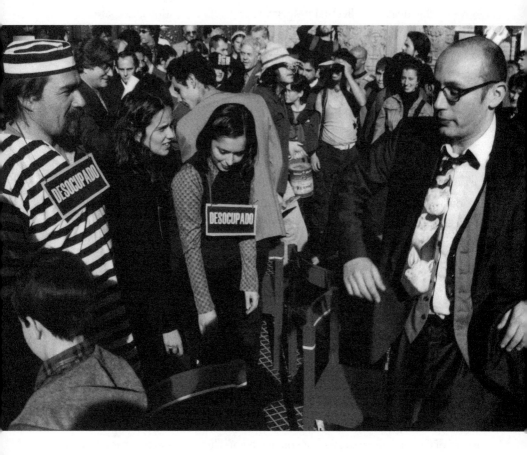

JUEGO DE LA SILLAS. S26. AT SÁENZ PEÑA AVE. AND FLORIDA STREET. SEPTEMBER 26, 2000. In solidarity with S26 against the G7 summit in Prague, a series of actions took place at different points in the city. *El juego de la silla* was a performance about unemployment and the lack of job security as a result of globalization and neoliberalism.

S26 refers to a series of protests worldwide against the International Monetary Fund and World Bank summit in Prague, which took place on September 26, 2000. The signs around the participants' necks read "unemployed," although the same word—*desocupado*—can been used to mean "unoccupied" or "empty." (Trans. note)

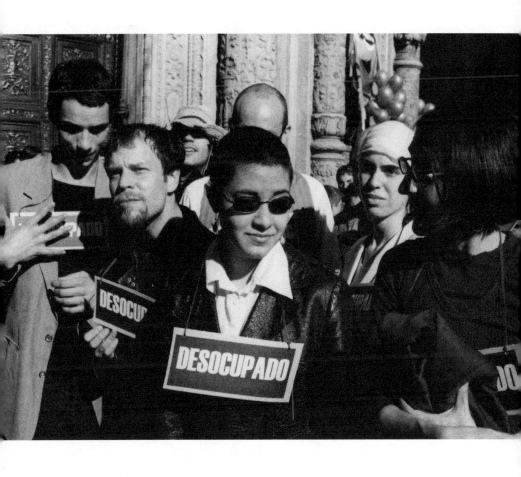

MINISTERIO DE CONTROL. PLAN NACIONAL DE DESALOJO.
APRIL 19, 2003. Within the context of a series of actions that sought to denounce the evictions implemented by the city government of Buenos Aires, "official" promoters from the "Ministry of Control" conducted polls in the food court of the Abasto mall.

***ROGGIO INTOXICA (ROGGIO POISONS)*. BROCHURE ABOUT UN-HEALTHINESS. OCTOBER 2002.** Supporting a reduction of the length of the workday for workers in the Buenos Aires subway and denouncing the levels of toxicity in the environment. Pamphlets, which explained the problem and mimicked the aesthetic style of the institutions, were handed out. The action was organized together with the workers of Metrovías.

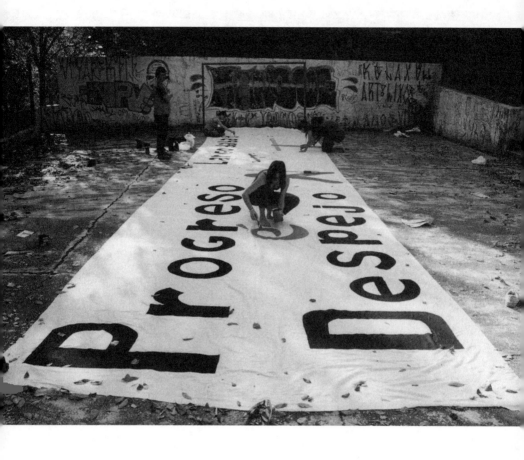

São Paulo, Brazil, 2004.

Painting the banner that will be put up at the Largo da Batata, together with Grupo Bijarí, as part of the Zona de Acción (Action Zone).

Largo da Batata is a large public area in São Paulo. The banner reads "Progress and Eviction," a pun on "Order and Progress," the Brazilian national motto, which is also featured on the flag of Brazil. (Trans. note)

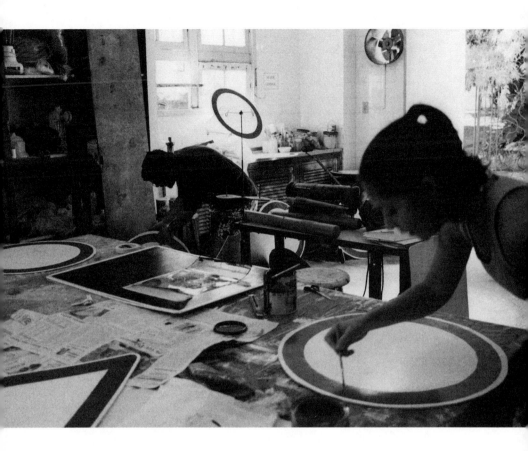

Rio De Janeiro, Brazil, 2000.

Working at the workshop to create a series of street signs that were put up to denounce Operation Condor.

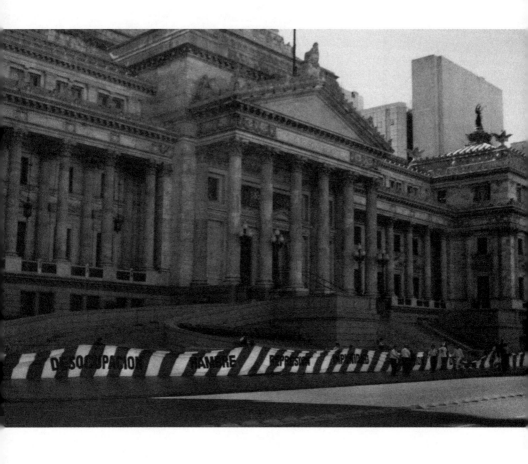

***BANDERA DE PELIGRO (BANNER OF DANGER).* DECEMBER 10, 2001.**
As part of the Colectivo Acción Directa, we made a banner designed to look like
caution tape, with the word "caution" replaced by a text that repeated lengthwise
over some one hundred meters of fabric: "Unemployment/ Exclusion/ Hunger/
Repression/ Impunity." The banner was created with the intention of hanging it
in front of the Congress on the day that deputies and senators officially assume
their offices. Later, it was hung from the Casa de Gobierno and the Ministerio de
Economía during demonstrations and protests.

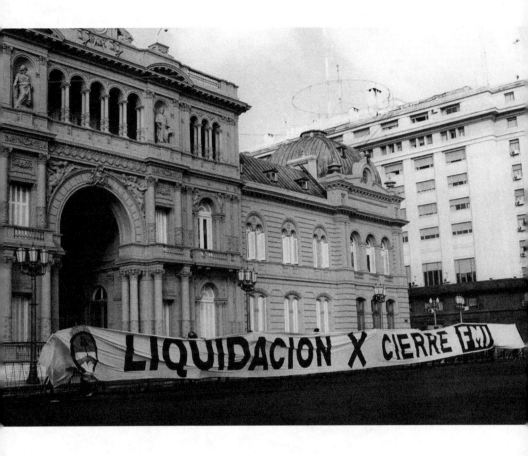

***LIQUIDACIÓN POR CIERRE (LIQUIDATION CLOSEOUT SALE)*. JULY
20, 2001.** As part of the antiglobalization protests against the G8 meeting in
Genoa, Italy, on July 20, 2001, a thirty-meter banner was made with the phrase
"Liquidation Closeout Sale." On the extreme left, it bore the national insignia, and
on the right, the acronym FMI [the Spanish acronym for the IMF (Trans. note)].
Our intention was to denounce the downsizing of the state; in order to do so, we
resignified a phrase typically used in commercial settings.

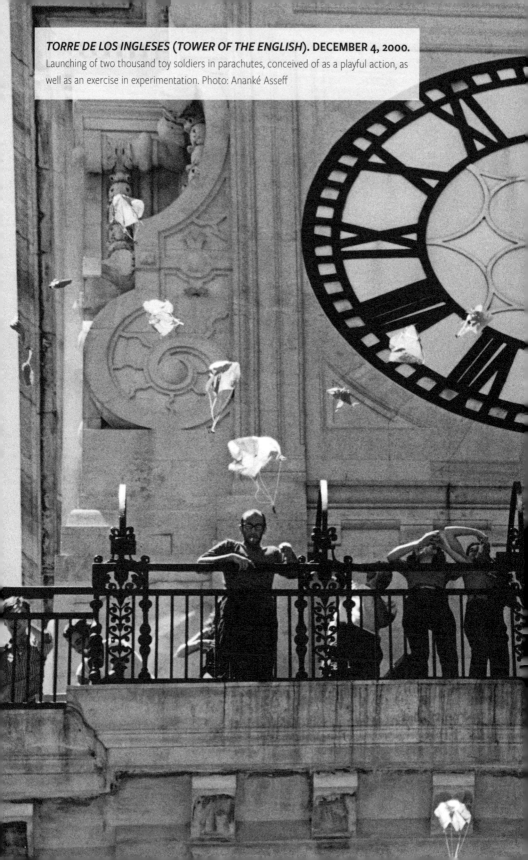

TORRE DE LOS INGLESES (TOWER OF THE ENGLISH). DECEMBER 4, 2000.
Launching of two thousand toy soldiers in parachutes, conceived of as a playful action, as well as an exercise in experimentation. Photo: Ananké Asseff

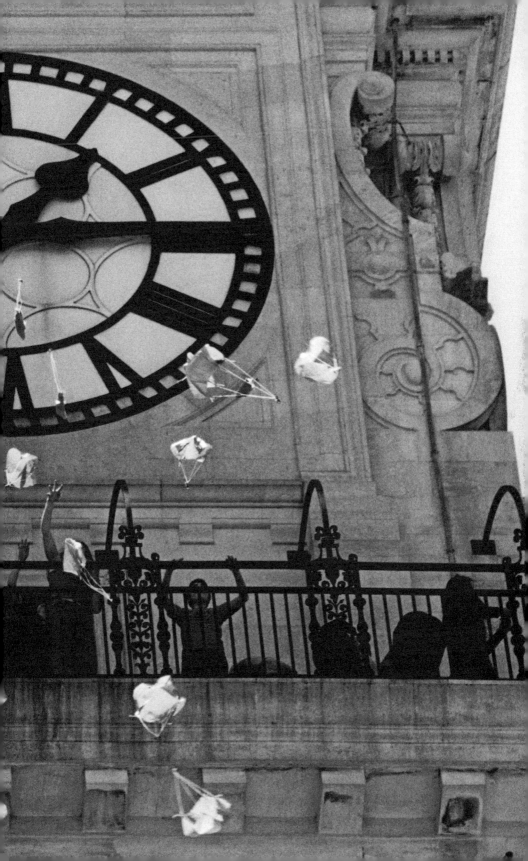

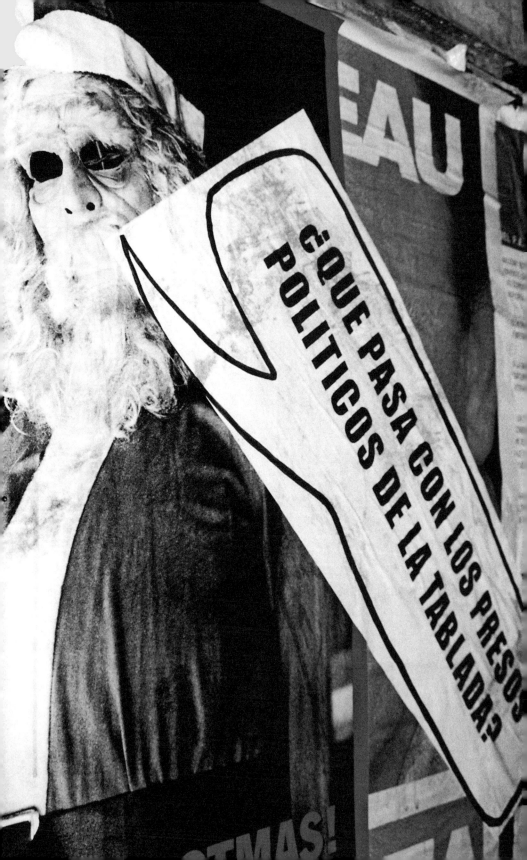

POLITICAL PRISONERS FROM LA TABLADA. INTERVENCIÓN DE AFICHES (POSTER INTER-VENTION). DECEMBER 25, 2000. In connection with the more than one hundred-day-long hunger strike carried out by the political prisoners of La Tablada, we decided to make a series of posters to paste on top of advertisements as a way to divert attention away from the content of the advertising and toward a questioning of the issue at hand. The speech bubble in the photo reads, "What's happening with the political prisoners from La Tablada?" (Trans. note)

PHOTOGRAPHIC RECORD

In the process of forming the group, we realized that it was necessary to create a record of our actions, both because of their ephemeral nature and so that we would have documentary materials that could be circulated. During the project *Docentes Ayunando (Teachers on Hunger Strike)*, which took place during 1997, we created a process of documentation that spanned both preparation and execution, including the ritual-like intervention of burning the pieces used for the action as kind of seal. We stipulated that certain shots had to be included: process/whole mural/fragmented mural/fire/covered mouths/group in front of the mural. After experimenting with the first mural, the group considered the possibility of continuing the process of documentation and of assigning a particular person to take on this role.

During the street signs project, which began in 1998 within the context of the escraches organized by H.I.J.O.S., our aim in creating an archive was still to document the process and the moment of the action. During the escraches, we changed our process of documentation, not taking pictures during the moments when there were only a few of us present to hang posters, etc., or in situations where it was "dangerous," since at that point we were leaving to hang posters away from the route of the march. It's important to keep in mind that during those years the escraches were suppressed, which made it difficult to put up posters. We were finding ourselves in situations where we were the ones being photographed, where it was extremely important that we not attract attention, and for that reason we produced no documentation.

However, at the same time, we did document much of the production of the posters, and portraits of many of those involved in the group began to emerge. This documentation of the group's social life, which didn't circulate, contains materials that record the everyday moments within our collective relationships, the human relationships that extend even beyond the group and that speak to the other places that we have in common. They generate a detailed and quotidian account of what it means to share a group. Also, the development of this practice generated discussion around the significance of documenting the meetings, the preparations for the actions, and the actual moments in which the posters were hung. We decided to continue documenting this sequence, since we considered the action a legitimate one.

We considered the action of documenting from within a group as forming part of a project. At the same time, as we worked with other groups or people and established ties with them, this too modified the record and prompted other attitudes toward the documentation process. In some cases, we decided not to document, either for external reasons or because we decided to take a different role in the action, as happened, for example, in the escraches mentioned above, or during some of the tributes to the people murdered on December 20th, 2001, cases in which we prioritized something that needed to be developed through action.

The circulation of this documentation was always important within the group, not only for communicating and sharing our experiences with other collectives, using the archive in a political way to establish ties and contacts, but also so that other people and groups could make their own use of the images and techniques. Our intention is that these images be mobile and transferable and that they not become a closed document; instead, they should be re-elaborated and reconstructed through exchange with others.

At the same time, other important transformations unfolded with regard to the function of the record. Photography started to be used as an action and not only as a record. We started to use photography in the design of some of the projects; for example:

CUADERNILLO DE BLANCOS MÓVILES (BOOKLET OF MOVING TARGETS). In the targets, photography is used to narrate a group journey involving several months' work and the exchanges with other collectives from inside and outside the country. This exchange also takes place on an archival level, in which photographs of the different organizations and places where the actions took place are used.

CUADERNILLO PROYECTO DE LEY ANTIMONUMENTO A ROCA (BOOKLET PROJECT ON THE ANTI-MONUMENT LAW FOR ROCA). The images are reproductions from magazines and reproductions of images from other compañerxs dedicated to investigation into the issue and into photography.

The circulation and exchange of materials are present in this kind of construction, which is based on earlier records and archives. The record as a mode of experimentation for developing a future action. For example:

DIAPOSITIVAS DE SOLDADITOS Y SOLDADITOS PARACAIDISTAS (SLIDES OF TOY SOLDIERS AND PARACHUTE SOLDIERS.) Before the invasion projects, the toy soldiers were used as objects and several photographic excursions took place at different significant locations in the city—Plaza de Mayo, Perez Companc, Fortabat, the Casa Rosada, SIDE, etc.—with the idea of invasion but without having yet developed the concepts behind the project itself. The "invasion" project unfolded based on these trials and experiments with the objects in different locations, and ultimately took place on December 19th, 2001.

The record as a process preceding an intervention or action. For example:

ASESINATOS SERIALES Y BS. AS-BELFORD (SERIAL MURDERS AND BUENOS AIRES-BELFORD). In the case of projects that needed prior surveillance of the space as part of the development of the intervention, in which the idea for the action was not very clear and photography became a tool for research and play.

We started to use video to record actions, and later we move from documentation to audio-visual production, for example in *Aquí viven genocidas* in 2001 (a tour through the residences of genocidists who were the focus of escraches and through the ex-clandestine detention centers) and in *El Juego de la Vida* (*The Game of Life*), in 2008.

We also started to create short documents in which we described and categorized some of the actions that shared a thematic trajectory. For example: *Cartografías* (*Cartographies*), *Vacas en la Feria del Libro en la Rural* (*Cows at the Book Fair in La Rural*), *Desalojo* (*Eviction*), *Invasión* (*Invasion*). Here the record also functions as a mobile archive, as photography does, and, at the same time, is also a product. It is a 1:1 reflection of the group's production, and it develops a thoughtful consideration of the trajectory of the group.

An important change in the archive, which was amplified by the advent of the digital camera, was the possibility for everyone in the group to take part in the recording. This happened in 2003, and it generated a change within the dynamic of recording itself, increasing the number of pictures and making their circulation easier as well. For the most part, this change was in conjunction with the use of 35 mm, a process that we never abandoned. The digital camera we use is a small compact camera that hasn't been updated. In the technological sense, we almost always worked with precarious tools, and the group never chose to invest in updating this kind of equipment.

Taking the photographic record as a member of the group alters the person who does it, as well as the record itself. To be inside the creative process changes the record, since it is always through the lens of construction that one films or takes pictures.

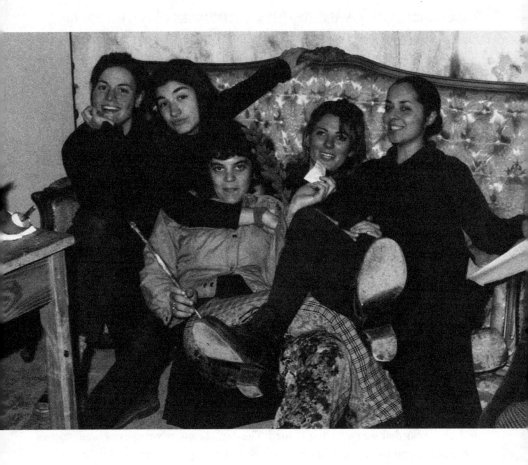

Taller Caballito (Little Horse Workshop), 1997.

GRUPO DE ARTE CALLEJERO: THOUGHTS, PRACTICES, AND ACTIONS

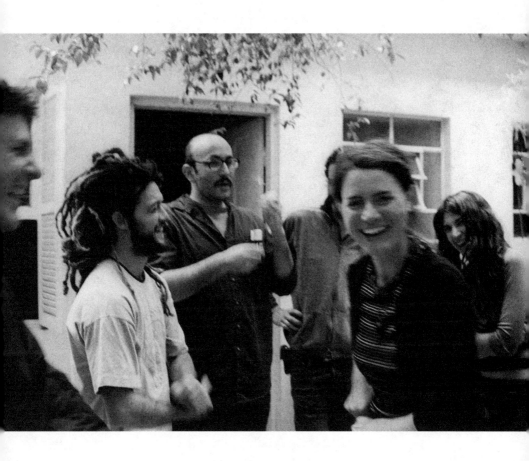

Sao Paolo, 2004.

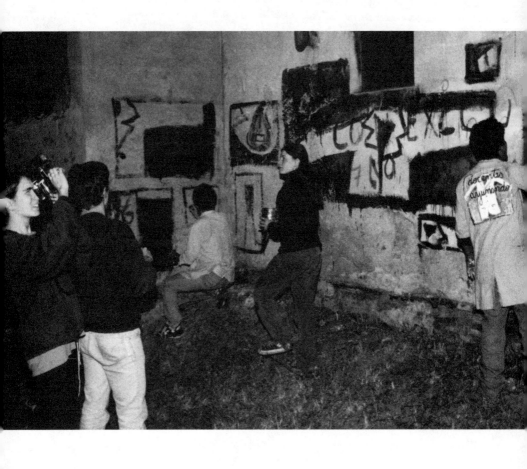

Docentes Ayunando (*Teachers on Hunger Strike*), 1997.

March on the 24 of March, 2006.

LAS RAFAELLAS. SUMMER OF 1999. On the tour through Bolivia, in which we performed in any place where they would let us dance—whether a bar, karaoke, whiskey bar, radio, cumbia club, or a car with stereo equipment on the street. We used inns and hostels as our divas' dressing rooms, inspired by *The Adventures of Priscilla, Queen of the Desert*.

LAS RAFAELLAS AT AVE PORCO. This time by invitation. Sometimes we would go out and wander around at night, carrying our own costumes and music, and we would go into different places asking if we could dance. If they said yes, we would do it. It was a kind of aesthetic attack. Ave Porco is a dance club in Buenos Aires, on one of the main drags. (Trans. note)

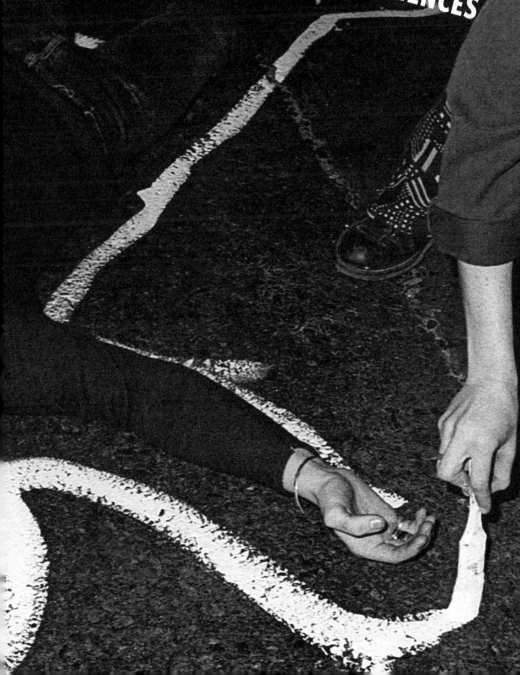

SPACES FOR RECOGNITION
AND LEGITIMIZATION OF EXPERIENCES

To what extent can personal or collective experience be transferred to others who haven't had the same experience? And in cases where they are transferable, can these experiences be accumulated? What degrees of accumulation and transferability can be given to each situation or context? Which kinds of dialogue or which ways of knowing the other must exist in order to facilitate this communication? Is a partial closeness sufficient to make an experience communicable?

One of our first collective inquiries was the attempt to break away from everything supposedly logically necessary to enter into the art circuit: this despite the fact that none of us was inside this circuit; we did not desire to enter it; nor was doing so understood as a necessity. Indeed, we were inclined to understand realities other than our own and rethinking ourselves was possible thanks to this openness and this willingness to understand our current condition through other stories related to our own. This exercise helped us in an unconscious way to interpret certain realities through our own frameworks, disobeying certain conventions and adhering to a certain ethics. At some point, our inquiries ceased to be individual. And be it by cause or effect of these unconscious means, we were becoming increasingly distant from what could be understood as producing art in the context of the nineties. In those days, we were carrying out games that parodied the artist's role inside of the art market. I remember the parodies of *vernissage*—preview nights before the formal opening at an art gallery—during the group's first year (1997), where we posted fliers, with drawings or paintings *we* and compañerxs had made, in the spaces meant for street advertising. It was a parody (a rather naïve one) related to the gallery and circuits of exhibition, but at the same time a reappropriation of the space designated for advertising, a space of control that we began to explore with greater depth later on. The idea revolved around that search for the appropriation of public space, in order to stop being a passive spectator and to find other means of relating, through generating our own connections.

A year later we would meet Etcétera and would begin to spend a lot of time at the surrealist press and go out with them in the Abasto neighborhood, where there was not yet a shopping center, when it still was just another neighborhood. Meeting Etcétera enriched us greatly—I think that *we* were enriched as much as they were: we expanded our inquiries and our content, and despite not working together, we shared the same instincts, and we came together in an almost fraternal way through our shared struggles and in the streets. But, above all, in that first moment we found in them a place of new sensibilities, in which we also felt accompanied and legitimated in our actions. In those days, we shared certain views of the art market and of how to intervene that we did not find in any other space, neither in the militancia, nor in art.

At that moment, at the beginning of 1998, we began a task of greater militancy, relating not only aesthetic work with political struggle, but also participating in

activities with other groups that, not coincidentally, did not participate primarily in collaborations with artists. Rather, these were people associated with the militancia, generally human rights organizations like H.I.J.O.S., Encuentro por la Memoria, and others.

During this experience, the group had its first reconfigurations during which some compañeras joined while others left, be it for personal reasons or the necessity of getting involved with other projects of various kinds. Those of us who remained immersed ourselves in this new experience of working with others, which was the consequence of a new political will. Working within spaces of conflict with existing power structures, denouncing and realizing that it is possible to generate other contexts: these were part of this first discovery, related above all to the empowerment at the heart of the practice itself. Because of this, we have always spoken of this stage as one of testing the boundaries of what is or isn't possible. In those days, the word *denunciation* had great weight, given that it was related to what couldn't be said and to what society itself was hiding. Making the hidden into something visible was one of our key slogans.

The proposed aesthetic for this new field was becoming even more blurred, acquiring new layers and complexities at the level of communication; the search for expression based on previous projects deepened, and this synthesis acquired greater force and resulted in new graphic elements. With regard to the methodologies, we began to experiment with serialized production that, although it was close to the sequence of a mural, distinguished itself from a mural in that one experiences a mural more as rite than as series.

Strategy no longer depended on internal discussion alone but also on a consensus between groups: a much more complex dialogue than our previous ones, a dialogue in which we had to learn certain ways of acting and of delegating even more than before. This meant generating various degrees of compromise and confidence, both of which had unfolded in good measure through the experience of group work on the murals, since those too had required movement beyond individual production.

The new experience of the escrache forced us to deepen our discussions around concepts such as: 1) group security, which was no longer dependent only on the members of the group and which required us to pay attention to the context generated by the carrying out of the practice itself; 2) effectiveness with regard to the interpretation of images that might come into being within the space of the street, during the action and after, and the staying power of those signs as such; 3) communication between actors who took part in the escrache and internal communication, as a multifaceted experience that crisscrosses diverse levels of dialogue.

Given that with H.I.J.O.S. and the escraches we were living a moment full of transgression and adrenaline as a result of both creative and bodily experiences,

when we began our identitarian search with regard to "the artistic" we did not find spaces that seemed right for us. We experienced a certain isolation as a group and except for Etcétera, we did not meet other groups that were working with images in contexts similar to those of the escraches. This was not so much due to the fact that such groups did not exist, but rather due to a mutual ignorance of each other's existence. At the same time, with regard to our artistic training, we were not aware of the groups from the sixties and seventies that did graffiti related to communication or politics.

In this context, defining, naming, and speaking about our own political and aesthetic search was very difficult. Leaving behind traditional formats and their corresponding spheres of interest also made for certain risks. And it was much more difficult to name, with regard to the self or the group, what we were building: what we were doing was not a work of art, nor could it be understood only as a performance, in spite of the performative qualities so often called for by the action.

However, there existed an aesthetic search that was a challenge on a communicative level and that suggested the convergence of at least two things: 1) the synthesis necessary to arrive at "a massive otherness" in the space of the street; 2) the intentional rituality at the heart of putting together a collective space, from which emerges the will to stay together and continue building over time, that is to say: the will to form a collective that is not ephemeral, prioritizing a certain ability to incorporate processes of understanding, rather than focusing only the aesthetic efficacy of the political action itself.

The group formation had a complexity that could be traced through our terms of exchange, through aesthetic languages, through group and personal empowerment, and through a specific relationship with our own limits and with the space earned in the streets. So public space became the venue in which, through a communicative strategy, we could raise certain issues, linking the passerby to the action itself, looking for any dialogue that might come out of that field of tensions in the streets; in the town square; in an encounter or confrontation with a neighbor at "the march;" on public transportation; in train stations, shopping centers and supermarkets—everything at once private and open to intervention if we are allied with the will of a small group of people and if we have something that needs to be said.

These spaces, in turn, had their own deployment for production in daily life as a backdrop to the constant coordination between subject and image, between the perceivable and its representation.

In the mass media we found that there was a way of publicizing what had happened in a style that was often very unfavorable; for example, public opinion in many cases was opposed to occupying a space. However, beyond what was being publicized, one might sanction or agree and applaud a general political energy, and we learned to establish a critical perspective with regard to the way an event was

being judged and to do a collective reading of all of these attitudes in order to generate a "contextual assessment" of our own. We started to think of public space as a site for construction, with a set of pre-established rules that are constantly litigated, and which are the result of power relations in which a collective resolve accompanies each struggle that asserts itself as legitimate, even beyond the normative framework that would categorize it only as legal or illegal.

Under these circumstances it became important that *we* visualize ourselves as creators of connections, capable of promoting difficult contact with others in a generous way, with the consciousness that we were growing an autonomous and unprecedented political being through the practice of transforming public space. Nevertheless, naming ourselves, saying what we were doing, continued to be difficult—only now it barely mattered. We were negotiating a context of denial, one barely permeated by the practical criticisms emerging from the new modes of representation that were being generated then; at the same time, a subjectivity formatted by power and by the "success-oriented" ways of living that proliferate in harmony with neoliberal economic and political models was extending its influence.

For this reason, when *we* imagined possible ways of explaining what we were doing, the first image, or the closest, was that of "crime," an idea that blocked dialogue due to its negative popular connotations. Not even the old ideas of the vanguard were familiar to the subjectivities in play, and they were unable to see what we were doing in any other light, either because it seemed so out of fashion or because they ignored our interventions.

Now it is more comfortable or simple when speaking to the outside world to refer to oneself using the label of "political art." This label was used by the art market to speak about what was going on just outside the market itself. Nevertheless, before 2001, talking about what we were doing involved a kind of particularity that couldn't be shared with everyone, and each explanation was extensive and brought on questions and strange looks. Everyone invariably knew that what we were doing "was not art" and faced with this dominant sense of confusion we decided that this was not a discussion of much importance. In any case, we were doing what we wanted to do and we were where we wanted to be. But where does one obtain legitimacy for what she does? Is it necessary to feel like what you do has a name and can be identified as a task or a practice?

Faced with these questions, at first, we looked for others who were doing similar things: I remember Viole and Charo going to meetings of artists to see "what was up" and leaving the meeting with nothing.

In those moments the space of artistic legitimacy was somewhere else. Ultimately this line of thinking ceased to matter to us given that our human and emotional connection to groups from the militancia was growing due to desire and hardwork from all sides as, in this moment, we built spaces of resistance. And it is

there where the legitimacy becomes real, given by one's own compañerxs. I believe that we did not know this when we began, and we discovered it through doing. It was very gratifying to get beyond the search for pre-established objectives and enter into the plane of mutual recognition that is born out of the necessity of the other. Parallel to the intensity of the seizure of space, it seemed that one movement brought another, and people converged there, between movements that crossed.

So there we can say that there are different perspectives that build legitimacy and, although it may seem obvious, it's a key variable when it comes time to be able to decide or sustain over time the will to build something.

Prior to 2000–2001, the majority of collectives that we know today, many of which are already broken up, we did not know of then (nor did they know of us). We understood that what was being done was already very strange to all the "legitimate" art spaces as *artistic practice*, but that understanding it as a *political fact* was even more difficult for the traditional militancias. We were, to put it one way, in a limbo between the two languages. Later we would see that we were one of several groups in this limbo and that it was not only a local phenomenon but rather, beyond the territorial contrasts, a whole cultural movement that sought ways of communicating about and working on multiple realities.

What does one, or what did one back then, understand by "a legitimate practice?"

Escraches and piquetes are today already incorporated by the political idiom but were, in their moment, new forms of resistance, open to absorbing, replicating, or developing creative practices in relationship to others. However, this type of practice or action of the activist type was not well regarded more broadly. There are certain moments when public opinion values and judges what happens according to the parameters of "legal" and "illegal." These moments are experienced in the street: the sensation was that of having to look after oneself right down to the anonymous passerby, of conceiving public space as private space and of every action in the same space in terms of "damage." Up to what point was public space public? Who had permission to put up posters and who was resigned to being only a spectator? How could people manage to take a more active position, as opposed to the narrow spaces of fear to which we were accustomed? Upon breaking with certain stereotypical images of the public place that a citizen should occupy, what was the place that was left to us, understanding that our complaints were legitimate? Establishing what is legitimate or illegitimate is a political process. And, in that sense, the struggle establishes itself when the tension between the established and the dissident appears.

The mechanism did not prove to be so easy to carry out, as the action of taking space was much more criminalized than today. The legality or illegality of the interventions was a point of conflict that many times negated from the beginning any type of reason or communicative purpose. It even happened with our friendships,

artist compañerxs, or even our families; for this reason, it was very rare to tell some-one what we were doing. Even the most "progressive" people were afraid: at the same time while they conceptually or theoretically supported the action or interven-tion, they feared the risks that it implied; for this we never lacked for someone that would suggest "alternate" and less controversial ways of doing the same thing. They were also less media driven and less able to draw energies together. But in the nine-ties the use of the media was interesting because of its ability to replicate events. And that was also a point of inflection regarding the legitimacy of the discourses. While television covered the escraches and the papers spoke of their repression, the images of dissent intermingled and space opened up—thanks to the strength of the experiences themselves—to discuss the legitimacy of these new practices.

Given that GAC began working with the slippage of that limit between legal and illegal, the question was then to what point could one stay in the street without permission. And that question took many concrete forms: from the murals and the posters to the interference in public and private spaces with the language of ove-ridentification or by way of visual attack. The limit is a field of constant exploration, which one discovers through the necessity of saying something and not on a mere whim. It is a field that is produced by taking or appropriating the right to be, that is, to be present. In this way, an ethic exists that precedes us even as one builds on it through these forms of exploration.

These new parameters for the possibilities of intervention, that vary with context, also brought us new ways and encounters with other groups or amongst ourselves and in our dealings, agreements, or decisions that we established with the militant compañerxs who aren't part of the group, together with those who were participating in a given action. For *us*, these considerations were a growth from the tactical to the constant exercise of *groupality* as one of the most interesting variables to research in these years during which we learned so much. Above all, as a result of our own errors, or the conceptual shifts necessary to reposition and return, time and again, to explain or say this or that. It is in this plane where one puts into play real legitimation, given by one's own compañerxs.

While working with unemployed workers organizations, I recall a moment re-garding an action that happened in 2003 against "trigger happy" cops, in which various organizations and MTDs converged. At one point, it was necessary to think about the course of things and redecide whether or not to paint the staircase of Lanús station. Although this action had been previously decided, it was reconsid-ered given the difficulty of the situation. Later we concluded that yes, we would do it, and that "everyone would uphold" that decision despite the presence of armed police who were bullying us the entire time with shoves and a show of arms to ter-rify everyone. In that moment, we knew how to respond and the action developed. It was—and continues to be—very moving how we sustained the action of painting

the staircase there because there are moments during which the decisions and the responses, above all others, exceeded expectations and generated strong effects that helped to nurture the quest for new experiences.

We think that the images that are constructed in any given moment come from a "political being" and generate not only ideas, but also spaces, roles, subjects, dialogues, and more images that are capable of communication. For this reason, we don't see any cultural product as naïve, nor as something closed off in itself, since we think that everything has its place and point of view, encouraged by a political will that brings it both ontologically and spatially into being. However, it is very common to think that the images that are culturally produced are less important than some political actions and, above all, if they are produced by "artists" they are understood as a harmless product, without ideological importance and incapable of changing anything.

For a long time, we took advantage of the supposed harmlessness of artistic action: a socially naturalized idea wherein we could only be "inoffensive." Sometimes we used this pre-constructed image in order to do our actions with greater liberty or to gain some time, or to evade the police while transgressing certain norms in public space. Since art and other symbolic forms of expression are considered incapable of being damaging or cutting, because supposedly they are harmless practices, the communicative capacity of an image is thus underestimated. Many times, this preconception helped us to achieve a certain impunity when appropriating a space. This is a characteristic that existed in the group during the first years with greater frequency and one which we later abandoned, because from 2001 to 2003 this supposed harmlessness of artistic expression no longer existed. In fact, we were then living in a performative context, and those acts of transgression were not understood as innocent: it was general knowledge that they had a political charge and a destabilizing intention. In those days, a neighbor, disguised, might leave her house to break something, while in the assemblies, people designed literal and symbolic actions to intervene in public space. What was seen as inoffensive in one moment came to be laden with meaning in another, but out of habit or inertia meaning continued to pass from the concrete to the symbolic. I remember when, during the actions before the parachute launch in the city center, we were gluing toy soldiers to a building, and a security guard (from the SIDE) approached us. We told him that this was nothing, that it was only a toy, to which he responded: "That is not a toy; that is a soldier." We then understood that things were changing.

Only for a brief period of time, during the summer of 2002 (perhaps a pair of years for others), were there other questions in the collective imaginary and these questions freed up other spaces of thought. A certain language shared by a small few started to gained currency in a broader expanse, legitimized by general discontent and endorsed by the media. Multiple spatial and political meanings populated the streets.

The words art and politics already were not two separate experiences: they were the vast spaces spanned by each concept, and there was no split between one word and the other. In practice there was and there is much that those reductive categories do not manage to cover, perhaps due to the coupling that they express. The term "art and politics" is not to our liking, but it is what allows the opening of another space of legitimacy, a possibility of enunciation, that was and is valued at the moment of making one's self understood. It also runs the risk of homogenizing the practices, without understanding their origins or diverse motivations. However, we do not believe that the term "art and politics" includes so many experiences; we continue to like voices without labels for the multiple visions that emerge from them, for their mobility.

However, in this moment, after ten years of being a group, with the sum of experiences of previous groups that we discovered along the way and with the compañeras who immersed themselves in this symbolic struggle, both for ourselves and to know where we were and how to continue working, we ask: once certain tools, languages, or symbolic forms become legitimate, what possibilities exist for these strategies, which already have a certain degree of legitimacy, to not become banal due to a demand for new images and meanings for consumption and to not fall, at the same time, into innocuousness? Given that their use as political tools is already less effective, it is notable that these strategies (including the escrache) have been adopted by political parties, especially by the right during this past year.

Fear was always a factor in the evaluation of the general state of situations and contexts in the social realm: the control of that factor, its possible manipulation, is one that makes the powerful more powerful and generates a greater lack of communication for everyone in general. It is for this reason that we are attentive to this type of search, to knowing where fear's place is today, to detect what it is that permits us to act and analyze the situation not from a point of paralysis but rather from the question itself. So, where does fear pass through today? What would the modes be for trying to disarticulate fear? Up to what point does fear form a necessary part of our existence, and to what point is it a repetition of a mechanism of social control?

Do possibilities exist for generating profound and lasting changes via the accumulation of methods and actions for resistance that try to knock down the barriers of fear? Is there a collective memory that detonates when these fears advance? In what ways does this occur? How do the parts of that detonated memory expand? Creating from this space is a constant challenge that maintains one in movement as a collective. Even though the decision may be to do nothing, assuming the decision under these parameters and rethinking oneself constantly involves taking a position, occupying a place either consciously or unconsciously, in the light or the shadows or somewhere in between.

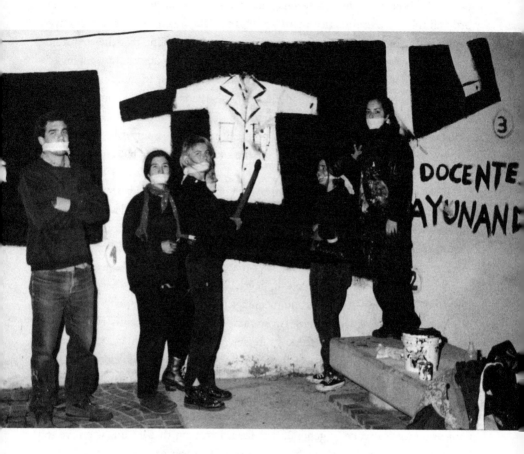

"This is the third mural made by GAC, at the intersection of Austria and Las Heras, close to the National Library in 1997. That was my first outing with the group and, among other things, the use of black clothing, the trace of fire upon finishing the collective painting, and the covered mouths astonished me." —**Charo**

The graffiti on the wall says "Teachers on Hunger Strike." (Trans. note)

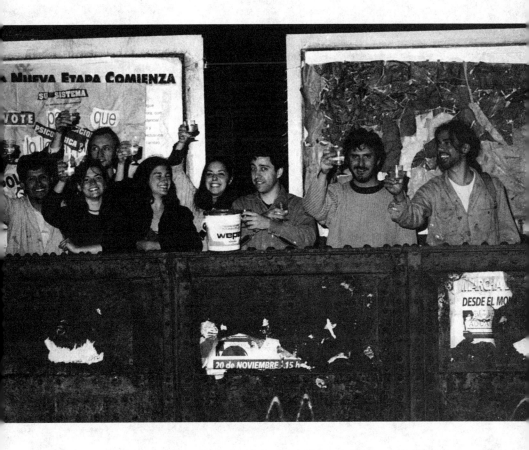

URBAN GALLERY, 1997. Occupation of space designated for advertising with various drawings and paintings by several invited people. After being mounted on the posting walls there was an opening celebration in the street with wine and music, creating an event for the guests and occasional passersby.

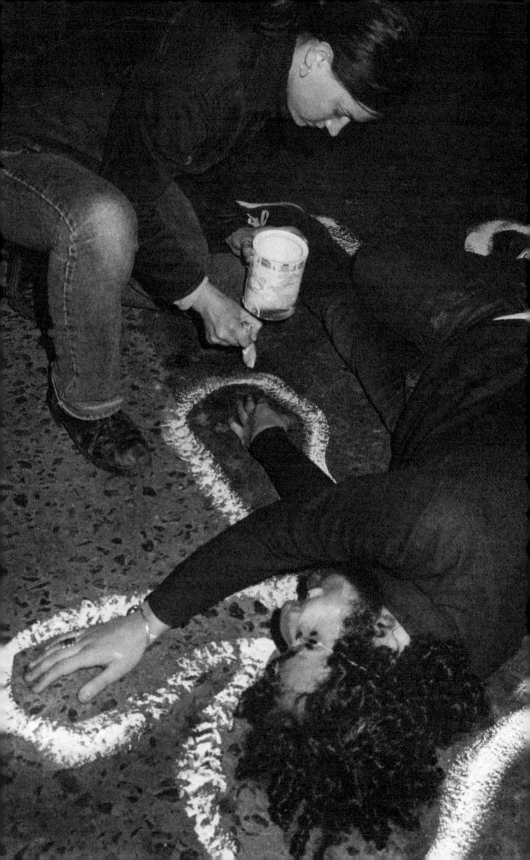

ANY OBJECT CAN HARM YOUR BODY, JULY 1998. *"We met GAC in 1998 when we got to know H.I.J.O.S. and the escraches. We invited them to use the printing press that we had occupied as a depository and workshop. They were very organized; we were very chaotic. Our cohabitation only lasted briefly, although in other social settings we managed to conceive of other possible realities to occupy together. In this photograph we remember a Sunday during which the women appeared at the press and they invited us to participate in an action. It was a denunciation of the deaths of construction workers due to a lack of safety at the worksite. This action was produced exactly when the Abasto mega shopping center was being built along with the mega towers and huge buildings of condominiums. The action was an urban intervention and very conceptual and very odd for this period. A species of mini siluetazo. We walked for long blocks through Almagro on Avenida Corrientes, etc. in a very surrealist state of happening, with masks and overalls, distracting ourselves in the theatrical game, until, all of the sudden, one of the women from GAC said to us, "Boys: get to work..." and one of us threw himself to the floor in a very theatrical way, making a silhouette on the pavement. While the women marked the silhouette, they took a photo, leaving the path marked. We let a few minutes pass while the neighbors observed what was happening, and in this way we continued until we arrived at Abasto."* —**Etcétera**

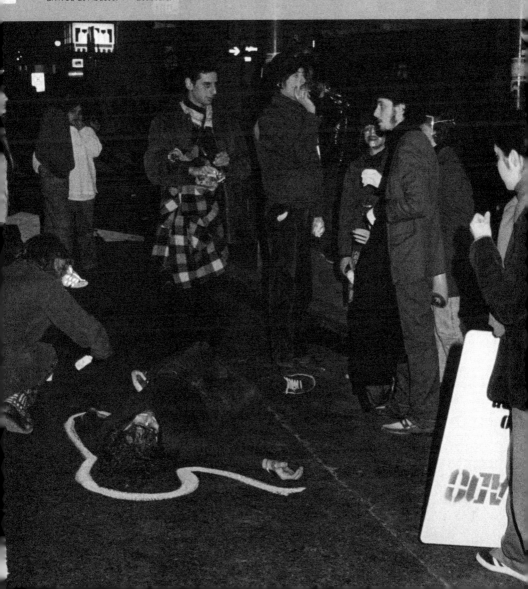

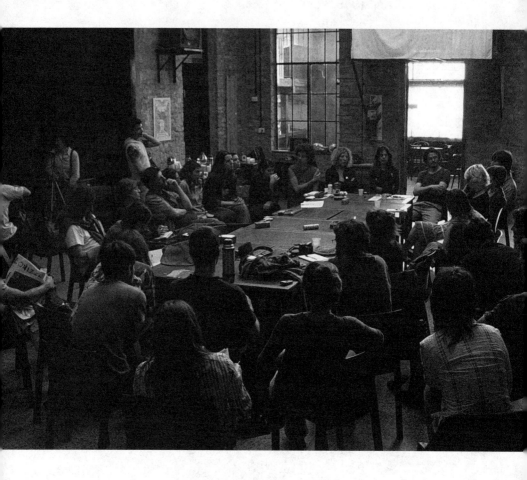

THE MYSTERY OF PUBLIC SPACE. ROSARIO, BUENOS AIRES. 2007–2008.
Debate session from El Levante (Rosario), when, alongside collectives of activists, we discussed the political context and other problems related to urban interventions. We exchanged photographic materials, videos, objects, and posters. Two meetings were organized in Rosario and Buenos Aires, together with Graciela Carnevale and the Paty Heartz Collective.

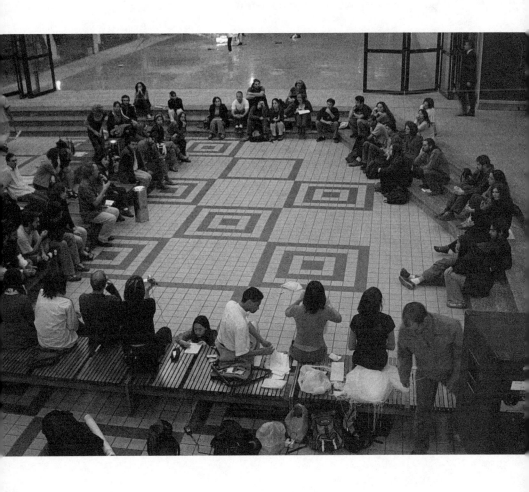

Meeting from the Zona de Acción, in São Paolo, Brazil, in 2004.

SEQUENCE OF ROAD SIGNS DENOUNCING OPERATION CONDOR, RIO DE JANEIRO, BRAZIL. JULY 2000. *"In 2000, Latin American artists, students, and activists occupied Avenida Chile, in downtown Rio de Janeiro, with an intervention that, through aesthetic signs based on street signs, remembered and denounced Operation Condor and the cultural and intellectual human genocide perpetrated by the military dictatorships in Latin America. I was there as a student at the University of Rio de Janeiro, and that meeting with GAC and with the collectives that made that action happen defined many of the aesthetic and political options of my life from then on. It is always emotional to remember that moment in my life. From what is left, the pictures are worth a thousand words. . ."* —**Alexandre Santini**

The sign reads in Portuguese: at 150 m/D.O.P.S./ex Center of Detention and Torture, along with the street address. (Trans. note)

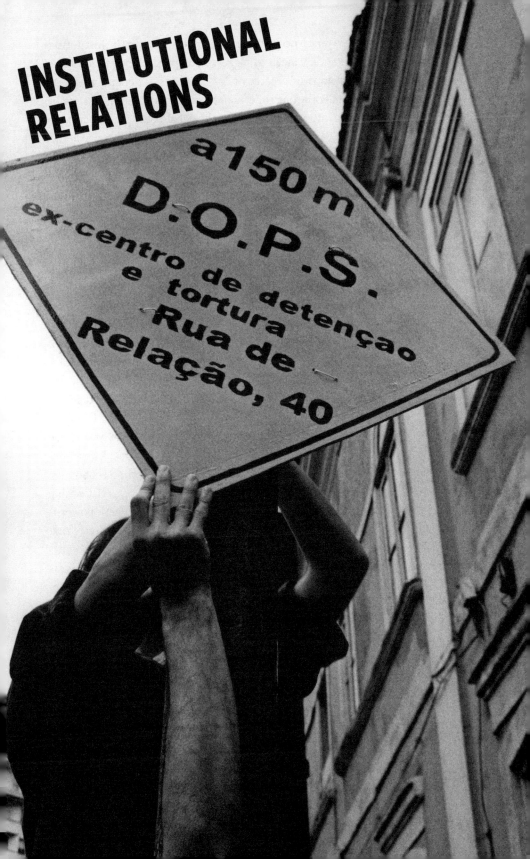

INSTITUTIONAL RELATIONS

a 150 m
D.O.P.S.
ex-centro de detençao
e tortura
Rua de
Relação, 40

When we refer on occasion to our connection with the institutional, we generally mean to suggest a complex relationship charged with tensions of greater or lesser intensity depending on the situation. For a long time, approaching this question was, for us, a dialogic exercise: was it worth our time to enter the debate over participating, or not, with respect to such and such a proposal put forth by an institution, whether from the state or the private sector? Obviously, we were not the only ones of our moment to consider this issue with such attention; in fact, other groups encountered similar disjunctures and adopted different stances. This diversity of positions, stemming from our differing viewpoints rests on the knowledge and know-how constructed by the movements that came before us—and that still circulate around the processes of avant-garde cooptation—concerning the disarticulation and takeover of dissident discourses by the "system." Even if this view of the institutions renders the system a monster with a hundred heads or ascribes to it an exceptional power, it has not managed to paralyze those of us who have made up our minds, on occasion, to produce right at the limit, or as they say, while "walking a fine line."

In addition, if we admit that the symbolic supremacy of the institution is permanent and immutable, we would condemn ourselves to a continuous reproduction of a theater of confrontation, to an asceticism uncontaminated by any particular utopic vision of how to produce "on the outside"—or we would simply condemn ourselves to silence.

This spectrum of options points to the principal contradiction that has defined our lives—as producers of symbols, but also as workers, compañeras, lovers—inside a capitalist society crisscrossed by institutions that regulate labor, economics, and social relations. Much more interesting than thinking about our relationship with the institution as a unidirectional relationship of coercion—where power is exercised unilaterally through the institution—is tracing the web of interests that flow from autonomous spaces (or those that present themselves as autonomous) toward the institutions. Without discounting the real power of the institutions, it is very helpful to be able to identify the real, transformative potential of some practices that, on occasion, are presented as "inside of" or "connected to" the institutions, but that, in actual practice, maintain their independence because they are part of a process of autonomous creation.

In our experience, we identify this situation as a "double game" in which through a relation of exchange the cultural institution makes use of the production of subjects in order to satisfy its need for recreating and renovating knowledge and, in so doing, its own legitimation within the capitalist system. In the meantime, on the other hand, subjects appropriate certain resources for themselves that allow them to experiment and innovate, to change the trajectory of these subjects, to capitalize on experience as feedback for practice, etc., or, eventually, to provoke

ruptures, crises of identity, reconsiderations, critique within and without, critique from outside. . . .

Given that the relations with different institutions in the fields of art and culture conditioned us almost since the beginning of our activities as a group, these relationships were always changing, and we have not always made the right decisions in this regard. In order to tell a bit about what these experiences were like, it's worth taking some time to situate ourselves in the period during which important transformations in form and content began to take place.

END OF THE NINETIES

There exists a crisis of representation: not only in what is being said, but also in who is doing the saying. One questions not only the message, but also the interlocutor. The emergence of new forms of struggle, in all their performative dimensions (the piquete, the escrache), generates a new type of symbology. The means of communication reproduce these images without acknowledging the capacity for reappropriating those practices that, together with a discontent on the verge of exploding, will spread in a multiplicity of creative forms, creating resonances in many parts of the world.

We begin to see a displacement of interests and a movement toward popular formats in the local artistic fields beginning with the process of visibility earned by the groups working in public space. They used their symbolic production in a tactical manner within the utopian collective of social change that happened since the end of 2001 and throughout all of 2002.

In the same vein, a part of the institutional circuit of national art begins trying to take over these emergent discourses, confirming an international tendency that had already become evident, in Europe above all, with the process of assimilation that some of the groups linked to dissident practices had suffered, such as guerilla communication practices.

For the moment, Buenos Aires is converted into an epicenter of alternative and critical cultural production, becoming a prized tourist destination for the politicized foreign gaze. Along with international activism in solidarity, offers from cultural institutions began to arrive, lending legitimacy to what had been going on for a while, but now under the heading of "political art." Invitations to exhibitions, meetings, and conferences piled up—whether as a speaker or attendee.

Faced with the first few invitations that we received, prior to 2001, we were used to being surprised. It was not easy to enter into the new classification that emerged from this movement. Nor was it easy later on. At those long ago discussion sessions, we would weigh, on the one hand, the conditions (of form and content) and, on the other, the possibilities that they might hold to reappropriate and divert

resources. Then a decision would be made. Generally, this method worked without too many conflicts, but, in time, we began to notice that as the relationship between the two unfolded, other things were happening.

The first feelings of discomfort had to do with the way that the institutions make use of the efforts of the "activist-artist." To be clear: there was an always imminent precariousness in the taking on of multiple roles in exchange for a legitimacy not expressible in terms of an economic relation. To put on the show, to prepare a talk or to give a workshop—activities without compensation, without accounting for work time—all of these undertaken for the sole purpose of having access to a privileged site of enunciation. This precariousness is based on the use of the supposition that all militant activity should be voluntary and disinterested (in economic terms), in spite of the fact that the precariousness would be happening within the framework of a culture industry.

Another aspect has to do with the kinds of appropriation that the institutions hold over artistic production. Not only do they create conditions for and cooptations of material productions, such as the requirement for using preestablished knowledge formats in place of others less "easily grasped" or less "presentable," they also result in an appropriation of means of doing and of knowledges that when published—catalogs, magazines, books, web, etc.—refills the institution's content and, consequently, makes its existence make sense. These doubts found form in a question: will this ultimately result in the conversion of knowledge into nothing but its exchange value?

And what happens with subjectivity and with the practices that constitute the identities of each group when they enter into this relationship? How is the axis of interest, the search for ways of doing and thinking, displaced when the work moves, even if only for a moment, into the bosom of an institution? How many times did this happen to us, that we'd say yes to an invitation, only to realize how much our acceptance distanced us from our concrete work in a public space and in a relationship with others? How much time did this take up in our lives and did it imply an abandonment of our real interests? The removal of subjectivity and of productions from the contexts in which they'd emerged seems to be an almost inescapable consequence, keeping in mind—above all—that not one of us "is sustained by art" nor by militancia, that we have jobs that require us to keep schedules, which means there are concrete limits on our time.

After all this, one asks: "Then why would you say yes?" As we noted at the beginning, this type of relationship is not unidirectional. At the same time that we were deciphering the cooptive nature of some institutions, we were beginning to elaborate a mental tactical manual for how to sort out these logics and take advantage of certain benefits that might present themselves. Even if there never existed a formula that could calculate the degree of advantage, there did exist a consensus on how to consider the potential uses that the group might make of

certain institutional proposals. Basically, we identified three modalities, which can be presented together in a single situation: 1) the use of the institutions as spaces of infiltration, taking advantage of its "cracks" to reveal conflicts from the inside; 2) as spaces of appropriation for diverting its material resources toward other ends, and 3) as spaces of creative and political exchange with other similar groups.

THE THEORY OF INFILTRATION

PARQUE DE LA MEMORIA, OR REMEMBRANCE PARK. An example of the first modality could be our participation in the sculpture competition for the Parque de la Memoria, starting in 1999. When we presented our installation project of road signs with images relating the history of state terrorism, we were looking to transgress rules and regulations. In the first place, as an installation, it escaped the label of sculpture. The proposal we presented was in and of itself a spatial intervention in the architecture of the park, questioning the idea of a sculpture as a monument in a park. The second question has to do with the thematic. The guidelines limited the representation to the period from 1976 to 1983, while the images and the texts on our road signs indicate that state terrorism began well before the dictatorship and that its effects continue into the present. Finally: our road signs use a language of denunciation, with pretensions to an almost exclusively pedagogical aim, that wasn't in tune with the aesthetic models of institutionalized art up to that point. We were convinced that our project would not be selected. Even if a park paying homage to the victims of state terrorism was the idea of some of the human rights groups, the organizing commission was also composed of legislators from political parties that were in some way responsible for, or complicit with, the amnesty laws denounced by our road signs. But when we found out that our project was one of the winners, this opened up for us a range of expectations that over time would transform into a platform of new conflicts.

A new field of communicative possibilities presented itself here, but at the same time, some members of the judges' panel and of the commission begin to place pressure on the group to make modifications to our original proposal. Using the excuse of a "formal quality," they begin to question the content, from the images to the text accompanying them, alleging that both were excessive. Over the course of six years, we received many types of comments (there are too many road signs; they block the river; the text is very long, etc.) that were nothing but ideological objections to our project. Each discussion was a fight for the affirmation of our discourse, and a test of tolerance in which, at this point, the most significant issue was maybe not so much the road signs erected in the park (they're still not there), but rather the process of confronting the interests that we deal with—from inside the group and out—and how this has transformed us forever.

DESALOJARTE EN PROGRESIÓN (EVICT YOURSELF IN PROGRESS). In 2003, at the peak of popularity for the "political art" groups, it wasn't so necessary anymore to give explanations about what they were doing. For this reason, it was quite easy participate in the open call for submissions for the show *Arte en Progresión* and to get around the preliminary filters that the curators placed on the participants and their work. In fact, nobody knew, up until the moment we arrived with Colectivo Situaciones what kind of work we were going to mount at the exhibition. All of these preliminary processes of negotiation over a supposed work that never existed were very important to create space for the surprise eruption of a set of visual and performative mechanisms on the day of the show's inauguration. The "stand" with the poster denouncing the Museo de Arte Moderno as responsible for the displacement of MTD San Telmo; the flags that took over the flagpoles and the entranceway to the museum, now called *Desalojarte en Progesión*; the pollsters handing out forms and speaking with the public; the arrival of the workwomen of Brukman. . . . All functioned in an unfolding of synchronized actions that were provoking a series of reactions on the part of the authorities in the city's cultural center, of the other artists, and of the public. In an attempt to strain the limits and expand them, we were evicted from each site where we had set up. Once again, the excuse of the "aesthetic quality" of the work was imposed as a parameter for judging in order to justify the marginalization that the work suffered, disqualified particularly by the Secretary of Culture of the City of Buenos Aires, Jorge Telerman. The goal was clear: to attack the indifference of a large part of the artistic field in the face of social conflicts. Even if that was the last time that they invited us to that space.

STRATEGY FOR THE APPROPRIATION OF RESOURCES

A POINT OF INFLECTION: THE FIFTIETH VENICE BIENNALE. It was one of the most controversial experiences, the one that generated the largest crisis within the group, and the one that provoked the most judgments of the group on the part of other similar collectives. When we received the invitation, we found ourselves working together with Alice Creischer and Andreas Siekmann on the project *Cartografías*, with which we would subsequently be participating in the show *Ex Argentina*, in Cologne, Germany. Because of this, in this first moment, it seemed coherent to be able to participate in the Biennale with an "advance" of the project in place of showing what everyone expected from GAC. The motivation was clearly economic; the joke at the time was "we'll send whatever and hope that it brings us cash," but that couldn't last. Since we knew that the price that we were going to pay would be more expensive, we began an exhausting debate over which formats would be less cooptable. We didn't want to show registries of actions, nor productions that we had considered for other contexts

(in the case of Madrid), nor, in the same vein, did we want to involve projects shared with collectives that might be in disagreement with the use of the Biennale space. It had to be something new, something that would be able to avoid the event's tremendous capacity to empty out meaning and, at the same time, would serve as an internal exercise in representation or presentation. We were naïve: to intervene in the space of the Biennale! . . . We were fantasizing at times with presenting our own absence from that space ("we are not here") and, nevertheless, however abstract what we were installing was, everything would hinge on being consumed by the force and vote of confidence that emanate from these mega-events of art.

Finally, assuming this as something inevitable, out came the idea of the graphic, of the semigeographic map (of the banks of the Riachuelo River), semiconceptual (of social conflicts), as the visual version of our first cartographic reflections. In this way, we weren't transforming our logic into an absolute, but we were taking advantage of current energies in order to begin giving form to an idea that we had been courting for a long time. And the money that we were going to save could be used for local projects.

By now, the group was immersed in an internal crisis, provoked by the impossibility of reaching any consensus. The points of view with respect to this idea were almost opposite, irreconcilable, and things could only materialize when a part of the group decided to move away in dissent in order to move the process along. This brought about a deterioration of communicative and affective links in the group. It took us a great deal more time to repair these wounds than to make the decision to participate. But at the same time, and from this moment on, the different positions were clear, in whatever place each wanted to be, up to whatever point the gaze or the judgment of your peers, of your friends, conditions you, along with the omnipresent existence of moral judgments from the outside—but also between ourselves, and how much more, sometimes, weighs the guilt unleashed from within, than the events themselves.

At that time, others talked a great deal about how "privileged" we were as "artists" to be able to transmit what was happening. One idea that had never occurred to us was that of privilege, or that of being part of a sector that in speaking its mind was forming part of an elite. On the contrary: we always felt part of what we were articulating, we weren't representing anyone with our actions or, if we were, it wasn't this desire that guided our actions. The result was that we found this vision limiting and distanced from our practices. Nevertheless, it was difficult to explain ourselves, above all when this vision was supported by some artists or other people who were beginning to observe what we were doing for the first time, perhaps understanding it as art or wanting it to fit in some definition, in part because of a prior acceptance that had come from a respectable "outside."

Written by Lorena Bossi in response to GAC's participation in the Venice Biennale

There is a power of the powerful
that pierces us, washes over us
One day its voices explode inside of us.
One day it disarms us and another it arms us;
"A State that breaks you and sets you right"
"A State that breaks you and pays you."
A not-belonging to an uninterrupted body
Nothing belongs to anybody, not voice, not thoughts,
not even the colors inherited from the body.
And given that not even the condition of living is ours;
it's likely that the same time
that gave us a place for the consummation of experience
today consumes it out of sight
out of sight of those who built it.

And in this way something goes pale,
something is missing,
as if something lost a long time ago
sounding for itself alone, under or maybe inside of a household object,
and all the walls would turn around. . . .
And there are no images for this.
When the power of the powerful pierces us and washes over us,
the image is the body standing up and turning its back
without even knowing how to speak.
When to resist is to stop looking, to not lend one's eyes,
abstinence converted into resistance as the ultimate resource:
a skirt of many folds inverted over the body
and your clothing turned inside out.

This outfit indicates that I am not here.
Here are those that passed in front of the living and baptized them
"lucky for being alive". . . .
Those that passed in front of the dead and called them
"privileged to be dead". . . .

Those that in one way or another have the first truth,
the impartial ones. They don't change, they make the difference,
 because they are the difference.

CULTURAL CENTER FOR COOPERATION (CCC): A FLUCTUATING COEXISTENCE. A little more than a year had gone by since the consolidation of the group when an opportunity presented itself for us to join with one of the departments of the CCC. It was the first time that we were given the possibility of obtaining financing for the materials that, little though it was, would allow for some relief in our budget, since in those days the only means for securing resources were the parties, not always successful, when each of us put in a little bit of money for the drinks, the photocopies, or the wheatpaste. With time, the budget was increasing on par with the formats we were taking on.

The Department of Social Sciences was the first to give us a site, although it wasn't entirely justifiable given the type of work they were developing—some members of the group were connected to other projects with them. But because of the character of our productions at that time it was clear that we weren't going to stay there for long. Subsequently, they moved us to the Artistic Department, which revealed once again our difficulties with integrating into a hierarchic structure that demanded that we function as a branch of the department and that we have a representative who would attend all stipulated meetings. I think that this lack of compatibility comes not so much from a radical "anti-institutional" or "antihierarchy" stance, but rather from the nature of the group itself, of its non-individualized functioning, or its functioning without a "head," or better yet, with many heads that come together as one. Another factor had to do with how, in general, our group activities do not look for a cost-effectiveness that permits us to generate enough profit to convert ourselves into a source of work for our members, so the time we invest in our own field of work cannot be replaced by what we're doing as a group. In no way does this constitute a manifesto or an ethical rule. It is simply a situation of coming together in which we try to make way for instances of greatest work stability in the face of the precariousness of other forms of work in the field of culture.

OTHER LESS ENGAGED EXPERIENCES, COLLECTIVES AND ASSOCIATES EXHIBITION, MADRID, APRIL 2002. An invitation that gathered together groups from Argentina with similar ones in Spain in a conventional show and a pair of meetings with roundtable discussions. The show was going to take place in the Casa de América.[1]

Since we were only awarded one ticket, we drew lots to see who would travel. The five days of lodging were covered: two for installation and the rest for the inauguration and the discussions. It was clear that the 600 euros we would receive as an honorarium and for the cost of the show was going to finance the purchase of a digital camera, so the spending in the city should be limited. In addition, the

1 Casa de América is a consortium created in 1990 and incorporated into the Ministry of Foreign Affairs via the Secretary of State for International Cooperation and for Ibero-America and the Caribbean, the Community of Madrid, and the City Council of Madrid), but it carried the seal of the Injuve (Institute for Youth).

exhibition did little more than gather the collectives under the same roof because there had been no proposal for any type of exchange between them. For these reasons, and because we decided not to create a separate "work" for this show, we decided to exhibit already created work: the triptych *Aquí viven genocidas* poster, video, and planners. Even if *Aquí viven genocidas* had been created for other contexts (sticker and distribution during protests, projection onto militant spaces) it would adapt well—with regard to its formal qualities—in the space of an exhibition hall.

Nevertheless, in the forcefulness of its denouncing, this piece clashed with the other works present. Three spaces with concrete information—places that had been escrached; residences and criminal records of perpetrators of genocide; and clandestine detention centers of the dictatorship, all exposed in the most literal way possible, divested of metaphors—allowing for a reading made even cruder in its contrast with the asceticism of the exhibition hall. But this reflection came only after the installation. At that time, there didn't exist in the group a specific knowledge of what and how to exhibit in that type of space, nor were we as sensitive to the moralistic prejudices of the art world that were made visible during other similar processes.

AS SPACES OF CREATIVE AND POLITICAL EXCHANGE WITH OTHER SIMILAR GROUPS: JOURNEYS THAT GENERATED RESONANCES

THE HEMISPHERIC INSTITUTE OF PERFORMANCE AND POLITICS CONFERENCE IN RIO DE JANEIRO AND IN MONTERREY. We were invited to participate in the first meeting of the Hemispheric Institute, in July 2000 in Rio de Janeiro, Brazil, by one of the directors of the Institute, Diana Taylor, who met us on a visit to Buenos Aires. It was the first time that we were invited to participate in an event on those terms, and it was the first time (and one of the only times) that the entire group would travel to another country. The organization H.I.J.O.S. was also invited to participate. The most interesting parts of the invitation were the possibility of giving a workshop that would allow us to connect with people from other countries in Latin America and the fact that there would be total freedom for presenting our proposal and making use of resources.

But the first contradiction took no time to reveal itself: the financing for the Hemispheric Institute comes from the generous support of the Ford and Rockefeller foundations. And just as it's inevitable to relate these symbols of American capitalism with the actions of the CIA in the Southern Cone—overthrowing progressive governments, supporting dictatorships, and training torturers—it was inevitable that we would plan an intervention that would make visible this fact. Within the workshop, we proposed a series of road signs denouncing Operation Condor and

the interference by the CIA. The action was planned together with H.I.J.O.S. and a human rights group from Brazil, Tortura Nunca Mais (Torture Never Again), which we contacted thanks to one of the participants. It turned into a true escrache at a former clandestine torture and detention center, called DOSP, in the center of Rio de Janeiro. Just like many of the CCDs in Argentina, the site was, at the moment, functioning as a police station.

The action had certain repercussions in the media, but the most important was the resonance that it generated with regard to the movement for human rights and for the family members of the victims of the dictatorship in that city. The posters stayed up for some time, and the association continued organizing periodic escraches at that site. Sometime later, we got the news that the site where the clandestine center DOSP once functioned was declared a space of memory.

ZONA DE ACCIÓN, SÃO PAOLO. Though few in number, the times in which the entire group could travel together to put on a direct action, an intervention, colloquium, or discussion were very fruitful; this was one of them, and at the same time it stands out for having been one of the richest experiences in that both the group as a whole came into contact with other experiences similar to our own, and at the same time strengthened our exchange over time with those other groups.

The event was organized by different groups that were beginning to explore the limits inside public space such as Contrafilé, Bijarí, and Frente 3 de Fevereiro. All of them were in a moment of creation and thought regarding the effectiveness and the reach of actions, in their case related to the fact of generating interventions in a city as visually contaminated and as immense as São Paulo. The meeting took place in the space loaned to us by the SESC (Social Service for Commerce of the State of São Paulo). Others that were invited were Suely Rolnik and Brian Holmes, Cobaia, and La revolución no será televisada (The Revolution Will Not Be Televised). Through the discussions and exchanges in workshops with each of the groups, we could participate in the development and realization of projects on which each collective had been working; with everyone we had a strong point of connection given that all participants were tackling themes that at some point the GAC had also worked on, such as gentrification and the evictions that the real estate market generates in huge urban areas, as in the case of Bijarí; such as the racism of the police, what we here call "trigger happy" cops, as in the case of Frente 3 de Fevereiro; or the bureaucratization of life, as in the case of Contrafilé, among others.

The Zona de Acción spanned the north, south, east, and central zones of the city of São Paolo: in each one a group would carry out an intervention with the thematics that they had been working on. To cover the different zones, to internalize and to observe some of the local problematics through extensive discussions with the groups, locating possible spaces, sites, objects, and symbols for

aesthetic reappropriation were very pleasant tasks full of much collective inter-action, given that we were speaking the same language, and the dynamic emerged in a fluid manner.

KLARTEXT IN BERLIN, AND SWAG: BARCELONA. The meeting began with a presentation-talk from the group and the formation of a workshop together with a group of students from the Berlin University of the Arts.[2] The first difficulty had to do with language: the talks were in German with simultaneous English translation. As Spanish-speakers, we remained at the margin of any possibility of intervening in subsequent debates, a situation that exposed a very annoying inequality. Luckily Konstanze and Adolfo, whom we had met in Buenos Aires through the project *Ex Argentina*, were there; Konstanze, once again in her role of translator, but at the same time as compañera, helped us a lot in building a connection within the space of the workshop. Right away, and in spite of the language barriers, communication began to flow from our production: a series of interventions inside the space of the university and its general vicinity: stencils, fake surveys with students, stamping the books from the Volkswagen library (yes, you read it correctly: a business is the owner of the university library) and other actions generally denouncing the neoliberal reforms applied at the universities and the privatization of knowledge and education.

At the same meeting we met Marcelo Expósito,[3] which immediately resulted in a flash visit by GAC to Barcelona, through the city's Museum of Contemporary Art, taking advantage of the geographic proximity and in exchange for a talk (which was quite informal, as there was very little time to prepare it given the spontaneity of the invitation) in that same venue. That was the excuse for creating another alternate circuit, which permitted us to approach and meet groups from Barcelona linked to occupations, such as the group Miles de Viviendas, with whom we could talk face to face, eluding the hierarchical platform that auditoriums have, in order to discover—just as happened to us at the workshop in Berlin—that we are not so unusual after all.

2 Some of them belonged to the group Interflugs, but on this occasion, given the nature of the project that was being developed the group was called Meine akademie, which means My Academia, and whose abbreviation corresponds to the inversion of the Volkswagen logo (VW), in allusion to the projects that the business has as an investor in some state universities and, in general, the influence of Volkswagen in the German economy.

3 Marcelo Expósito (1966) is an artist, curator, and coeditor for the magazine *Brumaria*, who lives in Barcelona. His current work on diverse fronts deals with an exploration of the ties between artistic practices and new political and activist practices. In the 1990s, his videos, installations, and texts critically confronted matters of historical memory regarding the Spanish Civil War and the transition. He has edited, both individually and in collaboration, monographs about filmmakers *Chris Marker* (2000) and *Pere Portabella* (2001), and the books *Modos de hacer. arte crítico, esfera pública y acción directa* (2001), and *Plusvalías de la imagen. Anotaciones (locales) para una crítica de los usos (y abusos) de la imagen* (1993). One could consult his text "Desobediencia: la hipótesis imaginativa" and the interview "Arte, política y transformaciones sociales."

EX ARGENTINA IN COLOGNE, GERMANY: FROM EXPECTATION TO DISAPPOINTMENT. The history of our process of participation in the project *Ex Argentina* is very long. At the beginning, we were excited to participate in a space in which one could discuss what "the political" is in the production of images and—and more controversially—what is the place of the artistic in the political, if this meeting between militancy and art has a real existence, above all given the explosive juncture at the end of 2001. We were also enthusiastic as a group to be able to collectively produce alongside others and to be able to debate certain things in depth (due in part to our good working relationship with Andreas Siekmann and Alice Creischer at the beginning of the project). There was a lot of initial enthusiasm, many Saturdays full of conversation and sharing practices and experiences, many good meetings (at the same time we met and began to work with Colectivo Situaciones). I think that in order to talk about *Ex Argentina* as a project I cannot abstract my own experience inside the group. In the moment that the project began (the beginning of 2002), our production as GAC was highly varied; we were participating in diverse proposals together with other spaces of the militancia, especially in the production of images, actions, and interventions. We began to experiment with a methodology that we called cartographies, a species of investigation of links and political relationships that evolve into images starting with the idea of the Cartografía de Control (Cartography of Control).

I think that the project passed through various moments and that it cannot be analyzed as anything but as part of a process. As part of a process, I would emphasize as most important the first period, in which I do believe the project made a space for collective construction in the link between the group (GAC) and the curators of *Ex Argentina*, Alice and Andreas—a link understood or felt from the point of being able to think, process, debate, and share with others. However, while collective construction was very important and contributed much to the group, it was not reflected in the culmination of the project, that is to say, in our show at the Museum Ludwig in Cologne, Germany. I believe that there the project became an exposition by a group of artists. Perhaps it would have been possible to achieve a collective production, but that was not what it was. And although this problem was evident earlier, it revealed itself more and more in the course of the mounting of our show. I believe that this had to do with several factors.

Perhaps we should talk about the failure above all with regard to the human relationships between those of us who participated in this project, a failure that became evident at the show in Cologne. Our failure was in the few links interwoven between the participants, in the lack of discussions and debates, and in the power of the institutions and how this could be seen in the dominance of a notion of artistic individuality. One could also think in terms of failure given that the only thing that remained exposed in the museum was the spectacular, and the dominance of the

concept of "showable work in the museum" engulfed and erased every dimension of process from the project. *Ex Argentina* could have been, but was not, a space outside of the hegemonic system of power. A space in which networks came together, a space of sharing similarities, likenesses, differences, modalities, and methodologies from the different groups of artists from Argentina and other countries. A space where one could consider questions and distinguish points of inflection in cultural possibility: between art and politics, between the militancy and art, while sharing with others the determination to investigate and create new practices that aim to transform reality and its representations. I believe that in these senses one could speak of a failure and of the potential of what could have been and was not.

A discussion ensued, obviously never closed, about whether one can talk about political-artistic practices inside the space of a museum. I believe that that discussion cannot be settled either. Beyond the fact that the failure does not stem from that side—since one would be naïve if one limited oneself to the affirmation that institutions are the root of all evil—the failure definitely was produced by the deterioration of links between people and because what prevailed was the individual production of the works instead of a collective construction.

During these years we were seeing how all of our lived experiences with institutions were shaping us, permanently reconfiguring our relationships to others. At the same time, seeing what other similar groups were experiencing in Buenos Aires—like Etcétera or Taller Popular de Serigrafía, which were stuck due to similar situations—we discovered the different positions that existed and exist between us. This mutability that is described in the preceding texts, this mobility of positions is what allowed us to always continue, to search permanently for a means of returning. Reformulating the contents, formats, mechanisms, the addresses: what, how, for whom. An exercise in thought and production that does not always leave one unharmed. . . yet which also taught us to say no on some occasions.

One thing worth salvaging from this whole process, or perhaps because I lived it as a positive transformation in the group, as a learning moment, is the passage from a "hard" position, excessively intransigent and judgmental, to a more permeable attitude that was less prejudicial and moralizing with regard to ties to institutions.

Going into this transformation more in depth, one could say that there was a moment in which our group identity was pervaded by a certain "purist" vision with regards to the matter, as a type of anticipatory distrust, fed by certain ethical dogmas from the most traditional militancia. A species of shared unwritten rules, which might not be more than just a stereotype for how to behave as a rebel but which a collective that self-identifies as militante should choose to follow.

That perspective was placed in crisis at the moment when we became the targets of that same judgmental gaze from other groups. Looking at it from the present, I think that perhaps the nucleus of that crisis became more clearly visible,

as I have already said, during our participation at the Venice Biennale. From that moment, there began a long process, at the time very hard, of reconsiderations and repositioning. I say hard because it is never pleasant to recognize such determining attitudes, so limiting in one's self and in the interior of the group to which one belongs. And the work that it implies to change this, to overcome these barriers and transform such deeply rooted conceptions is not something that many groups have achieved. . . . How many groups have dissolved attempting to cross this frontier? How many interesting experiences in the field of symbolic production fell into the mortal trap of alleged cooptation? How many remain enmeshed in the epistemological game "autonomy vs. institution," as if it were more legitimate to represent everything that one does in terms of an irreconcilable polarity?

CENTRO CULTURAL GENERAL SAN MARTIN

DESALOJARTE // EN PROGRESION

Desalojarte en progresion

1932
Der Aufstieg der Nazis
ändert die Geschichte
von Daimler Benz

Aufstieg seit 1933

DAIMLER·BENZ AKTIENGESELLSCHAFT

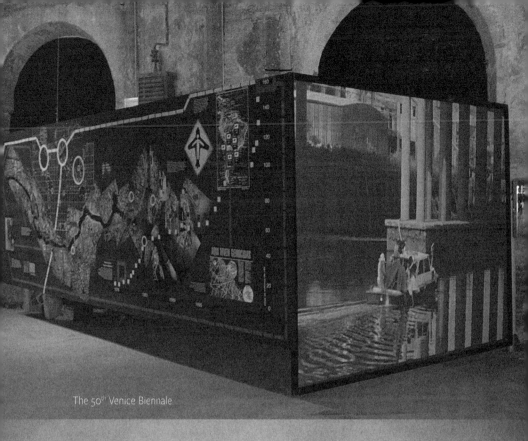

The 50th Venice Biennale

Participation in the show *Ex Argentina* took place at the Museum Ludwig in Cologne, Germany. Inside the space intended for *Cartografía* a map of four transnational corporations was installed. The intention was to generate a critical scrutiny of what we consume and how this consumption is related to, and entangled with, genocide, economic power, and landowning oligarchies over the course of history. The streets were leafleted with fragments of the map.

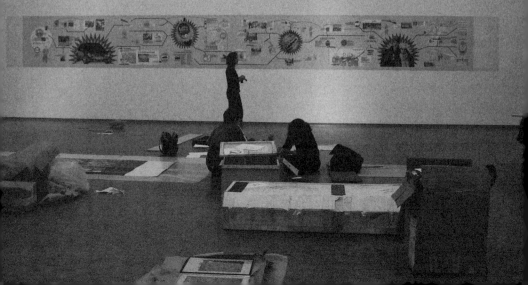

The Hemispheric Institute of Performance and Politics conference in Rio de Janeiro, Brazil. July 2000.

FMI is the Spanish acronym for the International Monetary Fund; Mercosur is the name of the free-trade agreement among nations in South America. (Trans. note)

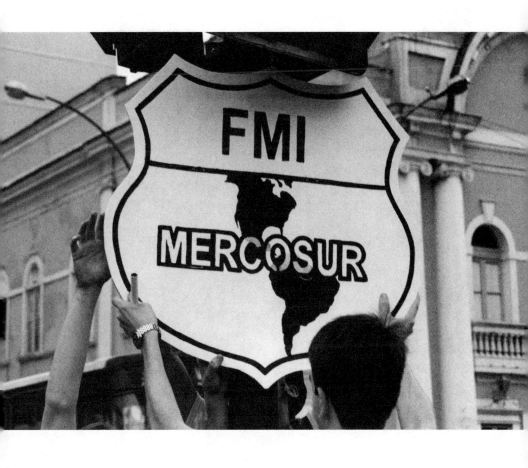

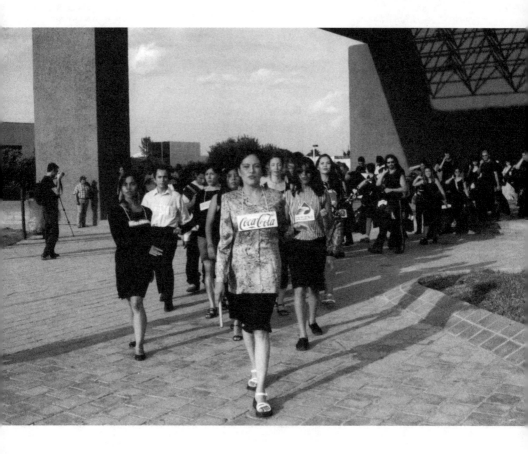

THE PERFORMANCE AND POLITICS CONFERENCE IN MONTERREY, MEXICO, 2001.

The action had as its objective a presentation of a parody of consumerism. It consisted of a "proces-
sion" directed toward the plaza located in front of the Governmental Palace, where we had hoisted
a white flag, six meters by four meters, with the logo signifying a "registered trademark" printed on
the upper right margin (this flag was hoisted in the space reserved for the official Mexican flag). The
participants in the procession carried black purses filled with garbage, which were printed with the
logos of different transnational corporations.

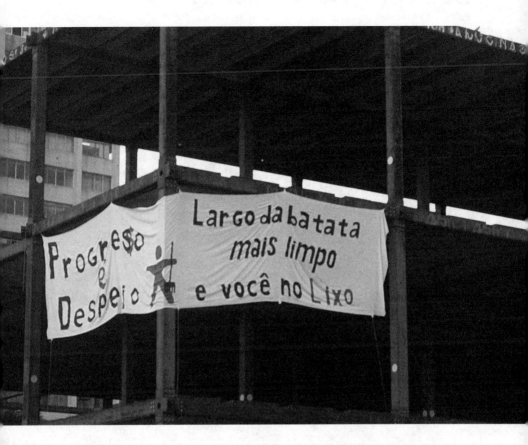

BOULEVARD BATATA IS CLEAN AND YOU ARE IN THE TRASH, AN URBAN RELATIONSHIP RITUAL. PROJECT ZONA DE ACCIÓN, SÃO PAOLO, BRAZIL, 2004.

"The project Zona de Acción (2004) created an ideal situation for bringing together five collectives in the city of São Paolo. The objective was to generate an exchange of experiences, doing actions and reflecting all together. Bijarí meets with GAC on the Largo da Batata (a street in the neighborhood Pinheiros), a popular transit terminal in the richest part of the city that is a target for gentrification and real estate speculation. GAC's proposal was to create a flag in this space. Beginning with the creation of this intervention and continuing through Zona de Acción, we set in place a ritual of relationships in which the bodies were being affected and were producing transformations. The entanglement of those who affect and those who were being affected came out of this process, spreading across the collectives and the city, transforming one into the other. It became impossible to remain indifferent to the imperceptible transformations produced in the bodies. Bijarí was never the same again, and neither was GAC; as for Largo da Batata and its passerby, who knows?" —**Bijarí**

The sign reads, in Portuguese, "Progress and Eviction / Largo da Batata is cleaner, and you are in the trash." (Trans. note)

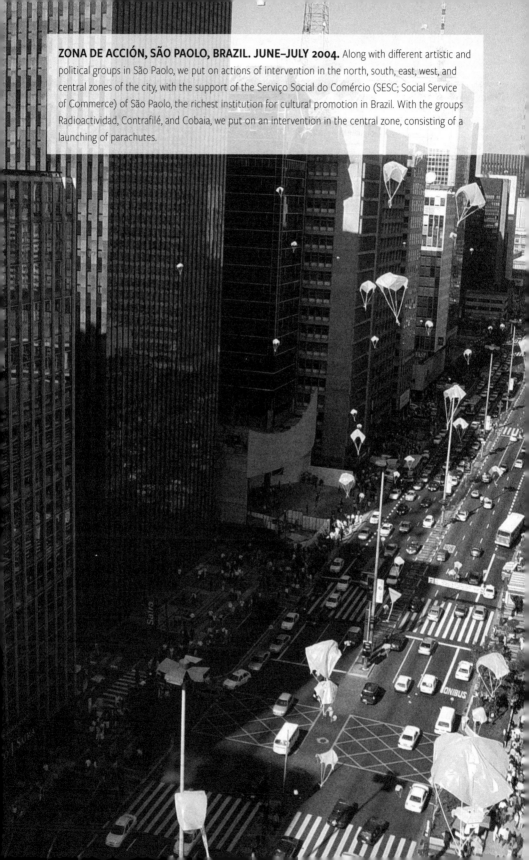

ZONA DE ACCIÓN, SÃO PAOLO, BRAZIL. JUNE–JULY 2004. Along with different artistic and political groups in São Paolo, we put on actions of intervention in the north, south, east, west, and central zones of the city, with the support of the Serviço Social do Comércio (SESC; Social Service of Commerce) of São Paolo, the richest institution for cultural promotion in Brazil. With the groups Radioactividad, Contrafilé, and Cobaia, we put on an intervention in the central zone, consisting of a launching of parachutes.

The writing on the about-to-be launched parachute reads in Portuguese, "We are cleaning São Paulo." (Trans. note)

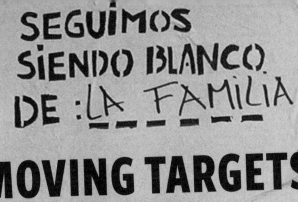

MOVING TARGETS

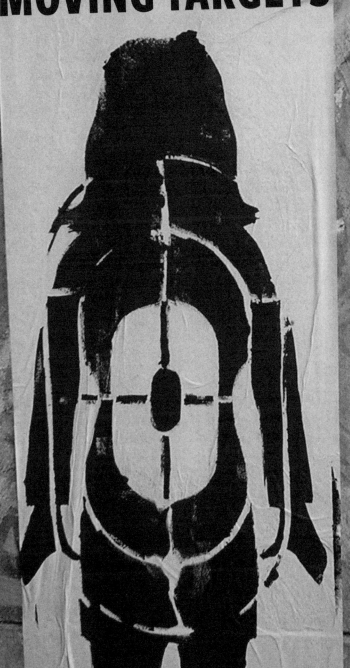

I.

The idea to work with the figure of "targets" emerged in 2004, when the images that had previously been part of a resistant politics of memory stopped being able to articulate a sensibility that could continue responding to new forms of repression. These images ran the risk of functioning as venerable objects from an official display case while at the same time existing in an irritating coexistence with an oppressive dynamic that questioned their former power.

Voices, slogans, references, and even names that were working to define the field of testimony and struggle, illustrating the internal connection among different powers, and maintaining a general alert regarding their permanent state of corruption, today seem neutralized. They don't trace borders anymore, nor do they provide coordinates against the narration and the action of power. This contrasts with the efficacy that past radical groups possessed in the production of differences and to point out injustice without any calculable reparations, to the point that the expression "human rights," amongst ourselves and in the heat of the struggles of the last three decades, was beginning to acquire a much richer meaning, more alive, and more active than that authorized by juridical and civil traditions.

The satisfaction we may feel because of certain achieved objectives, because of the handful of long overdue arrests of repressors, or because of some recognition of past struggles, is relativized when all these actions operate as points of arrival, when they set a conclusive mood in order to avoid questioning the ways in which that commitment continues and renews itself in the present. It is in this context that these new silhouettes, those of the targets, replaced the signs that sought Justice and Punishment during the last Marcha de la Resistancia.

II.

These silhouettes, then, appear to remind (us) that far from being safe, we are still "targets." Moving targets. They show the way in which the current perverse normality sets in: making us targets of a city that becomes a fortress. Like in the old feudal times, the "outside" is a no man's land and the interior spaces promise "security."

The moving targets are part of a struggle to subvert that normality, reminding us once again that it is not desirable, but also demonstrating the point at which it is no longer possible, because this normality is entirely made of exceptions, of a daily brutality and a savage precariousness. This outline is then tattooed on the skin of anybody, as a universal identity card within the "normalization." The moving target expresses a new fear. The one that comes from the relative solitude that each person experiences in this perverse stabilization, the black hole into which we have

fallen. It is from this vantage point that these figures have been adopted with so much force in the different activities that have been organized to demand the freedom of those arrested for protesting in front of the Buenos Aires City Legislature. In the plazas or in front of the courts they have accompanied the volunteers and the open radios. As stickers they have been designed with speech bubbles in order to intervene in advertising.

When Maxi and Darío were remembered in the Puente Pueyrredón (Pueyrredón Bridge), the targets were used with the decision to remove any victimizing connotation in order to shout that they were also targets who rejected the forms of inclusion-exploitation of the present and that our celebration, a producer of new images of happiness, cannot be stopped.

III.

What is to be done when violence is pure threat? When threat is pure violence? What happens when violence is prepared in the media surveys, in the television comments, and even in the gestures of neighbors? How has the stereotype of the "dangerous ones" incubated over time? How to react when state violence comes to be "provoked" by those who have long-term and legitimate complaints? And when the very dynamics of struggle turn into spaces that reproduce the crudest hierarchies?

It is necessary to ask ourselves why the long dialogue within the struggle, its protagonists and its recipients, so active during recent years, seems now to have been interrupted, in order to discover new impulses capable of reviving this dense and open dialogue.

IV.

What "silhouettes" convey is also a moment of hesitation. Who does the target fall on when many citizens loudly demand order? Who names, each time, the execution? The apparatus of security? Yes, but this apparatus is not limited to the official apparatus of repression. It extends to private security, into the necessities of public safety, public governance, walkable streets. . . .

If we are all targets, we are all also called to protest. Police power, its language and its schemas, increase its effectiveness when a general desire for order proliferates. More and more it's about "collaborating" in the fight against "crime." More and more we are forced to endure this double interpellation: moving target and potential "collaborator." "Report it!" asks the city posters; "Help us maintain control," the elected officials say. The current war, which was made visible to the

extreme in 2001, demands imagination and requires new operative modes. The whole city is diagrammed. The very notion of the urban changes. As such, the targets work in highly different sites and in the most varied situations. In Colombia or in Berlin, in Cordoba or in Brazil.

V.

Human silhouettes: they evoke the body as a battlefield, where the passage from terror to the ability to create plays out. Bodies in their double dimension of that which is tortured, humiliated, violated, terrorized, as what is bought and sold and annulled; but also living matter able to activate, re-act, desire, compose, grow, imagine, resist. Privileged material for the call to create and the last territory of all experimentation. Today the body is a stage of the political, where sadness becomes happiness or the contrary happens: target of violence and source of resistant aggressiveness. Object of powers and subject of rebellions; exploitation's obsession and a source of courage and cooperation; a substance sensitive to the gaze, to the word; a term of subjection or collective empowerment.

VI.

The "targets" appear when we run out of images. When we live as moving targets. When we decide to make that target a new surface on which to draw again. When we had to admit that being a target was also a double condition: of emptiness, but also of beginning.

The "moving" connected us with the circulation, indispensable for reactivating the powers of collective imagination. It renewed the movement without appealing to predefined knowledge or content. It allowed us to spread sensations marked by an evasive intimacy, that resisted being shown, being condensed into words.

The moving targets express and connect, allowing a new path to activism.

Empty and restless, indeterminate and open, moving targets inherit the power of the silhouette as an appeal to the neutral human body. With all the body's figurative points at its disposal. The human as a surface for recording ready to be intervened upon in dissimilar situations, in those situations that will always evoke a different meaning. They can be broken, painted, written. They are not sensing bodies but rather echoes that call for a new sensibility.

CHRONICLE OF THE MOVING TARGET

by Flavio Reggiani

We were traveling in the back of a truck with some compañerxs from the orchestra and a piano On the floor of the truck there was some cardboard and amidst the mud appeared a riddled silhouette, a used moving target. The reasons why this bullet-riddled character ended up as the background of the orchestra presentations, the homepage for the website and the back cover of *Mucha Mierda*,[1] the fourth CD of the orchestra, are not the focus of this story. What I want to tell you is what happened to me one night while I was waiting for the bus.

I was about to go play with the orchestra and I had my instrument and our bullet-riddled friend in a pompous gold frame, converted into a "work of art." Or at least that's what I tried to explain to the policeman, who, as soon as he saw me crossing the street, asked me what "is that?" and "how I get it?," as he demanded my documents. Apparently, my explanation did not convince him and neither did my refusal to show him my documents. He then proceeded (as some regulation must say to do) to threaten me with detention.

After a rather implausible discussion, the policeman told me that "that" was not a work of art, that it was a shooting exercise called FBI that consisted of something like emptying the magazine of the gun in ten seconds at a guy ten meters away. He also advised me to roll up the silhouette and carry it "like that always." Only after I did what he told me was I able to get on the bus to go play.

1 A Lot of Shit (ital.)

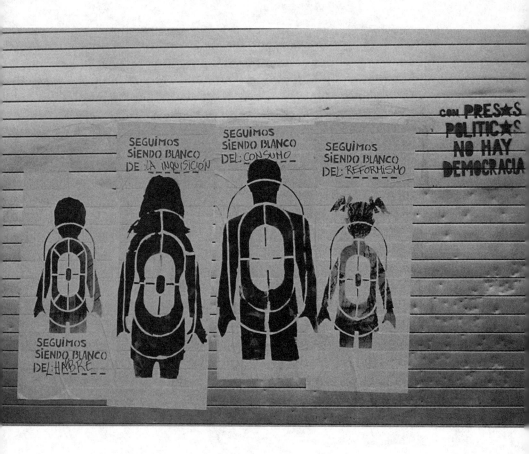

Intervention with Targets in the March of Resistance, Buenos Aires, December 2004.

The text reads:
We continue to be the target of: Hunger
We continue to be the target of: Inquisition
We continue to be the target of: Consumption
We continue to be the target of: Reformism
With political prisoners there is no democracy
(Trans. note)

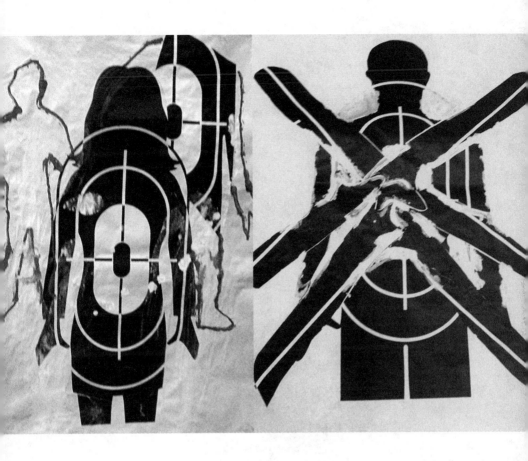

KASSEL, MAY 2005. The exhibition *Creatividad colectiva* (*Collective Creativity*) took place in The Fridericianum, a museum in Kassel, site of *Documenta*. The sponsor was the Siemens Art Program. The targets were distributed to museum technicians, some invited artists, and students from the local art university.

EL 10 DE MAYO DE 2002 FUE DETENIDA POR AVERIGUACION DE ANTECEDENTES. LUEGO DE SER BRUTALMENTE GOLPEADA Y TORTURADA POR VARIOS POLICIAS DE LA COMISARIA 1ra. DE F. VARELA FALLECIO EL 22/05/02 EN EL HOSPITAL MI PUEBLO.

ANDREA VIERA

THREE YEARS AFTER THE MURDER OF ANDREA VIERA BY THE BUENOS AIRES POLICE.

Tribute to Andrea Viera and escrache of Florencio Varela's 1st Police Station, where she was brutally beaten and tortured after being detained for a "a background check" on May 10, 2002. After being brutally beaten and tortured by many policemen from Florencio Varela's 1st Police Station, she died on May 22, 2002, at Mi Pueblo Hospital.

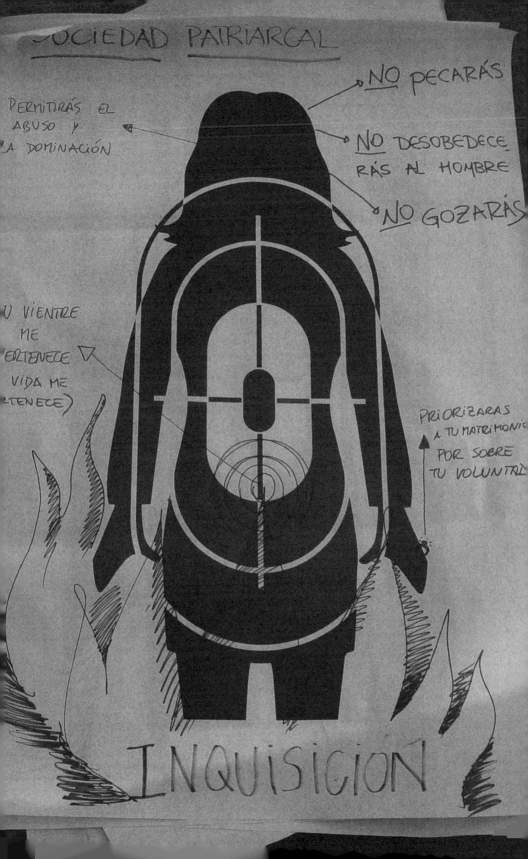

THINKING ON THE DEFENSIVE

What is security for each of us? If we go to the streets to ask this question, we probably know what we are going to find: fear of the other, of being robbed, kidnapped, or murdered. These are the most common answers to this question. This fear has been quickly internalized in the mainstream discourse, and far from protecting the population it makes the population more vulnerable because it prevents it from thinking of itself as inside a structure of power relations. This feeling of vulnerability neutralizes a priori the possibility of thinking about ourselves in relation to others. It is through this dynamic that stereotypical figures who ought to be feared are constructed, such as the delinquent or the terrorist, as well as any other figures that appear disconnected from this problematic and situate us within a fixed and predetermined place from which we cannot escape without thinking about our own bodies and their circulation.

These are questions that we are not used to asking ourselves and therefore the figure of the citizen ends up being reduced to the image of a subject who goes from home to work, an image of a subject who does not alter the functional order and allows the continuation of the present state of affairs. Everything gets then reduced to a struggle between good and evil, where victims will seek a messianic protector such as the state, the police, security forces, Superman or Juan Carlos Blumberg. But this mediation only makes evident our inability to deconstruct our own pre- established role and to imagine a common destiny or a unity. Paradoxically, the answers to the initial question (what is security for each of us?) do not attempt to find a higher degree of security but instead signal what frightens us. Why not talk directly about what can make us feel better—such as access to decent housing, a job that generates gratification and is well paid, good health and good education, a healthy diet, and to not be harassed on the streets for being a woman—along with other things that any person has the right to express? We have become accustomed to thinking of security in terms of its opposite: insecurity. And this "negative" reasoning only puts us in a defensive position, preventing us from visualizing a politics collectively built on a certain notion of "safety." It would be a true challenge for all of us to inquire into what makes us fragile; how collective fragility is constructed; what to do with the fear we feel towards the unknown; or how to establish a dialogue with other realities that are not our own, that seem enigmatic from an inclusive or analytic perspective, trying to give up a certain romanticism inherent in political militancia. It also seems pertinent to ask ourselves why we fit where we fit and whether this is in the position of the criminal or that of his/her victim.

This defensive vision only manages to impose what we could call "a politics of fences," whose basic impulse is the demand for more police and the proliferation of small private armies (where precarious jobs and poor education should be the

primary concerns) so that those who have, or believe they have, can protect themselves from the have-nots and those who don't wish to own.

The diffusion of images about what is secure and what we consider insecure is always associated to the market and consumption and configures a new way to think about ourselves in relationship to a given social context. Our familial and domestic experiences, the experience in our neighborhoods, our streets, our public spaces, recreational spaces and parties, have been created by the security discourse and adapted to the new market of the "politics of fences." We are witnessing a radical change in people's daily routine, dominated by the construction of an imaginary model in which the determiner of both private and public space is control.

If it is true that the form of the subject does not pre-exist the environment but, in a certain way, it is programmed within it, then it is important to analyze the creation of new subjectivities from the proliferation of "absolute" spaces. These absolute spaces are spaces that are "all inclusive:" the house, the gym, the swimming pool, the park. All these activities are linked together by the logic of vigilance. They are locations that create identity and social status. However, a portable version also exists, with the phone that is also simultaneously a camera, a camcorder, an email and internet device, a music player, etc.

Thanks to the growth of this market, fear becomes a force that is expanding. These new controlled subjectivities and the self-disciplined bodies manage to diagram and determine the tenor of the circuits in which we move, establishing new forms of living, not only more submissive and delimited, but also more foreseeable and comfortable. In order to achieve these levels of self-control, the fencing ideology uses not only weapons and armor; it also serves as a model of diversity, shifting objects used in daily life, such as house cleaning products and cell phones, to a certain notion of leisure based on the continuous observation of others' lives through television. In a very short time, the political discourse and the media assumed and produced this concept of "security based in fear," which provides them with both a way of selling and a common ethics supported by the majority of the population, putting under suspicion other possible ways of living that, while they exist, do not have spaces of mass representation.

HOW TO INTERVENE IN SUCH A SECURE AND NATURALIZED CIRCUIT?

As a test, we began to work on an action-intervention which took the name *Segurí$imo (Super $ecure)*—a kind of advertisement with an aesthetic similar to the one used by big supermarket chains to spread their sales door to door. In this case, the objects on sale were weapons and other defense objects, to which we added real facts about their history and technical characteristics, including, as a

reference point, numerical data on the results achieved. An example: "Remington Patria" the powerful rifles used by the army of General Roca in the Campaña del Desierto (Desert Campaign). "Twenty thousand massacred Indigenous people endorse this product."

This action was accompanied by a stand located in front of a supermarket where several compañeras, in the role of vendors, handed the passerby the Seguri$imo. The billboards around the area were also modified with the caption "Not consuming increases insecurity" in order to signal, crudely, towards the widespread idea that the more we consume, the safer we are. The idea was to use an overidentification, exaggerating the usual modes of representation until reaching something absurd or aggressive, to call attention to what has been considered logical and normal.

What most attracted our attention was the fact that many people took the Seguri$imo ads and, paying attention only to the images, consulted us about the security services we offered, whether they be weapons or alarms. Our surprise and irritation prevented us from playing along, and we were able only to explain our intention. But maybe with some acting skills we would have been able to sell them (in a symbolic way) a weapon.

These ads were spread in alternative print media, circulating around some neighborhoods in the suburbs and used by several neighborhood assemblies, even reaching certain performances, and were most likely used in other spaces without our knowledge. It was also the point of departure for other group or collective productions such as the video of La Comunitaria TV de Claypole (Community TV of Claypole), which was later used in different community television programming and in film screenings in various neighborhoods.

This enumeration allowed us to account for the circuits of reappropriation that an object-idea can undergo, starting from the repercussions that any given action has in other realities. The Seguri$imo ads illustrate the fact that modes of circulation exist that do not depend on high prices or advertising, but rather a survey of the experiences lived in the city, capable of sensing the possible channels of intervention, the strategic points from which to circulate the message and the energy to establish and transmit them. When this happens, circulation stops being the mere diffusion of what is produced and becomes one more instance of collective production.

Starting to work at the La Comunitaria TV de Claypole was a moment of group expansion that allowed us to share other ways of appropriating space. It all started with a stencil and short story workshop that some of the compañerxs from GAC and other groups imparted in the Movimientos de Trabajadores Desocupados from Don Orione (a neighborhood located in the south of the city), so that participants generated their own productions, which served as mini enterprises that were brewing while participants sought dignified economic alternatives.

At the same time, we were invited to participate in some broadcasts and shortly thereafter we decided to work together on the production of a short film, a sort of TV ad titled *Seguri$imo*. With what could be called a "Call Today!" aesthetic, an entertainer sold home protection kits and showed their multiple functions. The short film was created with neighbors from the area and with the help of an actor friend, Pablo Mikkosi. It was later broadcasted on different community television stations such as Abajo la TV (Down with TV), TV Barracas, TV de Flores, TV 26, Darío y Maxi, and as part of film series organized by associations or in assembly projections in different neighborhoods.

We got so excited about the possibility of experimenting with television that we had the idea of creating, with other people, a community TV in the capital, which would be infiltrated by our ways of using public space, with the territorial work of neighborhood organizations, using the playful and the festive as essential elements in the construction of the broadcast.

Together with Colectivo Situaciones and the MTD Solano, during this time we worked in discussion workshops on the security-insecurity problem in the neighborhood of San Martín. It was there that we learned how images of insecurity were spread in the suburbs of Buenos Aires, including in poor areas. In these meetings, things happen that go beyond what is produced: often we find new compañero/as and discover angles of vision that undo the suppositions and prejudices that one had or that one considered as truths. But in order to make that exchange of worlds possible, it is necessary to be very patient and find meaning in disappointments. Day after day we insisted on going to a place where at times we did not find things to discuss or people to discuss them with, where we got tired of proposing dynamics that did not work. This required listening, debating our presence in those spaces, and rethinking our own search as a group and the direction of actions to be done.

SEGURI$IMO

HIPERSERVICIOS

ESCOPETA ITACA
La que usa Gendarmería, muchas veces probada en manifestaciones y piquetes.

Desde 1976 reprimiendo los reclamos de la gente.

GARANTIZADA

BROWING 9 MM
¡Infalible! Utilizada por la policía en todo el país.

1600 casos denunciados de gatillo fácil la garantizan.

GARANTIZADA

PICANA PORTATIL
Las de la dictadura, ahora modernizadas para agencias de seguridad. (Especiales para confesar delitos no cometidos)

GARANTIZADA

Desde 1928 en todas las comisarías de la Argentina.

¡Especial coleccionistas!

GARANTIZADA

REMINGTON "PATRIA"
Los poderosos rifles que usó el ejército de Roca en la "Campaña al Desierto".

20.000 originarios masacrados lo confirman.

Atrás excluidos!!!

Hay un ejército de **80.000** guardias privados ¿Todavía no tiene el suyo?

INVERSION A FUTURO
La "seguridad" es el único negocio que crece al compás de la caída del empleo. Las casualidades no existen:

900 millones de u$s

GASTOS EN SEGURIDAD

EMPLEO

1994

2003

2600 millones de u$s

Tenga en cuenta que en la Argentina, hoy, se gasta más en seguridad que en educación o planes sociales, ¿qué mejor forma de asegurar su inversión?

Image of the brochure Seguri$imo.

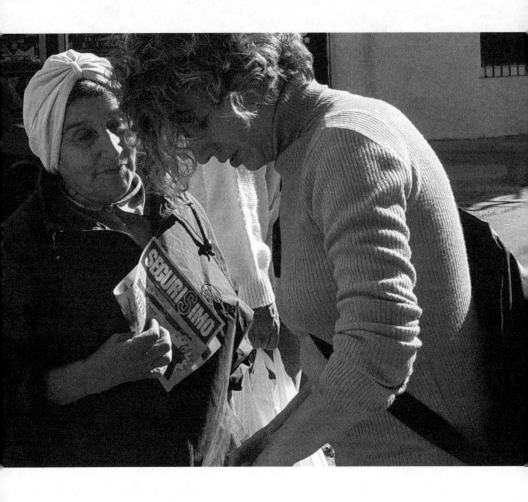

SEGURÍ$IMO. NOVEMBER 8, 2003. We handed out brochures that linked the security business with unemployment statistics, pointed out the reintegration of genocidists now working at private security companies, and the continuation of repressive methods used during the dictatorship.

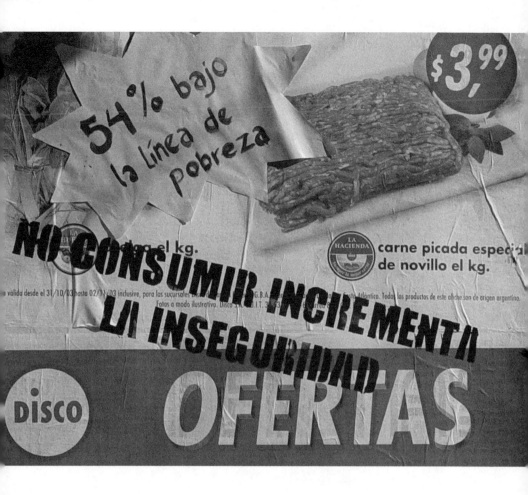

Image of a billboard with advertisement from a supermarket that was intervened with the sentence: "Not consuming increases insecurity."

ATILLO FÁCIL MPUNIDAD

THE APPLE
DOESN'T FALL FAR...

Police forces in Argentina have always participated actively in political repression. A phrase that was used frequently during the nineties notes this relation: "The apple doesn't fall far . . . It's not one cop; it's the whole institution."

The role of the police before and after the coup d'état of 1976 demonstrates this. Captain Alberto Villar, chief of the Argentine Federal Police, was one of the founders of the parapolice organization, the Triple A in 1974, under the political leadership of José López Rega, the Minister of Social Welfare from the Peronist government. In 1968, the journalist and writer Rodolfo Walsh described the police of the province of Buenos Aires as the "sect of the trigger and cattle prod."

In the investigation that gave rise to his book *Operation Massacre*, Walsh reconstructed the events of June 9 and 10, 1956, when eleven workers were kidnapped and transferred to a garbage dump in José León Suárez, on the outskirts of Buenos Aires, where they were executed by the police under the dictatorial government lead by General Pedro Aramburu. Several years before, Captain Ramón Falcón had gained fame by crushing the workers and anarchists' demonstrations in the first decades of the twentieth century. Still loyal to this tradition, the local and federal police of Argentina continue even today in the democratic period as tools of social disciplining and are a privileged tool of a state politics that advocate for "zero-tolerance policies." According to the documents and archives from the Coordinadora Contra la Represión Policial e Institucional (Coordinating Committee Against Political and Institutional Repression, or CORREPI), between 1983 and 2007, more than 2,400 fatalities from police brutality were registered.

TRIGGER HAPPY

This euphemism is used to name a police action that results in the death of those detained or involved in massive police operations, known as *razzias* (raids). The CORREPI notes that this type of summary execution performed by the police is, in general, covered up with verbiage like "a confrontation occurred." This extralegal death penalty has two moments: the execution and the cover-up.

Once the victim is shot in a pseudo-confrontation, a mechanism of complicity begins to operate which includes the planting of arms, the scrubbing of corpses, and the blaming of the victim, who is immediately described as a "delinquent with an extensive criminal record." To this is added the collaboration or the inefficiency of judicial experts and judges who allow the manipulation of evidence, resulting in an investigation against the victim. "There is objective data," according to a report from CORREPI, "that reveal as implausible the alleged and repeated version of this 'confrontation.' The disproportionate tally between civilian and police deaths leads

to two possible conclusions: either our police have the best aim in the universe, or they are the only ones who are shooting. . . . The almost nonexistence of civilian survivors in these so-called shootings shows that the police shoot to kill. . . . In a large number of cases, it is the police themselves who admit to 'accidents'. . . it is noteworthy that the bullets strike the temple, the nape of the neck, or the back."[1]

During the early nineties, neighborhood groups and organizations were created in order to fight against criminal police actions and to demand legal transparency. These groups were mainly organized by territory, neighborhood, or community, in which there were a high number of family members and friends of the victims. These organizations denounce "trigger happy" cases and also the incidences of torture that take place in police stations.

The first of these groups was created after the Budge Massacre to demand justice for three young people who were riddled with bullets by the police of Buenos Aires on May 8, 1987. However, it was after the mobilization for the crime against Agustín Ramírez, which took place in San Francisco Solano in 1988, and after the repercussions of the case of Walter Bulacio, who died after being arrested by the Federal Police on April 19, 1991, that the magnitude of these systematic crimes committed by police forces after the transition to democracy was revealed to the public.

The issue is not that these are isolated actions by a few violent police officers but rather a consequence of state policy, as demonstrated by the modus operandi and the profiles of the people persecuted, tortured, and killed by security forces—people who always come from the poorest social strata and are generally young people or immigrants from neighboring countries.

Human rights organizations, which were created to denounce the crimes perpetrated by the last military dictatorship, are also incorporating demands for justice for "trigger happy" cases into their activities and discourses. In this way, H.I.J.O.S. and later the Mesa de Escrache Popular are working to investigate the links between the repressive practices of the dictatorship and current state violence.

VISUAL POEM

In the GAC, we carried out several actions related to "trigger happy" brutality and police repression. On the one hand, we made the *Poema visual antirrepresivo (Antirepression Visual Poem)* from words composed in affirmative verb tenses which referred to actions carried out by security forces. It was created to be placed on stairs where a person could then read it going up the stairs, replicating the marketing strategy used in subways.

1 Information obtained from the article by Diego Manuel Vidal on the site *Al Margen*: http://www.almargen.com.ar/ sitio/seccion/ actualidad/policias/index.html.

In order to create the visual poem in 2002, we met with unemployed workers' movements from the Coordinating Committee in the Zona Sur, with organizations of family members of victims of "trigger happy" brutality, and with CORREPI for two months. During these meetings, we dealt with the testimonies of family members, who were denouncing the relationship between what happens in the neighborhoods and its connections to local power structures, in order to understand why security forces operate in a mafia-like manner. We also learned about the racism and xenophobia that characterizes our society, even though we rarely speak about it.

The visual poem was used in the stairways of train and subway stations, buildings and public institutions, placing each sentence on a step:

SECURITY?
IT WATCHES YOU
IT CONTROLS YOU
IT INTIMIDATES YOU
IT REPRESSES YOU
IT DETAINS YOU
IT TORTURES YOU
IT MURDERS YOU
POLICE-ARMY-NATIONAL GUARD

This text was used in different public spaces in which "trigger happy" or repression cases were denounced: at the march for the anniversary of La Noche de los Lápices (The Night of the Pencils), in the courts of La Plata, in the staircase of the Congress, in the Piquete Urbano, and in the remembrance activities for December 19th and 20th, 2001.

In fact, the use of this vehemently affirmative word was influenced by the police repression on December 20th, which is still very present among us. The murders of Maximiliano Kosteki and Darío Santillán, which took place on June 26, 2002, on the Pueyrredón Bridge, were also decisive for our determination. It was difficult for us to use images as metaphors due to the explicit evidence of the facts. For this reason, we use direct action verbs in the visual poem, because there is no place for poetry when the evidence is so compelling and the behavior of politicians and security forces allow no possibility for dialogue; as miserable liars, they demand instead the most vigorous denunciation.

POSTERS AND FLIERS ON BILLBOARDS

In a similar fashion, we created the poster, which uses a common expression: "The apple doesn't fall far. . . ." The acceleration of social events made it necessary to intensify our actions as well: the most repressive crackdowns in recent years were at the same time met with forceful mobilizations by people working with social movements, united in coordinating committees for struggle and rebellion. On June 27, 2002, one day after the murder of the two piqueteros, more than twenty thousand people marched under the cold rain from the Pueyrredón Bridge to the Plaza de Mayo, a long walk, during which many more people joined in, to repudiate the repression led by then-president Eduardo Duhalde. For this march, we made fliers that said "Don't Feed the Animals," which we placed on the fences separating the police from the people in the Plaza de Mayo.

It was only a few weeks after those murders that the first escrache was carried out at the police station of Avellaneda, the place where the police officers who shot Maxi and Darío had departed from. That day we went with all the images that we had to intervene in the space, exposing the murders as a setup. The images were carried and placed by the compañerxs of the MTD, friends, and family members of the murdered piqueteros. We participated only as demonstrators without any kind of activity, like spectators. They had appropriated our tools.

In October 2002, an homage was organized at the Lanús station to pay tribute to Carlos "Petete" Almirón, one of the young people killed on December 20, 2001, who at the time, was a militant in CORREPI and in the Teresa Rodríguez Movement. Maxi and Darío, militants from MTD Guernica and MTD Lanús respectively, were also remembered with this act. Our purpose was to point out what had happened through the march and the images or actions of different groups. We worked with the *Antirepression Visual Poem* on the doors of the Lanús town hall and later marched towards the station. During those days, the Federal Police guarded the subway stations with dogs, while the armed police was in charge of the train stations and platforms, especially the lines that went to the south zone, which were the means of transportation most frequently used by those people who participated in social movements. While we were trying to place the visual poem in the Lanús station, we found *ourselves* surrounded by armed police and were isolated for an instant, as the rest of the people who were participating in the demonstrations were concentrated outside the platforms. However, as soon as they realized the danger, our compañerxs appeared and blocked the way between the armed police and those of us who were writing the poem. In a matter of seconds, we passed from fear and desperation to feeling safe and protected, while hundreds of people sang, *"Pinte, pinte compañera, y no deje de pintar, porque todas las paredes, son la imprenta popular."* ("Paint, paint compañera, don't stop painting because all the walls are the popular press."

During 2002 and part of 2003, we went out to the streets several times a week in a joint struggle with different groups and urban movements, where the questions from the images were replicated and multiplied, although that did not prevent the appearance of difficulties in their production, forcing us to deepen their complexity and nuance. It was for this reason that we intensified our work with some of the Unemployed Workers Movements, building workshops for communication and visual production, with the idea of making widely available these kinds of tools. These were moments of endless and massive creation because of the responsibility we felt to respond quickly to the situation, beginning with a large demand that gave us a desire to create a kind of stockpile of images ready to be used by all of the collectives that we were meeting along the way. There were a lot of groups building with *us*, and the dialogue was frequent. During these months something remarkable happened: the discourse of "insecurity" disappeared as the repression started to respond to the parameters imposed by the social and political conflict.

In 2004, we began working with the Coordinadora Antirrepresiva del Oeste (Antirepression Coordinating Committee from the West Zone) to participate in the mobilization around "trigger happy" cases as well as to condemn the abuse by bouncers at bars where young people go to dance, as well as some incidents with young neo-Nazis. The idea we shared was to prepare a street intervention to appeal to the neighbors in the area, using questions as a communication tool. The action was aimed at passersby and was not intended to impose a closed discourse but rather to generate discussion. The questions were written on tabloid-sized posters, with a popular graphic style, in order to attract attention but blend in at the same time with the regular advertising landscape. Breaking with the traditional political poster schema, our intention was to pass unnoticed before the eyes of political militants, in order to draw instead the attention of a different public, one more temporary and heterogeneous. The posters were posted next to train tracks, from Haedo station to Morón—we separated into two different groups that worked at the same time along either side of the tracks.

Our intention was to explore the contradictions of popular common sense, appealing to a certain complicity in statements that we all use, like "the police are corrupt and stupid" or "it's linked to the kidnappings" and displaying the short-circuit that links these statements to a different kind of sentence, more related to the media but also widespread, such as "we need more security," therefore "we ask for more police in the streets" so that "they protect us from thieves." How can someone intervene in this dissociation in collective reasoning? We tried out several questions—"what do the police do best?" and "what do you fear more?"—as a way to share our own concerns. Starting from the common need to feel protected and safe, we asked ourselves: Where does this fear come from? And if it is real, who can we ask for help or not? Questioning oneself is perhaps the best way to reflect in a

context of generalized panic in which everyone is suspicious and fear becomes a daily experience as if it was hiding in every corner, while the police gain the support of neighbors, increasing their ability to act with impunity and impose greater control. Faced with the perplexity of a difficult period, where *cacerolazos* (massive pot-banging marches) spread through different neighborhoods to demand more police presence on the streets, when neighbors partnered with the Federal Police to design safe "passages" to be used by children on their way to school, it is necessary to keep raising questions, even if we do not have answers for them.

WHAT IS YOUR BIGGEST FEAR? is a question that aims to displace socially accumulated paranoia without negating it, but seeking instead to unveil other qualities that fear and trauma presuppose. There are people who are aware of their fragility and yet have no need to blame someone or label someone as dangerous. In order to confront the ideology of security, we felt we had to take seriously the common sense found in the not-at-all obvious answers of passersby.

WHAT DO POLICE DO BEST? is a positive question that opens up to all kinds of abominable questions.

THE COCKROACHES OF NORMALIZATION

After the irruptions of 2001, the capacity to generate movement began to decrease and a tendency toward normalization was imposed along with the resurgence of a strong need for security accompanied by the enclosure of individuals into a pacified daily routine. This withdrawal of social energy found its referent in the figure of the "engineer" Blumberg, a neighbor from the north side of Buenos Aires whose son was first kidnapped and then murdered on March 23, 2004, by a group of kidnappers who were later apprehended. The demands of the middle class against the "wave of insecurity" started to re-emerge with more strength than ever after this event, and several squares were packed with people demanding stiffer penalties for delinquents. They lit candles and sang the national anthem over and over. The media was a privileged representative of the desire for a "peaceful life," legitimizing this politics of insecurity, in which the enemy forms a part of society and has to be eradicated from it.

What can we do? Do we collaborate in this public construction? Is it possible to break with this logic? Surely it is possible to intervene in this chain of representations, but it is a very arduous and solitary work. In order to question the images in the media, we thought about working with stencils on the walls of the city. We drew cockroaches climbing the walls with the faces of politicians and journalists: Mariano Grondona, Bernardo Neustadt, Daniel Hadad, Carlos Menem, Eduardo Duhalde. It was a simple technique that could be reproduced easily using irony

and a doubled discourse with the goal of turning inside out the sentiment that was circulating: "They are the insecurity." This image was used in the capital and in the suburbs.

There are times when it is essential to feel one's own body, even when that body seems to have been annulled, withdrawn; in truth, it is never completely extinguished. It is our common body where the immediate memory of that situation of social potencia is lodged, that moment which was experienced by all of us in December 2001. It is not simply an illusion, but rather something verifiable by facts, even if it appears fleeting and diffused in the form of spontaneous responses, in explosions that destroy police stations, set buses on fire—a resounding force that forgets fear and disarms the discourse of security.

Andrea Viera was murdered in Florencio Varela's 1st Police Station after having been arrested on May 10, 2002, for a "background check." Two years later, the first action denouncing the case took place. The march and the escrache, organized by the family members of Andrea, was massive, and we went with our cockroaches. From this moment on, we found out about other cases, and we established links with the mothers, wives, and sisters of different people murdered by the police. We were impressed by the transformations experienced by family members as they decided to step into action. The escrache of the police station was powerful. The space between the train station and the police station was occupied by the demonstration and upon arriving at the police station, a big group went in to demand justice, while another contingent covered its entire façade with stencils and graffiti that expressed antirepression and antipolice slogans that included denunciations of "trigger happy" cases.

These practices took place in different contexts with the same demands, bringing to light the police practices related to repression. The action was repeated the following year, 2005, in front of the police station. Since our intent was to place a commemorative plaque similar to the one used to remember the young people assassinated on December 20th, 2001, we received an offer from the city council to contribute a bronze one that could be embedded on the wall of the police station. There wasn't group consensus, since our aim was to create a less official and domesticated remembrance. It is interesting to highlight that these kinds of offerings from the state were both constant and insistent after 2004. Most of the time we declined them, but it is not always easy to avoid the fact that certain images and practices that were born in the context of resistance can be included in institutionalized circuits that stabilize their meanings.

PARA MUESTRA

NO ES UN POLICIA.

"The apple doesn't fall far. . . It's not one cop; it's the whole institution."

BASTA UN BOTON

S TODA LA INSTITUCION

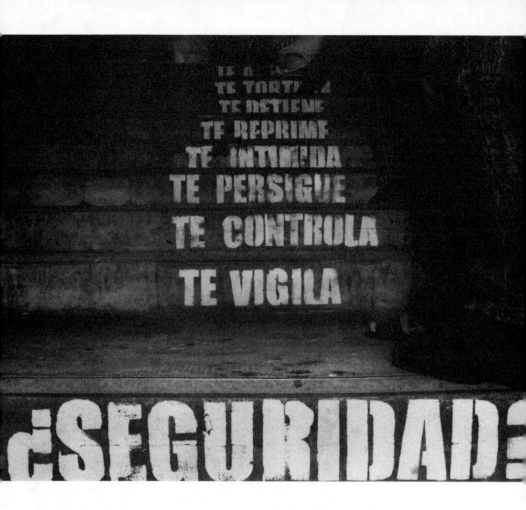

**POEMA VISUAL ANTIRREPRESIVO. FIRST INTERVENTION: LANÚS STA-
TION. OCTOBER 19, 2002.** A list of repressive actions carried out by the security
forces. The actions listed ascend in violence: the violence of the words grows with each
step. After the initial presentation, this action was carried out in other urban spaces.

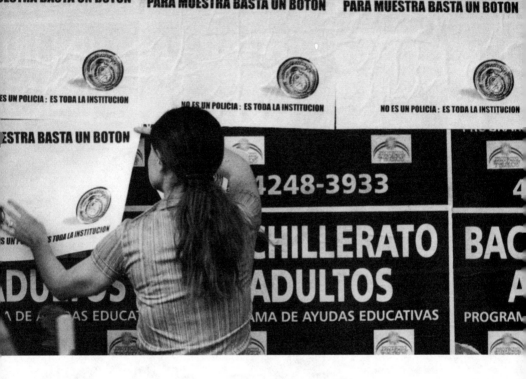

THE APPLE DOESN'T FALL FAR. . . . POSTER. 2002. Inspired by the word-play that the popular saying evokes, this poster was created to accompany marches and street actions where police were present.

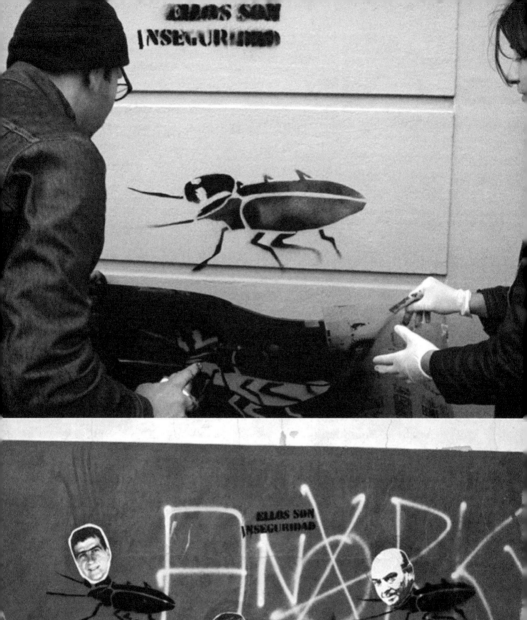

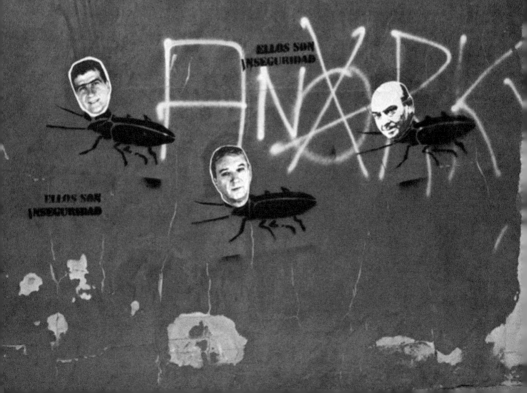

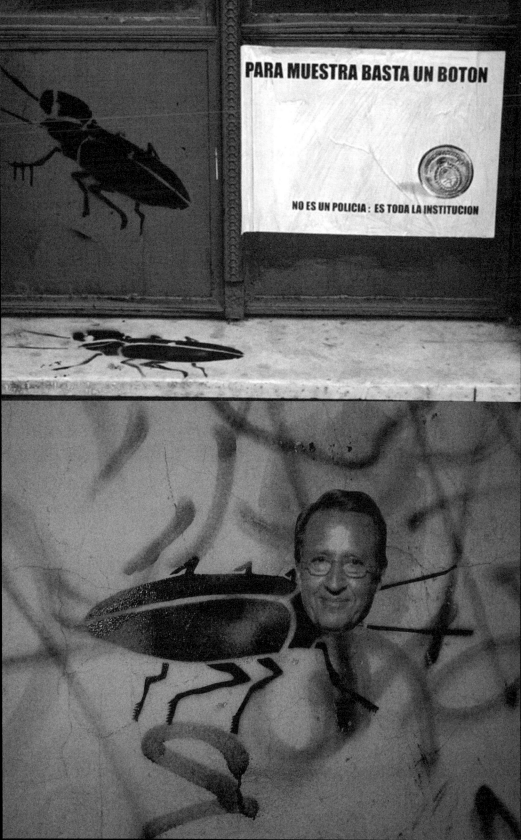

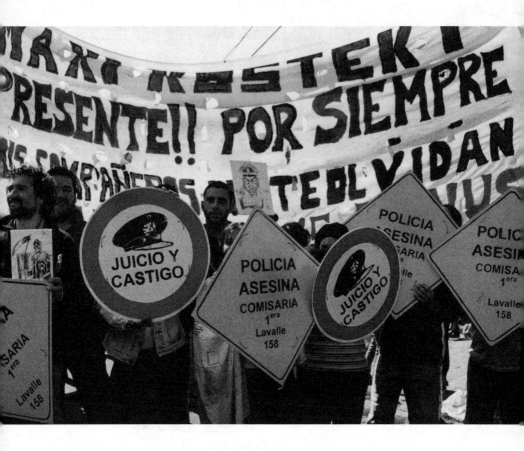

ESCRACHE AT THE AVELLANEDA POLICE STATION. The first escrache of the Avellaneda Police Station occurred a few months after the murders of Maxi and Darío, as this station housed the police who killed them. The above signs were carried and hung by members of the MTD and friends of the two murdered piqueteros.

GRUPO DE ARTE CALLEJERO: THOUGHTS, PRACTICES, AND ACTIONS

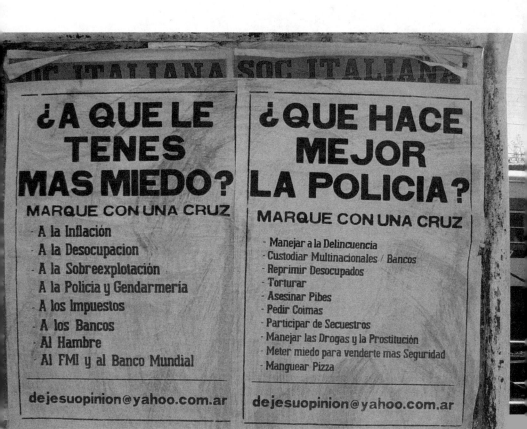

POSTERS MADE WITH THE ANTIREPRESSION COORDINATING COMMITTEE FROM THE WEST ZONE. The front is made up of various neighborhood organizations, unoccupied workers and the group H.I.J.O.S. from the west side of Buenos Aires. These posters were put on the main streets near train stations. They were modeled on opinion polls, in which an X could be used to mark an answer to the questions: What are you most afraid of? What do the police do best?

The poster on the left reads: "What are you most afraid of? Mark with an X: Inflation, Unemployment, Overexploitaiton, The Police and the Armed Police, Taxes, Banks, Hunger, the IMF and World Bank." (Trans. note)

The poster on the right reads: "What do the police do best? Mark with an X: Control Delinquency, Guard Multinational Corporations/Banks, Repress the Unemployed, Torture, Murder Young People, Ask for Bribes, Participate in Kidnappings, Managed Drugs and Prostitution, Provoke Fear in Order to Sell You More Security Services, Eat Donuts."

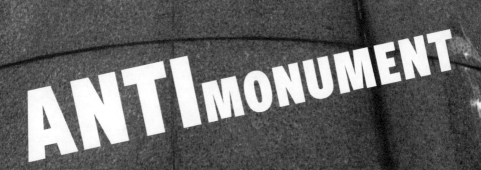

ANTI MONUMENT

PUEBLOS ORIGINARIOS

RESIGNIFICATION

Of historical memory: Forms of representation of power and modes of collective appropriation of urban space.

The identity of the Argentine state is maintained on the basis of periodic genocides. Since its foundation in the 1880s to the present day, the formula of its existence is the imposing of order by force and coercion. Thus, the formula of social coexistence was and is the culture of fear. We must try to find the archetypes, the symbolic edifice, the framework that maintain this situation in order to discover—and let's hope we can—the way in which this "cultural fear" turns into pure and complete state terror.

POLITICAL ART?

It is often said that the artists and cultural producers who find themselves committed to reality make "political art." Nevertheless, having carefully observed the cities that we've traveled to, we continue to discover that aesthetic political messages don't always come from a community that decides to produce its own symbols. On the contrary, the majority of the sculptures and buildings that we see are visual forms that correspond most fully to an exaltation of genocide and/or the complicity between the state and economic power. We live surrounded by images and symbols that come from power. Power produces political art; it creates historical accounts that are constituted as absolute "truth" in order to prevail against the truths of the defeated. The art of power is shown to us in monumental forms that embody a representation (the uniform vision) of history. These symbols institute models that control life and define our identity.

We move through the city of monuments; we identify places; we name the spaces that we inhabit in reference to these imposed labels. Power proposes a version of the past where there is no room for dissent. Bronze is melted in order to give shape to the hero (most of the time, they portray sinister characters) and in this way to shut down discussions over the possibility of appropriating our history for ourselves and of choosing on our own those whom we want to remember and vindicate. The model of memory that power offers us is a fetishized memory: all of it a vast iconography removed from original contexts and rendered as a child's cutouts, stripped of all connection to the present.

Today the state begins to examine and condemn the crimes and human rights violations of the last dictatorship at the same time that it proposes the construction of spaces for memory.

But what type of memory can emanate from a state that consolidates itself on the basis of extermination? From a state that organized itself by crushing other

peoples and that continues to polish the bronze statues of its most obedient assassins? What things do the state of 1880 and the current one have in common?

HOW IS AN EXTERMINATION LEGITIMIZED?

Criminalizing the other, dissent, the opposition, he who resists within his culture and has other images, other forms of representation.

- The Indigenous as an image of danger, of the other that terrorizes.
- The poor, the child thief, the piquetero as an image of danger.

Fear is transmitted through images that construct unequivocal relationships between supposedly good things and supposedly bad things, untrue constructions, that annul discursive processes and that cause us to repeat (as if they were somehow new) all kinds of stigmas.

Images of those who remain on the margins, those who—manipulated by the system—are the official representations of the criminal, promoted as much by Sarmiento as by Grondona, hanging in the Museo Nacional de Bellas Artes (National Museum of Fine Arts) or seen on corporate television.

DISCOURSES OF SECURITY AND NEW MONUMENTS OF THE SYSTEM

The discourse of security is that which is used to promote zero tolerance, that which is used to control. But what is being protected and by whom? How does control operate and who does the controlling?

The dead genocidists, honored with equestrian statues, are protected by the institutions that endorse them with gates and antigraffiti coating. The police barricades, along with the police forces and cameras, protect the living genocidists when they are confronted by a neighborhood that repudiates them with escraches. The rich are protected from the poor with the construction of inequality; the access to having or not having "a Roca"[1] in your pocket makes a difference.

The gated communities, the shopping centers, the privatization of public spaces, the idea of security as a massive cage. The media discourse, which promotes human immobility, and the marketing of self-control offers us a wide range of products to satisfy our consumer needs without guilt, protected by sophisticated mechanisms of domestic confinement. Cages for those who agree to be inside of them or earn that privilege.

1 The bill with the largest domination in Argentina carries a portrait of the cruelest of the "national heroes:" Army General Julio Argentino Roca.

There is nothing higher than this image of discipline as the key to paradise, wherein, to continue with the metaphor, Saint Peter would be employed by a private security firm. Thus, the new architectural space is not so new: it has its foundations in the same indoctrinations as always. This space can only be created through disciplining dialogue, composed of fear and silence, which are elements required for submission. And taken together with past forms, here are constituted new forms of relation, perhaps the only ones that realize the necessary structures of hierarchy.

DISOBEDIENCE PUNISHED

To be in disagreement, to not collaborate, to be neither part of nor accomplice to, to not obey the normalizing mandates. . . all variations on an active dissent that calls into question totalizing discourses. In the face of oneness, multiplicity. In the face of the overwhelming obedience of the herd, rebellion. Over time, our turn will come to be witnesses or protagonists in some act of disobedience that, in due course, will be resisted by diverse institutions, whether educational or repressive. It doesn't matter if it's a popular revolt or an act of personal self-determination, the mechanisms by which institutions operate is rather similar. In the schools there are residual images of a discipline juxtaposed with new discourses that reaffirm it. Who says what, to whom it is said, how it is said to them? The distribution of information in these environments requires unconditional acceptance on the part of the receivers.

We form part of those disciplinary mechanisms that require us to follow bureaucratic structures and norms, which aid the construction of a what-should-be within the system of oppression.

These what-should-be's are the roles established as hierarchies that convert our form of daily living into military parodies, which transferred into all the other institutions such as teaching, work, and family turn us into beings without any will to live outside of these patriarchal dogmas.

Each established role that we accept and represent, toward ourselves and toward others, causes us to enter into a game of polarities.

When we adopt the name and the identity that power has assigned us and labeled us, we turn into potentially classifiable and manipulatable subjects. In this way, power offers us a series of stereotypes from which we can choose; at the same time, it continues in its quest to coopt the elements and forms that stem from the tactics of cultural resistance themselves. It punishes us, also, by appropriating our practices in order to pick them apart and turn them into objects for consumption.

In the attempt to blur that scene (of the established role) we call this power into question from our own shifting identity.

OUR POLITICS: STRUGGLE IN THE SYMBOLIC

How many times in our lives have we pronounced a street named after a genocidist? How many times have we spoken the name of a multinational brand that enslaves and kills?

These names and products are so naturalized in our everyday life it is almost utopic to think we could rid ourselves of them, because we are, in part, constructed by them. Nevertheless, recognizing this, we can deconstruct these images and names. There are diverse, collective, individual, anonymous, or public practices that can effect real transformations in each context.

This is political struggle in the symbolic, which not only names the forgotten and victims of power's violence but also restores to us the power of constructing an autonomous identity capable of encountering liberty in this living process of building utopias.

There have existed and exist clear examples of this struggle from the symbolic, experiences of collective appropriation of public spaces. A few examples:

Che Guevara Square (formerly Ramón Falcón Square). In 2003, a set of social and neighborhood organizations decided to change the name of the square in their neighborhood. Over the course of several months, they conducted surveys in various locations of the Floresta neighborhood, asking what name residents would give to Ramón Falcón Square. The majority of the votes were for Che Guevara, and the square was reinaugurated with this name.

S. Radowitzky Street (formerly Ramón Falcón). During several years, groups of people had the admirable initiative to produce with their own hands a change in the name of this street in Buenos Aires.

"Cities of Iraq" Street (formerly United States). In 2002, several neighborhood assemblies in Buenos Aires coordinated to change the name of United States Street to "Cities of Iraq" Street.

Homages to the disappeared in different neighborhoods (San Telmo, San Cristóbal, Parque Patricios and others). For many years now, residents and neighborhood organizations have realized homages to the disappeared who lived, studied, and worked with them. Using different methodologies these actions have recuperated the living memory of these neighborhoods.

WHY AN ANTI-MONUMENT?

Roca is considered a founding father, exalted by history textbooks and by the reactionary sectors of society. He led the so-called Desert Campaign, which was nothing more than the extermination of the Indigenous peoples of the Pampas and Patagonia regions. The lands usurped were distributed amongst the Argentine oligarchy and foreign companies, one of them being the Compañía Argentina Tierras del Sur which is currently property of Benetton. It's not by chance that Roca's statue sits at the head of a street that leads from the Plaza de Mayo towards the south, a street that also carries his name. This positioning aims not only to slowdown traffic but also means that any protest in the Plaza de Mayo has to confront the "father," the emblematic figure of control and repression, exercising his power over the multitudes.

The monument to genocide is located at the intersection of Diagonal Sur and Perú. It was inaugurated in 1941. In its base, formed of marble, are two figures that represent the fatherland and work. Crowning the monument is a sculpture in bronze, the work of José Zorrilla de San Martín. Various direct interventions were realized at the monument as well as a series of consciousness-raising talks touching allusively on history and related thematics. Out of this group of interventions, we'd like to highlight the Anti-Monument Law for Julio Argentino Roca.

THE ANTI-MONUMENT LAW FOR JULIO ARGENTINO ROCA

FUNDAMENTALS

It is indispensable to review the methods by which symbols are created and models which govern life and define the identity of political communities are instituted. For this reason, this initiative aims to make obsolete one of the many erroneous perspectives of history, which is based in the exaltation of genocidal figures as national heroes.

Distorted representations of historical truth have been constructed to be massively consumed, to discipline, to persuade, to silence dissident narratives. The present project of this law proposes as a first step, in a broader process of review, the removal and elimination of the figure of Julio Argentino Roca from the privileged place he occupies along with other false heroes within the iconographic hierarchy of the national symbols that are imposed within the education system.

CONSIDERING

- That the general Julio Argentino Roca is directly responsible for the murder of tens of thousands of Mapuches and other Indigenous peoples;
- That the Desert Campaign, better called a war of extermination, that the aforementioned led, not only meant the genocide of these peoples, but also the appropriation of their lands;
- That the illegitimately stolen land was given to corrupt "owners," both national and international, and that this is the origin of the large estates;
- That the southern landowners, yesterday and today, founding their power in the concentration of a disproportionate number of hectares—a product of looting and enjoying the protection of the law and that of the bloody national Armed Forces—are guilty of the shameful exploitation of thousands of Argentine citizens and immigrant workers;
- That the violent repression of the workers movement known as the Patagonia Rebellion destroyed a solidarity movement aimed at creating a more equal and just world, and that all of these massacres fortified the reactionary and fascist sectors of the country for more than a century;
- That these same sectors, illegitimate owners of the Patagonia, have promoted all of the political and economic repressions;
- That the destruction of and profiting off of natural resources, the cultivation of genetically modified crops, the mining, and the appropriation of the water reserves, alongside the installation of military bases and the "touristization" of our cultural values all form part of a relentless neoliberal propaganda that systematically violates so-called "human rights";

- That the exercise of memory is a necessity that is not restricted to the crimes against humanity that occurred in the last decades, but that should also encompass our whole history until the present;
- That the figure of Julio Argentino Roca is a symbol used by the most retrograde sectors in Argentina to assert their dominance over the majority of the population;
- That the exaltation of Julio Argentino Roca in the official history books, in the monuments in public spaces, in the hundred-peso bill, and in other elements of state iconography constitute a permanent humiliation of Indigenous peoples and Argentine citizens;
- That these crimes against humanity are perennial.

WE DECLARE

1. The illegitimacy and illegality of the properties concentrated in large estates;
2. The expropriation and restoration of such lands to the Indigenous people and other neglected sectors who live in the territory now called the Republic of Argentina, with a guarantee for the autonomy and self-management for the sustainable exploitation of said lands and the satisfaction of their right to food, health, education, and housing.
3. The immediate removal and/or destruction of the monuments with Julio Argentino Roca's figure, as well as the replacement of the designation of streets, plazas, parks, museums, schools, and other establishments that carry the name of this genocidist;
4. The urgent revision of the official history books and their correction according to historical fact, consulting the testimony and the record of the direct and indirect Desert Campaign victims;
5. The removal of the circulation of current hundred-peso bill and its replacement for one with a new design that will remind the Argentine population of the inescapable rights of Indigenous peoples;
6. Ensuring all the state guarantees and resources necessary for the realization of the points mentioned above;
7. A call for all the people in our countries to take the initiative to collectively accomplish this historical reparation through social organizations, and in places of study and work, discussing the best way to accomplish reparations and convoking a competition to collect the best ideas from each community.

Anti-Monument for Julio A. Roca Committee

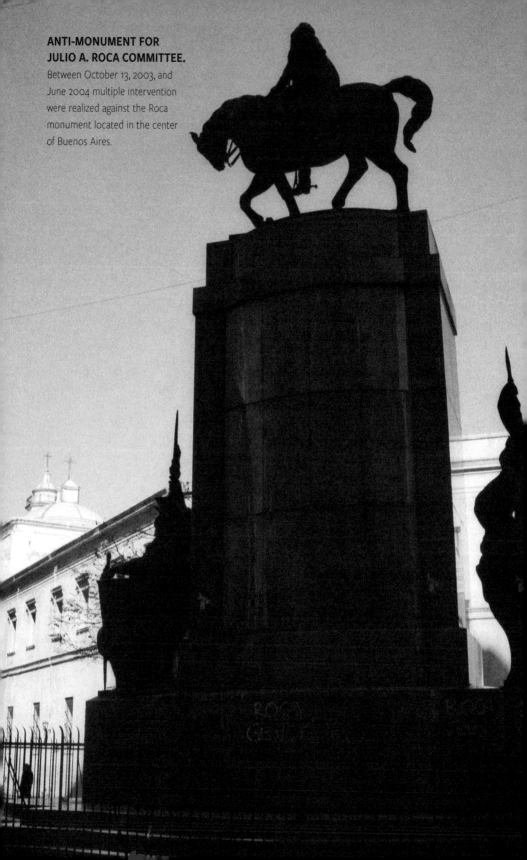

**ANTI-MONUMENT FOR
JULIO A. ROCA COMMITTEE.**
Between October 13, 2003, and
June 2004 multiple intervention
were realized against the Roca
monument located in the center
of Buenos Aires.

"A French May is better than an Argentine July ('Julio Argentino')" (Trans. Note)

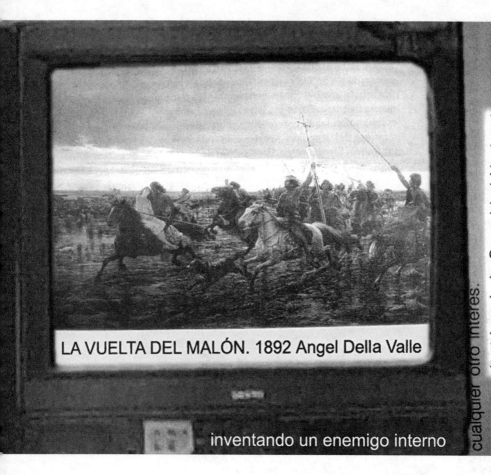

LA VUELTA DEL MALÓN. 1892 Angel Della Valle

inventando un enemigo interno

La doctrina de la Seguridad Nacional reelaboró el panel de las Fuerzas Armadas en cada país y generó una cualquier otro interés.

A HISTORY OF ARGENTINE CRUELTY. Some of the images published in *Historia de la crueldad argentina*, edited by Osvaldo Bayer, which discusses Julio Argentino Roca as a sinister figure in Argentine history. GAC created one of the chapters in this book, entitled "The Anti-Monument: The Resignification of Historical Memory."

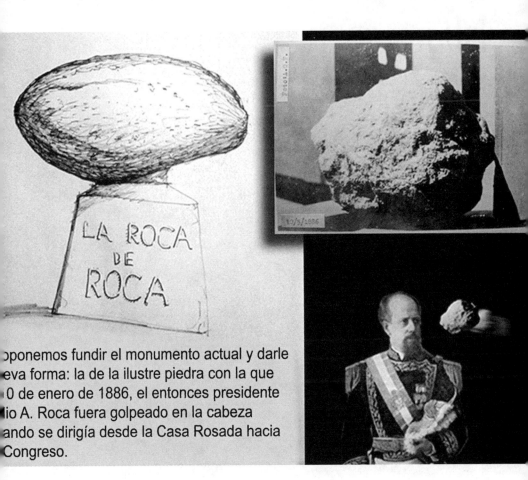

oponemos fundir el monumento actual y darle
eva forma: la de la ilustre piedra con la que
0 de enero de 1886, el entonces presidente
io A. Roca fuera golpeado en la cabeza
ando se dirigía desde la Casa Rosada hacia
Congreso.

Nuevos Desalojos Patagonia 2004

Atilio Curiñanco y Rosa Rúa Nahuelquir

A denouncement of the company Benetton for the displacement of the Curiñanco family.

TODAS LAS TIERRAS LAS ROBA BENETTON

En la Patagonia el grupo italiano Benetton, el mayor terrateniente en la Argentina con 900.000 hectáreas compradas durante el período menemista a precios irrisorios, está desalojando a sus habitantes originarios: los Mapuches.
Esta empresa no contenta con la explotación ovina (en sus estancias se produce el 40% de la lana que consumen sus locales en el mundo), se apropia de tierras ricas en yacimientos mineros (oro y petróleo) y se prepara, con ayuda estatal, para forestar cientos de hectáreas con especies comerciales que van a destruir el ya debil equilibrio ecológico de la región.

La familia Curiñanco, como muchas más familias mapuches y argentinas, está luchando judicialmente por el derecho a poseer tierras dignas para trabajar y vivir. Son las mismas tierras que fueron robadas a sus abuelos a punta de fusil hace poco más de 120 años en la llamada "Campaña al desierto" dirigida por el "héroe nacional" Julio Argentino Roca.
Esta campaña, en realidad el asesinato de miles de mapuches, fue llevada a cabo por el Ejército Argentino, la Sociedad Rural y terratenientes ingleses.
Hoy Benetton (y otros grupos económicos bajo su órbita) continúan esta nefasta historia.

Text reads: All Land is Stolen by Benetton (Trans. note)

In Patagonia, the Italian group Benetton, the largest landowner in Argentina with nine hundred thousand hectacres bought during the Menem government at ridiculous prices, is displacing the lands of the original inhabitants, the Mapuche. This company is not content with sheep production (it produces 40 percent of the wool consumed in its shops around the world). It appropriates lands rich in ore deposits (both gold and oil), and is preparing, with state help, to plant hundreds of hectacres of land with commercial tree species that will destroy the already precarious ecological balance in the region. The Curiñanco family, like many other Mapuche and Argentine families, are fighting for the right to own land to work and live on. These are the same lands that were robbed from their grandparents at gunpoint more than one hundred and twenty years ago in the so-called Desert Campaign led by the "national hero" Julio Argentino Roca. This campaign, in reality the murder of thousands of Mapuches, was carried out by the Argentine Army, the "Rural Society," and English landholders. Today, Benetton (and other economic entities in its orbit) continue this nefarious history.

ARGENTINE "RURAL SOCIETY," MAY 7, 2006. Disguised as cows, we interrupted the Feria del Libro (Book Fair) to denounce the landholding oligarchy and the large multinationals that have monopolized the land in the south of Argentina. This action was realized with the aim of presenting the book *Historia de la crueldad argentina*.

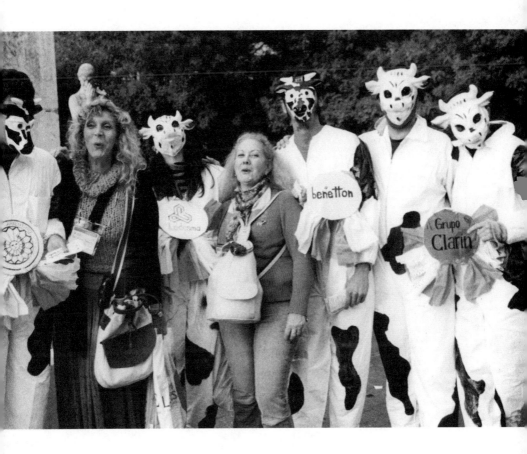

ACTIONS AND PROJECTS

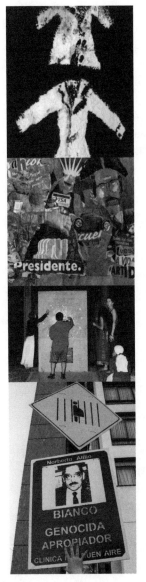

1997

TEACHERS ON HUNGER STRIKE. A collection of murals realized on different walls of the city. The motivation was to support the hunger strike, which the docents and teachers enacted against Congress after installing the "White Tent" as part of an open struggle against the Federal Law of Education. The paintings were made each Sunday throughout a whole year, without having direct contact with the unions that were participating in this conflict.

URBAN GALLERY. The occupation of spaces destined for publicity, making use of the drawings and paintings made by a variety of commissioned individuals, artists and non-artists, coming from the Escuela de Bellas Artes, secondary schools and cultural conferences. Once placed in these public spaces, an inauguration was held on the street, with wine and music, which generated an event in which both invitees and the occasional passerby participated.

OBJECTS IN THE PLAZA ARAMBURU. We prepared objects with materials found on the street that later we placed on the streets as sculptures. This action was intended as the realization of a collective purpose and the transformation of public space.

1998

ROAD SIGNS. The road signs, used to indicate the homes of the perpetrators of genocide and the location of former clandestine detention centers during the last military dictatorship, began to be realized in 1998 and continue as a form of work. Many different signs were used for different

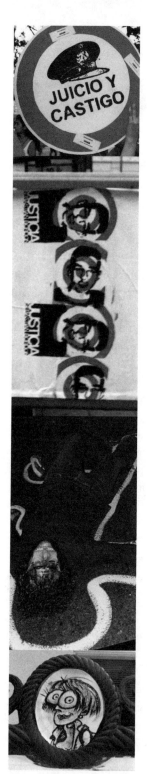

thematic installations and along trajectories to narrate certain histories.

The first time that we employed the signs was on March 19, 1998, in front of the Tribunales de Retiro, in the context of the trial of Admiral Emilio Massera. There they functioned as a placard, with the demand Juicio y Castigo (Justice and Punishment) against the repressors, and they were deployed by the group H.I.J.O.S. in conjunction with GAC. The next day they were used for the first time in an escrache, in front of the former clandestine detention center known as El Olimpo. On March 23, the signs were carried in the escrache of Massera and Harguindeguy. From that moment on, the signs became a resource used along the routes taken by each escrache.

POSTER AGAINST "TRIGGER HAPPY" BRUTALITY (APRIL 12). GAC got involved in denouncing cases of "trigger happy" police violence, accompanied by the family of Sebastián Bordón, in a march in front of Congress. The posters were designed in stencil on paper.

ANY OBJECT CAN HARM YOUR BODY (JULY). Performative action realized together with the group Etcétera when we shared the space of the former surrealist printer, Mario Bravo. This action consisted of a dissemination in the neighborhood of Abasto, painting silhouettes on the ground and next to them and placing posters next to them w that read: "Any object can harm your body." The act was associated with the murder of various workers in on-the-job accidents that happened during the construction of the Abasto shopping mall due to the lack of security measures. The construction site had been shut down at the time of this action.

STREET PICTURE FRAMES (SEPTEMBER). Playful action that intervened into advertising on the street, in particular over the place where the shield of the city of Buenos Aires would be located. Drawings and photographs were copied in large quantities and placed on various billboards on main avenues, which required multiple actions.

STREET ART ENCOUNTER (NOVEMBER). The first attempt realized by GAC to get to know and exchange experiences with

other artists and activists. We organized an exhibition and different talks in which contact was generated between groups that started in the eighties and those of us that began to work in this later moment, under the title of the *Encontronazo* (*Big Encounter*), a theater-based encounter. A "photographic walk-about" was also done to catalog stencils and existing paintings in the city of Buenos Aires and material was exchanged with artists who document graffiti art.

1999

PLACING OF OBJECTS AND DRAWINGS IN THE PLAZA ROBERTO ARLT. Installation of small images extracted from drawings and paintings affixed to the plaza with resin.

JUSTICE AND PUNISHMENT. On December 8, 1999, we resined signs with the slogan Juicio y Castigo (Justice and Punishment) around the Obelisk of the Plaza de Mayo in the context of the March of Resistance, an annual initiative launched by the Madres of Plaza de Mayo.

MEMORY SIGNS. The project *Memory Signs* arose as a consequence of work with the street signs (see Road Signs 1998) and was an elaboration, both visually and conceptually, of that work. GAC was selected in the sculpture contest for the Parque de la Memoria (Remembrance Park)—an homage to victims of state terror during the last dictatorship in Argentina. Our project was chosen in December 1999. It is composed of a series of fifty-eight street signs that, in historical sequence, narrate events that occurred in Argentina, from the seventies to present day.

RAFAELAS. The group Rafaelas was born during a party organized by GAC in the Centro Cultural Torquato Tasso in 1998. The group started with a dance to one song, "Para enamorarse bien hay que venir al sur" ("To fall in love you must come south"), to which it later added "Dame fuego" ("Give me fire") by Sandro and "Mamma mia" by ABBA and another song by Raffaella Carrà. The group cultivated a certain aesthetic exultation of the ridiculous in their dress, and the choreography was developed by Mane. We got together to practice and dedicated many hours to this task. On Saturday

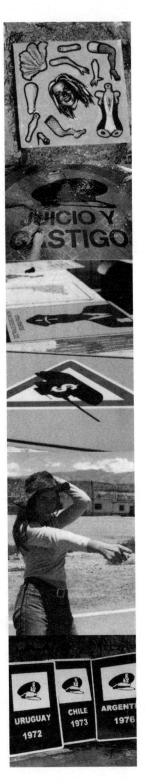

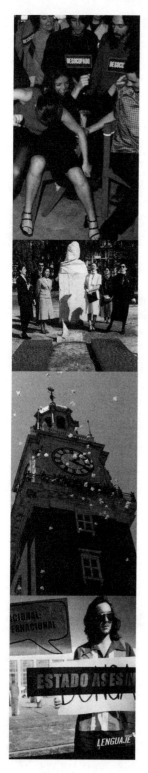

evenings throughout 1998 and 1999, this became our excuse to go out and join parties of family and friends and even to go to Ave Porco, Cemento, and Liberarte. In the summer of 1999, we went on tour, through Jujuy, Argentina, and Bolivia. Also in 1999, Antonia, Lore's mother, made matching gold suits for all the participants. The outfit was complemented by colored wigs and boas.

2000

OPERATION CONDOR SIGNS, RIO DE JANEIRO, BRAZIL (JULY). After receiving an invitation to participate in the Performance and Politics conference in Brazil, we organized an intervention in the city of Rio de Janeiro, consisting of thirty-six street signs that denounced Operation Condor, which was the systematic repression of popular resistance organized by the Southern Cone dictatorships with the assistance of the CIA and the support of the economic and intellectual sectors. Students, human rights groups, and Brazilian social organizations, such as Tortura Nunca Mais, the Movimento Sem Teto, and the Movimento por Uma Universidade Popular, all joined in this urban action. The street signs were installed along the Avenida Chile, all the way to the building which functioned as a clandestine detention center.

MUSICAL CHAIRS AT 26 SÁENZ PEÑA AVE (SEPTEMBER 26). As part of a global day of action against the G7 summit in Europe, actions were realized in different parts of Buenos Aires. *Musical Chairs* was a performance concerned with unemployment and precarity as a consequence of globalization and neoliberalization. It simulated a television game show which promised to the winner an unforgettable prize: a precarious job. This action was repeated in the IMPA, a factory whose bankruptcy had been decreed by its owners but was then taken over by its workers.

TOY SOLDIERS IN THE COURTHOUSE. Performative action accompanied by speeches and songs that parodied military manners using toy soldiers and a dais with red carpet, where the bust of a child soldier was covered up. It was the first action realized with the aim of being documented in video.

PARACHUTE SOLDIERS IN THE TORRE DE LOS INGLESES (DECEMBER 4).
Launching of two thousand toy soldiers with parachutes,
conceived as a playful action and as an exercise in experi-
mentation with materials.

POSTER INTERVENTION IN LA TABLADA (FROM DECEMBER 20 TO DECEMBER
25). In the middle of a hunger strike of more than one hundred
days by those jailed for the takeover of the military barracks
La Tablada (in 1989), we decided to make a series of post-
ers and paste them over advertisements in the street. We
designed two formats of posters. One with a black band and
white typography and three textual variants: "State Murder,"
"Complicit Journalism," and "National Justice, International
Shame." The second design was a speech bubble with white
background and black lettering, with two different texts:
"What's Happening to the Political Prisoners in La Tablaba?"
and "National Justice, International Shame."

The action was realized on the morning of December
20 and repeated on the 23rd of the same month during a
vigil organized in the Plaza de Mayo by human rights orga-
nizations. In this action we collaborated with H.I.J.O.S. and
other organizations. Posters were hung from downtown out
towards the metro stations of Retiro and Congress. Around
two thousand five hundred posters were hung.

2001

HERE LIVE GENOCIDISTS (MARCH 24). Triptych composed of a post-
er, video, and personal agenda that was distributed during the
march of March 24. The poster is a map of the addresses of
escrached genocidists, while the agenda contains their phone
numbers and home addresses. The video presents the homes
in two different moments: during any given day and then on
the day of the escrache. The poster was reprinted on March
24 of 2002, 2003, 2004, and 2006. Each instance transformed
the design and new addresses were added.

HEMISPHERIC INSTITUTE OF PERFORMANCE AND POLITICS, MONTERREY,
MEXICO. The GAC was invited by the Hemispheric Institute
of Performance and Politics to participate in the gathering
"Memory, Atrocity and Resistance" in Monterrey, Mexico
June 14–23, 2001.

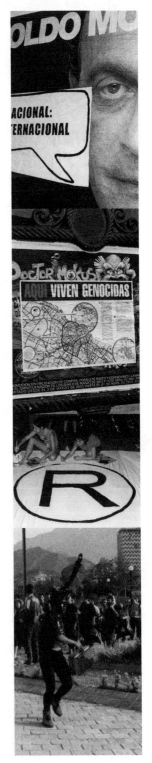

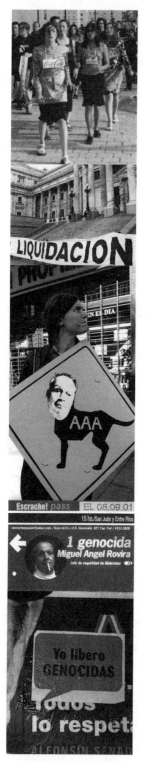

This project's backbone was to denounce the forms of production used by transnational companies in the Third World. Monterrey is an industrialized city very close to the U.S. border and has a number of maquiladoras. We collaborated in this intervention with a number of groups from around Latin America. The action sought to parody consumption, using the idea of a "procession" from the plaza in front of the Palacio de Gobierno, where a white flag painted with a large ® was raised. The flag was raised where the official Mexican flag would normally be. The participants in the procession carried black bags filled with trash that were imprinted with the logos of various transnational businesses. They were placed in a line between the Palacio de Gobierno and the "taken" flagpole. At the same time, a virtual action was undertaken, in which the websites of these companies were interfered with.

LIQUIDATION CLOSEOUT SALE (JULY 20). During the protests against the G8 in Genoa, Italy, a thirty-meter-long banner was fabricated with the phrase "Liquidation Closeout Sale." On the far left of the flag was the Argentine national seal and on the right the logo of the International Monetary Fund.

With the intention of denouncing the shrinking of the state, we resignified a phrase commonly used in a commercial environment. The action consisted of unfurling this flag in front of the Casa Rosada, the National Congress, and the Obelisco. Previously it was utilized in the context of mobilizations against the cuts and against the Zero Deficit Law.

ESCRACHE-PASS (SEPTEMBER 6). Thousands of passes were printed for the metro system, similar to those used by the company that administers the metro, escraching Miguel Angel Rovira, ex-member of the Triple A (Argentine Anticommunist Alliance) who at that time was employed in personal security. The "escrache-passes" were handed out during the peak hours of metro use in an intensive action across all the metro lines, both in the morning and afternoon, and in which we organized ourselves into multiple teams. We also undertook the sale of "tickets against impunity" inside the metro cars, and we affixed stickers denouncing the complicity of the company that controls the metro.

INTERVENTION OF ELECTION POSTERS (OCTOBER). As part of the coordinating group of Direct Action, we realized an intervention into election posters during the congressional race in October 2001. We designed two different models. The first with the form of a danger sign in which the word "danger" was replaced by either "hunger," "unemployment," "impunity," or "police brutality." In the other, a speech bubble contained different texts: "With me there is hunger," "With me there is unemployment," "With me there is impunity," and "I free genocidists." This intervention was realized for the week leading up to the elections in Buenos Aires and in several parts of the greater metropolitan area.

BANNER OF DANGER (DECEMBER 10). As part of the Direct Action collective, a banner one hundred meters long and one and a half meters high was created. Its design was a background taken from striped danger signs over which we wrote text that repeated the length of the banner: "Unemployment, Exclusion, Hunger, Repression, Impunity." The banner was conceived to be placed in front of Congress on the day of the swearing in of congresspersons and it was then placed outside in front of the building of the Ministry of the Treasury in the context of other mobilizations and marches.

INVASION (FROM DECEMBER 16 TO DECEMBER 19). Launch of ten thousand parachute soldiers from a building in the city center. During the week before the action, the surrounding area was covered with stickers of military icons: the tank, symbolizing the power of the multinationals; the missile, linked to media propaganda; the soldier, alluding to the repressive force necessary for the system to maintain the neoliberal order. The action coincided with the beginning of the popular rebellion during December 19th and 20th, 2001

2002

HOMAGE TO THOSE FALLEN TO POLICE REPRESSION ON DECEMBER 20TH, 2001 (JANUARY 10). A collective formed by family members and friends of victims of police repression organized several marches to demand justice. During the mobilizations the places where the fallen were slain by police bullets were marked, first with resined plaques and then with ceramic. The plaque in memory

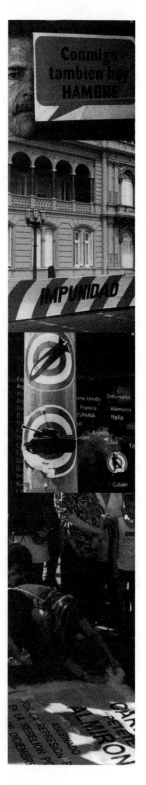

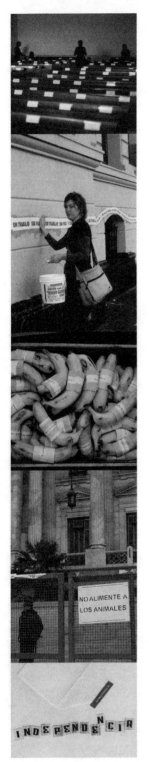

of Gustavo Benedetto was always destroyed the day after the mark, until one day those destroying the plaques were caught: they were the police in charge of watching the HSBC bank headquarters, which was the exact place from which the shots were fired that killed this young man.

STICKERS. On March 20, 2002, and April 19, 2002, hundreds of stickers were affixed to desks in the classrooms of the University of Buenos Aires School of Law, with the names of the disappeared who were students or who had worked at the school.

WITHOUT BREAD AND WITHOUT WORK (MAY 1). With the group Direct Action, posters were hung with this phrase, as a continuous border around the buildings of the court, City Hall and the Plaza de Mayo.

THE PEOPLE KNOW WHAT'S UP (MAY 25). Performance action to intervene in the Tédeum (national prayer day) on May 25, which took place as part of a march in front of the cathedral in Buenos Aires. In place of the traditional rosettes bearing the Argentine flag, bananas were handed out that read: "The People Know What's Up."

DON'T FEED THE ANIMALS (JUNE 27). Action of intervention on police barricades in a moment in which the city appeared assailed visually by this type of movable border due to the huge number of daily protests. We proposed an alteration of the meaning of these barricades, moving towards considering them as cages in a zoo in which the police themselves were enclosed.

INDEPENDENCE DAY (JULY 9). We handed out small envelopes with letters forming the word "independence" among people in front of City Hall, inviting them to put the word together in a game of anagrams. The people began to play on the ground, trying to figure out the word and then they put together other possible words by themselves or in small groups.

THE APPLE DOESN'T FALL FAR. . ." (SEPTEMBER 9). Congressional Plaza. Inspired by the idiomatic expression, a poster was created to accompany marches and street actions at which

police were present. The intention was to denounce repression and violence not as isolated incidents, but as a constitutive element in the functioning of the security apparatus. "Your reputation precedes you: it's not just a policeman; it's an entire institution" (reads the poster).

VISUAL POEM FOR THE STAIRS AT THE LANUS STATION (OCTOBER 19). A list of repressive actions by security forces, in ascending order by date, while the violence of the words increases with each step as well. This action was undertaken in other urban spaces as well.

ACTION FOR SIX HOURS (OCTOBER). In the context of a conflict between leaders of unions of metro workers demanding a reduction to the length of the working day due to toxic working conditions underground. Flyers explaining the reason for the mobilization were handed out with the same design as the instructional forms of the metro system. The flyers were developed with the collaboration of metro workers and handed out throughout the system.

WHERE THERE'S SMOKE… (DECEMBER 4). Activity of marking traces left by the burning of barricades in Plaza de Mayo during the popular rebellion of December 20th, 2001. The traces were marked with asphalt, paint, and stencil, making visible on the street the altercations that, almost a year after the events, continued to affect us.

CONNECTED (DECEMBER 14). Utilizing the aesthetic and format of posters that indicate that a building is being monitored and protected by a private security company, we denounced Segar, a private security company that employs the torturer Donocik. This small poster was hung around the neighborhood where the escrache was taking place.

2003

MINISTRY OF CONTROL. NATIONAL PLAN OF EVICTION (MARCH 9 AND 16). The action was carried out in San Telmo in order to question the evictions that were ordered by the city of Buenos Aires in various parts of the city, especially in the historical center of the San Telmo neighborhood. These

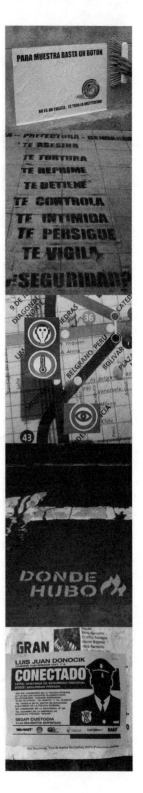

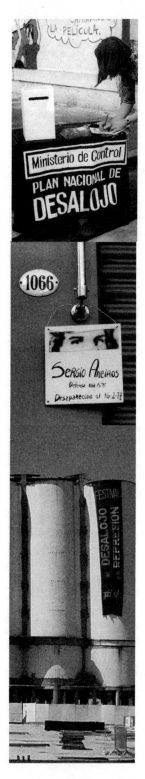

evictions were motivated by real estate and financial interests linked to the surge of tourism in the area. Some of them were violent and affected dozens of poor families. A week after these events, we placed a stand on the busiest corner of the central district, from where "official" promoters of the "Ministry of Control" polled neighbors and tourists. The questions were framed ironically, asking how they would like to get evicted, how best to waive the right to adequate housing, or how it was desirable to become one of the "excluded." The activity was completed several times and was expanded to different contexts.

EVICTION AND REPRESSION FESTIVAL (MARCH 9). As part of the Fifth Buenos Aires Tango Festival, the government of the city of Puerto Madero developed a performance titled "Puente de Luz" (Bridge of Light). We unfurled a seventeen-meter vertical flag from warehouses located near the stage. The crowd immediately associated the text in the flag—which included the government's seal—with the violent evictions that had occurred that same week.

HOMAGE TO THE DISAPPEARED OF SAN TELMO (MARCH 23). Activity, organized by neighborhood groups linked to the construction of memory and the defense of human rights, which consisted of walking to the houses where the disappeared from the neighborhood used to live. During this walk we marked the facades with posters and painted the sidewalks with fragments of poems and songs that people had suggested and which referenced the struggles of the seventies.

SHOPPING POLLS (APRIL 19). The Ministry of Control polls were also carried out in the food court of the Abasto Shopping Mall as part of a series of actions seeking to denounce the evictions implemented by the city of Buenos Aires.

WOMEN WORKERS WORKING. Road signs with the slogan Women Workers Working were put in the vicinity of the Brukman factory on the same day that its women workers were evicted. These signs sought to make visible two elements: the labor force represented by these women and the encampment they made—both united in the demand for a job with dignity.

CLOTHES HUNG IN THE NEIGHBORHOOD (APRIL). During the time of the encampment in front of Brukman, the women workers hung clothes in the blocks near the factory with different inscriptions on each piece of clothing, demanding the return of their jobs.

BANNERS FOR THE WORKERS OF BRUKMAN (MAY 27). Completion of a large banner composed of many paintings made by public school students in the suburbs, who worked with the women workers of Brukman to understand the recovery of the factories and the situation of unemployment. This banner was sewn during the encampment in front of the factory and it circulated in different schools in the Buenos Aires suburbs.

SHOPPING FOR ARTISTS (APRIL). A building next to the Buenos Aires Museum of Modern Art (MAMBA), which had been occupied by neighbors from the Movimiento de Trabajadores Desocupados de San Telmo, was the site of a new eviction. The jobless were pushed out in order to annex the land to the art institution, which is dependent on the city government. A poster that read "Shopping Center for Artists Coming Soon" was placed in front of the building.

EVICT YOURSELF IN PROGRESS (MAY 3). Centro Cultural General San Martín. The GAC was invited to participate in a collective show at the Centro Cultural General San Martín (funded by the city government) called *Arte en Progresión* (*Art in Progress*). People linked to the curation of the exhibition belonged to MAMBA, an institution linked to the eviction of the Unemployed Workers Movements, mentioned above. With Colectivo Situaciones, we presented the *Desalojarte en progresión* (*Evict Yourself in Progress*) project, challenging the indifference of local art world through the installation of sand with flags and posters promoting the opening of a "shopping center for artists." We carried out surveys among the public and artists who commented on what roles the museum could have in the newly vacated space. There was a strong tension when the Secretary of Culture of the City of Buenos Aires, Jorge Telerman, came in, who when pressed on his complicity in the evictions, tried to question the "artistic quality" of the "work."

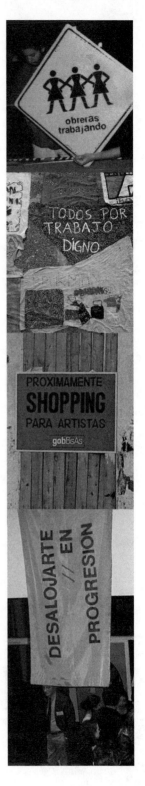

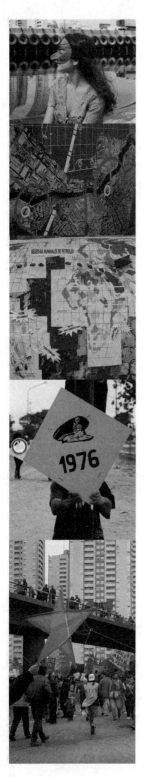

BOAT TOUR OF THE RIACHUELO (MARCH 28). We filmed a video during a boat trip on the Riachuelo, a river that borders Buenos Aires, in which we simulated riding a gondola. This audiovisual was projected as part of the show we had at the Venice Biennale.

CARTOGRAPHY OF THE RIACHUELO (JUNE 15). A map was created from the dividing line of the Riachuelo (which separates Buenos Aires from the suburbs), which allowed us to report different events: from the assassination of Darío and Maxi in Avellaneda and the denunciation of the Operation Condor to the *Aquí viven genocidas* (*Here Live Genocidists*) and the poverty index. We were working on each of these issues while preparing this cartography.

OIL MAP. As a way of participating in the protests against the U.S. invasion of Iraq, we built a world map with graphs of the oil fields, placing little toy soldiers and explosions like the ones used in comics, where we wrote about the different conflicts in which the United States interferes. Two of these maps were realized on walls adjoining gas stations.

PROTEST IN LEDESMA (JULY 26). Every year, there is a protest in the city of Libertador General San Martín in the province of Jujuy to repudiate the blackout, an event that occurred at the Ledesma sugar mill during the military dictatorship and which evidenced the close collaboration between the large companies and the military in the disappearance of people. We prepared a group of road signs that denounced this complicity, emphasizing the present-day consequences.

KITES. Kite-making workshop with social organizations in the south zone of the Buenos Aires suburbs. We used the caption Justice and Punishment since the goal was to fly them during the strike at the Pueyrredón Bridge where we denounced the assassination of Darío Santillán and Maximiliano Kosteki at the hands of the repressive forces on June 26, 2002.

ANTI-MONUMENT FOR JULIO A. ROCA COMMITTEE (FROM OCTOBER 2003 TO JUNE 2004). Roca is considered a national hero and he is exalted by history textbooks as well as by the conservatives. Among his greatest "works" was the Desert Campaign, which expanded the border of the emerging Argentine State at the cost of the extermination of the Native populations of the Pampas and Patagonia regions. The seized land was distributed among the Creole oligarchy, assigned in return to the victorious military men and sold to foreign companies, among them the Compañía Argentina Tierras del Sur, currently a holding of the international corporation Benetton. Various interventions were completed against the monument of Roca located in the center of Buenos Aires, including the change of the street name to recall the genocide. A publication was also printed.

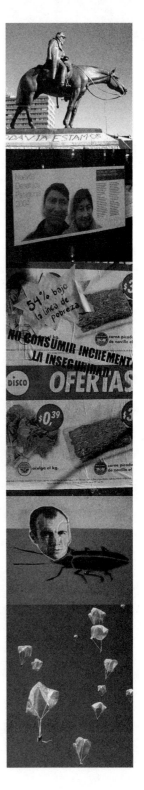

ALL LAND IS STOLEN BY BENETTON. In a poster we denounced Benetton for the eviction of the Curiñanco family, who, along with the rest of the Mapuche community, are the rightful owners of the lands pillaged both yesterday and today. In order to address the criticism, Benetton created an ethnographic museum in the zone (just another tourist attraction), where traditional cultures of the Natives are exhibited as an archeological trophy.

SUPER $ECURE (NOVEMBER 8). Media discourse promoted the criminalization of poverty and demonization of any type of protest, mobilizing groups to demand order, repression, and zero tolerance. Trying to combat the ideology of security, we distributed flyers where we linked the business of security with unemployment statistics and noted the reintegration of genocidists into private security companies and the continuation of the repressive methods employed during the dictatorship.

2004

THEY ARE INSECURITY (MAY). Stencils and wallpapers with images of cockroaches wearing police officer hats, or with the faces of the main ideologues of zero tolerance policies. We went on several outings, the first of them experimental, through the neighborhoods on the south side of the city.

ACTION ZONE, SÃO PAULO, BRAZIL (JUNE AND JULY). With different artistic and political groups of São Paulo, We carried out an action against the gentrification of the Largo de Batata neighborhood with the Bijarí collective, we developed an activity in the south side with Frente 3 de Fevereiro to denounce racial profiling, and finished a survey about contemporary forms of racism. We executed an intervention in the city center with the groups Radioactividad, Contrafilé, and Cobaia, which con- sisted in the launching of parachuted soldiers.

MAP OF CONSUMPTION (MARCH THROUGH MAY OF 2004). Created for the exhibition *Ex Argentina: Pasos para huir del trabajo al hacer* (*Ex Argentina: Steps to Flee from Work to Doing*), which took place in the Museum Ludwig in Cologne, Germany between March and May of 2004, with the participation of numerous groups and Argentine artists. In the space intended for cartography, we mapped four transnational corporations with the intention of creating a critical perspective on what we consume, making visible the relationships and entanglements between genocide, economic power, and the landed oligarchies throughout history. We also distributed flyers on the streets containing fragments of the cartography shown at the exhibition.

SAN CAYETANO, FOR THE SIX HOUR WORKDAY. Union groups and leftist political parties formed a committee to promote the reduction of the workday that currently exceeds eight hours and, in some cases, reaches twelve hours. As part of the series of actions promoted by this group, there was a massive distribution of prayer cards in the lines of the faithful who, every 7th of August, attend the San Cayetano church to ask the saint for a job. Each year thousands of people arrive from faraway places and camp on the streets during these weeks in order to be the first ones to enter the church. The prayer cards that we distributed reproduced the image of the saint and on the front (in prayer form) we printed the request for the reduction of hours in the workday, an end to exploitation, and an increase of salaries. Some prayer cards were given to the priests in charge of managing the ceremony.

MOVING TARGETS. Grupo de Arte Callejero was invited to a meeting in Medellín, Colombia. There we participated in a workshop with students and teachers from a school where a series of "moving targets" (paper bullseyes) were used as graphic support to be intervened upon by the boys and girls who then denounced the violence of everyday life. They were pasted at a street corner in the center of Medellín.

2005

SPEECH BUBBLES (MAY 24). During a protest on March 24, 2005, we pasted speech bubbles with a series of questions over advertising posters: "Do you know that Carmen, Marcela, and Margarita are imprisoned in Ezeiza because they asked for work?" "What happened with the political prisoners?" "Did you know that Elsa, Marcela, and Selva are imprisoned in Caleta Olivia because they asked for work?"

2006

MOVING TARGETS. We published a booklet with all the actions that emerged from the "moving targets" interventions by different groups and in different provinces or countries. Each collective that took the image (of the bullseye) as a support to talk about or denounce their community's problems inscribed into the image different contexts, which differed according to the identity of each social group and its history of participation in local struggles. The publication allowed us to construct a map of these dis-similar experiences, attempting to generate new positions from which to rethink them, searching to replicate what emerged as a multiple unity. We worked with FM La Tribu and Diego Perrotta to make a presentation and create a means of distribution for the booklets. *Antirepression Posters on the Westside.* Posters made with the Frente Antirrepresivo de la Zona Oeste, formed by neighborhood organizations, the Movimiento de Trabajadores Desocupados and the group H.I.J.O.S. They were placed in the main streets bordering the railroad tracks, like a survey, where a passerby could intervene by marking with a cross her response to the following questions: "What are you most afraid of?" And "What does the police do best?"

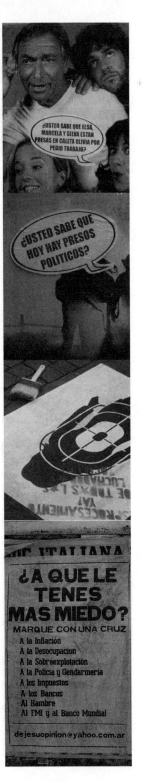

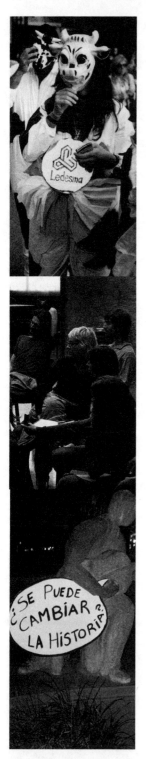

RURAL ACTION. Performative action in which a group of people dressed up as cows burst into the headquarters of the Sociedad Rural Argentina (Rural Society of Argentina), at the same time as the celebration of the book fair, to denounce how the landholding oligarchy and the large multinational corporations are monopolizing the lands in southern Argentina. This activity was held to mark the presentation of the book *Historia de la crueldad argentina*, which deals with the figure of Julio Argentino Roca and portrays him as a nefarious character in our history.

2007

THE MINISTRY OF PUBLIC SPACE (FROM 2007 TO 2008). We participated in the organization of two meetings in the cities of Rosario and Buenos Aires, and, together with various groups from across the country, we performed interventions in public space. During these meetings, days of debate took place in which we discussed the political context and we exchanged photographs, videos, publications, objects, and posters.

MARCH ON THE ANNIVERSARY OF THE MASSACRE IN MARGARITA BELÉN, CHACO. As part of the march, we designed speech bubbles to be placed by means of wires on sculptures and objects across the city. The phrases were proposed by the participants in the demonstrations. Resistencia, the capital of the province of Chaco, is distinguished by its promotion of culture through an international sculpture contest which began in the mid-twentieth century. Due to this, it has received a large number of works by numerous international artists that adorn every corner of the city.

2008

THE GAME OF LIFE. This audiovisual piece proposes a tour of the city and the suburbs of Buenos Aires, confronting the spectator with social inequality, consumerism, control mechanisms, the fear internalized and naturalized by the omnipresence of the zero-tolerance discourse, and tracing borders as visible areas that include or exclude people. It was an attempt to discover how public spaces change when

all of these government mechanisms are put into practice, and how the urban language is altered in order to investigate how efficient the interventions in these sites are and their effects on the bodies that pass through them.

2010

ANTI-MONUMENT (MAY 23–26). Gateway of the Bicentennial. Installation of an LED gateway for the official celebrations commemorating the Bicentennial of Argentina. A large LED arch was positioned above and around 9 de Julio Avenue which contained scrolling text like that used in LED signs exposing issues such as: colonialism, racism, the independence of peoples, history and the role of women, collective memory and heroism.

KEY ACTORS OF HISTORY (MAY 25). Intervention dedicated to historical disclosure carried out in the context of the Bicentennial with the "Vulgar History" collective. Series of debates hosted during the period of one year in the headquarters of MU La Vaca in order to make interventions into historical revisionism that included: postcolonial the- ories, the subaltern and emancipative discourse, and a Latin Americanist perspective. Creation of a "BILLIKEN" style booklet and of a street stand with key popular actors from the revolutions and popular revolts that changed history.

INTERVENTION CONCERNING THE POSESSION OF LAND AND GENTRIFICATION (NOVEMBER 13). Intervention with posters made with neighbors in the neighborhood of Las Tunas, municipality of TIGRE, on a wall that divides a working-class neighborhood from a country for the rich.

2011

TRIBUTE TO THE DISAPPEARED (MARCH 23) of the UNA (Universidad Nacional de las Artes). Paper lamps with the gazes of the university's disappeared illuminated by candles, a vigil following an attack on the images of the university's disappeared.

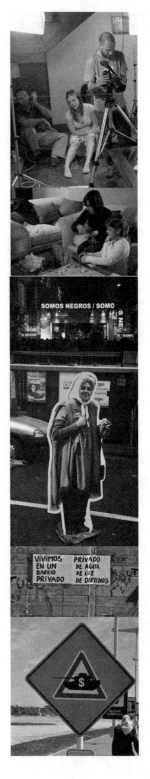

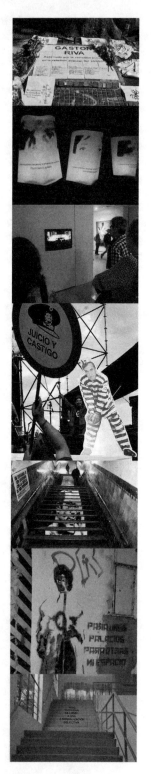

COLLECTIVE EXPOSITION, "EL PANTEON DE LOS HEROES", OSDE FOUNDATION (FROM MARCH TO MAY). Buenos Aires, curated by Isabel Plante and Sebastián Vidal Mackinson. ANTI-MONUMENT OF THE BICENTENARY: Video registration of the bicentennial gateways.

PATTI, PERPETUA. Doll with the torturer's face dressed in clothing characteristic of a prisoner. On the occasion of the sentencing of the torturer Luis Patti.

DARIO AND MAXI STATION (JUNE 6). Interventions on the staircase that leads to the platforms with the faces of Darío Santillán and Maximiliano Kostecky along with text.

GRAPHICAL INTERVENTIONS IN THE RODOLFO WALSH STATION (JUNE 7). Hanging of a large-format poster of the writer on the station platforms and textual interventions on the stairs by the disappeared journalist and writer Rodolfo Walsh: "THE WALLS ARE THE PRESS OF THE PEOPLE."

"FOR SOME A PALACE, FOR OTHERS NO SPACE" (NOVEMBER 18). Work on gentrification and real estate in the south of Buenos Aires. Stencil with an image of one of the women strikers who led the demand for lower rents during the tenant strike of 1907.

TRIBUTE TO THOSE MURDERED BY THE POLICE REPRESSION OF DECEMEBER 20, 2001. Restoration of the plaques. Realization of the event HOMAGE TO THE TEN YEAR ANNIVERSARY OF 19 & 20.

2012

CONTI EXPOSITON. "POETICAS DE LA MEMORIA." "ALL KINDS OF CRIME GIVE RISE TO SELECTIVE CRIMINALIZATION" (FROM MARCH 16 TO JULY 25). C.C HAROLDO CONTI. Curated by Gabriela Bettini y Andrés Labaké. Cristina Ramos y Barbara Tardón.

PHOTOGRAPHICAL INTERVENTION WITH THE PORTRAITS OF THOSE EXECUTED IN TRELEW, START OF THE TRIAL (MAY).

INTERVENTION AT THE RODOLFO WALSH STATION (JUNE 15).

STATION DARÍO SANTILLÁN AND MAXIMILIANO KOSTECKI (JUNE 25). Intervention at the tribute to Darío and Maxi with an inflatable cube for playing in the space of the station carrying the words: think them, say them, shout them, PRESENT!

INTERVENTION IN LEDESMA, JUJUY (JULY). At the start of the trials of the civilian accomplices of the dictatorship. Intervention on walls with the words: "BLACKOUT" – "FIEFDOM" – "HARVEST."

INTERVENTION "PRESENT" in the former ESMA, on the walls of the buildings, with large-format portraits of the faces of those disappeared in the ESMA, made with family members. Activity of several days that began on September 4, 2012.

2013

INTERVENTION "PRESENT" (MARCH 9) in the municipality of MORÓN. Tribute to the women of MORÓN who disappeared during the dictatorship.

EXCHANGE WITH THE GROUP "APARECIDOS POLITICOS" FROM CEARÁ, FORTALEZA, BRAZIL (FROM MARCH 29 TO APRIL 6). Talks, workshop on urban intervention, intervention with the faces of the disappeared of Fortaleza in the UECE Universidad de Historia.

EXCHANGE WITH THE GROUP "APARECIDOS POLITICOS" FROM CEARÁ, FORTALEZA, BRAZIL (FROM MARCH 29 TO APRIL 6). Intervention of denunciation at the mausoleum dedicated to the first Brazilian dictator, Castelo Branco. Realization of floating lanterns with the faces of the disappeared of Ceará.

INTERVENTION WORKSHOP AT THE UNIVERSIDAD DE ARTE OF SANTIAGO DEL ESTERO (MARCH 9). In the framework of the International Festival of Cinema and Human Rights, we created performative productions, posters, and direct actions in the context of the trials for crimes against humanity in that province.
POLITICAL APPEARANCES (FROM SEPTMEBR 17 TO SEPTEMBER 23). Exchange in Buenos Aires with GAC. Joint work on interventions in recovered torture sites and talks.

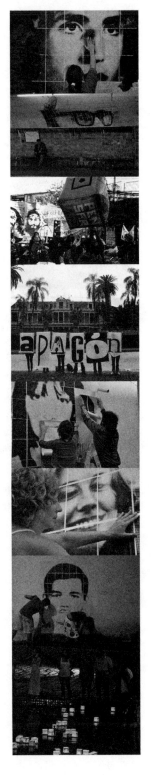

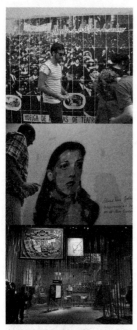

MAP – SCENE (OCTOBER 11). Intervention with an image of the actors' strike from the early 1900s, within the framework of the recovery of the memory of a neighborhood via a journey through performance spaces.

2014

COLLECTIVE EXHIBITION "DISOBEDIENT OBJECTS" (2014–2015), Victoria & Albert Museum, London, England. Curators Catherine Flood and Gavin Grindon.

2015

EXPOSITION "VOLÁTIL FELICIDAD" (FROM MAY TO OCTOBER 2015). Sala PAyS of the Parque de la Memoria. BP15; curator, Rodrigo Alonso.

ART PRODUCTION FOR THE DOCUMENTARY SERIES "HIJOS DE UNA MISMA HISTORIA" ("Children of the Same History"). Tells the story of the group H.I.J.O.S. in five chapters. Canal Encuentro.

BP.15 en el Parque de la Memoria

EXPOSITION RESISTANCE PERFORMED: AN ANTHOLOGY ON AESTHETIC STRATEGIES UNDER REPRESSIVE REGIMES IN LATIN AMERICA. (FROM NOVEMBER 21, 2015 TO FEBRUARY 7, 2016). Migros Museum, Zurich, Switzerland; curator Heike Munder.

ANTI-MACRI CAMPAIGN (SEPTEMBER AND OCTOBER). Realization of a series of interventions in relation to the second round of the presidential elections of 2015. In neighborhoods of the federal capital, replicated by other groups in different spaces of militancy.

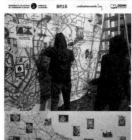

2016

WE ARE NOT "GNOCCHIS." (JANUARY 29). In popular tradition the 29th is when you eat an Italian pasta called gnocchi, which in popular slang means "lazy" and often refers to state employees. Following the start of cuts to state services and firings in both the public and private workforce, we organized a ñoquiada in different parts of the city with extensive media coverage and union and popular participation. GAC

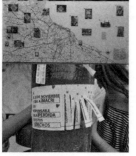

participated with other groups in its production and organization. Plaza Congreso.

INTERACTIVE COMIC, TO BE PHOTOGRAPHED AND UPLOADED TO SOCIAL NETWORKS (FEBRUARY 24). First strike of the government of Mauricio Macri with mobilization of CTA-ATE and trade unions. Dialogue bubbles, with the slogans: STOP! – WORKERS ON STRIKE – THE BEST POLITICAL POSITION.

PERFORMATIVE ACTION DURING THE MARCHES FOR THE LIBERATION OF MILAGRO SALAS, popular leader of Jujuy, political prisoner of the governments of Morales and Macri. Creation of masks with his face (MARCH).

INTERVENTION "WITHOUT BREAD AND WITHOUT WORK" (MARCH 12), in the Centro Cultural de la Memoria Haroldo Conti during the action against workforce firings, with union organizations and workers. "EL CONTI NO SE ACHICA."

STICKERS (MARCH 24). On the economic complicity of the current government with the civil-military dictatorship.

ACTION WITH THE BANNER "LIQUIDATION CLOSEOUT SALE IMF" (APRIL). Hung in front of the National Congress during the vote concerning the payment of the Argentine foreign debt to bondholding vulture funds.

"WITHOUT BREAD AND WITHOUT WORK (NOVEMBER). On the occasion of the retrospective exhibition of De La Cárcova at the Museo Nacional de Bellas Artes, cu- rated by Laura Malosetti Costa. WITHOUT BREAD AND WITHOUT WORK was a reference to the work of De La Cárcova of the same title, one of the most important works of Argentine political art.

2017

INTERVENTION SUPPORTING THE "ITINERANT SCHOOL" (MARCH). After brutal police repression, we made posters with the message: "For rent or trade. Recess by the law of educational financing" and "For rent or trade. Recess for educational wages." In front of the National Congress.

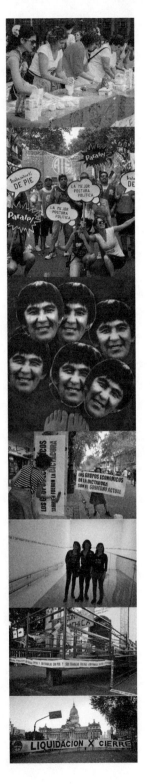

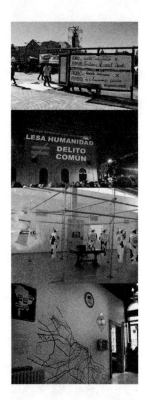

NO TO 2 FOR 1 FOR GENOCIDISTS (MAY 10). Massive march organized by human rights organizations, workers, unions, and other organizations. Projection of texts on the wall of the metropolitan cathedral. Action carried out together with Proyecciones Nómadas. Plaza de Mayo.

COLLECTIVE PROJECTION (JUNE 3). A collective projection during the march against feminicide, GAC with Proyecciones Nómadas and Mujeres Públicas. Plaza de Mayo.

GAC RETROSPECTIVE "LIQUIDATION CLOSEOUT SALE: 20 YEARS OF GAC" (FROM OCTOBER 2017 TO FEBRUARY 2018). In La Sala PAyS of the Parque de la Memoria. Curators: GAC, Florencia Battiti. Catalog texts: Ana Longoni.

2019

ARTIVISM EXPOSITION, ORGANIZED BY THE AUSCHWITZ INSTITUTE FOR PEACE AND RECONCILIATION (AIRP) (FROM MAY TO NOVEMBER). Venice Biennale. Curators: Kerry Whigham, Francesca Giubilei and Luca Berta.

EPILOGUE

By Colectivo Situaciones

I.

Having finished reading this book, we had the feeling that the three letters that form GAC had been completely deranged. As if each had gone crazy on its own and infected the others to the point that they had been overcome by a convulsive state of trance. Now, more than a name, these three letters are a magic formula.

The very idea of a *group* was disguised, in these pages and across these years, in tones of the first person that lived promiscuously alongside the most varied collective actions. The group is a concrete operation: it is necessary to enter its working each time, and this is never done the same way twice. It is constructed and deconstructed following the discussions the group is having or according to the journeys that it is ready to undertake. The GAC is not a group but a repertory of operative forms, which make of their plasticity a production that is at the same time local, detailed, untimely, and collective.

Their methodological thought, as *they* have described it, implies a set of procedures that unite materials, strategies, and political decisions in a desire for intervention. And in this sense the group is nothing more than the name of the fantasy or surface of a "production through movement." The movement they search for, detect, and coproduce—but also their thinking and planning—is what activates each intervention. They move and produce, offering nothing to no one (they don't offer "artistic" services) and, at the same time, making themselves vulnerable to everyone (opening a public space with others).

They have laughed without end at the very notion of *art*. First it was a trick: using it to be considered "innocuous." Art as the perfect excuse to appear inoffensive. Using art as one uses a false passport. But later *they* have to be alert: art began to be in fashion if attached to the adjective "political." Then, the word art was a stain that could spread, a sticky substance with a devastating effect: banalization. From

the innocuous to the banal, the group decided to think and discuss a *use* against the various offers of "stardom."

A criterion was constructed for their own practice: that of risk. What does a risky action mean? On one hand, the risk of chance. As a form of escaping the pure calculus of effects, to enrich the intervention with a dimension that was never completely planned. The risk of an opening to what might happen. And this risk is only run in one place: by being in the street.

The street obliges us to imagine secret relations between hacked street signs and neighbors who once walked by unhurried but now are assaulted by a new memory of the present. It also allows for the tracing of unexpected connections: between soldiers who drop onto the rooftops and a president who escapes across them. And it produces entanglements charged with violence: between fake functionaries of non-existent organisms of control, the un-occupied who protest, and the artists who exhibit in museums.

If in some moment the GAC said that it felt suspended in a "limbo of languages," without knowing where to get a grip, we risk the hypothesis that it has finally managed to drive mad all the languages it has been offered. And now its innovations are free, as virtual and real marks in the city. The wake of the intervention is stamped on a plaque of homage in a plaza that resists traces. Or in the immateriality of the memory of a neighborhood that drove out a genocidist with whom it lived but that has now condemned his impunity.

II.

What is a collective? What happens when public action, or better yet, common action (which being already "for everyone," doesn't offer itself up to the administration of the state) is developed via collectives?

First, we witnessed the so-called crisis of representation, a vague or academic way of naming the abandonment of certain relations which, one had supposed, were "natural" institutions for processing our discontent: the parties, unions, museums, the state. Then appeared the possibility of limiting ourselves to individual careers, while collective action appeared oriented towards the NGOs and the volunteers of civil society. Finally came the media codification and privatization of affects. But what happens with politics, that is: with the collective treatment of this discontent?

During a time, we spoke of "social movements," or more accurately of "new social protagonisms." Something fleeting, perhaps, but both effective during the crisis and mobilization and useful in unfolding new territories of critique and problematization. We placed a great deal of emphasis on interpreting these new actors as a site of elaboration of heretofore unseen subjectivities.

Perhaps this is the time to speak of *the collective* as that which exceeds the present of the collectives, to open the horizon of its possibility.

What can we say of this here and now from which we speak? To begin, we have to realize how the common space of the movement has been subordinated and fragmented. This is not something that is easy to speak about, as we have always been skeptical of unity as the basis of political protagonism. In fact, we have lived with joy the plural character (in the organization, the styles, and the perspectives) of the social initiatives which emerged during the mid-nineties. We argued as much as we could against the idea of homogenizing these expressions, from a hegemonic conception of concerted action. And we sustained that in this multiplicity there were sufficient forces and intelligence so that the work of co-ordination would be a kind of comparison of various rich experiences, capable of partial syntheses, fueled by a destituent power. We have witnessed to what point this multiplicity produced a new political space, making possible practices, points of view, and singularities that circulated and nurtured in a complicated manner this set of groups. When we speak, now, of subordinated fragmentation we are not referring to this or that movement but rather to the weakening that this dynamic politicization suffered.

We don't want to repeat ourselves yet again, and return to speak of the same, with this tone of taking account that never makes a difference. This time we pose for ourselves a concrete question: what happens with the "collectives" or more accurately with *the collective* as an instance of politicization, which, against every prediction, has not only not disappeared but, moreover, continues elaborating the coordinates of a new vitality of the common?

Clearly not everything in the collectives is interesting. This duty to "groupality" is particularly boring and annoying when not placed in service of the truly common. In our experience the group is not always a space for *the collective*, especially when it solidifies as a set of persons already formed, with opinions and feelings already defined, with stable identities. But *the collective*, that we are naming here, inspired by the images that this book of the GAC gives us, is *temporalization*, testimony and record; a trans-individual basis that sustains voices and bodies, in their attempt to gather forces, to go beyond what we are or what we were. The collective exists in the ability to invent for itself functions that unfold in a self-determined manner. What is this self-determination that, while free, is not capricious, because it supposes a convergence of desire, a putting in movement of the social? What is the collective when it doesn't conform to unity and consensus, because it prefers to follow the laborious intuition of a social energy that is always displacing itself? How to obviate today this dimension of the collective, when narratives are placed again in dispute and the necessity of the invention of expressive forms is reopened, now overwhelmed by semiotic complexity and chaos?

The collectives have been frequently reproached for lacking a political perspective capable of institutionalizing social creativity. In the current moment, when the attempt to re-establish the system of parties and the play of representation places the movements in a subordinated position (as carriers of demands), the experience of the GAC reminds us to what point the deepening of the political process requires a reanimation of an authentic democracy of collectives.

III.

During the process of construction of this publication we have perceived the motivations and feelings that animate it. The first time that our friends in GAC spoke to us of the idea of a book, we felt the difficulty that it implied: "We don't want an antiseptic record of artistic catalogues; nor a biography of a successful group, with its inevitable posthumous tone; nor a beautiful story of lost youth."

There is a "memory of potencia" constructed via what was lived in Argentina in recent years that resists being converted into yet another pseudonym of power. It is not just a naive or innocent memory, in the sense of being a mere remembrance. At the same time, it is necessary to avoid any consecration, however well-intended it might be, because every attempt to offer a "legacy" to those to come will accomplish nothing more than putting into play once again generational hierarchies, instituting new pantheons that must be revered. What interests us is the persistence of certain sensorial intensities, as an echo that returns but whose meaning is difficult to make out, but which serves to question the closure of experimentation in the name of "normality." If this persistence reminds us of something—though it doesn't offer any certainties— it is that the world is an infinity of perceptions, essentially incomplete, eternally unsettling, where it is always possible to re-begin the search without having to retreat and even less without having to search for justifications.

It is true that it is not easy to synthesize this temporality of an everyday made up of insecurities and pathologies, in which panic and the most varied symptoms of stress are diffused, and in which we attempt to weather the storm with therapy or consumption. When the collective dimension of suffering is annulled, psychologized or spectacularized by the diffusion of semio-capitalism, our work becomes an attempt to not position ourselves in this territory of worries and "working hours." We have to invent procedures that take as their focus the counter-performative capacity of making things with words and images, to vomit up this threatening world that the ideology of insecurity wants to inject into us and, beyond this, to externalize the illusions that our fragile existences contain.

Working with signs, undoing their relations, altering their meanings, is exactly what the GAC has not stopped teaching us in these years and what today constitutes

an indispensable labor, since the abject totalization of the commodity-spectacle creates our mental horizons and serves us as a "second nature." But counter-performativity is not the work of just one group—rather is is a diffused political labor, a dissident affectivity that is constructed beyond the distinctions between "art and politics" in this common place where making is saying, demonstrating, inciting, fleeing, decoding, elaborating, instituting, and dramatizing our collective existence.

—Buenos Aires, February 2009

AFTERWORD TO U.S. EDITION

Ten years have passed since the publication of our *Thoughts, Practices and Actions* (2009). And we are very pleased that the translation collective Mareada Rosa and Common Notions decided to publish this version in English. Especially so in political contexts like the current ones, where GAC's actions resonate as contemporary, not only in Argentina but in other countries. For this edition in English, we updated the chapter "Actions and Projects," which contains an enumeration of works in chronological order, adding interventions, projects and expositions from recent years.

By way of an epilogue we have decided to include a series of texts that were made for the exposition marking twenty years of the GAC called "Liquidation Closeout Sale" (2017–2018). The authors are friends, militants and compañerxs, who are close to the GAC and who in turn form a part of our militant networks. The GAC exhibition was held in La Sala PAyS of the Parque de la Memoria, and for the first time in the group's history it was possible to rethink and elaborate an exhibition discourse, in a collective curatorial exercise and editing of our archive.

The following texts construct a contemporary analysis of the work of the GAC. Each text contextualizes, analyzes and discusses an area of the exhibition. These areas address issues or foci central to our work and are not chronological. This method of grouping work aims to give the process of collective actions a pride of place, and a visibility to fluctuating historical and social conjunctures, beyond the visual operation performed by the exhibition itself.

A LABORATORY OF SELF-EDUCATION

I've run into, more than once, people who assume that the GAC ceased to exist a while ago. They know the beginnings of the collective: their participation in the escraches promoted by H.I.J.O.S. since the mid-nineties, the subverted traffic signals with which they populated the neighborhoods in which the genocidists had lived quietly and which gave a visual identity to that form of radical political action that emerged to demonstrate against impunity and generate social condemnation. But apparently many lost sight of the group and took for granted its dissolution. One scene summarizes that perception in my memory. I think it was in 2004 or 2005. Lorena was late for dinner, after participating in an assembly of activists that brought together many young people for whom the GAC was an almost mythical reference. She had asked for the floor to propose something, and since the group had been invoked, she mentioned that she was part of it to the incredulous surprise of many: "Are you really from the GAC?" That night, while we were assembling sushi rolls with others, we laughed, surprised at the strangeness. There is something of an (un)self-fulfilling prophecy wherein some believe that the GAC no longer exists. The choice of group name (as a generic wild card that could designate everyone and anyone) and the decision not to sign their name to productions so that anyone could appropriate them and use them without permission, evidences a reversal of traditional modes of authorial construction. After the crisis unleashed in the GAC by the invitation to the Venice Biennial in 2003, when the group was catapulted (without passing through the intermediate stages) from street activism to one of the most glamorous and legitimizing events of the art world, its members decided to renounce what they did as "art," considering it rather as a specific type of militancy. That crisis erupted, no doubt, in the face of discomfort and interpellation by others, but what followed was not dissolution. From that experience the GAC emerged reaffirmed and convinced of the need to ignore or drastically limit invitations from the artistic circuit. It is therefore highly unlikely to meet the members of the GAC at an opening or in any of the instances of sociability typical of the art world. And, in counterpoint, there is a very good chance of finding them militating in the streets, in mobilizations, in conflicts. In Buenos Aires, in Trelew, in Ingenio Ledesma, in São Paulo, in Mexico City, in the center or at the end of the world. Insisting and inventing their resources. Propagating and mutating their ways of doing. Transmitting and mixing with many other groups and social movements. Meeting on Mondays, every Monday. Across many years. Twenty years. And more.

But many others know (and we know) that the GAC is alive, continuously advancing its actions and interventions since 1997, in a persistent and essential course. If that has been partially invisible to the art world, it is because what GAC does escapes from its codes and occurs beyond its scope. On this point, I wonder

about the effects that this recapitulation exercise of two decades of work can have, and above all the fact that it occurs in the Parque de la Memoria, a key node within the local artistic scene and at the same time a site of unforgettable tragedy within the collective memory of recent Argentine history. It is from this double, and simultaneous, condition that the Parque de la Memoria is able to generate a site to house this unusual exhibition, which gathers records and documents from a cluster of practices that happened and continue to happen in the streets.

The history of the GAC is, on the other hand, a crucial chapter (known only partially) within the intense and prolific saga of artistic activism since the beginning of the twentieth century in Argentina. Crucial, I say, especially when it comes to establishing a bridge or exploring the relationship between the most recent activism and that which emerged in the eighties, during the period from the end of the last dictatorship to the beginning of the post-dictatorship. This is an era that has been blurred, invisible, or opaque before the mythical dimensions that the process of artistic and political radicalization of the sixties has acquired, in particular the collective action "Tucumán Arde" (1968). It was in this difficult situation marked by state terrorism that new ways of articulating art and politics emerged, from the use of creative resources that pushed the human rights movement to make visible the public demand for the 30,000 disappeared, to sexual dissidence and the emergence of underground territories, liberated spaces in which a "strategy of joy" was experimented with (in the words of Roberto Jacoby) as another way of confronting terror. The new cycle of artistic activism that begins in the mid-nineties (not only in Argentina but also in many other parts of the world) connects with this history via strong ties that are not always manifest but intense and direct, in terms of biographical trajectories and also in terms of consonance in method. I refer in particular to the links that can be drawn between the graphic actions carried out in those years by Juan Carlos Romero, the CAPaTaCo group and the artists who promoted the Siluetazo, Rodolfo Aguerreberry, Julio Flores and Guillermo Kexel, in articulation with the human rights movement headed by the Mothers and Grandmothers of Plaza de Mayo, and its reverberation in the GAC and in other collectives that emerged later, after 2001. (In fact, Romero, Flores, and Kexel were teachers at the Prilidiano Pueyrredón School and their classes were attended by Lorena, Charo Golder, and Mariana Corral, members of the GAC since its inception: an example of instances of transmission of a shared legacy between generations of artists-activists and also of a web of affective complicities.) There is a direct dialogue between Romero's graphic installations such as "Violencia" (CAyC, 1973) and the poster prints that have interrupted or cut words, which the artist (from 1995 onwards) put up in the streets or in various artistic events, and the GAC's intervention "Danger Banner," which interfered with the buildings of the Congress, the Casa Rosada and the Ministry of Economy with a police-crossing type tape, on which the words "exclusion," "unemployment," "hunger," "repression,"

"impunity" repeat, delimiting a temporarily autonomous space within the context of the protests and marches of December 2001. Or the clear affinity between the "forbidden soldier" icon, the profile of a soldier crossed by a red diagonal line that was printed by CAPaTaCo for the marches against the Punto Final and Obediencia Debida in the eighties, and the logo "Justice and Punishment" that the GAC printed on banners and affixed to streets from 1999 onwards. Or, also, the action that in 1998 pushed the GAC together with the group Etcétera to mark the deaths of construction workers due to the lack of safe working conditions along Corrientes avenue, painting together silhouettes of fallen bodies on the pavement, in a direct allusion to the procedure of the Siluetazo: using the body to give a trace of what is not there.

All these references and imbrications, far from being a detriment of the "value" of the practices, as the art world's preferred terms of originality or authorship might have it, contribute to thinking of activism as a reservoir, an available toolbox, "an actually useful knowledge."[1] In these coordinates, this exhibition can also be thought of as a pedagogical experiment, of self-education, in that it rehearses forms of transmission for activist experiences since the nineties to the most recent activisms. Not as a mere archaeological exercise but as a "memory of the present"[2] able to sharply question the darkness of today, to agitate and disrupt it, and at the same time to let us know in what genealogies (interspersed and sometimes inaudible) we can recognize ourselves.

Or could we not go out today to paper the streets with the posters of the campaign which the GAC launched as part of the Anti-Monument Commission of Julio A. Roca, "New Evictions Patagonia 2004," which emulates the colorful publicity of Benetton to denounce the eviction of Mapuche families at the hands of this company that has accumulated hundreds of thousands of hectares in Patagonia during the Menem regime? Or disguise ourselves as cows (as the members of the GAC did at the Book Fair in 2006) to draw attention to the old and new complicities between the Argentine State and the Sociedad Rural (Rural Society)?[3] Where is Santiago Maldonado?[4]

—Ana Longoni

1 "An Actually Useful Knowledge" (Un saber realmente útil) was the title of an exposition of activist art by the What, How and for Whom collective in the Reina Sofia Museum in Madrid in 2014 and which makes reference to the nineteenth century workers self-education movement.

2 In the words of Roberto Gargarella.

3 Sociedad Rural (Rural Society) is a business association of the largest landholders in Argentina. [Trans. note]

4 Santiago Maldonado participated in a roadblock in support of a Mapuche community on August 1, 2017 and then disappeared. His body was found months later and it is suspected that he was forcibly disappeared and killed by Argentine state police forces. [Trans. note]

ZONE 0

Can you remember how your great friendships, your most intense loves were born? Don't think about those connections that are long-living. Nor those that stretch only a few years. Think of those encounters that change us forever. They usually start more or less in the same way: a casual crossing, a coincidence in space and time, a spark that ignites and turns two strangers into part of the same family.

At the moment we cannot register it, but over the years these moments become epic. They are the myths that build our biography. We review them and they seem as fragile as they are decisive. Would I have missed knowing the love of my life if one January afternoon I had not turned that corner? What would have happened to our lives if that morning I did not take a stand and instead followed my family's advice to study chemistry? What if I was placed into another cohort upon admittance to art school?

If you can find such a moment in your memory, if you have ever experienced that vibrant moment that brought you together forever with others, then you can understand how the GAC was born.

Because we are not just a political art collective. The GAC is a vital experience. Did it start because one of them arrived late for the first day of a drawing class and sat next to the other one? Why were two art students given the same group project? Did it start during a causal conversation during a train ride?

The magic of chance only has an effect when the conditions for synchronicity are there. That happened with the GAC. Imagine that group of girls in their early twenties in 1997. In Buenos Aires, teachers are on hunger strike in front of Congress. In the south, the piqueteros are facing off with the police. The group H.I.J.O.S. was pointing out the houses of genocidists. The model of the nineties began to crack everywhere. There were still those who went to Miami, but unemployment was already raging.

Every Sunday, they met in a house to eat noodles. Sharing food was the first ritual before going out. They had few rules: you had to go dressed in black, respect the notions of "minimum coexistence" and take a picture at the end of the activity. One of the records shows them sitting on the floor against a wall: all in dark uniforms and their mouths covered with a white cloth. The first murals were in support to the teachers of the white tent. They used different materials, sometimes rather precarious: real overalls glued to the walls, held in place with grout and burned with a torch to mark their outline. Over the weeks their resources became classic and cheaper: ferrite and lime. That activity was sustained for a whole year. Every Sunday they painted a different mural. Sometimes the group was reduced to the original nucleus; others times, upwards of twenty people. "There are people who find out"

the GAC compas would write later telling their own story, "and who want to participate without really knowing what it is about."

The group became an organism with the capacity to expand and contract. Over the years, they managed to define its contours in a very natural way. In the photos of those days, we can see, repeated, the faces of those who would later be its permanent members. We see everyday situations, partying, and others of pure public and collective activity. That's what the GAC is about. It is the party to which we were invited, it is the public space intervened in, the symbols of the city subverted to give us new messages.

When the images of those years were taken they could not know it, but they were writing the first chapters of a story as intimate as it was public. A story that would not only build its own biographies, it would also leave its indelible mark on a whole era.

—Sebastián Hacher, journalist.

ZONE 1
ESCRACHE: MEMORY MADE VERB

What's here around us speaks of the same history. If you lived it, if you remember it, if it was told to you or if you are getting to know it, this moment smells like burned rubber in a road blockade; it is white in color because there are teachers hunger striking in a tent in front of Congress; hunger is being fought with cooperative cooking, at the ninth district police station in La Plata, Miguel Brú has disappeared; every Wednesday retired people march for their rights; Walter Bulacio is being tortured in the thirty-fifth police district station to his death; the genocidal Scilingo narrates on television what the flights of death were; the genocidists cannot be judged under the laws of impunity (Obediencia Debida and Punto Final).

An entire society coexists with the genocidists: military personnel and civilians who were part of the state terrorism that existed between 1976 and 1983, but which had begun before and which took a long time to finish. In the bakery, in the elevator, with the uniform on, are those who kidnapped, tortured, disappeared, murdered, stole babies, raped people who were arrested or disappeared, indebted the country, gave away sovereignty, forced thousands into exile, censored: they committed crimes against humanity.

Impunity is everywhere. The Mothers, Grandmothers, Fathers, Relatives, Survivors, continue fighting for Memory, Truth and Justice. The white handkerchiefs are out every Thursday in the Plaza de Mayo. A group of sons and daughters of genocide victims begin to gather and organize. They are named: H.I.J.O.S. (Sons and Daughters for Identity and Justice against Forgetting and Silence). And they make another decision: to fight for Justice and the Punishment of the genocidists. There they become comrades of the GAC and shout through the neighborhoods: If there is no justice, there is escrache!

In 1996, the escraches began to denounce judicial impunity. The drums of La Chilinga are already sounding. There are already artists who ask how to participate. Those social bonds that the last civic-military dictatorship tried to destroy through fear, are remaking themselves here. Judicial impunity is answered in the neighborhoods with social condemnation. Collectively, with the neighbors, with talks in the squares, schools and other places, the escrache seeks to cement the repudiation of the genocidists. The escrache, in a certain way, emerges as a reaction that then organizes itself as action.

In the street, painting the pavement or cobblestones, hanging signs to indicate where a genocidist lives, the escrache shows that if a government does not judge, condemn and put the genocidist in jail, the people can imprison them in their homes.

Maybe you are one of the neighbors who applaud from the balcony, or who stops cooking and joins the escrache, or who knows that the neighborhood harbors a genocidist and points them out to be escrached. A nightmare for spell checkers, difficult to pronounce in certain countries, a question for some, a conviction for others, the escrache is memory in action.

Five hundred meters ahead a genocidists lives, warn the signs of the GAC. "Here live genocidists," says a map that calls on society to think about space: in all those marked houses, a genocidist lives. The neighbors realize that genocidists live in these neighborhoods and look to see if one lives in their neighborhood or to provide a piece of missing information. Because the escrache is that: a collective rebellion against impunity.

After weeks of working in the neighborhood, the escrache arrives. We go from the square to the house. Let's say who the genocidist is and what he did. There is dancing, singing, emotions. We start walking and we walk the streets. From the windows they look, until they begin to join. And we are more and more. We arrive. Some megaphone or microphone will start saying, "Like with the Nazis: wherever they go we will look for them" and the song will start again every time you hear "olé, olé, olé, olá." Here, in front of the door behind which he lives in impunity, we name the crimes of the genocidist. And the paint is already on the wall: here lives a genocidist. It is there now, the paint is still fresh, it will say it tomorrow and every day. Every time someone passes, they will know who lives there and what they did. This is not a neighbor: it is a genocidist. We start to leave, but we come back. Now there is music on these corners where we are saying goodbye in the middle of the street. Tomorrow, when the genocidist goes to buy the bread, the escrache will be a verb.

—H.I.J.O.S. Capital
(Sons and Daughters for Identity and Justice against Forgetting and Silence)

ZONE 2

FROM THE DOCTRINE OF NATIONAL SECURITY TO THE DOCTRINE OF SOCIAL SECURITY

The return to the functioning of constitutional institutions in 1983 meant an enormous hope for the Argentine people, quickly frustrated by the continuity of an unjust political, economic, social and legal system that institutionalized impunity and conserved the repressive apparatus, adapting it to the needs of the new era of formal democracy.

"THE DOCTRINE OF NATIONAL SECURITY," which until that moment had as its main actor—but not the only one—the Armed Forces, is reformulated as "THE DOCTRINE OF SOCIAL SECURITY," with the police (both provincial and federal) becoming its main—but not only—actor.

The police become daily news due to the tortures that are carried out in police stations, for arbitrary arrests, for cases of forced disappearances and especially for the many deaths by means of what came to be called "hair trigger."

In May 1986, the Ingeniero Budge massacre took place, where for the first time a whole neighborhood organized to fight against this repressive tactic. From there emerged the expression "hair trigger" when one of the lawyers of the families of the victims, Dr. Leon "Toto" Zimerman, took an expression of Rodolfo Walsh referring to "trigger happy" and reformulated it as "hair trigger," an expression that over the years was popularized to name murders committed by members of the security forces in Argentina.

The group that came to together to fight the Budge Massacre arrived at the conclusion that the way to confront this repressive tactic was through unity, organization and struggle. The relatives and neighbors of the victims of "hair trigger" killings began to realize that this fight must occur in the courts and on the streets.

"Hair trigger" killings usually result in an "easy acquittal," endorsed by the justice system, with the necessary and essential participation of the spheres of political and economic power.

To all this is added the so-called "discourse of insecurity," which by manipulating "public opinion" identifies delinquency with the impoverished sectors of society.

The theory that to guarantee the safety of citizens requires an "iron fist" was definitively launched at the end of the nineties, when the country became an experimental test site for the "broken window doctrine" and others emerging from the factories of North America thought with William Bratton at their head. Under the pretext of crimes against property, the official or unofficial media sold this idea to the middle classes seeking to obtain and broaden the consensus to facilitate social control and repression.

But the "war on crime" does not stand alone: as popular resistance grows to exclusionary socioeconomic policies, the system's need to try to discipline those who confront it increases, even in response to small concrete demands. This is what we call the "criminalization of protest."

The police presence in social mobilizations is threatening and massive; the harassment by security forces of trade unions or social leaders or activists increases; an intolerant and intimidating discourse is imposed on those who demand salary, employment, or education; multiple legal cases are initiated against leaders of social movements for crimes allegedly committed during protests; the imprisonment of militants for political reasons increases. In short, we are again branded as "terrorists" but this time by the "law" and everything. It is an action directed at organized popular sectors, usually social movement leaders, often ones with a certain political education. All this comes combined with direct repression against organized militancy, which has over the years expanded its list of victims to include those like Carlos "Petete" Almirón, Darío and Maxi, Carlos Fuentealba and Mariano Ferreyra, to name just a few. Add to these the forced disappearances of Jorge Julio Lopez in 2006 and Santiago Maldonado who, on August 1, 2017, was kidnapped by the police in the context of a brutal repression carried out in the presence of one of the top officials of the Ministry of National Security.

We can say that at present the popular sectors suffer from the combination of these two relatively different repressive methodologies. Although there exist, in between each, gray areas that prevent an absolute and sharp differentiation, the truth is that the distinction is useful for understanding these new forms of social control, in permanent evolution.

We can say that the GAC—with that exact combination of art and resistance that distinguishes them—has directly participated in the fight against both methodologies.

We can say that this retrospective is a collective invitation to continue on that path.

—Sergio "Cherco" Smietniansky

ZONE 3
CRISIS OF NEOLIBERALISM

The words crisis and neoliberalism are used together frequently. But the combination which is least often used is what produces the present zone: the crisis of neoliberalism. A zone of street and neighborhood dispute. A zone where affects (fear and anger, discomfort and celebration) were woven into the open air. A zone that the GAC marked with concrete, forceful, anticipatory actions.

The crisis of neoliberalism happened when its legitimacy fell apart, on the edge of the new century. It was not magical or spontaneous. The crisis was produced by a desire to question the neoliberal normativity that was imposed with a quiet violence. It was not a purely macroeconomic phenomenon or the result of calculations (good or bad) of elites. The crisis of neoliberalism is unthinkable without the subjectivities of the crisis: those practices and words with which we pushed against it and named it; those practices and words with which we lived in it without knowing how those days would end. The crisis of neoliberalism is today, also, a memory always alive in that way of being in the crisis. Memory and remembrance in our collective body of a way of saying enough is enough!

Exclusion and precarization were consecrated in Argentina with the phenomenon that marked the last years of the nineties: unemployment. The set of "musical" chairs that the GAC installed as street choreography in 2000 showed that sinister dance which they wanted to force us to see. Some pushing others out of the way, each seized by the desperation of seeing their neighbor as a threat. The proposal from above was simple: the competitive management of scarcity as a frantic game. The crisis of neoliberalism began when many people stopped participating in this game of musical chairs and began to organize as unemployed movements. The crisis of neoliberalism had these movements as its main architects and doers.

The crisis of neoliberalism was also the way in which we managed to denounce the complicity of the political system, resonating with that machine of popular justice that was started by the escrache. The banner with the phrase "Liquidation Closeout Sale," with which the GAC surrounded the Congress, synthesized, also in 2001, what some time later would be consecrated in that popular chant that "emptied" the institutions of legitimacy and that pushed them to the edge of the abyss: "¡Que se vayan todos!" That banner of "Liquidation Closeout Sale" was already etched on our retinas: we had seen it in factories and shops at the height of the privatization booms. Now the slogan was reversed: the action of the GAC displaced the sense and, when wrapped around the Congress, evidenced how the complicity between the state and certain companies (national and transnational) in favor of the interests of the capital had been continued. What had been cemented in the last military dictatorship was enshrined under "democratic" procedures.

Faced with these signs, we saw that neoliberalism planned a last "invasion": as predicted by the GAC, soldiers in pink parachutes flew from the windows of Buenos Aires in a strategic and surprise landing, while stickers of tanks and missiles appeared on banks and advertisements. They were the last signs of that neoliberalism that believed itself to be safeguarded by the financial "bullet proofing" with which the credit agencies relaunched the public debt and which the government of that time celebrated. The action "invasion" happened between December 16 and 19, 2001. The "invasion" ended when the popular uprising began. That uprising was what really inaugurated the crisis of neoliberalism. That zone that the GAC, with its mode of street intervention, had been marking out, anticipating with images, as when one almost has a premonition of things to come.

There is no crisis that does not produce counterattacks afterwards. After came repression and eviction. The GAC invented an institution of the future: the Ministry of Control. Through surveys that formatted citizen consensus, the Ministry organized the eviction of everything that hindered business. Spaces occupied by "unemployed" workers were especially targeted for displacement. It happened in San Telmo to allow real estate gentrification at the hands of a museum and in the Brukman textile factory, an icon of the factories recovered by their workers. Events against eviction and repression began to remake the city, aiming to conjure up the memory of the crisis and that untimely commune that lived in factories and pickets, in assemblies and escraches.

"The crisis of neoliberalism" is the mark of history. The unforgettable luster of historicity. That which makes us "remember" and "know" (a sensual and intellectual, corporeal and imaginative knowledge) that we have the collective capacity—furious and cheerful, desperate and contingent—to put neoliberalism in crisis. And today we say neoliberalism taking into account its renewed "invasions" (each time testing out new weapons). Therefore, it is not by chance that the GAC banner "Liquidation Closeout Sale" is not a museum work or a historical artifact: it returned to surround Congress last year.

—Verónica Gago, CONICET researcher
and member of Tinta Limón publishing

ZONE 4
19&20

Ten days after one of the bloodiest repressions suffered by our people in the democratic period, shortly after the fateful end of 2001, when the government of the day gave powers to the police to kill 39 Argentines, we were alone. The only call we received was from the GAC. We began to mourn. Our fallen and our, at first vague emotions, slowly became a reflection of a pent-up rage, with the weight of our fallen upon our shoulders.

We were putting together the phrases, the ceramics, the writing and the baking of the plaques that recalled what their relatives wanted to remember of them.[5] Always with the doubt that it was not what they wanted.

Facing the police made us strong in the street, gave us courage to denounce, pushed us into the fight.

We walked every month, on the 20th, during the first year, the same streets that those who took a stand walked and where they fell.

The silence of many before these injustices marked out a territory, it was located in the sidewalks, in the walls, in the songs of protest, in the loud voices, in the sweat, in the air.

We lived together, the crying and the anger of having lost our relatives.

We had to put up with the plaques being removed. They vandalized our memories. Forever.

In moments of great pain, the GAC comrades knew how to find the right words, which we could not say.

They had the courage to break with structures, even in times of disillusionment.

When everything seemed lost.

They taught us to explode ourselves, from art, against injustice and impunity. Ideas of a handful of people were transformed into a collective action preventing forgetfulness from doing its work and finding its place.

They urged us to fight from street art, from where our companions left their lives.

From the commitment, to be together, with incessant companionship, we uncovered the ability to turn into love, the sudden pain, even if they continue to hurt us. Being able to confront those who killed, dressed in their murderous uniforms, ignited our desire to continue on this path, not without disappointments, not without failures, with great despair, but with the certainty of having done the impossible.

From the interventions of the GAC, our streets speak. They are not mute, because it could be translated into street art, the violence exerted against the people, and the response of the victims, punishing the perpetrators.

5 See pages 133–137 of this book. [Trans. note]

The suffering became a scream, a single scream, wiping away the tears, unfolding the banners, scattering the smoke left by the ashes of spilled young blood, to be able to shout loudly:

GASTÓN RIVA, PRESENT!
ALBERTO MÁRQUEZ, PRESENT!
DIEGO LAMAGNA, PRESENT!
CARLOS ALMIRÓN, PRESENT!
GUSTAVO BENDETTO, PRESENT!
OUR FALLEN LIVE ON IN OUR STRUGGLE.

—María Arena, partner of Gastón Riva,
killed by police repression on December 20, 2001

ZONE 5
ANTI-MONUMENTS, DE-MONUMENTALIZATIONS, AND POPULAR MONUMENTS

What names identify our streets, schools and cities?
Who do we want to remember or claim?
Who do we forget?
How many identities are erased each time a monument is erected?

Every monument refers to or has its origin in the past, it is something that is already given. It represents a version of an historical fact or actor validated by inherited tradition. The materiality of a monument carries an idea of solidity and durability through the ages. The stone, the bronze, the marble, the concrete, the iron, the steel: they are materials that bear the weight of their physical qualities and the history that ratifies them. A materiality usually more immutable than the ideological models that ground it.

The struggles that began in the mid-nineties with the crisis of neoliberalism not only questioned the implementation of an economic model but also the imposition of a symbolic system that has left out of history for more than five hundred years the cultural identities that pre-existed the colonial invasion. This symbolic system was consolidated in Argentina during the generation of '80, in the formation of a national state that looked to European models. Not coincidentally most of the monuments that "adorn" public spaces were erected in this period, copying the aesthetic models of the invading culture. This process is observed in all countries with a colonial past.

But when these versions of history begin to be questioned, a de-monumentalization process begins. Faced with these solidified forms, new demands for meaning arise. Challenging a monument implies deconstructing it, denouncing it. We speak of an anti-monument as the negative of that official version, as an opposition, and at the same time also as an affirmation of a new emergent subjectivity.[6] In our approach we take the concept beyond the field of art, moving towards the intersection between poetic discourse and militant political practice.

6 The concept of anti-monument or counter-monument is taken from James E. Young, who refers to the works of a generation of artists, above all in post-Holocaust Germany such as Horst Hoheisel. The Nazis used the monumental to glorify their ideology, therefore the language used to remember their victims can never be similar. However well-intentioned a monument may be, it will always pose a problem: it functions as a definitive solution to the subject of memory, taking responsibility away from subjects for the work of keeping it alive. To avoid forgetting, one must remove the viewer from their comfort zone and place them face to face with the task of reflecting on the experience.

The social movements in Argentina and other Latin American countries produced their own forms of anti-monumental symbol making, while at the same time creating other forms of recalling their struggles and the memory of their martyrs. The human need to build memorial sites occurs without the permission of the state or the market. We could consider these productions as popular monuments, emerging from the de-monumentalizing processes that took place in Argentina in 2001. The anti-monument entails a reactive intervention on the objected to monument (direct actions, graffiti, acts of repudiation, etc.), while a popular monument promotes the visibility of what is overlooked.

The popular monument does not need noble materials, accepting the possibility of its own destruction. It does not impose itself, but rather mixes with the living environment, dialogues and is permeable to constant transformation by its co-creators and observers. It goes beyond the simple commemorative charge: it involves taking control of the machinery of symbolic production itself.

The popular monument and the anti-monument are generators of strong political and territorial disputes, triggers of conflicts in the contexts in which they arise. The maintenance of these practices over time exerts a real political pressure that, given the conditions, allows for official recognition and validation, as seen in the case of the approval of the name change laws of certain sites (Darío Santillán and Maximiliano Kosteki Station, Rodolfo Walsh Station), and even the creation of new monuments (Juana Azurduy).

We are currently observing a strong retreat from these conquests. A new conservative restoration has been advancing on the horizon. The images that represent us and for which we have struggled for so long are now the target of a new attempt at concealment. We are facing an unalterable logic in which every new position of power tends to erase and punish dissidence. The owners of almost everything return to claim the everlasting bronze and the total occupation of the screens. It will be a question then of ingeniously supporting the periodic renewal of our memories and overthrowing the pedestals of post-truth.

—Mariana Corral, member of the GAC

ABOUT THE AUTHOR

Grupo de Arte Callejero (GAC), Group of Street Artists, formed in 1997 out of a need to create a space where the artistic and political could be collectively reappropriated as a single means of production. Their work blurs the boundaries between militancy and art and develops confrontational forms and strategies that operate within determined contexts: the street, the occupation, the demonstration. From the beginning, their work has searched for a space for visual communication that escapes the traditional circuit of exhibition and exploitation, taking the appropriation of public spaces as its central axis of production. A large part of their work is anonymous in character, which allows for the continued elaboration of these practices and methodologies by like-minded individuals or groups. Many of their projects have emerged as collective constructions with political movements, groups, and individuals, creating a unique dynamic of production that is in permanent transformation due to this constant exchange and putting into political practice.

ABOUT THE TRANSLATORS

Mareada Rosa is a translation collective based in Michigan interested in bringing critical work in the areas of politics and culture from North and South America into English. Its members are Catalina Esguerra, Laura Herbert, Hilary Levinson, María Robles, Brian Whitener and Silvina Yi.

ABOUT COMMON NOTIONS

Common Notions is a publishing house and programming platform that advances new formulations of liberation and living autonomy.

Our books provide timely reflections, clear critiques, and inspiring strategies that amplify movements for social justice.

By any media necessary, we seek to nourish the imagination and generalize common notions about the creation of other worlds beyond state and capital. Our publications trace a constellation of critical and visionary meditations on the organization of freedom. Inspired by various traditions of autonomism and liberation—in the U.S. and internationally, historically and emerging from contemporary movements—our publications provide resources for a collective reading of struggles past, present, and to come.

MONTHLY SUSTAINERS

These are decisive times, ripe with challenges and possibility, heartache and beautiful inspiration. More than ever, we are in need of timely reflections, clear critiques, and inspiring strategies that can help movements for social justice grow and transform society. Help us amplify those necessary words, deeds, and dreams that our liberation movements and our worlds so need.

Movements are sustained by people like you, whose fugitive words, deeds, and dreams bend against the world of domination and exploitation.

For collective imagination, dedicated practices
of love and study, and organized acts of freedom.

By any media necessary.

With your love and support.

Monthly sustainers start at $5, $10 and $25.

At $10 monthly, we will mail you a copy of every new book hot off the press in heartfelt appreciation of your love and support.

At $25, we will mail you a copy of every new book hot off the press alongside special edition posters and 50% discounts on previous publications at our web store.

Join us at commonnotions.org/sustain.

MORE FROM COMMON NOTIONS

19 & 20: *Notes for a*
New Social Protagonism

Colectivo Situaciones

Translated by Nate Holdren and
Sebastián Touza

978-1-942173-03-8
$20.00
264 pages

In the heat of an economic and political crisis, people in Argentina took to the streets on December 19th, 2001, shouting "¡Qué se vayan todos!" These words – "All of them out!" – hurled by thousands banging pots and pans, struck at every politician, economist, and journalist. These events opened a period of intense social unrest and political creativity that led to the collapse of government after government.

Colectivo Situaciones wrote this book in the heat of that December's aftermath. As radicals immersed within the long process of reflection and experimentation with forms of counterpower that Argentines practiced in shadow of neoliberal rule, Colectivo Situaciones knew that the novelty of the events of December 19th and 20th demanded new forms of thinking and research. This book attempts to read those struggles from within. Ten years have passed, yet the book remains as relevant and as fresh as the day it came out. Multitudes of citizens from different countries have learned their own ways to chant ¡Qué se vayan todos!, from Iceland to Tunisia, from Spain to Greece, from Tahrir Square to Zuccotti Park. Colectivo Situactiones' practice of engaging with movements' own thought processes resonates with everyone seeking to think current events and movements, and through that to build a new world in the shell of the old.

Zapantera Negra: An Artistic Encounter Between Black Panthers and Zapatistas

Edited by Marc James Léger
and David Tomas (Editor)

978-1-942173-05-2
$20.00
232 pages

What is the role of revolutionary art in times of distress? When Emory Douglas, former Minister of Culture of the Black Panther Party, accepted an invitation from the art collective EDELO and the Rigo 23 to meet with autonomous Indigenous and Zapatista communities in Chiapas, Mexico, they addressed just this question. *Zapantera Negra* is the result of their encounter. It unites the bold aesthetics, revolutionary dreams, and dignified declarations of two leading movements that redefine emancipatory politics in the twentieth and twenty-first century.

The artists of the Black Panthers and the Zapatistas were born into a centuries-long struggle against racial capitalism and colonialism, state repression and international war and plunder. Not only did these two movements offer the world an enduring image of freedom and dignified rebellion, they did so with rebellious style, putting culture and aesthetics at the forefront of political life. A powerful elixir of hope and determination, *Zapantera Negra* provides a galvanizing presentation of interviews, militant artwork, and original documents from these two movements' struggle for dignity and liberation.

Finally Got the News: The Printed Legacy of the U.S. Radical Left, 1970–1979

Edited Brad Duncan
and Interference Archive

978-1-942173-06-9
$27.95
256 pages

Finally Got the News uncovers the hidden legacy of the radical Left of the 1970s, a decade when vibrant social movements challenged racism, imperialism, patriarchy and capitalism itself. It combines written contributions from movement participants with original printed materials—from pamphlets to posters, flyers to newspapers—to tell this politically rich and little-known story.

The dawn of the 1970s saw an absolute explosion of interest in revolutionary ideas and activism. Young people radicalized by the antiwar movement became anti-imperialists, veterans of the Civil Rights and Black Power movements increasingly identified with communism and Pan-Africanism, and women were organizing for autonomy and liberation. While these movements may have different roots, there was also an incredible overlapping and intermingling of activists and ideologies.

These diverse movements used printed materials as organizing tools in every political activity, creating a sprawling and remarkable array of printing styles, techniques, and formats. Through the lens of printed materials we can see the real nuts and bolts of revolutionary organizing in an era when thousands of young revolutionaries were attempting to put their beliefs into practice in workplaces and neighborhoods across the U.S.

Abolishing Carceral Society
Abolition Collective

978-1-942173-08-3
$20.00
256 pages
20 Illustrations

Beyond border walls and prison cells—carceral society is everywhere. In a time of mass incarceration, immigrant detention and deportation, rising forms of racialized, gendered, and sexualized violence, and deep ecological and economic crises, abolitionists everywhere seek to understand and radically dismantle the interlocking institutions of oppression and transform the world in which we find ourselves. *Abolishing Carceral Society* presents the bold voices and inspiring visions of today's revolutionary abolitionist movements struggling against capitalism, patriarchy, colonialism, ecological crisis, prisons, and borders.

Abolition Collective masterfully assembles this collection of essays, poems, artworks, and interventions to create an inciteful articulation and collaboration across communities, movements, and experiences embattled in liberatory struggle. In a time of mass incarceration, immigration detention and deportation, rising forms of racialized, gendered, and sexualized violence, and deep ecological and economic crises, abolitionists everywhere seek to understand and dismantle interlocking institutions of domination and create radical transformations.

In the Name of the People

Liaisons

978-1-942173-07-6
$18.00
208 pages

The ghost of the People has returned to the world stage, claiming to be the only force capable of correcting or taking charge of the excesses of the time. *In the Name of the People* is an analysis and reflection on the global populist surge, written from the local forms it takes in the places we inhabit: the United States, Catalonia, France, Italy, Japan, Korea, Lebanon, Mexico, Quebec, Russia, and Ukraine. The upheaval and polarizations caused by populist policies around the world indicates above all the urgency to develop a series of planetary revolutionary interpretations, and to make the necessary connections in order to understand and act in the world.

How do we distinguish the new from the old? What are their limits and potentials? What is the nature of the affective flows that characterize their relations? How do we address the indeterminacy inherent in mass movements and mobilizations, as well as their confusions, fears, and hesitancies? This truly internationalist and collectivist publication boldly examines the forms of right and leftwing populism emergent in the fissures of the political world. Experimental in both form and analysis, *In the Name of the People* is the commune form of thought and text.

An Encyclopedia of Political Record Labels,
3rd edition

Josh MacPhee

978-1-942173-11-3
$24.95
208 pages

An Encyclopedia of Political Record Labels is a compendium of information about political music. Focusing on vinyl records, and the labels that produced them, this groundbreaking book traces the parallel rise of social movements in the second half of the twentieth century and the vinyl record as the dominant form of music distribution.

From A-Disc (the record label of the Swedish Labor Movement) to Zulu Records (the label of free jazz pioneer Phil Choran), *An Encyclopedia of Political Record Labels* is a compelling panorama of political sound and action, including over 750 record labels that produced political music. Each entry features the logo of the label, a brief synopsis of its history, and additional interesting information. International in scope, over two dozen countries and territories are represented as well as a myriad of musical styles and forms.

MORE FROM COMMON NOTIONS

For Health Autonomy: Horizons of Care Beyond Austerity—Reflections from Greece

CareNotes Collective

978-1-942173-14-4
$15.00
144 pages

The present way of life is a war against our bodies. Nearly everywhere, we are caught in a crumbling health system that furthers our misery and subordination to the structural violence of capital and a state that only intensifies our general precarity. Can we build the capacity and necessary infrastructure to heal ourselves and transform the societal conditions that continue to mentally and physically harm us?

Amidst the perpetual crises of capitalism is a careful resistance—organized by medical professionals and community members, students and workers, citizens and migrants. *For Health Autonomy: Horizons of Care Beyond Austerity—Reflections from Greece* explores the landscape of care spaces coordinated by autonomous collectives in Greece. These projects operate in fierce resistance to austerity, state violence and abandonment, and the neoliberal structure of the healthcare industry that are failing people.

For Health Autonomy is a powerful collection of first-hand accounts of those who join together to build new possibilities of care and develop concrete alternatives based on the collective ability of communities and care workers to replace our dependency on police and prisons.